Chagall

Patron

His Excellency Monsieur Emmanuel de Margerie
Ambassador of the French Republic

This exhibition has been made possible in Philadelphia by
The Pew Memorial Trust, The Bohen Foundation, CIGNA
Foundation, Knight Foundation, and an indemnity from the
Federal Council on the Arts and the Humanities. The
exhibition was made possible at the Royal Academy of
Arts, London, by The First National Bank of Chicago, The
Prince Charitable Trusts, and an indemnity from Her
Majesty's Government under the National Heritage Act
1980.

Susan Compton

Philadelphia Museum of Art

Royal Academy of Arts
January 11–March 31, 1985

Philadelphia Museum of Art
May 12–July 7, 1985

Library of Congress Cataloging in Publication Data

Compton, Susan P.
 Chagall.

 Catalog of an exhibition held May 12–July 7, 1985 at
the Philadelphia Museum of Art, originating at the Royal
Academy of Arts.
 Bibliography: p.
 1. Chagall, Marc, 1887– —Exhibitions.
I. Philadelphia Museum of Art. II. Royal Academy of Arts
(Great Britain) III. Title.
N6999.C46A4 1985 709′.2′4 85-3395

ISBN 0-87633-062-6 (pbk.)

Set in Monophoto Apollo, printed and bound by
BAS Printers Limited, Over Wallop, Hampshire, England
Color Separations by Newsele Litho Limited, Italy
Color printed in Italy by Printers Srl for L.E.G.O., Vicenza

Contents

Chagall

It was in Washington DC that I had the pleasure of meeting
Chagall for the first time, when he came for the inauguration
of the beautiful mosaic he did for John and Evelyn Nef's
house in Georgetown.

Since then, I saw him a number of times when I was the
head of the French Museums—at Nice, at Vence, and at
Paris—for instance, when the President of the French
Republic gave a luncheon in his honour and conferred upon
him the highest rank in the Légion d'Honneur on his
ninetieth birthday. And I have always had the rare feeling
that one had the privilege of seeing someone who already
belongs to history.

Two characteristics strike me in the personality of this
great painter: how modest he is, and also how intelligent.
He wants to look at his work with the objective eye of the
stranger, not only with the fatherly look of the creator: and
if he smiles with pleasure at the result, it is only after the
smallest fraction of doubt and heart-searching. 'Pauvre
Chagall!' he likes to say, talking about his wonderful life,
during which he has seen, gone through, and understood,
so much. His judgments on men and events are as
penetrating as his views on art; he has a strong sense of
spiritual values, tinged with sympathy for suffering. He also
keeps an air of faint surprise at the ways of the world,
always associated with a benevolent smile, which is deeply
linked to his attitude to life and to his painting.

Emmanuel de Margerie
Ambassador of the French Republic

Lenders to the Exhibition

CANADA
Toronto, The Art Gallery of Ontario

FINLAND
Helsinki, The Art Museum of the Ateneum

FRANCE
The Collection of the Artist
Estate of Aimé Maeght
Nice, Musée Marc Chagall
Paris, Fondation nationale d'art contemporain
Paris, Musée d'art moderne de la ville de Paris
Paris, Musée national d'art moderne, Centre Georges Pompidou
Saint-Paul, Fondation Marguerite et Aimé Maeght

WEST GERMANY
Cologne, Museum Ludwig
Düsseldorf, Kunstsammlung Nordrhein-Westfalen
Essen, Museum Folkwang
Hamburg, Kunsthalle
Stuttgart, Staatsgalerie

GREAT BRITAIN
d'Avigdor-Goldsmid, Lady
Clore, from the estate of the late Sir Charles
Estorick, Mr and Mrs E.
London, The British Library Reference Division
London, The National Art Library
London, The Trustees of the Tate Gallery
London, Trustees of the Victoria & Albert Museum
Newman, Hans

ISRAEL
Jerusalem, The Israel Museum
The Tel-Aviv Museum

ITALY
Venice, Museo di Arte Moderna

THE NETHERLANDS
Amsterdam, Stedelijk Museum
Eindhoven, Stedelijk Van Abbemuseum

SWITZERLAND
Basle, Kunstmuseum
Chagall, Ida
Diener, Marcus
Lugano, Thyssen-Bornemisza Collection
Zurich, Foundation E.G. Bührle Collection
Zurich, Kunsthaus

UNITED STATES
Abrams Family Collection
Albee, Edward
Baal-Teshuva, Mr and Mrs Jacob
Brown, Himan
Buffalo, Albright-Knox Art Gallery
Chicago, The Art Institute of
New York, The Solomon R. Guggenheim Museum
New York, The Jewish Museum
New York, Pierre Matisse Gallery
New York, The Museum of Modern Art
New York, Perls Galleries
Philadelphia Museum of Art
St Louis Art Museum
Serger, Helen
Sharp, Evelyn
Smith Miller, Katherine
Smith Miller, Lance
Westreich, Leslie and Stanley
Zeisler, Richard S.

Also many owners who prefer to remain anonymous

Foreword

It is more than thirty years since Marc Chagall, one of the greatest and at the same time most accessible of all twentieth-century European painters, enjoyed a major museum exhibition of his work in Great Britain or in the United States. The Royal Academy and the Philadelphia Museum of Art are particularly proud, therefore, to join hands in celebrating, with the fullest support of Marc Chagall and his wife and daughter, the lifetime achievement of a most remarkable artist.

Marc Chagall was born in 1887 in Vitebsk in Russia. He came to St Petersburg, as it then was, in 1907 and found his way to Paris in 1911, returning to Russia before the Revolution. Already, he was closely involved with many of the greatest painters and poets of his time. Throughout his life he continued to recall and then transmute, with an ever increasing intensity of colour, the memories of his youth in Russia. These, as if in a dream, have been combined in his work with the experiences of his life in France and elsewhere. It is perhaps now, more than ever, that we can fully realize the significance of Chagall's painterly achievement. In addition to his paintings there are his extraordinary contributions in other media, in the areas of print-making, drawings and watercolours, in his designs for stained glass, mosaics and tapestries, and in particular perhaps his work for the theatre. His indeed has been a full and enriching lifetime's work. This exhibition, we hope, will give a memorable impression of Chagall's unique view of our world.

Over the last twelve months a number of very important exhibitions devoted to the work of Chagall have taken place in Europe. Among these, pride of place must go to the exhibition of paintings at the Fondation Maeght, Saint-Paul, close by Chagall's own house, mounted last summer in honour of the artist's ninety-seventh birthday. In addition, an important travelling exhibition of Chagall's works on paper was inaugurated at the Musée National d'Art Moderne in Paris in June, while an exhibition of designs and maquettes for stained glass was shown at the Chagall Museum in Nice, where is housed the celebrated cycle of paintings of the Biblical Message. Finally, a retrospective exhibition of his work is being held at the Beyeler gallery in Basle, a city with which Chagall has many connections.

As always we must express our thanks to all those connected with this exhibition. To Jean Louis Prat, Director of the Fondation Maeght, Dominique Bozo, Director of the Musée National d'Art Moderne, Sylvie Forestier of the Musée Chagall in Nice, Pierre Provoyeur at the Académie de France in Rome and Ernst Beyeler, who have offered us every assistance in the realization of this project. Of our colleagues who have been involved in the organization of the exhibition, none has borne a heavier responsibility than Dr Susan Compton, who has chosen the paintings and has been indefatigable in the many complex arrangements for this exhibition. She has written and edited a catalogue that will surely stand as a major contribution to the understanding of the artist. To the many lenders, both private and public, who have consented to part with their paintings for an extended period of time, we offer our most grateful thanks. For the most part the exhibitions in London and in Philadelphia are identical—in some cases certain works of art can only be shown in one location. Finally, special gratitude is due to Mr and Mrs Pierre Matisse, the artist's friends and representatives in the United States, who have played an essential role in the realization of the exhibition.

An international endeavour of such scope depends upon the generosity of many. The exhibition in London was supported by The First National Bank of Chicago and The Prince Charitable Trusts, and we owe much to the enthusiasm of Mr William Wood Prince. In Philadelphia, the exhibition was made possible by grants from The Bohen Foundation, CIGNA Foundation, Knight Foundation, and The Pew Memorial Trust, which has supported so many important projects at the Philadelphia Museum of Art. We are also grateful to Her Majesty's Government and to the Federal Council on the Arts and the Humanities in the United States for indemnifying the exhibition.

Above all, we owe heartfelt thanks to the artist and his family. They have endured countless visits and telephone calls and are themselves lending most generously to the exhibition. To Marc Chagall, who honoured the Royal Academy in 1979 by accepting Honorary Academicianship, and who is represented by distinguished works in the permanent collection of the Philadelphia Museum of Art, it only remains for us to express our gratitude for having enriched the world with the fruits of his imagination.

Roger de Grey
President
Royal Academy of Arts

Anne d'Harnoncourt
The George D. Widener Director
Philadelphia Museum of Art

January 1985

Acknowledgements

*The Royal Academy of Arts and the Philadelphia Museum of Art would like to thank the following individuals, in addition
to the lenders, who contributed in many different ways to the organization of the exhibition and the preparation of the catalogue.*

His Excellency the French Ambassador in Washington
His Excellency the Royal Netherlands Ambassador
 in London
Dina Abramowitz
Jeanne Amoore
Chrysostome Apsis
Felicity Ashbee
James Ballinger
Vivian Barnet
Nicholas Baum
Juliet Benn
Aloïs van de Berk
Peter Beye
Danièle Bourgois
Liza Bowers-White
John Bowlt
Anselmo Carini
Gilles Chouraqui
Arthur Cohen
E.L. L. de Wilde
Bernd Düting
Wolfgang Fischer
Matthew Frost
Rudi Fuchs
Christian Geelhaar
Olle Granath
Christopher Green
Robert de Haas
Jurgen Harten
Werner Hoffman
Carol Hogben
Pontus Hulten
Anne James
Joop Joostens
Annely Juda

Beatrice Kernan
Christian Klemm
Margaret Kline
Dora Kogan
Harold Landry
Gilbert Lloyd
Roberta Louckx
Valentine and Jean-Claude Marcadé
Charles Marq
Thomas Messer
Franz Meyer
Iuri Molok
Isabelle Monod-Fontaine
George Noszlopy
Klaus Perls
Irene Randell
Marthe Ridart
Anne Rorimer
Cora Rosevear
Angela Rosengart
Irving Sandler
Marc Scheps
Werner Schmalenbach
Anne Schuster
Adolf Simonsz
James Speyer
Harvey Spiller
Stephen Spiro
Michel Strauss
Martin Summers
John Tancock
Catherine Thieck
Christine Thomas
Vivienne Tolley
Nicole Weill

Photographic Acknowledgements

The exhibition organisers would like to thank the following for making photographs available.
All other photographs were provided by the owners of the paintings.

Christopher Archer Cat. 173, 174, 175, 176, 177, 178;
 figs 3, 15, 19, 20, 21, 22
Galerie Beyeler, Basle fig. 38
John Bowlt fig. 18
Dr Susan Compton figs 1, 16
Prudence Cuming Associates Ltd Cat. 6, 50, 180
Documentation Photographique de la Réunion des Musées Nationaux,
 Paris fig. 53
Jacques Faujour, figs 39, 42, 44, 52
Fondation Maeght, St Paul de Vence Cat. 3, 5, 80, 105, 108, 114, 118,
 123, 124, 125; figs 28, 37
Fotoatelier Siegfried AG, Basle
Giacasselli Fotografia-Eliografia, Venice Cat. 43
Roger Hauert fig. 48
Photo Hazan fig. 25
Herbert Michel Fotograf, Zurich

Hinz Colorphoto SWB, Basle Cat. 30, 86
Walter Klein, Essen Cat. 4, 36
Lauros-Giraudon fig. 10
Marlborough Fine Art Ltd Cat. 23; figs 7, 31
Pierre Matisse Gallery, New York, fig. 47
Peter Moeschlin, Basle
Albert Mozell, New York Cat. 51
Nigel Paine, fig. 9
Eric Pollitzer, New York Cat. 8, 14, 110, 112, 113, 116, 117, 120,
 121, 122
Galerie Rosengart, Lucerne fig. 36
John D. Schiff Cat. 77, 89
Nic Tenwiggenhorn, Düsseldorf Cat. 16, 31
Photo H. Roger Viollet figs 43, 46
Bill Wyman frontispiece

Author's Note

Works indicated with an asterisk (*) are not exhibited at the Royal Academy of Arts.

The author is indebted to Monica Bohm-Duchen, who provided much
of the information for the Jewish iconography, and to Adrian Hicken,
who generously contributed from his doctoral research on the Paris period.
Additionally, the patience of the publisher's editor, Johanna Awdry,
has been a great support, as has the practical help of Christina Wilton.

It would not have been possible to undertake this work
without the pioneering study of Chagall by Franz Meyer.
Including a full bibliography and over 1500 photographs
arranged in a classified catalogue, his monograph is
indispensable. Reproductions are cited here by page
number or cat. number as appropriate.

Titles of works follow those established by Meyer where possible;
alternative titles have been noted in the entry when necessary.

Dates in brackets are those provided by the lenders;
those without brackets are inscribed by the artist on the canvas.
It was not the artist's practice to place a date on the picture
in his early years and, like many artists, he added one when the picture was exhibited
(some from his first visit to Paris bear the inscription 1911–4).
The order of the exhibits in the catalogue follows the artist's system.

Dimensions are given in inches and centimetres, height before width.

Published sources referred to throughout the catalogue
have been abbreviated as follows:

My Life Marc Chagall, *My Life* (trans. D. Williams), London, Peter Owen, 1965
First Encounter Bella Chagall, *First Encounter* (trans. B. Bray), New York, Schocken Books, 1983
Meyer Franz Meyer, *Marc Chagall, Life and Work* (trans. R. Allen), New York, Abrams, n.d. (1964)

Quotations given in the catalogue entries are identified
by author and page number. Full bibliographical details are given
in order of quotation under 'References' below the entry.

All uncredited translations by the author.

Transliteration from Cyrillic follows the Library of Congress system
in notes, although in the main text Russian names are given according to
established practice, for instance, Chagall, not Shagal; Benois, not Benua.

The name of the city of St Petersburg was changed to Petrograd in 1915
and to Leningrad only in 1924 in memory of the death of Lenin.
It appears therefore as St Petersburg before, and Petrograd after 1915,
and as Leningrad when mentioned after 1924.

Susan Compton

THE SECRETARY OF THE ROYAL ACADEMY
Piers Rodgers

EXHIBITIONS SECRETARY
Norman Rosenthal

DEPUTY EXHIBITIONS SECRETARY
Annette Bradshaw

EXHIBITION ASSISTANT
Elisabeth McCrae

EXHIBITION DESIGNER
Ivor Heal

GRAPHIC DESIGNER
Philip Miles

DIRECTOR OF THE PHILADELPHIA MUSEUM OF ART
Anne d'Harnoncourt

CURATOR OF TWENTIETH-CENTURY ART
Mark Rosenthal

SPECIAL EXHIBITIONS COORDINATOR
Suzanne Wells

REGISTRAR
Irene Taurins

INSTALLATION DESIGNER
Tara Robinson

GRAPHIC DESIGNER
Laurence Channing

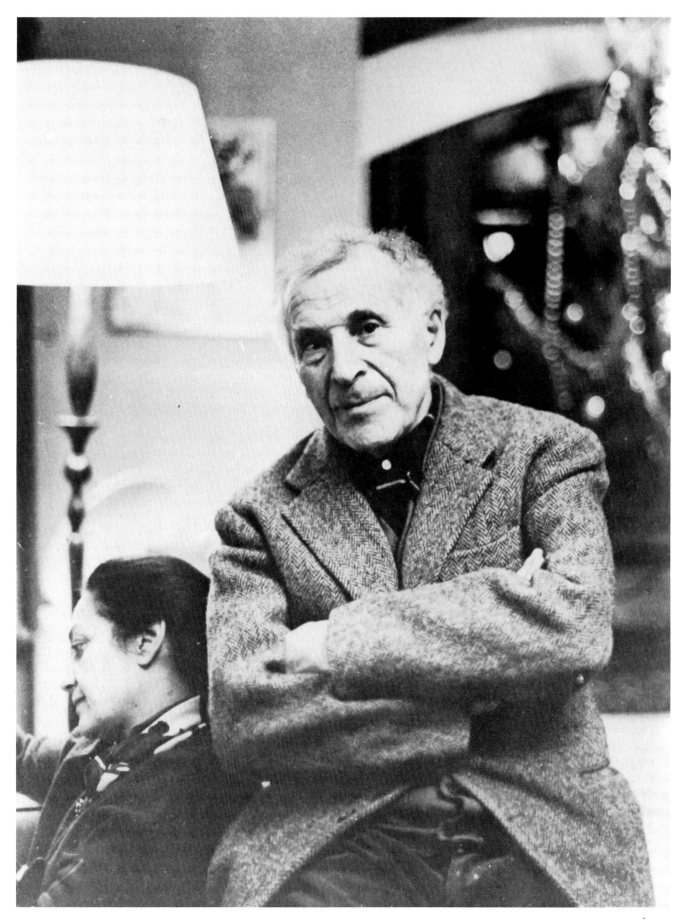

Marc and Valentina Chagall

Marc Chagall

Smiling among the trees, talking to a tethered goat, watching the doves and looking at the flowers which find their place in the studio as well as the garden, Chagall is a magician who conjures colour on canvas, dazzles his audience with glowing stage-sets and draws pilgrims to gaze at his stained glass. Furthermore, he reaches into the homes of countless art lovers through his generosity with the lithographic press. Yet, lurking behind this tranquil picture is a restless spirit whose world of the imagination strikes deep into the fears and hopes of all—his lovers and flowers may delight and calm, but his visions of war, of suffering and of heroes of times past provoke a response at a deeper level.

Chagall, so charming, so warm and full of life, is still at heart the boy from Vitebsk, who by the powers of imagination and against all odds, broke away from that dreary Russian provincial town to become a great success in his own lifetime. Yet that background has clung to him; through years of grinding poverty, literally starving in his studio, the nightmares of his childhood fed his eye and hand. When he paints men and women, he captures the pent-up emotions of superstitious humans; he shares that human frailty which bursts into passion in the dark days and long nights of a snowbound winter. We can meet them not only in his pictures (like *Birth*, Cat. 18), but in the pages of Chekhov's not so well-known story, *Peasants*—in which that dissector of the drawing-room turned his gaze onto a slice of Russian life in the raw. And this is where the Russian Chagall takes precedence over the adoptive Frenchman, or even the Jew: the peasants in *The Violinist* (Cat. 36) seem to encapsulate the degrading poverty of the life which Chekhov described, though they have come out of their house to listen to the musician's plaintive sounds, admiring though uncomprehending, like Chekhov's village characters. Is not Chagall's soldier, drinking his endless cups of tea (Cat. 24), prefigured in Chekhov's coarse woodman who, drunk, but not wishing to disgrace himself before his Moscow relations, drinks ten saucers of tea from the samovar rather than beat his wife? Chagall has expressed a predilection for Chekhov, and, like that writer, he portrays human weakness without passing judgement.

Through his art, however removed from everyday experience, we can share in the human condition: it is not a matter of the head or the heart, because throughout his long life Chagall has spoken to both. Using colour and image he has hacked his own way through a jungle of art in a century marked by stylistic invention; he has borrowed any device which suits his purpose, resulting in a constant and sometimes confusing stylistic development, which makes sense only if we recognise in Chagall, that artist who in his art has kept alive for this century human emotions which we all

share. Nowhere is this more apparent than in his etchings for that classic of Russian literature, *Dead Souls* (Cat. 165–72). Gogol wove his fantastic story round a preposterous theme (a tax, payable for some years after the death of a serf, allows his hero to traffic in dead souls). This enabled him vividly to portray Russian rural life in the 1830s and caricature the manners of the inhabitants of small towns. In addition, it gave Gogol the scope to philosophise about his homeland, using his characters and their stories as an allegory of life. While Chagall creates a visual accompaniment to the tales, the basis of his art seems often a *Homage to Gogol* (Cat. 61). He even went so far as to pair himself with the author in a frontispiece for *Dead Souls* (Cat. 172), though he has rightly been angered by critics who have seen his art as literary.

There have been few artists this century who have combined such a sensuous enjoyment of the act of painting, with such wide-ranging and thought-provoking subject-matter. It is his genius at responding to the age-old comedies and tragedies woven by man into legends and myths which gives Chagall's work in every medium such depth of meaning in addition to its appeal to the eye. He can be singled out as the artist who has brought to the fore again the riches of a cultural heritage that was in danger of being overtaken by lesser heroes in an age of popular images. The joy of his art is that it encompasses so wide a field: he has made reference to very many well-known (and obscure) myths, plays, and even poems—always recreating them for his own ends, just as the great story-tellers have always done.

Finally, Chagall has shown himself to be the greatest religious artist of our times: in his 'Biblical Message' (see Cat. 105, 106) he recreates God and his angels who have guided Western man in a continuous tradition as old as the people of Israel. In this art all is majesty and, often, foreboding, for modern man has stepped aside to worship other gods. Indeed, in this century he has taken his own God in vain, and Chagall has not failed to indict him in that masterpiece, *White Crucifixion* (Cat. 81), a great ikon which doubles as a powerful political work.

Those who have known Chagall only as the master of imagination, the painter of *Cow with Parasol* (Cat. 89), the master of flower-painting (Cat. 70, 72) and the inventor of countless fantasies, will be surprised and even amazed at the strength of imagery which explodes from canvas, glass or print. In each technique he remains an inventive practitioner, never indulging the common temptation to allow a medium to overtake his message. It is indeed a privilege to have assembled such a fine collection of work which will delight and surprise those who, like the author, had not fully realised the range and power of Chagall's life-time dedicated to art.

Themes in the Work of Chagall

Throughout his life certain themes recur in the work of Chagall: the circus, lovers and peasants take their place beside more sombre themes of suffering and death. Very often, angels and animals accompany man, in his role as the mediator between God and his creation. For the themes in Chagall's art are timeless, not confined to a single epoch of history, but reminding man of the continuity of life for generation after generation, since the earliest days of recorded time. Thus his recent *Players* (Cat. 109) greet their public wearing masks from ancient art, bringing an ancient tradition into a present-day Parisian setting. Likewise, ancient gods can be found in pictures painted long ago in Paris, masquerading as cows or bulls (see 'The Russian Background' p. 36 and Cat. 15).

Nevertheless, as Chagall himself avers, the figures in his pictures are dictated as much by the needs of the composition as by their power to convey a particular theme. In this way he breaks new ground, working on his canvas in a manner which is almost as abstract as other masters of twentieth-century art, though he does not restrict himself to the formality of their geometric shapes. But it is also possible to analyse the organisation of his compositions using traditional art-historical terms; moreover, he has often returned to a much earlier mode of representation found in the Italian frescoes by Giotto and other masters whom he admires and, equally, in the less familiar tradition of ikon painting in Russia.

Ikons prefigure much twentieth-century art, since their pictorial space is created not so much by reference to the world which surrounds the artist, as to a world of other realities, prompted by tradition and periodically revitalised by imagination. Chagall has made great play with that compartmentalisation which is characteristic of the composition of Russian ikons, allowing the religious artist to include events, irrespective of a particular time or place, in scenes distributed over his picture surface in a unity of space in an illogical sequence. Chagall has made use of the device over and over again to convey the narrative form which many of his themes require. For instance, in *The Large Circus* (Cat. 110) the episodes are given their own coloured spaces, each incorporating its appropriate scale, so the picture can be more readily received by the viewer as a series of allusions to different times and places (in this instance, perhaps all in the mind of the artist). He has included himself, looking down on the scene with his palette, in a compartment next to a motif borrowed intact from the ikon tradition, representing as it does the hand of God. The circus theme of this painting is especially poignant and mysterious, readily illumining the words written by the artist himself:

'These clowns, bareback riders and acrobats have made themselves at home in my visions. Why? Why am I so touched by their make-up and their grimaces? With them I can move toward new horizons. Lured by their colours and make-up, I dream of painting new psychic distortions'.

(Marc Chagall, *Le Cirque*, New York, Pierre Matisse Gallery, 1981).

Throughout his working life, Chagall has been fascinated and entranced by the theme. One of his earliest pictures, *Village Fair* (Cat. 2), includes a clown and acrobats: the same characters inhabit many of his most recent works (Cat. 116, 120). But although one could point directly to the evenings he spent at the Cirque d'Hiver with Vollard in the late 1920s (when the artist was going to make a suite of etchings on the circus), or those months in Vence (when he was invited to attend the shooting of a circus film in 1956), his clowns and acrobats, his equestriennes and musicians are clearly not a simple record of a particular time or place.

The circus has a profound relevance for the artist as a mirror of life; it is no surprise to open a 1953 edition of *The Great Fair*, the autobiography of the great Yiddish writer, Sholom Aleichem, and find a frontispiece drawn by Chagall (fig. 3). With a rather similar Russian-Jewish background, Sholom Aleichem explained his choice of title, by drawing an analogy between the experience of his own fifty years and a Great Fair. Chagall has seen a parallel between life and a circus, rather than a fair: 'It is a magic word, circus, a timeless dancing game where tears and smiles, the play of arms and legs take the form of a great art' (Marc Chagall, op. cit.).

So the artist included the theme in some of the most important works of his life: in the murals that he painted in Moscow in 1920–21; in the monumental canvas, *Revolution* that he planned in the 1930s; in *The Concert* (Cat. 98) which, twenty years later, is introduced by clowns.

In each of these instances Chagall was following the practice that he had first devised in his early years in St Petersburg, when he painted *Village Fair*. For none of these pictures is specifically a circus, though in each of them, characters whom we can identify from the sawdust ring add a nuance to a complex subject. Using clowns and acrobats, Chagall introduces by inference a question about the complex relationship of life and art: does it simply portray a familiar world of scenes from everyday? In *Village Fair* this is invoked by the group on the balcony, merrily pouring water onto the figures below. They are watched by an enigmatic clown whose presence indicates that this is no ordinary genre scene, as does the coffin bearing a wreath, borne away to the right.

fig. 1 *Self-Portrait*, Plate 17 from *Mein Leben* portfolio
(printed in *Chalastre*, no. 2, Paris, 1924, with exerpts
from his autobiography in Yiddish)

These elements provoke another query: is the painting an illustration of some well-known story that we should recognise? Surely not, although Chagall has introduced an old symbol in a new guise (the figure of Death was represented traditionally in Western art as a living figure, holding a scythe—see Cat. 19). He has here shown death in the form of a coffin which is 'real' enough, as are the loved-ones left behind, but the clown and the acrobats add a note of uncertainty: they are humans whose work is to act a role in life, inviting the viewer to ponder on problems of what is real and what is not.

In contrast, in the vast canvas which Chagall painted for the foyer of the new State Kamerny Theatre in 1921, acrobats play a rather different part. They take their place alongside figures who are recognisable as the artist and the director of the theatre, with a group of musicians occupying the centre of the scene. No doubt they remind the audience of the performance which is about to take place on the stage: by its very nature, the play will ask questions about reality and illusion. However, the acrobats also commemorate the tradition of impromptu dance and tumbling, a folk-art performed informally by the Purim players each year in Vitebsk at that Jewish feast. They share the canvas with farm animals in a juxtaposition which must also have reminded the audience of the words of a fellow artist, Annenkov, who had promoted the circus as a therapeutic agent in city life, seeing it as a welcome return to the healthy and 'natural' life of the countryside, an aspect which Chagall reiterated in an amusing lithograph quoted from the mural (Cat. 159, see also 'The Russian Background', p. 42).

When Chagall came to paint *Revolution*, another large oil-painting (surviving only in the finished sketch, Cat. 80), he again borrowed motifs from the circus to make a telling political point. He depicted Lenin in a more fantastic manner than the acrobats standing on both hands in the mural dating from the days of the Revolution. He gave the hero an unlikely position, balancing upon one hand on a table, using the other to indicate a scene taking place on a disc like a circus ring. By this means, he likened Lenin's task of leading the people and giving freedom to the oppressed, with the delicate balance which a circus acrobat needs to maintain the fine line between comedy and tragedy.

In contrast, in 1957, Chagall used clowns to introduce his rapturous *The Concert*, bordered by musical clowns—not now associated with the drama of death, but celebrating the initiation of new life by the couples who dominate the scene. Here the circus figures help to provide the music of the concert; they are a human counterpart to the divine figure, the David/Orpheus musician who accompanies the central lovers (see Cat. 98). Here also, the clowns bridge the gap between art and life, as well as pointing to different levels of reality suggested by the sweeping arcs of colours of contrasting pitch. In this picture, more than in any of the circus themes discussed so far, the artist has integrated his subject and his manner of execution: here his colours have as much importance as any of the musicians, clowns or lovers. The colours play an independent role, but the figures add that element of recognition which allows us to participate more fully in the scene.

Chagall is perhaps most popularly known for his theme of lovers, one that continues in his work to the present day. Indeed, some of his most recent paintings are of lovers, for instance, *Couple on a Red Background* (Cat. 123) of 1983, dedicated to a young couple whose love is symbolised by intense colour, much brighter than that of *The Concert*. It is now dazzling, with the reds heightened to a new pitch of intensity. Here, too, with a casualness which at first seems naïve—but is actually very sophisticated—he has placed his own figure in the position that we have come to expect to find a clown. He has again linked two themes, with their separate overtones of meaning. Whether in this picture the artist introduces the scene, remembered from his own youth, or alternatively stands for the vision seen by the young lover reclining on the bank, we are left free to decide; the picture evokes a stream of lovers that Chagall has invented throughout his lifetime, though here enjoying a new freedom of brushwork as well as masterly use of colour.

It was a vision of 'real' love, that love which the artist was to share with his bride Bella, which in 1915 transformed the *Lovers* (private collection; fig. 2) imagined in Paris the year before, into the positive couple of *Birthday* (Cat. 48). In its own way, this celebration by the lovers is equally fantastic, for their joy has levitated them from the ground. Their faces are real enough (unlike the masks of *The Lovers*), but now

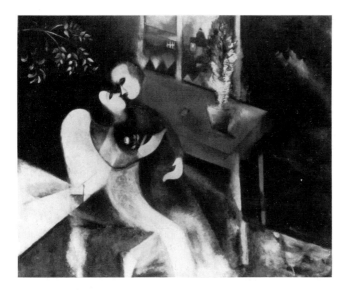

fig. 2 *The Lovers*, 1911–14. (Galerie Beyeler, Basle)

their position is imaginary. Yet by this device Chagall has conveyed the magic carpet of human love, borrowed perhaps from the world of the folk-tale, where the hero and heroine live happily ever after. Moreover, the story of the artist's wooing of his bride matches the conventional fairytale, for the way of true love was displeasing to Bella's parents, foremost citizens of Vitebsk (*My Life*, pp. 119–21). Even seventy years later, in *Couple on a Red Background* he remembered the need he had had to become a great artist, covered with glory and honour, to vindicate his marriage.

In the 1920s Chagall continued the theme with a series of paintings including the sensuous *Lovers under Lilies* (Cat. 67) where he tricks the viewer into confusing the couple with a flower vase. In *The Rooster* (Cat. 75) he plays a different game, by placing the woman astride a life-sized bird, borrowed perhaps from *Chantecler*, a play performed in Paris in 1910, which had been a *cause célèbre* (nine hundred kilos of feathers had been needed for the costumes of the actors, dressed as life-sized inhabitants of a poultry-yard. However, Chagall indicates that he intends his *Rooster* as an allegory, by marking the background with little drawings. In this way he anticipates a device which he developed a decade later, when he painted a different type of lovers' scene, his *Madonna of the Village* (Cat. 83) begun in 1938. There the smaller figures and animals begin to contribute a much more open element of fantasy to the composition, which includes a cow and a violin.

This introduces another theme in the art of Chagall: his love of music, nowhere more movingly expressed than in the mythical *Solitude* (Cat. 79). There the quiet meditation of the seated Jew—holding his Torah scroll as tenderly as an infant—is accompanied by the curious juxtaposition of a cow and violin. The artist has even gone so far as to place the bow across the instrument, which is tucked under the heifer's chin, as though in some illogical way she could match the profound music of the psalms, or rival the hosannas of the angel, hovering quietly above.

Chagall had himself learnt the violin as a boy and one of his uncles was a fiddler. It was that music which cheered many a Russian wedding (see Cat. 9) and individual players featured in Chagall's work from the earliest time (see Cat. 34, 36, 64). Yet in *Solitude* the inclusion of a cow and a violin has a more precise connotation for many viewers, considered further in 'The Russian Background' (p. 41): years before in Vitebsk, by placing a cow on top of a violin, the Russian artist Malevich had attempted to clarify the a-logical approach put forward by fellow avant-garde artists as an alternative to Realism and Symbolism. By developing a kind of psychic nonsense, they had hoped to shift the mind from a predictable path onto a plane where other realms of imagination would appear as real as the reality of everyday. So the logic which had governed so much art of the past was over-ruled in order that a new art might have a more profound effect on the viewer.

In a similar vein, Chagall made unlikely juxtapositions; for instance, in *The Musician* (Cat. 157) he used a cello to double as the body of its player. But many of his a-logical pictures are not painted in an arrestingly avant-garde style, for he returned the cow and violin to a more naturalistic mode. So *Solitude* gives even more curious vibrations, for the eye accepts the convention; only the mind finds the imagery puzzling.

The violin occurs again in *Red and Black World* (Cat. 93) where the artist himself, streaming down from the disc-shape of the sun, makes the music to accompany his pair of lovers; a cow-like creature is released from its violin and offers a bouquet instead. Here, in a forceful maquette for a tapestry, the artist has finally resolved his different layers of reality and illusion by allowing his imagination to play over the entire surface, unbounded by laws of logic or pictorial convention.

As has already been suggested, when music became the subject of *The Concert*, colour was allowed such a free role that it served as a kind of music in itself—a device which Chagall developed in *Music* (Cat. 101). From the late nineteenth century, artists and writers had been fascinated by an analogy between colour and music: it was thought that the one might play on the emotions as the other. But whereas music was accepted as an abstract art form, painting was not, so artists discussed whether colour could play an equivalent role without the need for representation. In his later paintings Chagall has given colour a controlled freedom, very like the bursts of sound from some great symphony concert, but his colour additionally denotes the figures of musicians themselves.

It would be a mistake to give the impression that Chagall's themes were always lighthearted. As was suggested in the opening pages of this catalogue, his art is equally imbued with seriousness and even tragedy. Nowhere better is this revealed than in his many depictions of a crucifixion. For generations growing up with the trivialisation of agony, agony repeated over and over as it happens, relayed on the small screen in the living-room, Chagall recreates an individual pain which each person conceals even from himself. He has not shunned placing himself on the canvas on a cross, where, in *In Front of the Picture* (Cat. 111) he marries the theme of suffering with

the theme of love. Although that picture superficially records his personal experience, the deliberate pairing of the two themes has a wider religious interpretation: from the time of the Prophets, Israel has been likened to the Bride of God; God's people have for the most part rejected that precise symbol of suffering, Jesus crucified. Chagall places his own parents next to his figure on the cross, as though reinforcing an interpretation of the Crucified as human, like himself.

Chagall sees the Cross, that potent symbol of suffering, not as a symbol belonging only to Christians, but as the inheritance of all descendants of the Jewish Jesus. Nowhere is this more forcefully stated than in *Exodus* (Cat. 105), in which the crucified figure dominates a tableau of figures from the Old Testament, balanced by scenes from the history of this century. Many people of the Jewish faith find his use of the Crucifixion profoundly disturbing. Likewise, Christians wonder at the profundity of thought and understanding which allows this artist of Jewish upbringing to juxtapose imagery which they have always received as a Christian interpretation of the history of Israel.

The misunderstanding of Chagall's position—which, today, he explains by his reluctance to be bound by any single set of religious beliefs—has surely arisen in part

fig. 3 Frontispiece to *The Great Fair* by Sholom Aleichem (New York, Noonday Press, 1958)

because of an early feature of his Russian background. This is set out in a revealing article by the Israeli scholar, Ziva Amishai-Maisels, cited in a number of catalogue entries (see Cat. 81, 105). She gives a reminder that the most important sculptor in Russia at the turn of the century was a Jew, Mark Antokolsky, whose letters were published posthumously in St Petersburg in 1905; they contain a frank and considered exposition of how he was able to reconcile two conflicting religious viewpoints, the Jewish and the Christian. Antokolsky accepted Jesus in the line of biblical prophets, as one whose teaching was apt, not simply for the times in which he lived, but also for our own. He welcomed that love which was, he felt, displayed at its highest in this figure, believing that the followers of Jesus had distorted his teaching and turned it into that Christian religion which he could not accept. When Chagall was studying in St Petersburg, it was hoped by his enlightened Jewish patrons that he, too, would become a second Antokolsky, a hope that was expressed each time a young art student showed signs of promise. But in this case, it is even possible that Moshe Shagal gladly took the name of Marc Chagall on account of that well-known sculptor who had reached the heights of fame, then open to so few Jewish artists in Russia.

None the less, beyond drawing attention to the precedent, it would be misleading to suggest that Chagall followed in the footsteps of the nineteenth-century sculptor: to begin with, the name of Antokolsky is little-known outside Russia and his art is not of international significance. In contrast, Chagall has enlarged and enriched the field of religious art in this century and, by accepting commissions for stained glass in Christian churches, he has carried his own vital interpretation of the Biblical Message beyond the restrictions of any one location. Furthermore, by his astonishing conception of the Prophets and his technical invention in using the huge areas of, for example, the windows in the Fraumünster in Zurich, he draws countless visitors who, through him, gain a remarkable religious experience.

On another scale entirely, in All Saints' Church at Tudeley in Kent, the Russian-Jew of French nationality gives way to the man with a unique message for all God-seeking people in our times. The windows for that church (Cat. 149–52) show the way Chagall has married the peaceful countryside without to the worshipping congregation within, by using a sonorous blue as a paradigm of a summer sky and filling the branches of trees with the presence of the angels of God. The east window there may seem the most Christian Crucifixion that the artist has made: it is a memorial to the accidental death of a girl, whose soul rises in successive states past the crucified figure above. Yet although it seems to confirm a vision of the resurrection of man—the ascension of an individual following the story of Elijah (see *The Flying Carriage*, Cat. 35)—it would be mistaken to see the imagery of this window as signifying the Christian view of the Resurrection of Christ. Nowhere in the art of Chagall is this implied or set out; rather, in each of his crucifixions, the cross is partnered by a ladder—a traditional symbol found especially in folk-art (fig. 4) to be interpreted as a bridge between man and God. The ladder is, of course, seen entirely in that light in the story of the *Dream of Jacob* which Chagall has used for stained glass

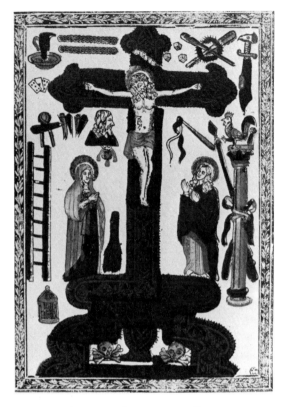

fig. 4 French nineteenth-century woodcut

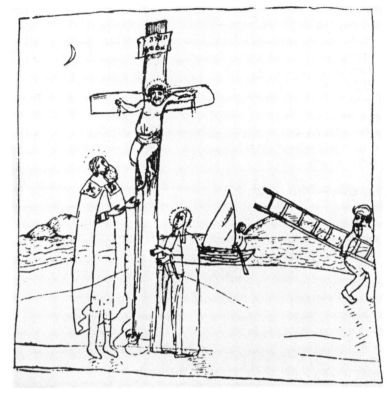

fig. 5 Drawing published in *Sturm Bilderbücher 1/Marc Chagall*, 1923

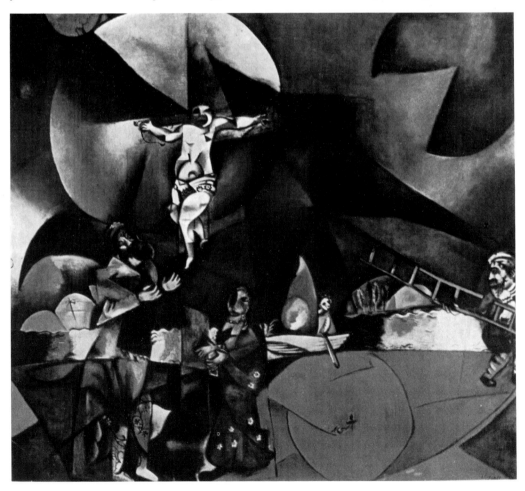

fig. 6 *Golgotha*, 1912 (The Museum of Modern Art, New York)

(Cat. 141) and in illustrations for the Bible (Cat. 187); it has also inspired his poetry (see Cat. 141).

Since the 1930s Chagall has visualised the Old Testament, thereby, as he would see it, remedying the lack of a visual tradition hitherto developed by Jewish artists. But his earliest religious subjects were treated in a very different way: for instance, *The Family or Maternity* (Cat. 8) has been recognised as a Jewish 'in-joke' in the catalogue entry. When he first drew a Crucifixion (fig. 5) he represented Jesus like an old man, closely related to the type of a popular French woodcut from the early nineteenth century (fig. 4). When he came to paint the subject (fig. 6), he replaced the old man by a child (see *Calvary*, Cat. 27), because, as he said later, he wanted to get away from the tradition of Russian ikons. Nevertheless, it was that tradition—as has been said above—which allowed him to paint *White Crucifixion* (Cat. 81) in the tense political climate of the 1930s.

That masterpiece gives a fine instance of how Chagall's earlier approach to *Calvary*—with its multiple references to different cultures—gave way to a sober confrontation (described in the catalogue entries). But in *White Crucifixion* there is an unexpected 'secret' reference to a classic Hasidic story, 'The Burning of the Torah'. Near the bottom right the unwound Torah scroll has white light streaming from it: once, when a bishop tried to burn the sacred writings of the Jews, the mighty prayers of Rabbi Israel went to the palace of the Messiah; the bishop thereupon fell in a fit, frightening all the others who had been intending to burn the Torah scrolls. Chagall's white light, symbolising the power of the Word of God, is traversed by a green-clad figure with a bundle, the Elijah from *Over Vitebsk* (Cat. 46), who comes back to help his people in times of trouble. This figure is a favourite of Chagall: he is seen on the easel in the frontispiece for *The Great Fair* (fig. 3), in the centre of *War* (Cat. 107) and even in the *Dream of Jacob* window (Cat. 141), although he is clearer in the maquette (Cat. 143). He is so vividly portrayed that he brings alive Chagall's childhood expectation of seeing Elijah each year on the Day of Atonement (*My Life*, p. 43).

Chagall has said: 'If a painter is Jewish and paints life, how can there help being Jewish elements in his work! But if he is a good painter, there will be more than that. The Jewish element will be there but his art will tend to approach the universal' (to S. Putnam, when asked about the Jewish sources in his art). Twenty-five years after these words were published (by A. Werner in 'Chagall in the Anglo-Saxon World', *Jewish Book Annual*, 15, 1958), the universal nature

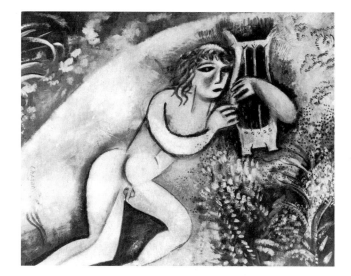

fig. 7 *Orpheus*, 1913–14 (private collection, Japan)

of Chagall's art is even clearer than it was then. This is because, in addition to extending the religious theme (in the ways outlined above), he has dedicated major works to the great myths of the classical tradition. Early on in Paris, his choice of *Orpheus* (fig. 7) can be seen in the context of the current art movement, Orphism, but in 1977 *The Myth of Orpheus* (Cat. 118) is a far more complex work. Here Chagall has alluded to an ancient parable of life and death, which he has seen as a pictorial conundrum: the juxtaposition of figures with abstract forms and colour. Whereas he often cuts out shapes and adds them to sketches for stained glass as an indication of colour intensity, here he paints the shapes, which double as figuration in the work. Thus he approaches the universal in his theme with full awareness of the possibilities open to the artist of today. On a huge scale and with consummate skill he has captured *The Fall of Icarus* (Cat. 115), making a parable for the space age as well as pointing to an ancient dilemma of man's folly and ambition.

It must be clear from these pages that themes in Chagall's art cover a wider range than in the work of most twentieth-century artists, but, in spite of the fascination of following from one to another throughout his long life, it is finally the works themselves that must reveal to the viewer his joy in painting, in marking the surface, which shines triumphantly through his intensely human works.

Chagall 'over the Roofs of the World'

NORBERT LYNTON

In Russian 'Chagall' suggests striding along, taking great steps. Marc Chagall's progress has been legendary, from the *shtetl* boy of Vitebsk, called Moses by his parents, to the world's best-known supplier of large-scale and encyclopedic images: Paris, New York, Jerusalem and many other points on the globe; Opéra, United Nations Headquarters, Hadassah Medical Centre, cathedrals and churches, Jewish memorial chapels, an entire shrine of Bible images, not seen but dreamt by him[1] and that dream 'not the dream of a single people, but of all mankind'.[2] The egocentric painter, sometimes accused of narcissism, wishes to be and as evidently *is* the global artist, embracing all in his art and his sometimes sweet, sometimes epic, always affectionate vision. His poetry is, as Valéry Larbaud wrote of Whitman in 1919, *'une poésie du moi délivré de l'égotisme'*, of a self liberated from the egotism that stops within the self.[3] His subjects outreach any listing: birth, death, hardship, contentment, domesticity, isolation, social events, the longings and the delights of love, rabbis and poets, family, Bella, their daughter Ida, Vava, himself in many guises, crucifixions of Christ and others, the Russian Revolution, the Old Testament, angels, *The Magic Flute*, Orpheus, *Daphnis and Chloë*, the circus, acrobats, cows, cocks, donkeys, fish, clocks, most of these with and without violins, flowers, Vitebsk, Paris, the Eiffel Tower. It is best not even to start imagining the other possible lists, of the materials he worked in, the many functions his art serves, the art and artists that he has allied himself to from early ikons to Modernists via shop-signs and ancient symbols, lest our heads spin off our shoulders in precisely the way he describes.

What does he not cover? He has said many times that he is against scientific tendencies in art, against any system.[4] His work tells us that he is against any movement or style that limits expression and mobility. He is no classicist or neo-classicist; some of his best graphics are so economical as to suggest otherwise, but he is first and foremost a colourist to be seen in the tradition of Venetian painting, Rubens, Delacroix. He is wholly against emphatic realism, of the Courbet, Impressionist or Cubist sorts, yet he uses Cubist devices and paints naturalistic scenes that come close in spirit, if not technique, to Impressionism. He passionately admires Monet and drew much inspiration from Gauguin in his early years.

In Paris, arriving in the heyday of Fauvism and Cubism, he was labelled mockingly 'the poet' and told he was too literary.[5] They were both right and wrong and he, even then, knew it. He had become a painter because painting 'seemed to me like a window through which I could have taken flight toward another world'.[6] Coming from a Russian of his generation such words point to the cosmic adventuring prophesied by Nikolai Fedorov, sung by the Cosmist poets ('We shall arrange the stars in rows and put reins on the moon'), and realised in abstract visual form by Malevich and his disciples.[7] But Chagall is no Utopian. His art does not touch on idealised futures. Nor does it arraign the world, past or present, nor berate the heavens for mankind's sufferings. He is—he would surely wish one to say in summary—the painter of love, not just of the romantic love he portrays so often, nor of the love of parents and child, though these are not excluded, but of the wider, vastly more romantic love which embraces all mankind and all beings. 'In [love] lies true art: that is my technique, my religion; the new and old religion handed down to us from times long past';[8] and 'are not painting and colour inspired by Love? . . . In our life there is a single colour, as on an artist's palette, which provides the meaning of life and art. It is the colour of love'.[9] Apart from fame and a comfortable situation it is love of this global sort that is his ambition, the sort of love that Rembrandt enjoys without even filling walls, ceilings or windows with his art. His ultimate self-reassuring boast is, 'I'm certain Rembrandt loves me'.[10]

fig. 8 *Self-Portrait with Seven Fingers*, 1912–13 (Stedelijk Museum, Amsterdam)

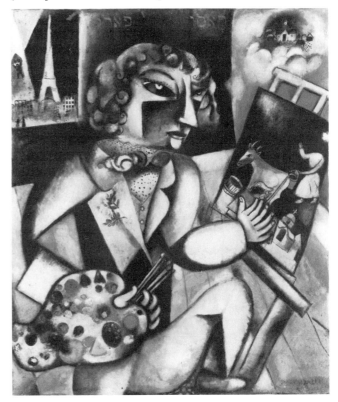

All this may help us to sympathise with his one area of defensiveness: his refusal to explain his symbolism or to let others explain it. Chagall is a Hasidic Jew, a western Russian, an eastern Parisian, a European visitor to America, and a good friend of Israel who prefers to stay in France: he surely need not fear being pinned down by scholarly explication. It is interesting to learn that there is a Yiddish saying about doing something with all seven fingers, i.e. doing it really well, when we look at his *Self-Portrait with Seven Fingers* (fig. 8), and that the hours indicated behind the Adam/Eve androgyne in *Homage to Apollinaire* (Cat. 22) are not just part of a dial but specify the hours allocated to the Fall of Man in the Talmudic version of the story of Creation.[11] When he inscribes a picture with Hebrew lettering, even paints extensive Hebrew quotations, should we not want to know what it says and means? What do those objects that frequent his canvases mean to him, the cows, clocks, donkeys, Eiffel Towers with and without boots on? If colour is so important, what does his red signify, or his pale and dark blues, the near-white of his *White Crucifixion* (Cat. 81)? 'Judge me by form and colour, by my philosophy, not by the separate symbols', he answers. 'One can see all the questions and answers in the pictures themselves. Everyone can see them in his own way, interpret what he sees and how he sees'.[12] 'For the Cubists a painting was a surface covered with forms in a certain order. For me a picture is a surface covered with representations of things (objects, animals, human beings) in a certain order in which logic and illustration have no importance. The visual effect of the composition is what is paramount.'[13]

His fear is that interpretation of parts will intervene between him and us, rewarding those who read more than they look, and distance those who come to look and have no urge to read. In fact, just as closer study of his work is establishing the awesome inclusiveness of his allegiances within art, so also the growing study of his symbolism serves to reinforce his role of vision-maker to all the world. In the process his subjectivism is shown to be purposeful and considered rather than capricious and momentary; the warmth and width of his vision take on the quality of wisdom.

The desire to be widely understood—to be a popular painter—is itself neither wholly personal nor arbitrary. More than his origin, it is the reason for the religious timbre and often directly religious subject-matter of his art. He knows that religious formulae as well as religious images address themselves to a large public, whether or not that public is committed to a specific faith. Russians know this better than anyone. It was the basis of much Russian Symbolism, especially Symbolist poetry; it was the essential programme of Kandinsky and, in another mode, of Malevich and Suprematism. It is a profound force in Stravinsky. It was very much part of the dynamic that produced the Revolution. To give one relevant instance, it was the heart of Lunacharsky's conception of social change. In his *Religion and Socialism* (two volumes, 1908 and 1911), Lunacharsky identified all constructive enthusiasm with religion and argued that Marxism should be seen as a religion in which Man is God and revolution is 'the greatest and most decisive act in the process of "Godbuilding"'; without this, 'it is not given to man to create

anything great'.[14] Lenin objected strongly to this diversion of materialism, yet the cultural product of the Revolution is fraught with it. Lunacharsky became the first Commissar of Education and Enlightenment in the new Soviet state, and charged Chagall not only with establishing the Vitebsk art school he had proposed, but also with animating and directing the cultural life of Vitebsk province. Chagall is known to have had some contact with Lunacharsky in Paris before the war, and it is established in this catalogue that Chagall was influenced by some of his writing.[15] When the Revolution began to muffle its religious sonority, Chagall chose exile.

But similar stimuli were active in the West, some of them especially in Paris. We see them in the rise of Theosophy and Anthroposophy (influential in Russia too), in theories and fantasies about evolutionary developments in human consciousness expected to yield new spiritual and practical powers, in Whitman's sudden fame, in Jules Romain's poems *La Vie Unanime* (published in Paris in 1908)[16] and the Unanimist movement of which that volume was the manifesto. Unanimism soon found expression in painting amid the secondary Cubists, notably Gleizes and Severini, and then also in some of the exhibits in the show of Italian Futurism at the Galerie Bernheim-Jeune in Paris during February-March 1912. The Unanimists' theme was not identical with Marinetti's, however. Where he looked for an imperious seizure by aggressive individuals of the powers offered by modern technology, Unanimism welcomed technology as humanity's friend, destined to facilitate the co-operative network on which modern existence depends and to lead to perfect concord. Whitman provided the main impulse behind Unanimism but a strong supporting voice came from Russia, from Tolstoy.

Apollinaire too expresses this, warmly in his poetry, more hesitantly in his art writing. His opinions about art reflected what artists close to him were saying. 1912 saw him vacillating between championing the studio-centred investigations of Picasso and Braque and responding to the human note heard in the work of some of the other Cubists and the Futurists (fig. 9). He criticises the Futurists for their 'popular, flashy art', contrasting it with the pure plastic concerns of the Cubists, but he can also pluck up the courage to announce, *à propos* Delaunay's *La Ville de Paris* (Musée national d'Art moderne, Centre Pompidou; fig. 10)—'definitely the most important picture in the Salon [des Indépendants]'—that now 'it is no longer a question of experimentation, of archaism, or of Cubism', but that 'from now on, young artists will dare to approach and interpret *subjects plastically*'.[17] Both the words here italicised are significant of a change of position, under influence. It was during 1912 that Apollinaire was especially close to the Delaunays, even living for a time in their apartment, and it was during 1912–13 that they came closest to achieving their implicit ambition, of seizing leadership of Paris vanguard art from Matisse and Picasso and heading a transcendental, emphatically international school of painting.

This is not the place to describe their artistic and social aims in detail. Some points are essential, however, if we are to understand Chagall's position amid the tendencies calling for his attention at this stage. Sonia Delaunay, born Terk, was

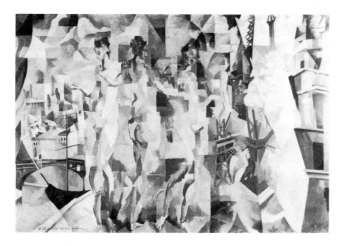

fig. 10 R. Delaunay, *La ville de Paris*
(Musée national d'Art moderne, Centre Pompidou, Paris)

of Russian origin and befriended Russian artists working in Paris. The Delaunays also kept open house on Sundays for artists and their writer and dealer friends. Chagall was frequently their guest in Paris, and in the summer of 1913 he visited them in their country house at Louveciennes, probably together with Archipenko, the Russian sculptor resident in Paris since 1908.

In October 1912 Apollinaire disrupted the 'Section d'Or' exhibition at the Galerie la Boétie in Paris by announcing the

fig. 9 J. Metzinger, *La femme au cheval*
(photograph from *Du Cubisme*, 1912)

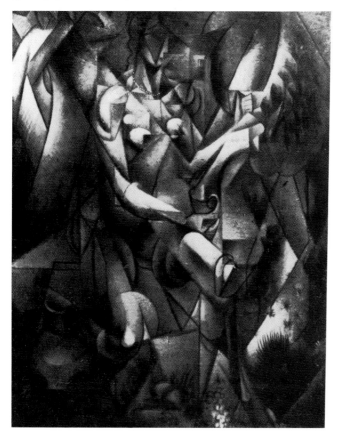

birth of a new kind of painting, represented by a few of the exhibitors and not by the rest. He was lecturing in the exhibition, and he singled out Delaunay as the originator of this new art, and Léger, Picabia and Duchamp as postulants 'struggling' towards it.[18] Three days later he described it dramatically as 'an art of pure colour . . . an entirely new art which will be to painting what, until today, one had imagined music to be to poetry.' An article he published that December in Paris, and in a slightly longer form in the Berlin magazine *Der Sturm*, devoted two-thirds of its space to quoting Delaunay's own account of this art in which light, engendered by colour contrasts, is organised 'to inspire human nature toward beauty'. In a final paragraph Apollinaire stressed that this art replaces the 'sterile' art of the past: 'artists have for too long strained toward death'.[19]

Altogether Apollinaire used his power as critic during 1912–13 to promote Delaunay as *chef d'école* and to define the particular character and aims of this school. 'It is the art of painting new structures with elements which have not been borrowed from visual reality, but have been entirely created by the artist . . . The works of the Orphic artists must simultaneously give pure aesthetic pleasure, a structure which is self-evident, and a *sublime meaning*, that is to say, *the subject*'.[20] This was probably written in October 1912. Five months later, in March 1913, Apollinaire changed tack: Orphist paintings represented 'a more subjective, *more popular*, more poetic vision of the universe and of life'.[21] A year earlier he had used the word 'popular' in association with 'flashy' in denunciation of Futurist art. Soon after, he spoke of artists interpreting subjects 'plastically'. By March 1913, when the Salon des Indépendants opened, he had travelled to Berlin with Delaunay for Delaunay's one-man show, his most important to date, at the Der Sturm gallery. It amounted to a selection of paintings and studies representing Delaunay's development from the last *Eiffel Tower* paintings of 1911, via the extensive *Windows* worked on during the summer of 1912 to a new series, the first of which was shown in Berlin but had been finished too recently to be listed in the catalogue: *The Cardiff Team* now in Eindhoven Museum. At the same time, Delaunay was working on another series, more obviously sublime, the *Discs* of 1912–13. These he exhibited in quantity in Der Sturm's First Autumn Salon of September–December 1913, together with the third, largest, and final version of *The Cardiff Team*, now in Paris (Musée national d'Art moderne, Centre Pompidou). It is possible to see the *Windows* and the *Discs* as nearly and wholly abstract compositions, communicating through sensory stimulus rather than through the responses invited by identifiable subjects or objects. That is how Apollinaire read them. But it is also relevant to stress that the *Windows* were variations on a photograph taken from the top of the Arc de Triomphe, looking towards the Eiffel Tower across the roofs of Paris, available to all in the form of a postcard, and that the *Discs* are poetic representations of the heavens and of sun and moon (and are usually titled or sub-titled to indicate this), thus providing poetic images of one of the most familiar sights known to mankind through all time. With *The Cardiff Team* there can be no doubt that Delaunay, basing himself again on a photograph, a newspaper half-tone picture of a rugby football

match played in Paris, intended to create an ensemble that would be at once sublime and popular. Football, the Eiffel Tower, the great ferris wheel that stood south of the Tower and was one of Paris's most popular attractions, colourful hoardings, plus that other object of international excitement and French national pride, the aeroplane, are brought together in a celebratory whole that echoes the great Ascension and Assumption altarpieces of Venetian painting and the Baroque. Without abandoning the quasi-musical uplift provided by his rhythmic colour structures, Delaunay plugged into themes of current pleasure and interest.[22] The spectator responding to the assembly of familiar, even topical subjects is uplifted by their affecting context of pulsing light. In *The Cardiff Team* series figures and objects are woven into the abstract structure, but the three *Prism-Sculptures* Delaunay

fig. 11 R. Delaunay, *Cheval, prisme, soleil, lune* (documentary photograph)

showed in the First German Autumn Salon imply that this close interweaving is not necessary. Found, made or adjusted objects stand before a painted *Disc*-type backdrop. The stimulus to this came undoubtedly from Archipenko's ventures into *sculpto-peintures* in 1912–13. We know one of them from an old photograph: it shows a toy horse in front of an assertive colour disc (fig. 11). The disc is quartered to receive contrasting colours; the horse is painted with colour patches that in some places blend into the colour patches behind it, in others contrast with them as colours and as shapes.[23]

In short, Delaunay had returned from what seemed to be an ever more transcendental venture to the everyday world, without casting off the wings his art had grown in the process. That Apollinaire understood this and was sympathetic to it is apparent from his writings, especially those associated with the 1913 Salon des Indépendants in which the third *The Cardiff Team* was shown. Orphism, he writes in March 1913, 'is heroically manifest in Delaunay's gigantic canvas' and in a few other paintings including, significantly, Gleizes' *Football Players*, Delaunay's stands out as 'the most modern painting in the Salon . . . A suggestive, not merely objective kind of painting, which acts on us in the same way as nature and poetry'.[24] And a week later, noting 'how many other painters

converge in their investigations' on Orphism, Apollinaire drew attention to 'Chagall's *Adam and Eve* [Cat. 26], a large decorative composition, [revealing] an impressive sense of colour, a daring talent, and a curious and tormented soul'.[25] He had got to know Chagall during the summer or Autumn of 1912, probably through the Delaunays. We do not know at what point precisely he visited Chagall's studio to utter the pregnant word *surnaturel*, 'supernatural', nor when exactly he introduced Chagall to Herwarth Walden, founder-director of *Der Sturm* journal and gallery. From that introduction came Chagall's great exhibitions in Berlin, in April–May 1914 with Kubin, in June 1914 by himself, his influence on German Expressionism and also, accidentally, the temptation to visit his family and his fiancée in Russia and thus, being trapped there by the war, his second Russian period. Walden was certainly in Paris at some point during the second half of 1912.

In 1912–13, then, Chagall was awarded and to some extent accepted membership of the scarcely existing Orphic school. More important, he took from Delaunay and Orphism methods of structuring that are essential to his finest pre-war paintings and have continued in his work to the present. Bakst and the experience of Fauvism had already directed him towards colour and an expressive visual poetry dependant on brushwork and distorted representations as well as on colour as such. Cubism, especially the Cubism of such men as Le Fauconnier (whose school La Palette Chagall visited at times), taught him to dramatise figures and other subjects by interrupting their forms and hues and at the same time to tie them into the picture by linking fractures and colour changes across the canvas. By the time of *Dedicated to My Fiancée* (Kunstmuseum, Berne; fig. 33), exhibited in the Salon des Indépendants in March 1912, he was capable of carrying through a monumental composition, quite realistic in some parts and positively earthy in theme, as well as positively unreal in some of its colours and colour changes and in its distorted and partly mythical representation of the two figures and their relationship. But with *Homage to Apollinaire* (Cat. 22), *To Russia, Donkeys and Others* (Musée national d'Art moderne, Centre Pompidou; fig. 23), *I and the Village* (Cat. 19), *Self-Portrait with Seven Fingers* (fig. 8) and *Calvary* (Cat. 27), and especially with *Half Past Three* (*The Poet*) (Cat. 20), Chagall attains maturity and mastery. The miracle of it—the Chagall-ness of it—is that he does not have to abandon anything in the process. The particular point to be made here is that he owes much in this development to Delaunay. Other influences were at work too, but it is primarily and specifically Delaunay from whom he learnt the art of giving a composition an all-over epic structure, of using colour not just brightly (after his often dark Russian paintings) but also lightly, strong enough to give sensations of light but also transparently, freshly, so that light seems to come through the canvas as well as from it. From now on his paintings, and aptly enough his stained-glass windows also, are experienced often as colour chords first, luminous and resonant, and as representations second. Another aspect of this influence relates to the question of subject-matter and communication, but this leads us to another, perhaps even more compelling and valuable influence.

Asked what had been the most important events in his life, Chagall answered, 'My meeting with Blaise Cendrars and the Russian Revolution'.[26] Chagall is one of those artists who do not find it easy to acknowledge other artists as friends and equals, let alone as guides. Picasso is the most famous instance, and, like Picasso, Chagall has always preferred the company and interest of poets. Of his closeness to the Delaunays there can be no doubt; apart from anything else he will have enjoyed the hospitality and the Russian conversation offered by Sonia Delaunay. It is clear, too, that he had an affectionate, slightly mocking regard for Apollinaire, and recognised his usefulness as manipulator and informer of the Paris art scene.[27] But he knew Cendrars before he knew Apollinaire, and probably saw how much Apollinaire and the Paris avant-garde scene as a whole owed to Cendrars. In his eyes Cendrars was undoubtedly the worker of a revolution in the spirit and also in the methods of the arts, from which Delaunay too benefited and which altogether altered the artistic spirit of Paris, and if such a view might have seemed excessive at the time, it seems less so now that particularly Apollinaire's indebtedness to the Swiss writer is more widely accepted. By referring to the impact of Cendrars upon his life as comparable to that of the Russian Revolution, which liberated him as a Jew and temporarily put him in a position of national power and leadership, Chagall signalled the overwhelming importance of that friendship.

Again, this is not the place to enter into a full account of Cendrars' relationship with Chagall. Suffice it to say that there are many references to Chagall in Cendrars' writings and recorded conversations and that, in the two well-known Chagall poems, *Portrait* and *Atelier*, written in 1913–14, he proved his intimacy with the Russian's art with an aptness of words and expression rare among poems about art, including Cendrars' own.[28] Chagall's admiration and affection for Cendrars is likely to have been in part that of a rather shy, in-turned exile for an outgoing, I've-been-everywhere-Man, muscular exile who reveals depths of learning, sympathy and self-doubt behind his gruff exterior, and goes on to use his art as a vehicle for fictional and factual constructions that come close to being apologias for a rootless, hungry life. More particularly, Chagall saw in Cendrars a great *animateur*, bringing energy to others as well as actual collaborative input. From early 1913 Cendrars was closely involved with the Delaunays, especially with Sonia with whom he worked on the astounding visual presentation of his second long poem, *La Prose du Transsibérien*. She valued him as 'the truest and the greatest poet of our time',[29] enthused also by his first major poem, *Les Pâques à New York* (Easter in New York). This he had brought with him when he arrived in Paris from New York (via Switzerland) in July 1912. He had taken a copy of it to Apollinaire, whose only acknowledgement of it was the writing of *Zone*, the opening poem of the collection *Alcools* (published in 1913). By the end of 1912 Apollinaire was using Cendrars on a variety of ghost-writing tasks.[30]

There are specific areas in which Cendrars can have directed or supported Chagall's interests. The young Swiss, born 'by chance' as he would have it in La Chaux-de-Fonds, and about four months younger than Chagall, spent 1904–07 in St Petersburg, working for a Swiss jeweller and spending much time in libraries. He arrived in Paris about the same time as Chagall, in late 1910, and spent some more time in St Petersburg during 1911. Chagall will have been pleased to meet someone who could chatter in Russian. They would certainly have been able to talk about the artistic life of St Petersburg, and it is possible that the more self-confident young writer had made contacts there that the diffident Russian envied him. From December 1911 until June 1912 Cendrars was in New York, taken there by a ticket for the sea passage sent him by his future wife Féla Poznanska. Féla subsequently joined him in Paris, arriving in May 1913. She spoke Russian well, and seems to have been very close to Chagall. He in turn may have been stirred by the coincidence that Féla's best friend, from girlhood on, was a girl called Bella who had been Blaise Cendrars' mistress before he met Féla. Chagall was engaged to Bella Rosenfeld back in Vitebsk, and was troubled by the possibility that she, a jeweller's daughter of many attractions, might be losing interest in her long-absent fiancé; Chagall had encountered his Bella through his close relationship with Thea Brachman (see Cat. 6). For a time, so to speak, Chagall immortalised Féla by making her name the title of the painting known as *The Pregnant Woman* (Stedelijk Museum, Amsterdam; fig. 12) when it was shown in Amsterdam in May-June 1914.[31] In April 1914 Féla had given birth to her first son. He was named Odilon, after Odilon Redon whose work Cendrars especially admired and had written about; it is likely that Cendrars, like others at this time, saw Chagall's work as related to Redon's in its mingling of factual representation and fantasy.

It is precisely in this area that Cendrars was best able to support Chagall. It is clear that Chagall, arriving in Paris, found much to admire, yet looked in vain for guidance towards what he himself aspired to among the artists and the exhibitions. The art of Paris spoke of freedom and energy; it showed a command of what Chagall calls 'chemistry', the efficient and affecting disposition of pictorial means, but it seemed to him lacking in human resonance. Cendrars' poem *Pâques* is a passionate prayer to a half-believed-in Christ, an insomniac's incantatory account of personal and observed miseries, with much of the pulse and dirt of Manhattan built into its hurrying couplets. Cendrars liked people to think that his idiom had been begotten in the subway and on the 'El' of New York, and claimed to have written the poem, almost exactly as published, in one feverish night. Yet the religious form and references, the elements of memory relating to Cendrars' life and also to his wide reading, give the poem a universality that descriptions of it do not suggest. *La Prose du Transsibérien* recalls a journey on the great railway taken in the company of one Rogovine whom Cendrars identifies as a Jewish jeweller from Warsaw but who could well be the artist I. Rogovin (French transcribers would add a final 'e'). Rogovin, together with Larionov, Goncharova and Tatlin, illustrated one of the most important of the Futurist miscellanies of pre-war Russia, Kruchenykh and Khlebnikov's *Worldbackwards*, published in Moscow in December 1912.[32] Cendrars is likely to have visited exhibitions in St Petersburg and Moscow, and may have penetrated literary circles. The possibility that the new Russian poetry and prose contributed to his literary formation remains to be explored, but the

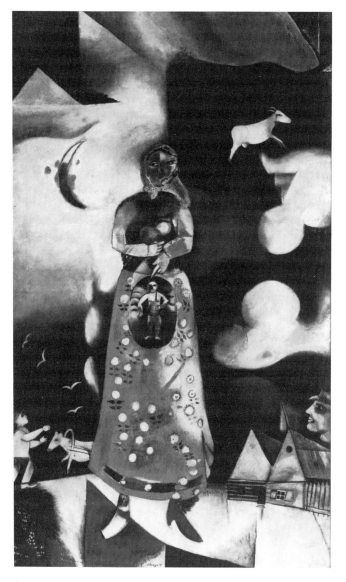

fig. 12 *Pregnant Woman*, 1913 (Stedelijk Museum, Amsterdam)

kind of urgency and universality. Cendrars in this way returned to the Russian painter an intimate combining of the sacred and the profane learned from Russian literature, particularly from Dostoevsky. What Cendrars' writing sought to attain, and what he valued in the work of others, was 'psychic unity',[34] compounded of inner and outer factors that rational discourse cannot bring together. The phrase is echoed in Chagall's reference to 'psychic construction', 'psycho-plastic resemblance', etc.;[35] it is clear from his use of such words that he too meant them to stand in opposition to conventional unities and point to profounder levels of apprehension.

One other impulse from Cendrars must be touched on briefly. Though Cendrars' poetry has never achieved the popularity of Chagall's paintings it was his aim to move poetry and poetic prose towards journalism and the widest possible democratic appeal. This was partly a matter of language and of common human concerns; it was also part of his self-image as a writer who placed his experience at the service of the world and consumed the world in search of that experience. This was not unique to him, of course: it is in the American poet Whitman, and 1912–13 marks the climax of *le Whitmanisme* in France. And though there is in Cendrars (as also in Chagall) an undercurrent of pain and fear that can surface to shocking effect, Cendrars' brisk modernity also brings with it a good admixture of Whitman's optimism and sense of a new dawn. What this meant to Paris is perhaps best expressed in three articles written by Jacques Rivière in 1913 announcing a change of heart and a new appetite for 'violent and joyful pleasures'.

'Once more it is morning . . . All our contacts with the world became a delight because of this sudden youthfulness; we need only go ahead to enjoy pleasures, the pleasure of being in the midst of things, the pleasure of being among men. The pleasure of being someone to whom something happens. The symbolists did not know this pleasure . . . We are lighter in spirit, thank God!'[36]

Rivière went on to propose a new kind of fiction in terms that fit perfectly Cendrars' partly autobiographical, partly invented narratives. This acceptance of the world with all its pains is also at the heart of Unanimism, itself a partial off-spring of Whitman. The leading spokesman of Unanimism, Jules Romains, saw Cendrars as a crypto-Unanimist, more brutal, more disordered and more wide-ranging in his view of the world than most. Romains points especially to his juxtapositioning of heterogeneous elements and the 'quasi-cinematographic acceleration in the unrolling of his mental images'.[37]

Cendrars' tempo was not Chagall's, nor could it be, but they shared heterogeneity, an encyclopedic hold upon the world, confusing and partly contradictory relationships to Symbolism, Cubism and the Futurisms of Italy and Russia. They shared, above all else, the conviction that the arts are communication between men, muted and falsified by conventions of language and syntax and by conventions also of propriety and genre, and that modern times as well as that force which powered their individual creative energies demanded the saying and the doing of certain things.

kaleidoscopic quality of, especially, *La Prose du Transsibérien*, its procedure by association and contrast rather than by good sense, suggest the shifts and the a-logicality of Russian Futurism and recalls Chagall's repeated assertions of his art as remote from the demands of rationality.

The multiplicity and mobility that Cendrars demonstrated was also cultural. He had travelled amazingly, physically and mentally. His reading by this time, though primarily in French literature of all ages, included Goethe, Heine, Spitteler and Ewers, Darwin, Taine, Durkheim, Tolstoy, Dostoevsky and Turgenev, as well as mystics and hermetic philosophers. His appetite was enormous, and so was his memory. Cendrars was to explain Chagall's representations of Christ on the Cross as justified by the painter's sufferings as a young man, but his own use of Christian imagery, not least in *Pâques*, was powerful and is one instance of a direct contribution to Chagall's work,[33] especially as an element to be mingled with others of a largely non-religious sort to achieve a particular

It is difficult to imagine Chagall as Commissar for the Arts in the Vitebsk region without the prior experience of Cendrars, assertive, hyperactive, headlong. With the Revolution achieved or at least initiated, it was time to demonstrate the Tolstoyan vision of a new public art, devoted to the spiritual themes of the time. We know that things went wrong, that Chagall's leadership became the victim of Malevich's missionary zeal for Suprematism. Chagall the striding man nearly became a colossus, bestriding Vitebsk and its environs where, not long before, he had been nothing but a Jewish boy of few rights and little presence.

Chagall's private art, back at home, suggests an attempt to bring a sophisticated French naturalism into Russia, an easy idiom that might please many and puzzle none, but the public work of 1917 and after fuses the sublimating geometry of Delaunay with the warmth of ikon painting. Suprematism ousted him from the Vitebsk school, but before it could do so Chagall produced the joyous combination of a striding, leaping man and Suprematist squares: a figure of joy and energy and a backdrop in which the forms of Suprematism are used in the spirit of Orphism. This is a time when Chagall's figures become lithe and lively, leaping, floating, arabesquing their way through the world, acrobats and tumblers presaging the biomechanical antics of Meyerhold's revolutionary theatre, bringing the *vox populi* of circus performers into art and on to the stage. When Chagall designs for the stage he fuses the Hebraic and the folkloristic with revolutionary forms and symbols as though he too had been one of the Futurists, anticipating the Revolution in his work. Geometry comes to the foreground, and why not? At school, 'What I liked best was geometry. At that, I was unbeatable. Lines, angles, triangles, squares, transported me into the realms of delight'.[38] Now it seemed that geometry was being established

as the visual language of a new humanity. His proposal for *Playboy of the Western World* (fig. 13) of 1920 was too revolutionary and Revolutionary to be acceptable to the Stanislavsky theatre. The text would presumably have been adapted, in the manner of the time and place, to turn it into a parable dealing with Russian issues. Chagall's décor for it presents the interior of 'Trinidad Bar' in almost Constructivist terms. He hints at tables and chairs, bottles, glasses and barrels, but our attention is held by a vertical ladder, a sloping bar or line that sustains a figure suggesting Christ Crucified, and a red spiral, also rising diagonally. The juxtapositioning of the ladder and the spiral refers directly to Tatlin's *Monument to the Third International*, shown in model form in St Petersburg and Moscow during the winter of 1920–21, much visited, much written about and much discussed. Some of Chagall's other stage designs required shapes of various sorts to be erected on the stage, as opposed to traditional combination of painted wings and backdrops framing actual furniture and other props. His anti-realism had already made difficulties for him with the producers who visualised the action and props of their plays in more or less naturalistic terms. The statement that accompanied his theatrical designs, exhibited in March-April in Moscow, in an exhibition that included the work of two other Jewish artists, Al'tman and Shterenberg, has all the ardour and conviction of the avant-garde of the day: 'In the dawn of the Russian Revolution we shall either die or enter on a new path'. It is legitimate to read Chagall's drawing for *Playboy* as representing a constructed rather than a painted set. If we can go one step further, a step demanded by the forms themselves, and visualise it as a kinetic structure, then Chagall's proposed set becomes the forerunner of Popova's for *The Magnanimous Cuckold* and other Constructivist stage works done, primarily for Meyer-

fig. 13 Sketch for décor of *The Playboy of the Western World*, 1921 (collection of the artist)

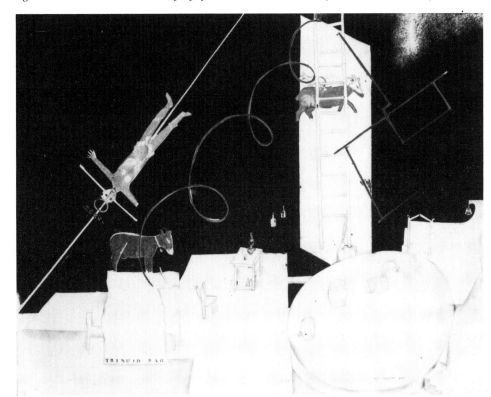

hold, during 1922–23. It would not take much technology to make the spiral twist and the cow behind the ladder rise or descend intermittently or at key moments in the action, but it requires the vision of a Meyerhold to recognise and harness its dramatic power. Meyer, describing the design, refers to 'an assortment of platforms' and 'slanting walls, poles, ladders, metal spirals', and the figure of Christ 'revolving like a weather vane'.[39]

Cendrars, his friend, had not accused him of being a literary painter. Returning to Paris in 1923, Chagall was 'agreeably surprised to find another artistic generation—the Surrealist group—who in some ways were rehabilitating the pre-war term [of abuse] "literature"'.[40] Here at last was a tendency that paralleled his interest in working with mankind's inner reality and not with the conventional naturalism of discourse and image that was the nineteenth century's dominant heritage, especially on the popular level. Yet he was not to feel real kinship with Surrealism, and it is easy to see why. The Surrealists' anti-conventionality became itself a convention, a sophisticated one at that, more aimed at challenging bourgeois values than at engaging a wide public in any sort of revolution. Their art seemed to him hermetic rather than an open invitation to everyman to 'look in his own way, interpret what he sees and how he sees'. When Breton, most publicly in his manifesto of 1924, gave priority to 'psychic automatism' as the Surrealist method *par excellence*, Chagall turned away. How could art address mankind if it did not originate in mankind? Varied though the visual phenomena of Surrealism turned out to be, this movement too seemed to him to be imposing a system and restricting allegiances. Though he was becoming a star among Western artists, Chagall sensed himself once again an isolated figure. His friends were again writers rather than artists. Jacques and Raïssa Maritain were especially valuable. Both were to write about his work; Maritain did so in 1929, in an issue of *Sélection* dedicated to Chagall, and more followed in the 1930s and 1940s, up to 1950.[41] Moreover, the Maritains were at the centre of a markedly civilising circle of writers and were happy to associate Chagall with it. Another of their artist friends and protegées was Georges Rouault, whom Chagall had contact with also through their association with the dealer and publisher Vollard. Obviously the two artists had much in common, and it is tempting to speculate on the intimacy and the exchange of ideas and professional knowledge that would come from it. It appears, however, that Rouault was deeply offended when Vollard commissioned a suite of Bible illustrations from Chagall in 1930, rather than from himself, and this terminated any relationship that may have been forming.[42] Perhaps the similarities shown by their work are only skin-deep, though evident enough when we consider the themes both treated, notably the Bible and the circus, and the priority both gave to expression through colour. Hazarding a nutshell formulation of the tendency, the characteristic warp, of each artist, we could say that Rouault's art is marked by the expectation of death and darkness, Chagall's by an assertion of an ultimate triumph over death—an assertion found also in the later Russian Symbolists, such as Blok, Bely and Scriabin, as well as the generation of Tatlin

and the Revolution itself.

There was no second Cendrars amongst Chagall's acquaintances of the 1920s and after. Perhaps, with growing self-confidence and status and as a devoted husband and father, Chagall had less need of such a friend. To some extent the role of Cendrars was taken by travelling, in search of data and the right tone for the illustrations he was making for Ambroise Vollard; to some extent it was the books themselves: Gogol, La Fontaine and above all the Bible (see Prints section, pp. 259 ff.). When the Nazis destroyed his paintings at Mannheim in 1933, the act and what it represented acted as another sort of impulse. With his *White Crucifixion* (Cat. 81) of 1938 Chagall initiated a series of epic, often large paintings, marked by a spiritual vehemence of which his earlier work gives little hint. Yet there was no change of idiom, let alone direction, just as *Golgotha* (Museum of Modern Art, New York; see Cat. 27), with its combination of a dominant colour chord and typically Chagallian adaptation of iconography, does retrospectively prepare for his grasp on themes that would normally be thought beyond individual ownership. It was now that Rembrandt largely displaced Gauguin as the subterranean well upon which Chagall draws. Chagall calls Gauguin 'the only revolutionary' of his generation,[43] presumably because he was the only great dreamer of that generation and had moved further than those around him from the descriptive role given to painting by the heirs of Courbet and Impressionism. Gauguin's exoticism is paralleled by Chagall's Eastern vein, much noticed in the pre-war Paris world.[44] There are elements of this in Rembrandt too, not least in his use of Jewish models, but it is not any exoticism in the Dutch master that Chagall is gripped by: Rembrandt reveals himself now as the super-realist whose grasp on visual and felt reality is so compelling as to lift factual representations on to levels of the most exalted poetry. Paris and St Petersburg gave him access to major works by Rembrandt; in 1932 Chagall visited museums in the Netherlands, and in 1934 he was in Spain (in pursuit also of El Greco), thus greatly increasing his first-hand knowledge of the world's masterpieces. To Erben Chagall said, in 1955 or 1956, 'Rembrandt, Masaccio, Grünewald, and perhaps Grünewald is the greatest'.[45] In Masaccio we recognise another painter to go through realism to heights of tragic expression, yet his election to Chagall's triumvirate of masters remains surprising: Italy would seem to have contributed least to his reservoir of knowledge and experience. But Rembrandt and Grünewald pair better than one would at first expect. Rembrandt is, Chagall teaches us, the most Russian of European masters, because the most pious, the most earthy, the most generous at some moments, at others the most egocentric. The Isenheim altarpiece's most famous component, the Crucifixion with St John the Baptist, can be thought of as the most potent ikon ever painted, in which extremes of realistic detail and symbolic figuration collide awesomely.

With the 1930s Chagall established unquestionably his universality. Popular taste will perhaps always incline to his more joyously lyrical compositions, his lovers amid spring blossom, his smiling cows and donkeys and his circus folk, not least because of their multiplication through prints and reproductions. Yet the time has perhaps come for him to be

recognised by the wider world as one of the few artists of our century capable of joining masters of past centuries as visualisers of religious themes. Many a twentieth-century painter has tackled religious subjects, partly because that was the surest way of reaching a public, but there is none, apart from himself, whom one would risk showing in the company of the old masters Chagall has named. Unless, that is, we grasp the nettle and insist on including abstract works among those dealing with religious content. Chagall's own generation witnessed a number of painters turning to non-objective art in pursuit of ways of conveying transcendental themes. Several of them were Russian; some of them were Russian Jews. More recently, another Russian has proved the power of non-descriptive dispositions of colour as an essentially religious mode of expression: Mark Rothko was only sixteen years younger than Marc Chagall.

This brings us to perhaps the most telling, and truest, reason why Chagall wishes to leave his imagery untranslated. Turning it into words, however well it is done, runs the risk of coating his paintings with a veneer of literature. In the process, that with which literature copes least well, the visual sonority of the painting as a whole, is lost sight of, forgotten. With Rothko we have to try; he leaves us little else to fix upon. There are some things we can say about his paintings, about his process of clarification, but soon we are brought back to their religious character and turn from them to Rothko's mind—what he read, what he said, what we think he thought—in order to know what sort of religiousness this is. Rothko and his circle gave primacy to 'The Subjects of the Artist',[46] but these subjects were, it seemed, to be at once highly personal and sublime, general intimations of significance rather than anything specific. Both Rothko and Barnett Newman were willing to see their compositions associated with the Book of Genesis; Newman sometimes titled his compositions with Old Testament names. Both painters conveyed their meaning through the psychological impact of areas of colour, their scale and relationship to adjacent colours, their character as membranes (soft-edged and cloudy, firm and taut, etc.), their emotional quality as colour. For both these great and influential painters 1947 was the turning point, when the clarity both sought was found as the culmination of a slow process of testing and exclusion.

1946 had seen the climax of Chagall's period of exile in the United States. Working in Mexico on the *Aleko* sets and costumes (Cat. 126–39), and, with Massine, on the ballet itself, had unleashed in him energies which emigration had locked in. The ballet was then seen also in New York, and in 1945, when the death of Bella had shut the painter in upon himself, the sudden, urgent call to design *Firebird* brought him again leaping into action. The work Chagall did during his six years in North America is, taken all together, very varied. It also includes his vast stage-sets and his most potent use of colour. More, even, than before, colour areas exist independently of the objects, figures, animals, or whatever he places on and into them. More than ever before, paintings are devoted to one or two large colour zones. In conversation with James Johnson Sweeney, Chagall even spoke as though painting objects into his pictures was an entirely secondary business, a filling in according to his whim. In 1946 Sweeney organised

and presented a retrospective Chagall exhibition at the Museum of Modern Art (it was shown again at the end of the year in Chicago), and this was an occasion for much discussion of Chagall's art in the magazines and the major newspapers, as well as the publication of Sweeney's catalogue as the essential, up-to-date and intelligent English language text on the artist. A substantial number of the exhibits listed in it were already in American collections (the Museum of Modern Art had earlier acquired the first of Chagall's great colour compositions, *I and the Village*, Cat. 19); others came from the Pierre Matisse Gallery in New York, where Chagall had exhibited several times since 1941. The general effect of all this was to release Chagall from the superficial association with Surrealism that had tended to occlude his art in American eyes. Sweeney's fine account of it markedly makes no reference to Surrealism, but stresses what he calls 'a notable clarification of his palette' and his 'bright, contrasting blues, reds and greens', drawing particular attention to *The Juggler* (The Art Institute, Chicago) and *Listening to the Cock* (Cat. 85).[47] The latter, privately owned in New York, could almost have been an intentional signal for Rothko, with its hovering purple cloud over a sea of vivid red.

Erben uses the heading 'Pictures like Mighty Ikons' for a section on the colour-dominated paintings executed by Chagall after his return to France in 1948.[48] Whatever produced Chagall's enhanced use of colour in Mexico City and after, the painter himself has always thought of Russia as his ultimate source of colour, whatever skills of control, etc., French 'chemistry' armed him with (see further p. 223). On the face of it there would seem to be no common ground for ikon painting, however colourful, with its canonical subjects, designs and even colour allocations, and for Chagall's insistently personal and a-logical visions, yet there it is—in the primacy of the colour statement. We are led to wonder whether his recourse to a wide but limited range of ever more familiar symbols, especially when they are left floating free of too final identifications, does not make him the perfect ikon painter in an age suspicious of established myths.

Newman, like Klee before him, speaks of creating out of chaos. Similar words could be used of Rothko. Moreover, we could say of Rothko and Newman, and probably of Klee too, what Thomas B. Hess has written of Newman in dealing with *his* essential religiosity: 'He is the artist as modern man, alone, surrounded by chaos, by social events over which he has no control, a transient material being—absurd'.[49] Whether or not this will be the final view of Newman or his posture as artist (it has a marked period flavour), it certainly represents a powerful element in Newman's and also Rothko's self-image. It illuminates Chagall for us by demonstrating what he is not. He can be funny, self-mocking, flighty, extravagant; he can be profoundly tragic in his direct and indirect treatments of suffering and fear; he can be joyous in a lasting, convincing way as well as sentimental. If he creates out of any chaos, it is not the cosmic chaos of disorientation and centrelessness but the chaos or, better, tumult of visions, memories and associations. Alone among modern painters, but like some of the world's greatest writers, he convinces us that we are not excluded, but see with him and are part of what he sees.

NOTES

The title of this essay is taken from Walt Whitman's *Song of Myself* (line 1033).

1. Meyer, p. 384.
2. Charles Sorlier (ed.), *Chagall by Chagall* (trans. J. Shepley), New York, Abrams, 1979, p. 189.
3. Quoted by Jay Bochner, *Blaise Cendrars: Discovery and Re-creation*, Toronto, University of Toronto Press, 1978, p. 268, n. 2.
4. E.g. Sorlier, op. cit., p. 107; Alfred Werner, *Chagall Watercolors and Gouaches*, New York, Watson Guptill, 1970, p. 15.
5. Meyer, p. 144; Werner Haftmann, *Marc Chagall*, New York, Abrams, 1973, p. 8.
6. Meyer, p. 591, quoting Chagall's Chicago lecture of 1958.
7. Stephen Lukashevich, *N.F. Fedorov*, Newark, University of Delaware Press, 1977; words from a poem by V. Kirillov of 1919, quoted by James Billington, *The Icon and the Axe*, London, Weidenfeld and Nicolson, 1966, p. 490.
8. Meyer, p. 591.
9. Sorlier, op. cit., pp. 190, 195.
10. *My Life*, p. 170 (last sentence of the penultimate chapter).
11. Ziva Amishai-Maisels, 'Chagall's Jewish In-Jokes' in *Journal of Jewish Art*, vol. 5, 1978, especially pp. 88–89.
12. Meyer, p. 14.
13. Sorlier, op. cit., p. 53.
14. Sheila Fitzpatrick, *The Commissariat of the Enlightenment*, Cambridge, Cambridge University Press, 1970, p. 4.
15. Meyer, p. 147, on Chagall's contacts with Lunacharsky in Paris; and see entry for Cat. 36.
16. Whitman's fame in Europe: see Gay Wilson Allen (ed.), *Walt Whitman Abroad*, Syracuse, Syracuse University Press, 1955. Complete or very substantial translations of *Leaves of Grass* appeared in Italian, German and Russian in 1907 and in French in 1909.
17. Leroy C. Breunig (ed.), *Apollinaire on Art*, New York, Viking, 1972, respectively pp. 225 (10 October 1912), 219 (20 March 1912), 212 (19 March 1912), 219 (21 March 1912), 216 (3 April 1912).
18. Virginia Spate, *Orphism*, Oxford, Oxford University Press, 1979, p. 37.
19. Breunig, op. cit., pp. 261 (14 October 1912), 262–65.
20. Spate, op. cit., p. 73.
21. Loc. cit.
22. Kandinsky's use of popular religious imagery suggests a comparable attempt to address his art to a wide public, but through references to devotional themes.
23. The catalogue of this exhibition, Walden's 'Erster Herbstsalon', lists also *Une parisienne*, *Prisme electrique* and a *Oiseau, prisme du matin*; the horse's backdrop is described as *Prisme Soleil Lune*. See Donald E. Gordon, *Modern Art Exhibitions 1900–1916*, Munich, Prestel, 1974, vol. 2, p. 739.
24. Breunig, op. cit., pp. 282, 291 (18 March 1913).
25. Breunig, op. cit., pp. 284–85 (25 March 1913).
26. Walter Erben, *Marc Chagall*, London, Thames and Hudson, 1957, p. 64.
27. *My Life*, pp. 111–14.
28. Cendrars' *Dix-neuf poemes elastiques* was published in 1919, but all but one ('Construction') were written some time before and eight of them had been published before the war in Paris journals and *Der Sturm*. The artists some of them refer to, apart from Chagall, are Sonia Delaunay, Roger de la Fresnaye and Léger. See Monique Chefdor, *Blaise Cendrars*, Boston, Twayne, 1980, p. 49.
29. Jacques Damase, *Sonia Delaunay, rhythmes et couleurs*, Paris, Hermann, 1971, p. 49.
30. Marc Poupon, *Apollinaire et Cendrars*, Paris, Minard, 1969, p. 59, and a letter printed in Blaise Cendrars, *Inédits secrets*, (Paris, Club Français du Livre, 1969, pp. 320–21) appears to be most certain of the review referring to Chagall's *Adam and Eve* (note 25, above) as being Cendrars' work. Monique Chefdor (op. cit., p. 71) accepts his view; Jay Bochner says, admirably, 'As for myself, I cannot tell' (op. cit., p. 247, n. 26). In any case, the question would remain to what extent Cendrars' task would have been limited to putting Apollinaire's comments or notes into printable form.
31. Amishai-Maisels, op. cit., pp. 87–88, associates this title, written *Félah*, with a Hebrew inscription meaning 'wonder of wonders'. She argues that this, together with other elements of the painting, signals a sarcastic attitude to the mystery of the Virgin Birth. It would seem to me to be out of character for Chagall to make hidden fun in this way of any valued religious belief. A gouache with a similar representation of a pregnant woman, this time without the bearded profile, probably done somewhat earlier, is entitled *Russia* (Meyer, p. 196). Both figures depend on the ikon type known as the 'Maria Blacherniotissa' (Meyer, p. 203).
32. See the invaluable list of Futurist books in Susan P. Compton, *The World Backwards*, London, British Library, 1978, p. 125.
33. But see also Susan Compton's essay on Chagall's themes (pp. 16–19 above), and her account of the stimuli behind his use of the Crucifixion theme. Chagall may also have noticed Apollinaire's praise of a *Humiliation of Christ* amongst Henri de Groux's paintings shown at the 1911 Salon d'Automne; he is more or less certain to have seen the exhibition. For Apollinaire's review see Breunig, op. cit., pp. 181–82 (30 September 1911).
34. See, *inter alia*, Cendrars, *Aujourd'hui*, Paris, Graffet, 1931, p. 201, quoted by James Johnson Sweeney, *Marc Chagall*, New York, Museum of Modern Art, 1946, p. 16: 'the verbal image is a psychic unity anterior to the word'.
35. E.g. Sorlier, op. cit., p. 185.
36. The articles, entitled 'Le roman d'aventure', are reprinted in Jacques Rivière, *The Ideal Reader*, London, Harville Press, 1960, pp. 35–81. My quotation is excerpted from pp. 46 and 47.
37. Jacques-Henry Lévesque, *Blaise Cendrars*, Paris, Seghers, 1947, p. 32.
38. *My Life*, p. 55.
39. See Meyer, pp. 287, 292, and Matthew Frost, 'Marc Chagall and the Jewish State Chamber Theatre', in *Russian History*, vol. 8, parts 1–2, 1981, pp. 90–107. Chagall's design, not discussed by Frost (because not part of his subject), is in the artist's collection and was recently shown in the exhibition 'Marc Chagall: Œuvres sur papier', at the Centre Georges Pompidou in Paris in June–October 1984 (cat. 90, colour plate p. 127).
40. Sorlier, op. cit., p. 12.
41. See Meyer, p. 719, item B324, for details of the Chagall issue of *Selection*.
42. Pierre Courthion's Rouault monograph (London, Thames and Hudson, 1962) lacks all reference to Chagall.
43. Meyer, p. 13.
44. Meyer, p. 132.
45. Erben, op. cit., 13. Chagall would have had an opportunity to visit Colmar and see the Isenheim altarpiece in 1933, on his way to or from Basle to attend the opening of his large retrospective at the Kunsthalle there, on November 4.
46. 'The Subjects of the Artist' was the name of the New York painting school opened in 1948 by Rothko, Newman (who proposed the name), Baziotes and David Hare.
47. See Sweeney, op. cit., especially pp. 63 and 25.
48. Erben, op. cit., p. 128.
49. Thomas B. Hess, *Barnett Newman*, London, Tate Gallery, 1972, p. 39.

The Russian Background

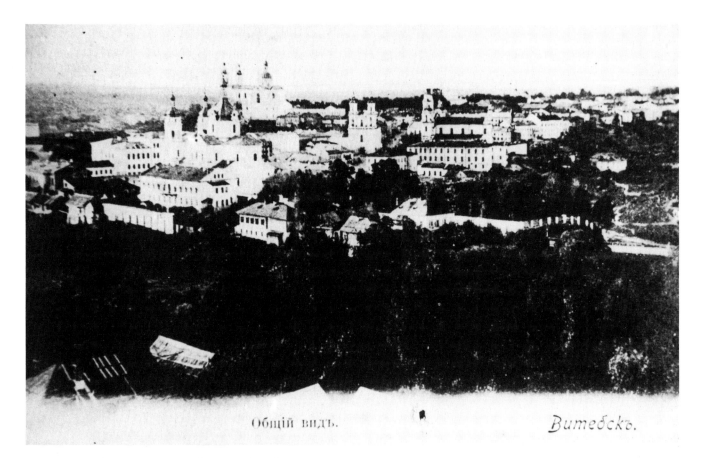

fig. 14 View of Vitebsk, postcard (collection of the Belo-Russian Library, London)

Chagall has lived and worked in France for such a large part of his life that his origin as a Russian painter is often overlooked. Like his countrymen Archipenko and Soutine, Al't-man and even Lunacharsky, he was one of the Russian painters who inhabited La Ruche, a series of studios in Paris, many of which were occupied by foreigners in the years before the First World War.[1] When Chagall stayed there, there were so many Russian contributors to the Salon des Indépendants that it was even suggested that they should form a separate exhibit. It is remarkable that Chagall has been accepted so wholly by his adoptive country that his early years in St Petersburg are often forgotten.

For the current exhibition it has been possible to borrow a comparatively large number of works which Chagall made in Russia before his first visit to Paris (which lasted from 1910 to 1914). Most of these were made shortly before he left St Petersburg while he was a student at the Zvantseva School of Art, where, except for his trips to Vitebsk and the months that he spent at home there, Chagall worked from 1909 until summer 1910.[2] His teachers were Léon Bakst and Mstislav Dobuzhinsky, both of whom provided him with far more background than he has been wont to admit. In an interview he has expressed his debt to Bakst, whom he described as 'a breath of Europe': 'it was with him that I saw in reproduction, the first Fauve canvases, the sketches of Van Gogh and of Cézanne. It was there that my ambition to go to Paris was born'.[3]

Before finding the congenial Zvantseva School, Chagall had a previous history of school attendance in the capital, where he had arrived in the winter of 1906-07 at the age of nineteen. First he had taken the entrance examination to Baron Stieglitz's School of Applied Arts: he had to copy a plaster cast, a stem of vine with a bunch of leaves, but with his limited background of previous education at Jehuda Pen's

provincial art school in Vitebsk, he had failed to qualify. He subsequently applied to another school, sponsored by the Society for the Protection of Arts, where Nicholas Roerich soon became director.[4] This artist took an interest in Chagall, arranging for the deferment and then cancellation of his military service, and as early as April 1907, commended him in the board's report which gave him an award. Later that year, in September, he was granted a scholarship for fifteen roubles a month for a year.

This indicates some of the difficulties both educational and financial, which Chagall experienced in the capital, coming as he did from a modest Jewish family in Vitebsk. Unlike many of his co-religionists, he had been given a secondary education, for his parents had sent him to a Russian grade school when he left the *heder* (the Jewish school) at thirteen. As a Jew, he needed a permit to go to the capital and it could only be extended by his acceptance in a recognised place of study. To avoid the same difficulty, another young Jew from Vitebsk, the artist El Lissitzky, was sent by his parents to study abroad in Germany directly after his schooling in Smolensk, thus avoiding the problems of gaining permission to reside in St Petersburg or Moscow.

In a long note in her book on Russian art, Valentine Marcadé describes the special position of Jews in Russia before the Revolution, drawing attention to the fact that for several centuries admission into Russia had been strictly forbidden to Jews until the first partition of Poland in 1772, when White Russia, with its huge Jewish population, was reattached to the Russian Empire. She points out that it was the question of religion rather than race which was the base of the hostility towards Jews, who before the Revolution were limited to provinces in the south and west of Russia named the Pale of Settlement. In 1910 there were more than 1,500,000 Jews living in communities which it was impossible for them to leave without a permit, normally issued only to merchants and their employees for short visits connected with their business. That was how Chagall reached St Petersburg; his problem was how to remain there. He solved it at one time by the ruse of being nominally engaged as a footman by a philanthropic co-religionist. Marcadé notes that the concentration of Jews was of 'the utmost importance for the creation of a complete series of Jewish institutions, whose character was not only religious but also social and cultural. The high density of the population favoured the conservation of all national traits, and made the possibility of assimilation with a Russian milieu unlikely. But it brought spiritual forces to flower: the high number of books published in Hebrew is surprising. The Jews rigorously observed religious festivals, all fasts and dietary rules. They also wore a particular kind of dress. All this made Jews into beings completely apart.'[5] It would, however, be incorrect to imagine that Chagall's upbringing in Vitebsk was like that of Jews in Poland. In 1935 he went to Warsaw and was struck by the ghettos—'places apart'—of Polish towns and the harassment which Jews took for granted there. In contrast, Vitebsk was simply a town like many others in the Pale of Settlement with a high proportion of Jews making up the population.

Marcadé also includes a description of Chagall's more particular allegiance. 'In their religious communities Jews were

fig. 15 A. Benois, *View of St Petersburg*, postcard for the St Eugenia Society, n.d.

divided into two principal groupings, Hasidim and Misnagrim; the family of Chagall were Hasidim. They were distinguished by an extremely mystical state of mind. In Hebrew, their name means "The Pious". Their ethic was founded on charity, on mutual aid, on good works and was addressed to everyone without distinction of the faith, and even to animals, which Hasidim endeavoured not to overload with too heavy burdens. According to their belief, the souls of great sinners were transmigrated into the bodies of animals as punishment for their faults, and they wandered for centuries between paradise and hell. Since childhood, the Hasid was surrounded by a mysterious world of the Cabbala and fantastic, ancient legends. This was without any doubt the source of the lyrical fairytales of Chagall, of his people and animals flying between sky and earth, imponderable, enchanted, carried on the wings of love. Jewish literature is plunged in this mystical atmosphere where unreality has as much importance as reality.'[6]

This view of the world from which Chagall originated, written by a Russian art historian, helps to set into perspective the transition of Moses Shagal (a literal translation of his original name) to the Parisian Marc Chagall, by way of St Petersburg. One must not, however, overdramatise the transition, for Vitebsk was a large town, having over sixty thousand inhabitants, with a strata of rich and cultivated Jewish families into which Chagall had gained entry by his precocious skill as a draughtsman. However, the capital must have given him his first experience of the whole range of the history of art, both in the native Russian tradition, to be seen in the ikons in Alexander II's Russian Museum, and the western European, to be seen in the art galleries of the Hermitage Museum. The Hermitage is, of course, one of the great museums of the world, rivalling the Louvre in the range of its collections, and Chagall was certainly able to gain a very sure grounding by visiting the museums in St Petersburg. None the less, these pictorial traditions, with great richness of subject-matter and diversity of style, surely came as a considerable cultural shock to one whose background had been visually relatively limited by his upbringing.

Chagall's first problem in St Petersburg was to find what, for him, seemed the right kind of teaching. His only comment on his teacher Roerich in his autobiography was unfavourable—he 'wrote unreadable poems, books on history and archaeology, and smiling through clenched teeth read parts of them out loud'.[7] Yet this mentor gave his pupil a first glimpse into the Slavophile world, and also communicated his enthusiasm for prehistoric times. Roerich's passionate interests may have seemed dull to his young pupil, but they opened new vistas on the past.

It seems that Chagall had some training as a sign-painter, for apparently he fitted in an apprenticeship, according to his memoirs, failing the final examination. He remembered: '. . . I took a passionate interest in signs and I did a whole series of them. It was good to see my first signs swinging in the market outside a butcher's or a greengrocer's, with a pig or a hen fondly scratching itself nearby, while the wind and the rain, heedlessly spattered them with mud'.[8] The date of this apprenticeship is extremely vague, though another type of work which the artist was engaged in, re-touching negatives for a photographer, provided him with some money to live on both before he left Vitebsk and after his arrival in St Petersburg. The experience of both kinds of practical work in fields alongside 'fine' art contributed to the originality of his compositional inventions, while leading him to avoid the extremes of neo-primitive stylisation and photographic likeness. No doubt both sign-painting and photographic re-touching led him to an extra awareness of the role of style in art.

When Chagall was admitted to the Zvantseva School in the winter of 1908–09, his new teachers had been, like Roerich, members of the World of Art group.[9] But by that time their work could no longer be described as cast in an art nouveau mould; indeed, Bakst and Dobuzhinsky were in touch with the most progressive wing of the St Petersburg avant-garde at the time. While Bakst's reputation in the West still depends on his connections with Diaghilev's 'Les ballets russes', Dobuzhinsky's interests lay closer to hand: he was involved with the experimental theatre, and he designed several productions for Nikolai Evreinov, whose 'Old Time Theatre' season of 1907–08 was based on medieval mystery plays. Chagall may not have seen his drawing teacher's set and props for *Jeux de Robin et Marion* (fig. 16) but his own interest in theatre is very strongly suggested by one of the earliest pictures in this exhibition, *Village Fair*, 1908 (Cat. 2). Its unusual subject-matter makes a persuasive connection with the theme of an avant-garde theatre production which had provoked discussion the season that Chagall arrived in St Petersburg, *The Fairground Booth* (*Balaganchik*) by the poet A. Blok. It remained a subject for artists (for instance, another teacher at the Zvantseva School, Ulianov, drew the actor-director Meyerhold in his role of Pierrot in 1906).[10] Chagall's picture, described in detail in the catalogue entry, is a new type of narrative painting, which can be seen with interest by any viewer because of its combination of comedy and tragedy, but for anyone who knows Blok's play, a further rich dimension of meaning is to be found. The paradox of illusion and reality, life and death, suggested by the clown in the foreground (a character from the play) is at once recognisable: Chagall has, as it were, created a postscript or comment on the drama.

A portrait, *My Fiancée with Black Gloves* (Kunstmuseum, Basel, fig. 17) reflects stage production in a different way: it shows his future wife, Bella Rosenfeld, whom he met in Vitebsk that year. She was then attending lectures by Stanislavsky, the director of the Moscow Arts Theatre, and

fig. 16 M. Dobuzhinsky, design for *Jeu de Robin et Marion* (published in *The Golden Fleece*, no. 7–9, 1909)

fig. 18 M. Dobuzhinsky, *Window at the Hairdresser's*, 1906 (reproduced in *The Golden Fleece*, 1906, no. 6)

fig. 17 *My Fiancée with Black Gloves*, 1909 (Kunstmuseum, Basle)

the unusual pose may be derived from one of the drawings made by the designer Egorov for a stage production of 1907. The stylisations for this play by Andreev, *Life of Man*, depend on the effective silhouette which Egorov formed by outlining the costumes: one of his sketches,[11] though ultimately deriving from Beardsley, has inspired the view of Bella with her hands in black gloves, shown against a white dress.

Chagall may simply have heard about the production of *Life of Man* from Bella, but the play was topical, since it had been put on with a rival experimental setting devised by the director Meyerhold in St Petersburg the same year. The following year Meyerhold published a book in which he quoted a letter from Andreev: 'When one looks at a painting, one is always aware that it is composed of paint, canvas and brush strokes, but none the less it creates a heightened and clarified impression of life. Frequently, the more obvious the artifice, the more powerful the impression of life.'[12] This view epitomises Chagall's approach to narrative pictures before he left St Petersburg.

Leonid Andreev (1871–1919) has been largely overlooked by Western writers on art seeking a more radical approach than his; but his plays enjoyed enormous popularity, being produced as he wrote them between 1906 and 1910.[13] Painting remained one of his favourite pastimes, so he was writing to Meyerhold from his own experience and, in his *Life of Man*,

he had replaced the term 'act' by 'picture', an idea, he said, that had come from seeing Dürer's woodcuts in Germany. The play is based on medieval representations of five stages of life: the pain of birth, youth, a ball, old age and finally, death. The themes are closely related to the ones which Chagall chose in those years: *Birth* (Cat. 10) and death (*The Dead Man*, Cat. 3) are the most obvious, but there is also a drawing of a ball scene dated 1907.[14] Although Chagall's pictures are in no sense illustrations of Andreev's play, it seems likely to be more than coincidence that he chose the subjects. Furthermore, the single play by Andreev that was performed in translation in the West, *He Who Gets Slapped* of 1915, seems to have inspired the characters for at least one of Chagall's later pictures, *The Grand Parade* of 1979–80 (see further Cat. 121).

By 1909 there was a more direct link between Chagall and the Moscow Arts Theatre, for his drawing teacher Dobuzhinsky designed *A Month in the Country* by Turgenev for production that year. He produced a series of exquisite set designs, denoting a particular location appropriate for the historical time of the play which, no doubt, remained uninteresting to his pupil.[15] But another side of his work was to play an important part in Chagall's own paintings, especially after he went to Paris. For Dobuzhinsky made a series of small pictures, often in watercolour, in which he used dramatic profiles, cut-off figures and close-ups. In *Grimaces of the City*[16] (which was reproduced in the journal *Satirikon* in 1908) he added a particular kind of witty, yet neo-primitive flavour by introducing popular art forms, such as the shop signs to be seen everywhere in the streets in those days. In *Window at the Hairdresser's* (reproduced in *The Golden Fleece*, no. 6–7, 1906)[17] he depicted two dummy heads, one on a shelf above the other, in a manner which anticipates Chagall's similar device in *The Fiddler* (Cat. 34). No doubt the originals of Dobuzhinsky's heads were advertising wigs, but he has presented them in such a life-like manner, peering out into the dark street illuminated by a streetlamp which casts ominous shadows, that they seem like a commentary on the prevailing social unease represented by the man with his hands in his pockets who slouches away with a disconsolate stride. Perhaps this interpretation is made possible because of Dobuzhinsky's reaction to the events of 1905, when the abortive revolutions had provoked his cartoon *Idyll in October* published in a satirical journal.[18] There he had portrayed a street corner, with a building and pavement smeared with fresh blood: an abandoned doll lies on the ground nearby, and a single galosh and pair of spectacles occupy the foreground corner. In this understated way he used symbols to signify death on the street.

Although Chagall did not follow Dobuzhinsky's direct approach to political events, some of his own St Petersburg pictures can be read as a similar veiled commentary on the Jewish problem in Russia. In them, however, the political implications are hidden beneath a layer of witty parody. Chagall's humour, which has recently been picked out by Ziva Amishai-Maisels in her article on 'Chagall's Jewish In-Jokes',[19] is double-edged: in a picture which she discussed in this light, such as *The Family or Maternity* (Cat. 8), Chagall took a subject closely related to traditional iconography in

Western art, borrowing from the type of a Circumcision of Christ and altering it in a subtle manner that would have only been immediately obvious to his enlightened Jewish patrons. By this token he was able to remain loyal to his Jewish upbringing but investigate for himself subjects from the Christian canon, frequently found in museums, but presumably taboo for a Jewish boy from Vitebsk.

However, there was a precedent for a Jew to adopt a Jewish Jesus, for in the recent past the most important sculptor in Russia had been Mark Antokolsky (1843–1902) who had achieved his fame in spite of remaining a Jew. In his famous *Ecce Homo* (Tretiakov Gallery, Moscow), he had represented a life-size Jesus wearing the traditional Jewish cap (*kippa*), explaining that he understood Jesus of Nazareth as a last Jewish prophet.[20] This attitude was to be a profound inspiration for Chagall when, in later years, he painted such subjects as *Exodus* (Cat. 105); and in his autobiography he mentions Antokolsky several times when writing about his years in St Petersburg. He records that Max Vinaver (the patron who made it possible for Chagall to go to France) dreamt of seeing him become a second Antokolsky.[21] It surprises many people even today that Chagall adopted the Crucifixion so often, beginning with a drawing (fig. 5) before he left Russia, but within the context of rivalling the fame of Antokolsky the choice becomes comprehensible. (The subject is further discussed in the essay on 'Themes in the Work of Chagall' above.)

The clearest examples of Chagall's use of symbols are the major works that he made in Paris, such as *Golgotha* (see Cat. 27) developed from the Crucifixion drawing. The combination of precise symbol with implied wider interpretations in that picture suggests another important influence in St Petersburg. For the Zvantseva School occupied the building in which the philosopher Viacheslav Ivanov had his apartment.[22] This 'Tower' was a meeting place for Symbolist poets and painters and, without going so far as to suggest that Chagall himself met Ivanov, he must have known about him. From that circle Chagall mentions the poet Blok in *My Life*, but it would seem that Ivanov's essay 'Two elements in contemporary symbolism' was not unknown to him, particularly since it was first published in the progressive art journal, *The Golden Fleece* (*Zolotoe runo*), which included reproductions of works in current exhibitions and collections. As is indicated in the catalogue entry for *Birth* (Cat. 10), it seems reasonable to infer that Chagall knew the essay, since he gives so much prominence to the figure of the midwife that it almost illustrates Ivanov's dictum: 'as a midwife eases the process of birth, so should the artist help things to reveal their beauty . . .'.[23] Yet it would be a mistake to suggest that Chagall was literally portraying the advice of the Symbolist, for the picture can also be seen as a witty send-up of the idea. The connection, like the one between *Village Fair* and Blok's *The Fairground Booth*, is only available to anyone who already knows the reference. Furthermore it simply adds one more interpretation or allusion, since the subject has already been

fig. 19 Nineteenth-century Russian folk print from *Almanac der Blaue Reiter*, 1912

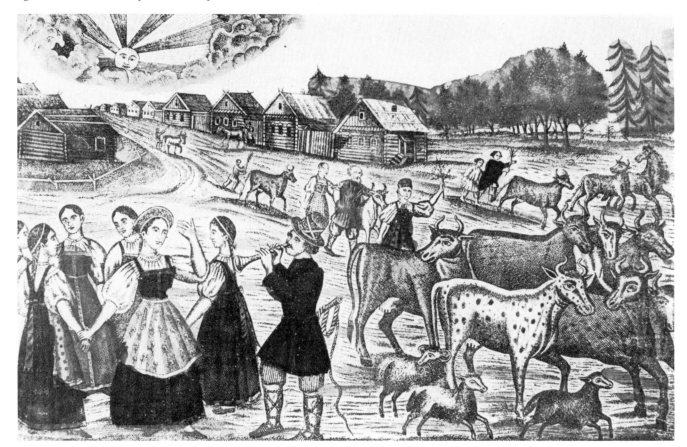

connected above with Andreev's *Life of Man*, and, as can be found in the catalogue entry, the subject had fascinated artists of the Moscow Blue Rose group in 1907.[24]

Chagall deliberately turned away from the stylisations that members of that group had favoured for their mystical pictures, with abstracted forms in pastel colours. They had adopted the mode as a vehicle for their view of a world beyond the picture, vaguely suggesting a subject and giving a presentiment of otherworldliness by stylising; hinting at 'the unspoken, of that which can be fathomed only by vague presentiment' as one reviewer wrote in *The Golden Fleece* in 1906.[25] By 1908, when the Blue Rose group was fading, a discussion had arisen on the nature of the symbol in Russian art, as to whether it should be hidden—as the Blue Rose artists had believed—or whether it should be stated so clearly that it transmitted a full range of meanings more openly. That was the position which Ivanov now held, and its appeal for the young Chagall is suggested in the catalogue entries referred to above. His pictures begin from the premiss that a subject deserves to be set out clearly in the same way that it had been for the greater part of the history of post-Renaissance art, and even in its derivative, the woodblock folk-print (fig. 19). Chagall's pictures cannot accurately be described as allegories, nor as illustrations, but they suggest their own story (as a folk-print does), even if its exact nature remains hidden from the viewer. In the case of Dobuzhinsky's cartoon *Idyll in October* described above, the reference is to a political event which has remained within the canon of history: but although particular references no doubt exist in Chagall's paintings, they are usually more personal and more arcane. Nevertheless, in *The Dead Man* (Cat. 3) the figure, lying in a street but surrounded by candles, remains such a potent idea that it works for the spectator in a direct way, unlike the transcendental symbols of the Blue Rose artists and their sympathisers.

Confusingly, one critic had written a review of the Blue Rose exhibition (held in March 1907) picking out the distortions used for expressive purposes: 'They have heralded that primitivism to which modern art has come in its search for a renaissance at its very sources, in creation spontaneous and unweakened by the weight of historical experience.'[26] It was neo-primitivism that preoccupied two avant-garde artists in Moscow, Larionov and Goncharova, for the following years. They were a little older than Chagall and had flirted with Blue Rose ideas before becoming interested in Post-Impressionist artists, whose work they could see more easily at first hand in Moscow than Chagall could in St Petersburg (both on account of exhibitions and the rich private collections of, for example, Shchukin and Morozov). Their work, like his, reflects an admiration for Gauguin, though they were more interested in *matière*, the surface and texture of the canvas, and less in a symbolic representation.[27] But when it came to their attempt to create a modern Russian style that would rival the one being developed by the Russian-dominated group of artists in Munich, or the Italian Futurists, Larionov can be said to have been predisposed towards a linear abstraction, both following in the wake of Impressionism and, perhaps unconsciously, taking up the devices of line and rhythm which had been essential ingredients of Blue Rose art.

This sweeping generalisation will find objectors, for Larionov's avant-garde style, Rayism, undoubtedly included a strong dynamic element. Even so, it is significant that, having avoided the earlier Moscow-based pictorial symbolism, Chagall was never tempted to push his art so far towards abstraction as Larionov. This was the case in spite of the fact that he shared Larionov's interest in folk art, and his outlook had seemed close enough for his work to be included in two of Larionov's Moscow exhibitions, in 1912 and 1913.[28]

By the same token, he remained disinterested in Futurism, which did not develop in Russia until 1912, two years after Chagall had left St Petersburg.[29] However, in spring 1910 a first collection of poetry was published by those writers who later identified themselves as Russian Futurists. It was called *A Trap for Judges* (*Sadok sudei*) and was organised by Elena Guro and published by her husband, Matiushin, who had been students with Chagall at the Zvantseva School. During

fig. 20 M. Larionov, *Relief of the Guard*, lithograph; postcard, 1912

fig. 21 M. Larionov, *Resting Soldier*, lithograph; postcard, 1912

the following year, Guro planned a sequel, jointly edited by herself and Aleksei Remizov. Both have been called Impressionists, though Remizov is also classed as a neo-Realist writer; he had a taste for the macabre in subject-matter, while she delighted in fantasy. Both drew in addition to writing.[30] So, at the time when Chagall left Russia, even if he did not move in exactly the same circle as Guro and Remizov, there were others close to him in St Petersburg whose modernist approach, like his own, was post-Symbolist and little related to the Moscow avant-garde. Thus Chagall went to Paris with considerable experience of the St Petersburg artistic world, arriving at a time when he was poised to develop his art. As a Russian, it was the light and colour and, above all, the freedom of Paris which, he said, affected him the most when he arrived.[31] Like many other Russian students, including Popova and Udal'tsova, he attended La Palette, a studio run by Le Fauconnier, who had a Russian wife.

Chagall's 'Russian background' continued in Paris, for he was at first helped by the critic Tugendkhol'd, the Paris correspondent of the journal *Apollon*, in whose offices in St Petersburg Chagall and other pupils of the Zvantseva School had exhibited their work in 1910.[32] Furthermore, a Russian language newspaper was published in the French capital, of which the pages allow glimpses of events that influenced his work, such as a violin-playing hero of the 1905 revolution who seems to have helped inspire the subject of a fiddler (see further Cat. 34, 36).

Likewise, it seems not unreasonable to link the subject of *The Flying Carriage* (Cat. 35) with the motif on the cover of the first number of the Russian journal *Helios* (*Gelios*) published in Paris in November 1913, especially since one of the editors, Ilia Erenburg, was the cousin of an artist whose studio Chagall had occupied for his first year in Paris. But the juxtaposition of St Petersburg pictures with those painted in Paris that can be seen in this exhibition makes it equally clear that other more specifically French influences joined together to lift the work of an extremely talented young student from St Petersburg into the first rank of modern European art. As has been suggested in many catalogue entries, the role of the realistic symbol, so clearly displayed in his pictures before he left Russia, continued to play a prominent part in his work in Paris (see especially *Calvary*, Cat. 27). He developed his range in an astonishing manner, allowing many allusions to be recognised in the paintings. This is particularly the case with *To Russia, Donkeys and Others* (Musée national d'Art moderne, Centre Georges Pompidou; fig. 23), for, while studies include the sun as well as the unlikely milkmaid and her cow and calf, the sun has been eclipsed in the finished painting. It has been covered with black paint in recognition, presumably, of the eclipse of the sun which was seen throughout Europe in 1912. A year later in Russia that eclipse prompted an opera,[33] with music by Matiushin; it was organised by those artists who had taken part in the exhibition 'The Donkey's Tail'.[34] Since Chagall had shown work there, it seems likely that the name contributed the dedication 'To donkeys' in the title of this picture. Furthermore, while an interest in Egyptian art among those same Moscow artists has been discussed elsewhere by this author,[35] that same art, used in an entirely different spirit, must have given rise to the child feeding from the cow. For although most writers have linked it to the legend of Romulus and Remus (who in ancient times had been suckled by a wolf) one of the Egyptian gods, Hathor, fits more clearly with the eclipse. She was the Egyptian deity whom the Greeks identified with Aphrodite, but legends tell that she was the great celestial cow, who created the world and all that it contains, including the sun. Thus she is sometimes represented as a cow and one statue in Cairo shows her giving her milk to Amenhotep II who kneels under her like Chagall's child in the picture.[36] Other legends explained that the sun-god lived within Hathor, being enclosed each evening within her breast, to be born again each morning: and that she welcomed the dead on their arrival in the other world.

While such interpretations may seem quite inappropriate if Chagall is thought of simply as a young Jew from Vitebsk, in the light of his years in St Petersburg, as examined in this article and in the catalogue entries, it does not seem so unlikely.

Chagall returned to Russia on 15 June 1914, leaving Berlin after attending the opening of his one-man show.[37] He had intended to return to Paris within the three months' validity of the passport he had obtained from the Russian consulate there; but by 8 August it was impossible to leave Russia because of the outbreak of war. He made an attempt to return to France in September 1915,[38] no doubt following the example of Larionov, who managed to reach Switzerland that year, as did Goncharova, or of Anton Pevsner, who was able to join his brother, Naum Gabo, in Oslo in spite of the war. Chagall found it impossible to leave and stayed on, taking an active part in Russian and Jewish avant-garde circles for the next five years.

fig. 22 V. Lebedev, motif, detail of a wrapper for *Gelios*, Paris, 1913

His desire to go back to France was perhaps due to the disorientation he must have experienced at finding himself back in his home town with none of the canvases that he had painted since he had left four years before. All his major oils and a large number of drawings were in Berlin; furthermore, pictures like *The Lovers* (fig. 2) were still in his studio in La Ruche.[39] So as well as the personal frustration that he must have felt on returning to the closed society of Vitebsk, he had the unprecedented difficulty of beginning again without the guide-lines which his own pictures would have provided. Although not represented in this exhibition, another side of his work in Paris was many drawings based on an idealised view of the environs of Vitebsk and the village of Lyozno, where he had spent many holidays as a child. Confined to the town, without the benefit of homesickness felt from afar, he was faced with its provincial reality. He set about making a number of studies from life, such as *The Praying Jew* (Cat. 43), in which he combined the observed features of a real person with some of the stylisations of his most recent pictures, such as *The Lovers*. This return to a way of painting based on observation was no doubt prompted by the very human desire to produce works which were accessible to his family (hence the many portraits and genre scenes). It may also have been a reaction to the Van Gogh exhibition that was to be seen at Paul Cassirer's gallery in Berlin in May and June 1914.[40] This was the largest exhibition that there had ever been of Van Gogh's work and included drawings as well as oil-paintings (and was later notorious for fakes). The intensity of feeling of a picture such as *The Potato Eaters* (Rijksmuseum Vincent Van Gogh, Amsterdam) matched the emotion conveyed by the masterpieces of Mantegna, to be seen in the Nationalgalerie in Berlin. As is suggested in the catalogue entry for *Feast Day* (*Rabbi with Lemon*) (Cat. 45), it seems that Chagall set about making a Jewish equivalent of classical Western art when he returned to Russia.

He did not, however, remain in isolation for very long. He began by cementing his connections with those artists who had organised the exhibitions 'The Donkey's Tail' and 'The Target' in which his work had been included while he was still living in Paris (in 1912 and 1913).[41] It does not seem that he knew the prime organisers, Larionov and Goncharova, personally, and he had missed the opening of their first exhibition in Paris held from 17–30 June, 1914. None the less he succeeded in showing twenty-five works in March at the spring avant-garde exhibition in Moscow called 'The Year 1915'; this was more than Larionov (who showed nine works), Goncharova (who showed four) or Kandinsky (who showed ten). However, whereas they contributed work in their most advanced styles, all Chagall's titles listed in the catalogue indicate new paintings from the life or from nature.[42] Three were grouped as 'Playing the Mandolin' and may have included *David in Profile* (Cat. 39); *The Praying Jew* may have been shown under the title 'Black and White'. For this exhibit Chagall was advised by the critic Tugendkhol'd who had mentioned his work in reviews of exhibitions in Paris.[43] At this time the artist met Kagan-Chabchai, who was collecting work for his proposed museum of Jewish art. He became a great patron of Chagall and, indeed, owned the first version of *The Praying Jew* as well as *Feast Day*.

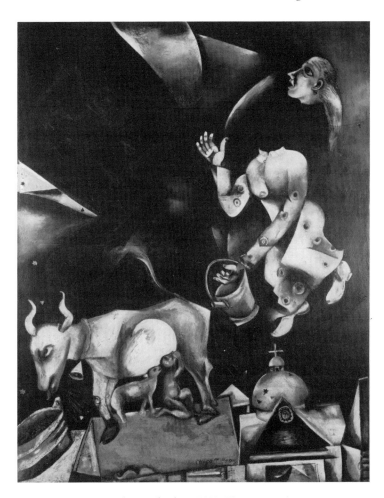

fig. 23 *To Russia, Donkeys and Others*, 1911–12
(Musée national d'Art moderne, Centre Pompidou, Paris)

Later in 1915 a further and lasting inspiration entered Chagall's work when he married his early love, Bella Rosenfeld. This was a major event in his life so far, both from an artistic and personal point of view. The wedding took place in July, a year after she had graduated from her studies at the faculty of History and Philosophy in the Guerrier College for Girls in Moscow. His love for her had aleady given rise to a nostalgic picture, *The Lovers* (fig. 2), before he left Paris, and was celebrated in a more concrete way in *The Birthday* (Cat. 48); *The Poet Reclining* (Cat. 49) was painted on their honeymoon. For thirty years Bella remained his constant companion and inspiration.[44]

Since from the autumn of 1915 Chagall was living in Petrograd, he must have seen the controversial 'Zero Ten' exhibition held at the gallery owned by N. E. Dobychina at the end of the year—the occasion on which Malevich launched his geometric 'non-objective' paintings under the heading 'Suprematism'.[45] In complete contrast, Chagall had a large one-man show in the same private gallery in April 1916, exhibiting sixty-three representational works described by Meyer as 'of the Vitebsk cycle'.[46] Later in the year he sent work to another avant-garde group exhibition in Moscow, the fifth one organised by the Knave of Diamonds group.[47] This was the longest lasting group among the Moscow avant-

fig. 24 *Lovers in Green*, 1916 (collection of the artist)

garde: founded in 1911 and at first uniting all progressive artists, Larionov's group had split from it after less than one year. In 1916 it reunited the most advanced artists of the avant-garde, including Malevich and his Suprematists. Once again, Chagall showed only representational work, including pictures 'from the series painted in Russia, Vitebsk 1914–15' and several portraits of his sisters as well as two of lovers. Unfortunately it has proved impossible to identify these pictures precisely, though *Lovers in Green* (fig. 24) was one of the titles cited in the catalogue.

Almost immediately, Chagall took part in another group exhibition organised in Petrograd by Dobychina under the title, 'Modern Russian Painting'.[48] A recent Soviet author of a book entirely devoted to the year 1917,[49] reproduces Chagall's *Over the Town* (Tretiakov Gallery, Moscow; fig. 25) as an exhibit from that show, which opened in December 1916. The picture must have been one of four with the catalogue designation 'dedicated to my wife', and raises the question of the dating, which has generally been given as later (1917–18). But as Chagall also showed drawings and illustrations for Der Nister's Yiddish tales, 'With a Little Goat' and 'With a Little Rooster' it is clear that he was already moving away from working from the life (as in the pictures of Jews) towards his own blend of fantasy with modifications borrowed from Cubism.

Although in *Over the Town* the fanciful positions of the artist and his wife in an ecstatic position in mid-air is a surprising conjunction with the town below, it seems likely that the picture was first on view with *The Birthday*, where, in an interior scene, the couple had also defied the laws of gravity. The earlier *Over Vitebsk* (Cat. 46) had included an unlikely figure passing over the roofs of the environs of his native town, so there was a progression from one theme to the next. In fact, these pictures are closer to 'reality' than the one which he had dedicated to the Russian avant-garde, *To Russia, Donkeys and Others* (fig. 23) which had been left behind in Berlin and was therefore never seen in Russia.[50]

In terms of contemporary Russian avant-garde art, the freedom with which Malevich and—by the end of 1916—other Suprematists, were manipulating geometric shapes on a white or coloured ground, was equally capricious, though they hastened to explain that their pictures were 'non-objective'. Since Chagall had set himself apart from these radical experiments, his own art might be compared with the post-Cézanne paintings of other exhibitors in the Knave of Diamonds group, such as Falk, Lentulov or Al'tman. The work of the latter may have inspired the stylisation which Chagall adopted for some of his figures from August 1915 onwards. For the poet in *The Poet Reclining* and the two flying figures in *Over the Town* resemble quite closely Al'tman's *Portrait of Anna Akhmatova*, painted in 1914–15.[51]

There is no doubt that Chagall was closely connected with Al'tman early in 1917, for the two artists, with El Lissitzky

fig. 26 *Anywhere out of this World*, 1915
(private collection, Switzerland)

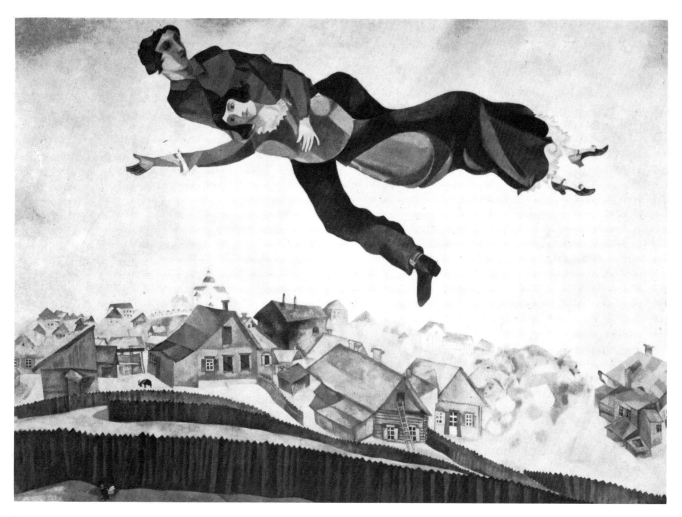

fig. 25 *Over the Town*, 1916 (Tretiakov Gallery, Moscow)

and others, announced the organisation of an exhibition by the 'Union of Moscow Jews' in a Moscow newspaper.[52] In practice, Chagall was still living in Petrograd at the time and he received a commission to paint a cycle of small murals for a secondary school attached to the chief synagogue there. Preparatory works are included in the exhibition, *Visit to the Grandparents* (Cat. 50), *Feast of the Tabernacles* (Cat. 51) and *Purim* (Cat. 52).

It is clear that during this 'second' Russian period, Chagall, as before, was confidently embarking on his own stylistic path, which was not in tune with the extremes of the Russian avant-garde, the Suprematism of Malevich, the abstract expressionism of Kandinsky, or even the stylisations of the post-Cézanne Knave of Diamonds group. However, he was not indifferent to matters which were preoccupying other avant-garde artists at the time, as can be seen in the unusual *Anywhere out of this World* (private collection, Switzerland; fig. 26). This picture seems to comment on arguments that had arisen round the Russian interpretation of Picasso's work in response to an article by the philosopher N. Berdiaev published in 1914 in which he described the associations which Picasso's paintings raised in his mind as he looked at them.[53]

As a result, the poet-critic I. Aksenov added a 'Polemical Supplement'[54] to a book he was writing on the leading Cubist, refuting the idea that works of art can or should provoke ideas outside an immediate tactile, visual experience, which the viewer should derive in front of them. He set out a detailed analysis of the physical nature of the surface in Picasso's pictures, describing his use of the decorator's comb amongst other devices, in order to provide texture. Chagall's *Anywhere out of this World* includes marks made in the thick impasto—apparently with a decorator's comb—as though alluding to Aksenov's pragmatic descriptions. (The signature in roman letters was added to the canvas by the artist later, together with the date, 1915.) Yet Chagall's picture is not a Cubist construction, for its subject-matter, a seated man with a sliced-off head and a little row of houses, turned so they run along the left side of the composition, alludes to the title, which is borrowed from that of a well-known poem by Baudelaire,[55] so Chagall has shown that an avant-garde artist can stimulate both eye and mind in spite of Aksenov's strictures.

In these years Chagall was confident enough to take part in the hoped-for renewal of Jewish art, a courageous position

to adopt, considering the pogroms during the Great War. No doubt his financial position was secured, both by his marriage and the post that he held in Petrograd instead of military service, for he spent some time in a dacha during the summer months of 1917 before returning to Vitebsk after the outbreak of the October Revolution. Something of his state of mind can be gleaned from a letter that he wrote to Dobychina in March 1918: '. . . This is my town and my tomb . . . I am working, may God help me . . .'.[56] Yet his official standing cannot have been low, for a first monograph on his work by the critics Tugendkhol'd and Efros was published (fig. 27);[57] another artist similarly honoured in the same year was Kandinsky, whose 'Reminiscences', first published in Munich in 1913, were translated for a book entitled *Artist's Text* (*Tekst khudozhnika*).[58] It seems likely that this poetic autobiography stimulated both Chagall's *My Life*, which he wrote in Moscow in 1922, and the unpublished memoirs of Malevich, who began writing at about the same time.

The paths of these two artists were soon to cross during one of the most stormy episodes in Chagall's life in Russia. In 1918 he was made Commissar with powers to 'organise art schools, museums, lectures on art, and all other artistic ventures within the city and region of Vitebsk' (*Vitebskiĭ listok*, 20 September 1918). An addendum to this letter of appointment, published in the same newspaper a week later, spoke of his right to intervene in theatrical matters.[59]

Chagall immediately began to organise his home town to rival Petrograd and Moscow (Lunacharsky had already been to Vitebsk to open a conservatoire of music there in June 1918). The street decorations for the first anniversary of the Revolution and the organisation of a museum and art school in a former banker's house took up Chagall's time, but he also went to Petrograd to summon help from his former colleagues. In a 'letter from Vitebsk', published in December in

fig. 27 Cover of the first monograph on Chagall, Moscow, 1918 (detail)

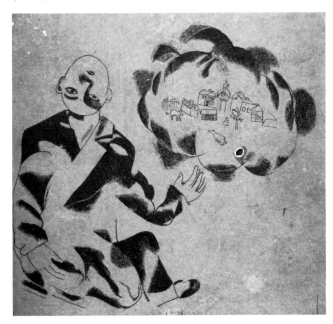

Art of the Commune, he asked for 'Men from the capital for the Province!'[60] He was evidently successful, for when the 'people's art school' was inaugurated at the end of January 1919, Chagall's former drawing teacher, Dobuzhinsky, was in charge of art, and his colleagues were: for propaganda, Puni (Jean Pougny) and for arts and crafts, Puni's wife, Boguslavskaia, though none of them remained there for more than a few months. Apparently Falk also taught in the school for a short time—according to an article in which the Soviet art historian E. Kovtun recently set out some unpublished facts about the school.[61] He said that the authorities (IZO) sent Vera Ermolaeva to Vitebsk in spring 1919 to replace Chagall because the school was considered too right-wing and bourgeois, so this twenty-six year-old was put in charge of the Vitebsk Institute for Art and Industry (as the Vitebsk art school was called). It was probably a political appointment, since Ermolaeva was more experienced in organisation than in making art herself: she had taken a degree in archeology, though she had also studied at a private art school in Petrograd.

Chagall had, perhaps unwittingly, paved the way for change by inviting El Lissitzky to come and teach in the school. Another Soviet historian, V. Rakitin, tells how Lissitzky decided in the summer to accept the offer to take charge of the Studio of Graphic Arts, Printing and Architecture in his home town because he knew that a new teacher, Malevich, would join the staff that autumn.[62] Lissitzky had apparently seen Malevich's pictures on view at the Tenth State Exhibition in Moscow in January 1919 and been much impressed by the artist and his work. So, although Chagall knew Lissitzky as one of the 'Union of Moscow Jews' (mentioned above) and for the Yiddish books that he had illustrated in a style fairly close to his own, it would appear that Lissitzky was predisposed to be influenced by the newcomer.

Ermolaeva, in her position as Director, invited Malevich to come and teach painting at the school, where he arrived on 5 November 1919. Although Chagall's pupils had 'worshipped him', the older and more experienced Malevich had a personal magnetism and a sense of direction which the students found hard to resist. Kovtun quotes a characteristic entry from the diary of Malevich's pupil, Iudin: 'How strong is this K.S. When our people begin to wail and complain about the high prices and it seemed really as if the world was going under, K.S. arrived and straightaway, everyone adopted a different frame of mind. He spread a different atmosphere around him, he is certainly the leader.'[63] Chagall's pupils, apparently, went over one after the other to Malevich.

Almost immediately, El Lissitzky began printing Malevich's text *On New Systems in Art*.[64] (Malevich must have realised that the facilities of the school's graphics department would enable him to disseminate his ideas more easily than had been possible in the Moscow Free Studios.) Strangely, it is not unlikely that, at first, Chagall was himself interested in the new viewpoint, for *On New Systems in Art* includes an analysis of and paeon of praise for twentieth-century art, which was subsequently published by Lunacharsky's Commissariat of Enlightenment as a separate pamphlet.[65] The excerpts were used as a vindication of modern art in general; much of the original version was, however, the expression

fig. 28 Vitebsk art school, 1919: Chagall seated, third from left; extreme left, El Lissitzky next to Vera Ermolaeva; third from right, Jehuda Pen

of the a-logical attitude that Malevich had evinced at an earlier period. This was subsumed in one of the illustrations, which shows a cow, executed in a realistic style, superimposed on a violin, which in turn overlaps a cubist construction. The awkwardly-worded caption expressed the notion that this picture represented the moment of struggle when a-logism is attempting to overcome logic by freeing the viewer from prejudice.[66] At the time Chagall often used a realistic depiction of a goat in a similarly unexpected way (see, for instance, Cat. 62), perhaps with some of the same inference of removing a barrier of logic which blinds the viewer. Beginning in the 1930s, he very often included the juxtaposition of a cow with a violin in his pictures, albeit not in a cubist construction (see Cat. 79, 83).

There is no doubt that in the painting department at Vitebsk, Malevich quickly imposed his own methods of teaching which cannot have accorded with Chagall's own. In January 1920 Malevich formed a group, POSNOVIS (Followers of the New Art), and in February transformed it into UNOVIS (an acronym standing for 'Affirmation of the New Art', 'Founders of the New Art' or even, 'Union of the New Art').[67] This group developed uncompromisingly abstract—or non-objective as they preferred to call it—designs for the decoration of buildings in the town, using triangles, circles

and rectangles, publishing some of them in an Almanac which came out in seven copies only on 20 May 1920.[68]

This is a date often given as the one on which Chagall left the school. Certainly, the UNOVIS standpoint was hostile to him, for although it was idealist, it left no room for those human values which are the central tenet of his view of life and art. Indeed, his remarkable image of a striding figure, invented as a decorative banner for the first anniversary of the Revolution, and transformed for a projected stage set in 1919 (see fig. 29), was now developed into a version which could be seen as his stand against the exclusive geometry of Suprematism. For now the figure, which is Chagall himself, is striding over the Unovists' squares in a remarkable small work which used to belong to the George Costakis collection.[69]

There is another side to the story: it has already been mentioned that a second announcement had followed the publication of Chagall's letter of appointment as Commissar of the Arts in Vitebsk. That addendum concerned his right to intervene in theatrical matters, and, during the next two years, these activities must have taken up a good deal of his time outside the art school. In a recent article on Chagall and the theatre, Matthew Frost tells how in January 1919, a Theatre of Revolutionary Satire was founded in Vitebsk, and

in the following season Chagall collaborated on nine productions put on for Red Army soldiers fighting on the Western front in the Civil War.[70] He designed sets for satirical sketches about Lloyd George, Poincaré and White Generals. One of his sets, for a popular production entitled 'At the Crossroads', was based on a picture by Vasnetsov entitled *Heroes (Bogatyri)*. He caricatured the knights of this painting, imitating the style of woodblock folk-prints, cutting holes at appropriate places to allow the actors to insert their heads and arms. (It may be added that a rather similar idea had been used in another frame of mind for the costumes of the mystics in Blok's play *The Fairground Booth* in the 1907 production referred to at the beginning of this article though, on that occasion, each actor had his own cardboard costume.)

During 1919 Chagall had also received a commission to design productions of two plays by Gogol recently identified by Pierre Provoyeur as for the Hermitage Studio in Petrograd,[71] founded that year on the initiative of Meyerhold, and a work in this exhibition is connected with the commission (Cat. 61). In the event, neither production was realised, although when the theatre opened on 12 July the only plays that were performed (before it was closed as being too bourgeois) were from the classical repertoire. They were directed by an artist, Iurii Annenkov, who put ideas from Marinetti's Manifesto of Variety Theatre of 1913 into practice (see Cat. 61). Under the pen-name B. Till, Annenkov wrote about his free treatment of the text, which he modified and edited 'according to his own concept of *mise-en-scène*'. He had used acrobats, trapeze artists and clowns recruited from the circus as well as actors for a play by Tolstoy, in which he had treated the second scene as a circus arena. Also in 1919, following the production, Annenkov published a manifesto in the journal *Life of Art* (*Zhizn' iskusstva*) entitled 'Merry Sanatorium' in which he stressed the parallel between the arts of the dramatic actor and the circus performer. He maintained that sickly-looking city people need a circus as a sanatorium: 'The city-dweller, with rare exceptions, is a man with a crippled soul and an unhealthy body. He is smothered by fumes of factory smokestacks, poisoned by toxic automobile exhausts, irregular sunshine or often the complete lack of it. The city-dweller is without the freedom of sweeping gestures, denied the physical exercises necessary to the strengthening of his body, trained from childhood to move along the plane surface of sidewalks and roads, tacking, zigzagging among torrents of the multitude'. Usually he says, doctors send city-dwellers to the country for recuperation, and continues: 'Now, if you need medical treatment, but are not able to go out of the town—go the circus/this merry sanatorium'.[72]

While clearly anticipating the revolutionary developments that Meyerhold himself carried out in Moscow from 1921 onwards, these ideas also seem to have influenced Chagall. For when he came to make the huge murals for the auditorium of the new Jewish theatre in Moscow in the winter of 1920–21, he used clowns and acrobats in conjunction with the farmyard animals that Annenkov regarded as so healthy for the city-dweller.[73] Likewise, in a remarkable design which Chagall made for *The Playboy of the Western World* (collection of the artist; fig. 13) by Synge, proposed for Stanislavsky's

theatre in 1921, he incorporated a goat and a donkey as well as a man flying through the air on a trapeze.

It would be incorrect to imply that Annenkov's 'Merry Sanatorium' was the only contributory factor for the subject-matter of this large canvas which Chagall painted to decorate the new premises of the State Kamerny Theatre. For it equally reflects traditional Hasidic tumbling in impromptu performances which took place in Jewish homes at some of the major festivals in Vitebsk vividly described by Bella Chagall in her memoirs. Chagall had encountered the newly-formed State Kamerny company and its director Granovsky, when it played in Vitebsk, on a tour from Petrograd where it was then based.[74] Efros (one of the authors of the monograph on Chagall) suggested to Granovsky that the artist should be invited to design the three short plays by Sholom Aleichem with which the theatre was to open when it moved to Moscow.

Frost gives November 1920 as the date when both the Jewish State Theatre and Chagall and his wife and daughter moved to Moscow and the artist records how he flung himself at the walls, for the period is vividly remembered in *My Life*, which Chagall wrote the following year.[75] A further slant is added by the artist Varvara Stepanova, who mentioned Chagall in two entries in her diary for autumn 1920. Since the first entry is for 23 October, he was evidently already in Moscow before November, though it is not altogether clear whether she is giving his impression of the opening of the XIX State Exhibition, or a later reaction to it. On 5 November she records him often at the exhibition and interested to know what Rodchenko and herself are doing (see also Cat. 63), and she gives a picture of Chagall as a shrewd but kindly analyst of the characters of the exhibitors. She said he 'saw an enormous difference between our works in the expression of the personality of the artist. I have a tempestuous, restless temperament, unbalanced with a wellknown dose of chaos'. Rodchenko, on the other hand 'is cold, peaceful, analytic with a leaning towards abstraction. He doubted whether Anti [her pet name for her husband] even at the beginning of his artistic career, could paint an object in a non-abstract style. In general he wasn't afraid, it seemed to me, to express rather openly his delight . . .'; after asking what she intended to do next, he suggested they exchange drawings.[76]

This vignette goes a long way towards correcting a mistaken idea that Chagall was uninterested in contemporary painting by other artists, even if he had quarrelled with the group led by Malevich. A photograph of Stepanova and Rodchenko's paintings on view at the XIX State Exhibition shows that her pictures were figurative compositions of severely stylised people engaged in quite strenuous activities, such as dancing. In her diary she included her answer to Chagall's question about her future plans: 'In my opinion there's practically nothing left to do in this direction. . .'.[77] As has been described at length by Christina Lodder in her book on Russian Constructivism, Stepanova and Rodchenko subsequently became engaged in heated discussions at the art school where they were teaching, on the nature of art in a post-Revolutionary society.[78]

The idealism of avant-garde artists was unimpeachable, but controversy arose because the role of art in society was

unclear. Chagall later explained that he had tried to carry art into life, to embellish it, citing the decorations that they had made in the Vitebsk streets.[79] But by the close of 1920 and particularly during the following year, Moscow artists (including Stepanova and Rodchenko) were arguing about a much narrower approach: because they restricted their practice of art to the use of its raw ingredients without representation, the roles of composition and construction predominated in their discussions. Gradually they reduced art to what in the English language is called 'design'. But during 1921, when these heated arguments were taking place, Chagall was preoccupied with his work for the theatre. At the same time his family was living outside Moscow, in a colony set up to rehabilitate young people orphaned and brutalised by the civil war. A touching photograph shows Chagall surrounded by his pupils there, but it is clear that he could hardly envisage philanthropic teaching as a life work.

In spring 1922 Chagall exhibited with Shterenberg and Al'tman,[80] an artist who was closely involved in setting up a large exhibition of Russian art in Berlin, to which Chagall contributed. This was the 'First Russian Exhibition' that opened at the Van Diemen gallery in October 1922.[81] Chagall left Russia in that year, but it is not certain that he arrived in Berlin while the exhibition was still on; he paused in Kaunas, where he showed the pictures which he had brought with him, many of them entrusted to the artist by the collector Kagan Chabchai. Thus he did not leave his homeland empty-handed, and was able to establish a continuity in his work that had been lacking in 1914.

Although the pictures on view in this exhibition make it clear that Chagall did not continue with the remarkable experiments that he had begun in his last years in Russia, many of the prints reveal a pictorial shorthand, derived from those experiments. This is especially true of the illustrations for Gogol's *Dead Souls* which brought Russia to life for him in the 1920s in Paris (see Cat. 165–72). When he sent a set of plates to the Tretiakov Gallery in Moscow in 1927 he dedicated it to the Russian people, with the words: 'Given to the Tretiakov Gallery in witness of my entire love as a Russian artist for his homeland . . . Marc Chagall'.[82] In a letter to a friend in the Soviet Union in 1934, Chagall wrote: 'The title "A Russian painter" means more to me than any international fame. . . . In my pictures there is not one centimetre free from nostalgia for my native land'.[83] It is fitting that when he returned to Russia in 1973, for his first visit in fifty years, he was saluted as a great Russian artist.

fig. 29 *Onward! (The Traveller)*, 1917 (Art Gallery of Ontario, Toronto; gift of Sam and Ayala Zacks)

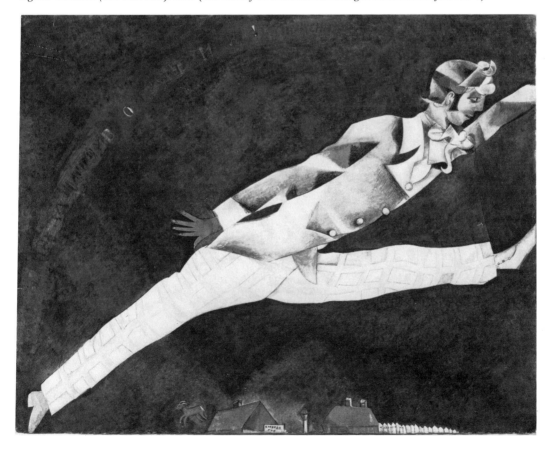

NOTES

1. '*La Ruche*' ('The Beehive') was the nickname given to studios built by a philanthropist, which were arranged in a cell-system inside a three-storey building constructed by the 'Eiffel' builders as a wine pavilion. This was the first of several structures from l'Exposition Universelle of 1900, moved by the academic sculptor Boucher to a vacant site next to the Vaugirard slaughterhouses; with the other buildings, there were two hundred studios let cheaply to artists.

2. Meyer, p. 60.

3. Interview with A. Parinaud, *Chagall*, Bordas, Club d'art, 1966, p. 52.

4. N. Roerich 1874–1947, artist, archaeologist, scholar, writer, poet; he was chosen by Diaghilev to design *The Rite of Spring* for 'Les ballets russes' in 1913 because of his knowledge of ancient Russian customs.

5. V. Marcadé, *Le renouveau de l'art pictural russe 1863–1914*, Lausanne, L'Age d'Homme, 1971, p. 362, n. 478.

6. V. Marcadé, op. cit., p. 228.

7. *My Life*, p. 88.

8. Op. cit., p. 87.

9. See J. E. Bowlt, *The Silver Age: Russian Art of the Early Twentieth Century and the "World of Art" Group*, ORP Studies in Russian Art History, Newtonville, Mass. Oriental Research Partners, 1979.

10. Reproduced by E. Braun, *The Theatre of Meyerhold, Revolution on the Modern Stage*, London, Eyre Methuen, 1979, p. 71.

11. Reproduced in colour in *Majakovskij, Mejerchol'd, Stanislavskij* (exhibition catalogue), Milan, Electa, 1975, p. 98.

12. V. E. Meĭerkhol'd, *Teatr, kniga o novom teatre*, St Petersburg, 1908; English translation from E. Braun, *Meyerhold on Theatre*, London, Methuen, 1969, p. 63.

13. See further J. M. Newcombe, *Leonid Andreyev*, Russian Literary Profiles, no. 1, Letchworth Herts, Bradda Books, 1972.

14. Artist's collection, reproduced by Meyer, 1964, cat. 3.

15. *Zelenaĭa komnata*, Tretĭakov Gallery, Moscow; see colour plate in V. Petrov, *Le Monde Artiste/Mir iskusstva*, Moscow, Izobrazitel'noe iskusstvo, 1975, pl. 71.

16. *Grimasy goroda*, 1908, Tretĭakov Gallery, Moscow; see colour plate in E. Loginova, *Watercolours, The Tretyakov Gallery*, Leningrad, Aurora, 1974, pl. 21.

17. *Okno parikmakherskoĭ*, Tretĭakov Gallery, Moscow; see colour plate in V. Petrov, op. cit., pl. 66, p. 139.

18. *Oktĭabr'skaĭa idilliĭa*, 1905, reproduced in *Zhupel* 1905, no. 1; colour plate in V. Petrov, op. cit., pl. 69, p. 143.

19. Z. Amishai-Maisels, 'Chagall's Jewish In-Jokes', *Journal of Jewish Art*, 5, 1978, pp. 76–93.

20. See Z. Amishai-Maisels, 'The Jewish Jesus', *Journal of Jewish Art*, 9, 1982, pp. 84–104.

21. *My Life*, p. 98.

22. Elizaveta Nikolaevna Zvantseva had founded her school in Moscow in 1899, but moved it to St Petersburg in 1906: see Meyer, pp. 59–60.

23. V. Ivanov, 'Dve stikhii v sovremennom simvolizme', *Zolotoe runo*, April–May, 1908; republished in *Po zvezdam, stat'i i aforizmy*, St Petersburg, 1909; English quotation from J. West, *Russian Symbolism, A Study of Vyacheslav Ivanov and the Russian Symbolist Aesthetics*, London, Methuen, 1970, p. 51.

24. See *The Burlington Magazine*, no. 881, vol. CXVIII, August 1976, pp. 566–74.

25. N. Tarovaty, 'Na vystavke "Mir iskusstva"', *Zolotoe runo*, no. 3, Moscow, 1906, p. 124.

26. S. Makovskiĭ, 'Golubaĭa roza', *Zolotoe runo*, 1907, no. 5, p. 25.

27. There are exceptions in the work of Goncharova, for instance, *Haymaking* (Tretĭakov Gallery, Moscow, reproduced by M. Chamot, *Goncharova, Stage Designs and Paintings*, London, Oresko, 1979, p. 38).

28. The two exhibitions were: March 1912, 'Donkey's Tail' (*Oslinnyĭ khvost*), M. Chagall, cat. no. 286, Death; April 1913, 'Target' (*Mishen*), M. Chagall, cat. nos. 125–127 *** [sic].

29. See further S. Compton, *The World Backwards, Russian Futurist Books, 1912–16*, London, The British Library, 1978.

30. See S. Compton, *Domarsumpen [Trap for Judges]*, Stockholm, Bokomotiv, 1983 (in Swedish) chapter one, Elena Guro.

31. M. Chagall, 'The Artist', speech at conference at Holyoke College, 1943, in English in *The Works of the Mind*, ed. R. B. Heywood, Illinois, University of Chicago Press, 1947.

32. For a cartoon of the exhibit (on which the titles are given as 1) M. Shagal, *Pokhorony* (Funeral) & 5) *Obed(?)* (sic; Dinner), see Meyer, p. 28).

33. The opera was *Victory over the Sun*; see S. Compton, op. cit., 1978, chapter 3, Theatre.

34. See note 30 above.

35. S. Compton, 'Italian Futurism and Russian', *Art Journal*, winter 1981, vol. 41, no. 4, pp. 343–48.

36. See 'Hathor', *Larousse Encyclopedia of Mythology*, London, Hamlyn, 1959, pp. 23–24; statue reproduced p. 22.

37. Chagall's exhibition of 40 oils and 160 gouaches and watercolours at Herwarth Walden's Der Sturm gallery opened at the beginning of June, 1914; no catalogue is known.

38. Meyer, 1964, p. 217.

39. It was bought from La Ruche by G. Coquiot.

40. The catalogue is reproduced in D. Gordon, *Modern Art Exhibitions 1900–16*, vol. I, Munich, Prestel, 1974, pp. 827–29.

41. See note 28 above.

42. See Gordon, op. cit., pp. 869–70.

43. See *Calvary* (Cat. 27).

44. She died in 1944.

45. See E. Kovtun, 'The Beginning of Suprematism', *Von der Fläche zum Raum/From Surface to Space, Russia 1916–24* exhibition catalogue, Galerie Gmurzynska, Cologne, 1974, pp. 32–49.

46. Meyer, p. 244.

47. *Bubnovyi valet*, see Gordon, op. cit., pp. 894–95.

48. See Gordon, op. cit., p. 898.

49. V. P. Lapshin, *Khudozhestvennaĭa zhizn' Moskvy i Petrograda v 1917 godu*, Moscow, Sovetskiĭ khudozhnik, 1983, p. 27.

50. It was shown at Walden's *Erste Deutsche Herbstsalon*, September-December, 1913, cat. 77, and reproduced in the catalogue; see Gordon, op. cit., vol. 2, p. 269.

51. Colour plate in *Zasluzhennyĭ khudozhnik RSFSR Natan Al'tman 1889–1970*, Moscow, Sovetskiĭ khudozhnik, 1978.

52. 25 January, *Utro Rossii*: announcement of an exhibition to be held in April at Lemers'e Gallery. See V. P. Lapshin, op. cit., p. 314, who gives no mention of such an exhibition in April: no doubt the intervention of the February Revolution was responsible for the event not taking place.

53. N. Berdĭaev, 'Pikasso', *Sofia* no.8, Moscow 1914; English translation in *A Picasso Anthology: Documents, Criticism, Reminiscences*, ed. M. McCully, London, The Arts Council of Great Britain with Thames & Hudson, 1981 pp. 110–12.

54. 'Pablo Picasso the painter: a polemical supplement', translated by C. Thomas (manuscript) from I. Aksenov, *Pikasso i okrestnosti*, Moscow, Centrifuga, 1917: part of her translation is printed in *A Picasso Anthology* (see note 52) pp. 113–18.

55. 'Anywhere out of this World' (title in English), poem translated in *Baudelaire* introduced & ed. by F. Scarfe, 'The Penguin Poets', Harmondsworth, Middx, 1964, p. 192.

56. Meyer, p. 255.

57. A. Efros, ĬA. Tugendkhol'd, *Iskusstvo Marka Shagala*, Moscow, Gelikon, 1918.

58. V. V. Kandinskiĭ, *Tekst khudozhnika*, Moscow, Otdel Izobrazitel'nykh Iskusstv Narodnogo Komissariata po Prosveshcheniĭu, 1918.

59. Meyer, p. 605, n. 2.

60. *Iskusstvo kommuny*, no. 3; see Meyer, p. 605, n. 19, no page reference given.

61. E. Kovtun, 'Wera Michailowna Ermolaewa', in *Künstlerinnen der russischen Avantgarde/Women-Artists of the Russian Avantgarde 1910–1930*, exhibition catalogue, Galerie Gmurzynska, Cologne, 1980, pp. 102–09.

62. V. Rakitin, 'El Lissitzky 1890–1941' in *Building in the USSR 1917–1932*, ed. O. Shvidkovsky, London, Studio Vista, 1971, p. 35.

63. See note 61 above.

64. *O novykh sistemakh v iskusstve*, Vitebsk, 1919, English translation in *K. S. Malevich, Essays on art, 1915–1933*, vol. I, ed. T. Andersen, London, Rapp & Whiting, 1969.

65. *Ot Sezanna do suprematizma. Kriticheskiĭ ocherk*, Moscow, 1920.

66. A literal translation (made by C. Thomas) is: 'Logic always put an obstacle in the way of new unconscious movements and in order to become free from prejudices, the movement of alogicism was advanced. The drawing shown represents the moment of struggle—with the juxtaposition of two forms, a cow and a violin in a cubist construction.'

67. See note 59 above.

68. Several pages of this typewritten almanac are reproduced by L. Zhadova, *Malevich Suprematism and Revolution in Russian Art 1910–1930*, London, Thames & Hudson, 1982.

69. *Forward!* 1919–20, reproduced in colour in *Russian Avant-garde Art, The George Costakis Collection*, ed. A. Zander Rudenstine, London, Thames & Hudson, 1981, p. 86.

70. See M. Frost, 'Marc Chagall and the Jewish State Chamber Theatre', *Russian History*, vol. 8, parts 1–2, 1981, pp. 90–107.

71. P. Provoyeur, Catalogue, in *Marc Chagall, Œuvres sur papier*, exhibition catalogue, Musée national d'Art moderne, Centre Georges Pompidou, Paris, 1984, cat. 54, p. 92.

72. Yu. Annenkov, 'Merry Sanatorium', trans. L. Ball, in *The Drama Review*, vol. 19, no. 4 (T-68), December, 1975, pp. 110–12.

73. *Introduction to the Jewish Theatre*, reproduced by Meyer, pp. 284–85.

74. M. Frost, op. cit., p. 93.

75. *My Life*, pp. 155–64.

76. V. Stepanova, 'Diary entries on the XIXth State Exhibition', in *Sieben Moskauer Künstler/Seven Moscow Artists, 1910–1930*, exhibition catalogue, Galerie Gmurzynska, Cologne, 1984, quotations from pp. 257, 260.

77. Loc. cit., p. 260.

78. C. Lodder, *Russian Constructivism*, New Haven & London, Yale University Press, 1983, especially pp. 83–94.

79. A. Salmon, 'Chagall', *L'Art Vivant*, no. 22, 15 November, 1925, p. 1.

80. M. Frost, op. cit., p. 98: the exhibition was held in Moscow in March-April, 1922.

81. See *The First Russian Show, a Commemoration of the Van Diemen Exhibition Berlin 1922*, exhibition catalogue, London, Annely Juda Fine Art, September-December 1983.

82. Iu. Molok, 'Marc Chagall à Moscou', *Œuvres et Opinions*, no. 180, December 1973, p. 179.

83. Meyer, n. 5 to 'The Circus and New Experience of the Landscape', p. 608.

Chronology, with Major Exhibitions

1887 7 July: birth of Marc Chagall in Vitebsk.

1906 Studied in the studio of Jehuda Pen in Vitebsk.

1906–07 Moved to St Petersburg.
Attended the school of the Imperial Society for the Protection of Fine Art, directed by N. Roerich.

1908–09 Entered the Zvantseva School, directed by Bakst and Dobuzhinsky. Patronage of Max Vinaver.

1909 Introduced to Bella Rosenfeld—his future wife.

1910 April–May: two pictures in an exhibition of work by pupils of the Zvantseva School at the offices of the journal *Apollon*.
Autumn: Bakst prepared the décor for *Narcisse* for Diaghilev's 'Les Ballets russes' with Chagall's help.
Vinaver provided financial support to enable Chagall to go to Paris.

1911–12 Lived in a studio in the Impasse du Maine, Paris.

1912 Spring: moved to La Ruche.
Exhibited at the Salon des Indépendants and Moscow 'Donkey's Tail' in March and at the Salon d'Automne.

1913 Exhibited at the Salon des Indépendants and in September at Walden's First German Autumn Salon, Berlin; went to the opening with the poet Blaise Cendrars.

1914 Salon des Indépendants, Paris.
April: work shown at Der Sturm with Kubin.
May: went to Berlin for the opening of his one-man show during June and July at Der Sturm.
Travelled on to Vitebsk; visit to Russia indefinitely prolonged by the outbreak of war in August.

1915 March: exhibits at 'The Year 1915', Moscow.
Married Bella Rosenfeld.
Went to Petrograd, where his work in the office of War Economy exempted him from military service.

1916 Birth of his daughter, Ida.
November: contributed to the 'Knave of Diamonds' exhibition, Moscow, and 'Contemporary Russian art' in Petrograd.

1917 February and October Revolutions in Russia.

1918 Appointed Commissar of Art in Vitebsk and region, with responsibility for a museum, an art school and theatre production.
Organised street decorations for the first anniversary of the Bolshevik Revolution.
Founded an art school and a musuem.
Had a room in an exhibition at the Winter Palace.

1919 Spring: Dobuzhinsky, Jean Pougny and Pen taught at Vitebsk art school, to which the Petrograd authorities sent a new rector, Ermolaeva.
El Lissitzky and, in November, Malevich, joined the art school staff.

1919–20 Worked for the Theatre of Revolutionary Satire, Vitebsk.

1920–21 Invited to decorate new premises in Moscow for the State Kamerny Theatre; designed the opening productions.

1921–22 Taught at two colonies for war orphans, Malkhovka and IIIrd International. Began writing *My Life*.

1922 Left Russia for Kaunas; exhibited the work he brought with him.
October: two pictures in the 'First Russian Show' at the Galerie Van Diemen in Berlin.
Learnt etching, and was commissioned to produce illustrations for *My Life* by Paul Cassirer.

1923 *Mein Leben* portfolio of etchings published.
Returned to Paris at the invitation of Ambroise Vollard, who commissioned etchings for Gogol's *Dead Souls*.

1924 First Paris retrospective exhibition at the Galerie Barbazanges-Hodebert.
Holiday in Brittany.

1925 Vollard commissioned illustrations for La Fontaine's *Fables*.

1926 First exhibition in New York at the Reinhart Galleries.

1926–27 Gouaches for La Fontaine's *Fables* and for a project on the circus proposed by Vollard.

1927 Presented ninety-six etchings for *Dead Souls* to the Tretiakov Gallery, Moscow.
Contract with Bernheim-Jeune.
Considered the leader of the Ecole de Paris.

1928 Agreed to make etchings for the *Fables*.

1930–31 Vollard commissioned illustrations for *The Bible*.

1931 Visited Palestine, Syria and Egypt.

1932 Visited Holland (where he studied the work of Rembrandt).

1933 Retrospective exhibition at the Kunsthalle, Basle.
Auto-da-fé of his pictures at Mannheim by order of Goebbels.

1934 Visited Spain (where he was impressed by paintings by El Greco).

1935 Travelled to Vilna; in Warsaw he was struck by the isolation of Jews.

1936 Spent the summer in the Jura and winter in Haute Savoie.

1937 Took French citizenship. Enjoyed the Exposition Universelle from new home nearby.
Visited Florence, made 15 *Bible* etchings in Tuscany.

1939 Awarded the Carnegie Prize.
Left Paris for the south of France, where he moved his pictures in September when the Second World War broke out.

1940 January: took his work (including *Revolution*) back to Paris for an exhibition at Yvonne Zervos' Galerie Mai.
Received an invitation from the Museum of Modern Art in New York to leave France for the United States; this invitation extended also to Matisse, Picasso, Dufy, Roualt, Masson, Ernst.

1941 Moved to Marseilles.
April: was arrested but released on the intervention of the American Consul General and Head of Emergency Rescue Committee; May: went to Lisbon.
23 June: landed in New York as the Germans attacked Russia.
November: exhibition at the Pierre Matisse Gallery, New York.

1942 Summer: prepared the ballet *Aleko* with the choreographer Léonide Massine for the American Ballet Theatre.
August: travelled to Mexico City; September: première of *Aleko*.
October: première in New York.

1943 Michoels and Itzik Feffer sent by USSR on cultural mission to New York where Chagall saw them each day.
Etchings executed in the New York studio of Stanley William Hayter.

1944 September: death of Bella.

1945 Designed sets and costumes for *Firebird* for the American Ballet Theatre.

1946 Retrospective exhibition at the Museum of Modern Art, New York and The Art Institute, Chicago.
Produced colour lithographs for *One Thousand and One Nights*.

1947 Exhibition at the Musée national d'Art moderne, Paris.

1948 Awarded the Graphics Prize at the XXIV Biennale, Venice.
August: permanent return to France, to Orgeval near Paris.

	Exhibition at the Stedelijk Museum, Amsterdam and the Tate Gallery, London.
1949	Moved to Saint-Jean-Cap-Ferrat.
	Painted murals for the Watergate Theatre, London.
1950	Exhibition at the Galerie Maeght, including pottery.
	Moved to Vence.
	Made ten wash drawings for Boccaccio's *Decameron* published in *Verve* no. 24.
1951	Exhibition in Berne and Jerusalem; visited Israel.
	Carved his first sculptures.
1952	La Fontaine *Fables* published by Tériade.
	July: married Valentina Brodsky.
	Made gouaches on honeymoon in Greece following a commission by Tériade for illustrations for *Daphnis and Chloë*.
1953	Visited London.
	Travelled to Turin for a retrospective at the Museo Civico.
1955	Planned a series of biblical pictures.
1956	The *Bible* published by Tériade.
1957	Third visit to Israel.
	Worked on a ceramic panel and stained glass for the chapel at Assy, Savoy.
1958	Commissioned to design *Daphnis and Chloë* by the Paris Opéra. Gave a series of lectures in Chicago and Brussels.
	Painted maquettes for stained glass windows for the Cathedral at Metz.
1959	Visit to Glasgow where he was awarded an Honorary Degree at the University.
	Retrospective in Paris, Munich and Hamburg.
1960	Designs for stained glass windows for the synagogue of the Hadassah Hebrew University Medical Centre, Jerusalem.
	Awarded an Honorary Degree at Brandeis University, United States and the Erasmus Prize at Copenhagen.
	Painted *Commedia dell'Arte* for the foyer of the theatre in Frankfurt.
1961	Exhibition of stained glass for the Synagogue at the Hadassah Medical Centre, Jerusalem at the Louvre, and the Museum of Modern Art, New York.
1962	Finished the stained glass for first window at Metz.
	February: travelled to Israel for the inauguration of the Jerusalem windows.
1963	Retrospectives in Tokyo and Kyoto. Visited Washington.
	Began work on the ceiling of the Paris Opéra.
1964	Visited New York for the inauguration of the *Peace* window in memory of Dåg Hammarskjöld, at the United Nations building.
	Made the first glass for the church at Pocantico Hill, New York State, in memory of J. D. Rockefeller, Jr.
1965	Awarded an Honorary Degree at Notre Dame University, Indiana.
	Began work on costumes and sets for Mozart's *Magic Flute*, and murals for the Metropolitan Opera, New York.
1966	Moved from Vence to Saint-Paul, Alpes-Maritimes.
	Eight windows of the Prophets installed at the church at Pocantico Hill.
1967	Eightieth birthday retrospective at Zurich and Cologne.
	Exhibition of Chagall's 'Biblical Message' at the Louvre, Paris.
	Commission for a memorial window for All Saints' Church, Tudeley, Kent.
1968	Visited Washington DC.
	Exhibited at the Pierre Matisse Gallery, New York.
	Completed the stained glass for the triforium in the north transept at Metz cathedral.
	Designed a mosaic for the University at Nice.
1969	Foundation stone laid for the Musée Message Biblique, Nice.

	June: opening of Knesset building, Jerusalem, with floor and wall mosaics and three tapestries by Chagall.
	December–January 1970: 'Hommage à Marc Chagall', exhibition at the Grand Palais, Paris.
1970	Retrospective of graphic work at the Bibliothèque nationale, Paris.
	Stained glass windows in Fraumünster church, Zurich, unveiled.
1971	Exhibition of lithographs in Zurich.
	Wall mosaic for the Musée national Message Biblique, Nice.
1972	'Four Seasons' mosaic commissioned by the First National Bank of Chicago.
	Exhibition in Budapest.
	Designed stained glass windows for Musée national Message Biblique, Nice.
1973	June: visited Moscow and Leningrad; exhibition of lithographs at the Tretiakov Gallery, Moscow.
	July: inauguration of the Musée national Message Biblique Marc Chagall, Nice.
1974	Exhibition of graphic work in Dresden and East Berlin.
	Window at Reims Cathedral unveiled.
	Travelled to Chicago for the unveiling of his mosaic.
1975	Worked on lithographs for Shakespeare's *The Tempest*.
	Publication of *The Odyssey*, containing 82 lithographs.
1976	Designed a mosaic for the chapel Sainte-Roseline aux Arcs, Var.
1977	Awarded the Grand Cross of the Légion d'Honneur.
	Visited Italy and Israel.
	Worked on stained-glass windows for the Art Institute of Chicago.
	Exhibition at the Louvre.
1978	Exhibition at the Palazzo Pitti, Florence.
	Inauguration of stained-glass windows at Sainte-Etienne, Mayence.
	October: window at Chichester Cathedral, Sussex, unveiled.
1979	Exhibition of paintings 1975–78 at the Pierre Matisse Gallery, New York, and of *Psaumes de David* at the Galerie Patrick Cramer, Geneva.
1980	Exhibition of *Psaumes de David* at the Musée national Message Biblique Marc Chagall, Nice.
	Painted a harpsichord given by himself and his wife and the American Friends of Chagall Biblical Message.
	Exhibition of prints and monotypes at the Musée Rath and the Galerie Patrick Cramer, Geneva.
1981	Print retrospective at the Galerie Matignon, Paris.
	Inauguration of third series of windows at Saint-Etienne, Mayence.
	Lithograph exhibition at the Galerie Maeght, Paris.
	Exhibition of recent work at the Galerie Maeght, Zurich.
1982	September–December and January–March 1983: retrospective at the Moderna Museet, Stockholm and the Louisiana Museum of Modern Art, Denmark.
	Exhibition of illustrated books at the Galerie Patrick Cramer, Geneva.
	Exhibition of paintings at the Pierre Matisse Gallery, New York.
1984	June–October: 'Œuvres sur papier' exhibition at the Musée national d'Art moderne, Centre Pompidou, Paris.
	July–October: 'Vitraux et sculptures: 1957–1984' exhibition at the Musée national Message Biblique Marc Chagall, Nice.
	July–October: 'Marc Chagall, rétrospective de l'œuvre peint' at the Fondation Maeght, Saint-Paul, France.
	November–December, exhibition at the Museo Campidoglio, Rome.
	November–February 1985: exhibition at the Galerie Beyeler, Basle.

Love of all the world is the most important thing,
and liberty. When you lose liberty, you lose love.

Chagall to J. Marshall, from 'A visit with Chagall',
Arts, vol. 30, April 1956, p. 11.

Everything may change in our demoralized world except the
heart, man's love and his striving to know the divine. Painting,
like all poetry, has a part in the divine; people feel this today
just as much as they used to. What poverty surrounded my
youth, what trials my father had with us nine children.
And yet he was always full of love and in his way a poet.
Through him I first sensed the existence of poetry on this earth.
After that I felt it in the nights, when I looked into the dark sky.
Then I learnt that there was also another world.
This brought tears to my eyes, so deeply did it move me.

Chagall to W. Erben, from *Marc Chagall*, trans. M. Bullock,
London, Thames & Hudson, revised edition, 1966, p. 149.

4 *Self-Portrait with Brushes* (1909)

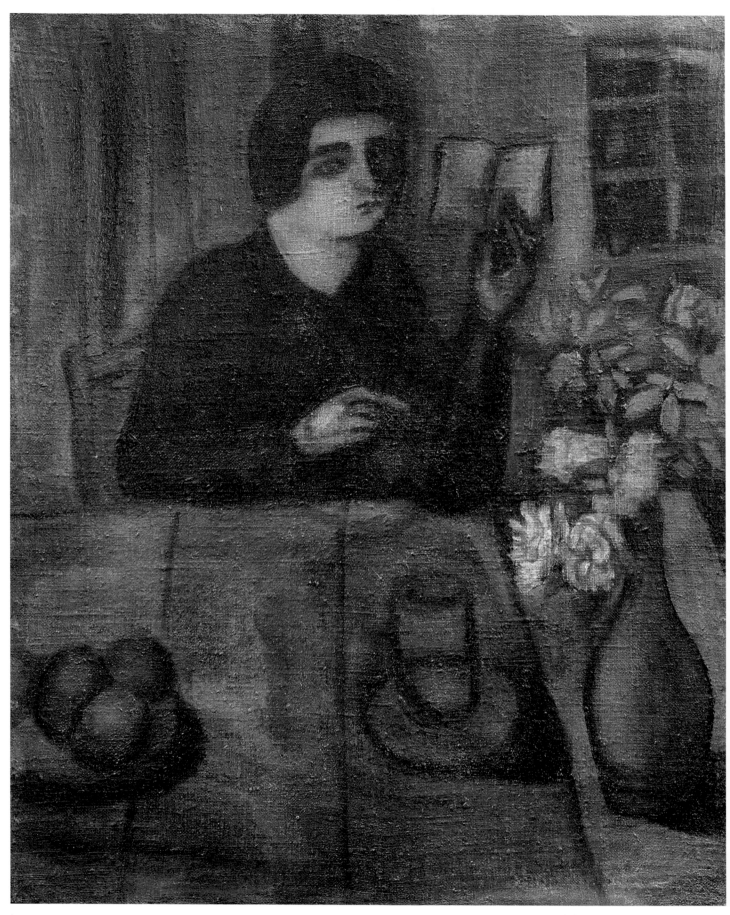

7 *Portrait of the Artist's Sister* (1909–11)

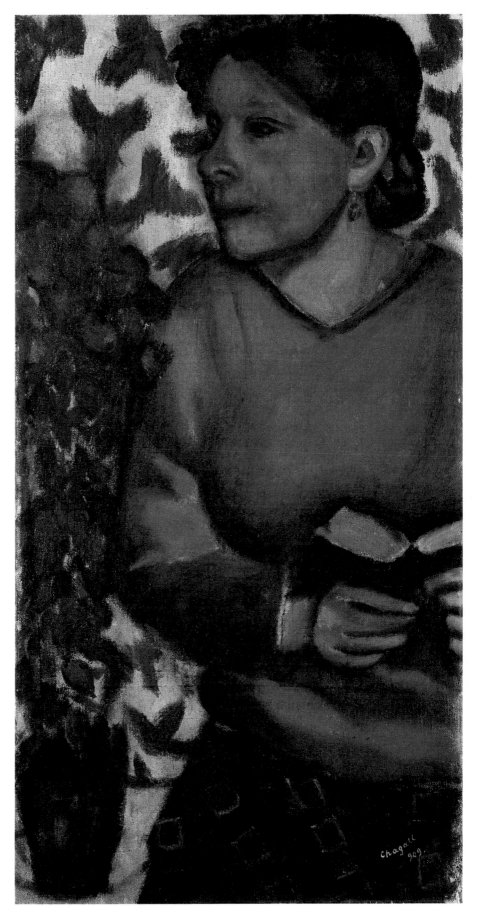

5 *The Artist's Sister (Mania)* (1909)

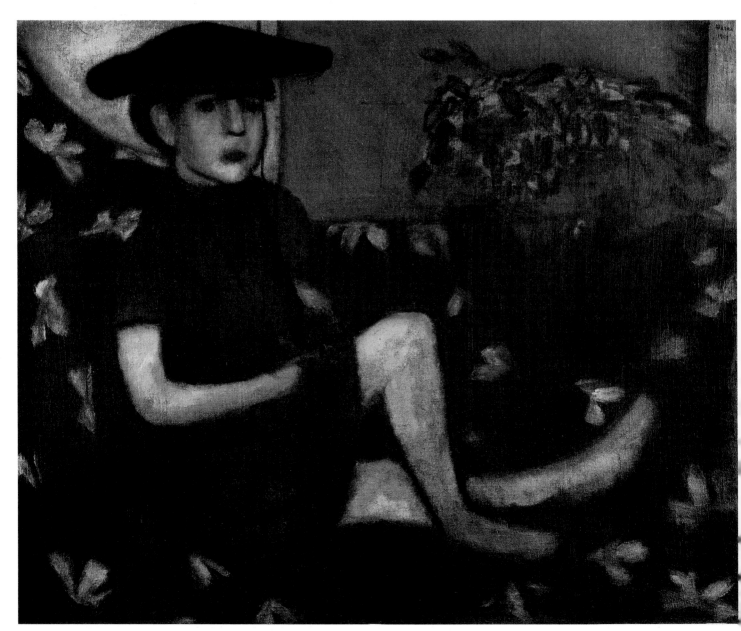

1 *Young Girl on a Sofa (Mariaska)* (1907)

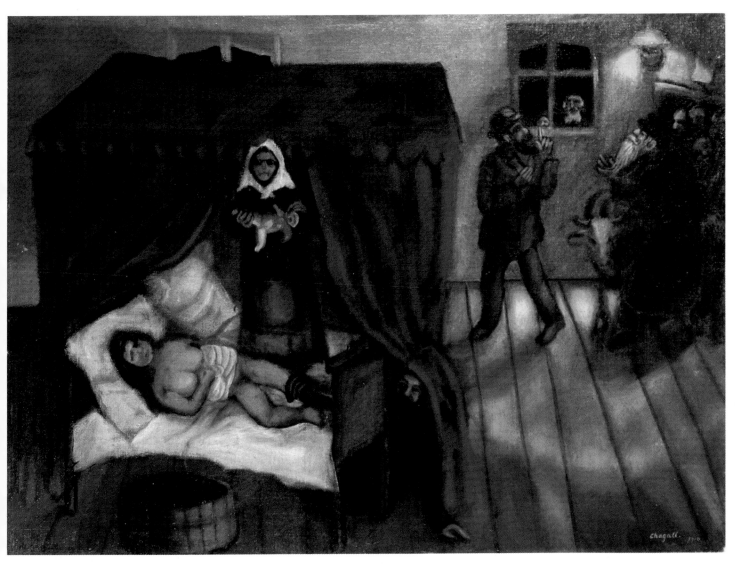

10 *Birth* (1910)

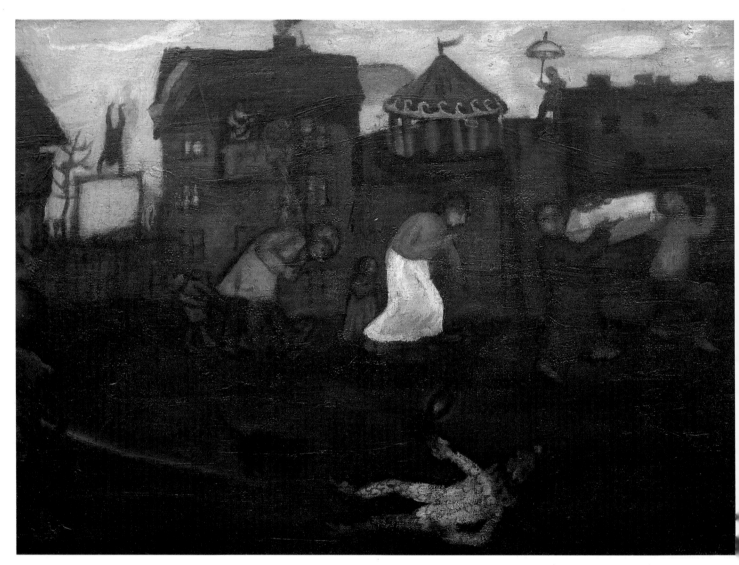

2 *Village Fair* (1908)

8 *The Family or Maternity* (1909)

11 *Portrait of the Artist's Sister (Aniuta)* (1910)

6 *Red Nude Sitting Up* (1908)

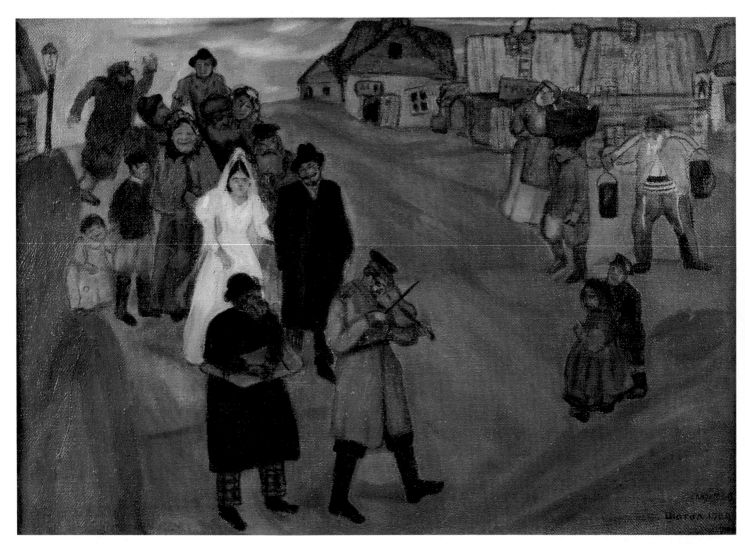

9 *Russian Wedding* (1909)

12 *The Model* (1910)

14 *Bride with Fan* (1911)

13 *Woman with a Bouquet* (1910)

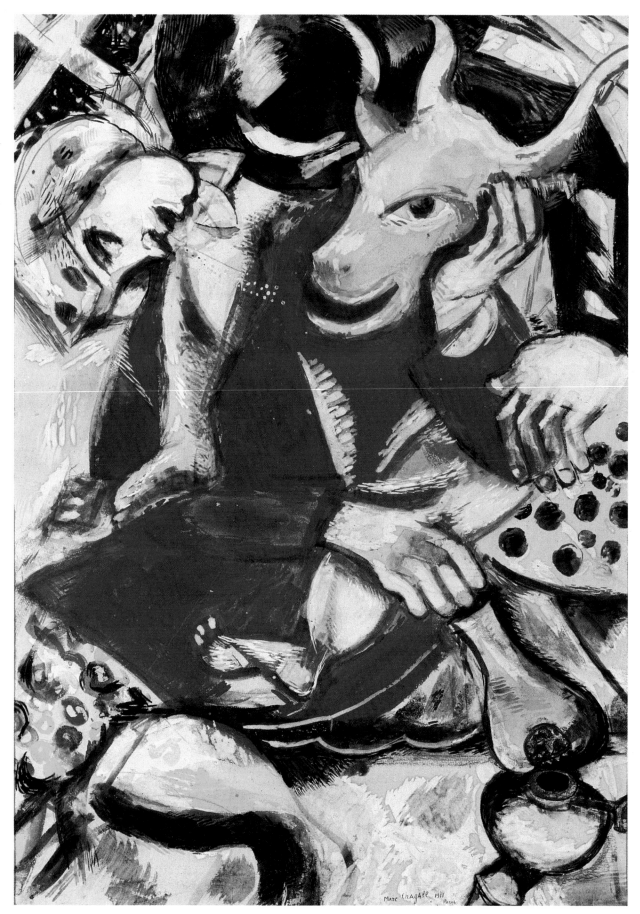

15 *To My Betrothed* (1911)

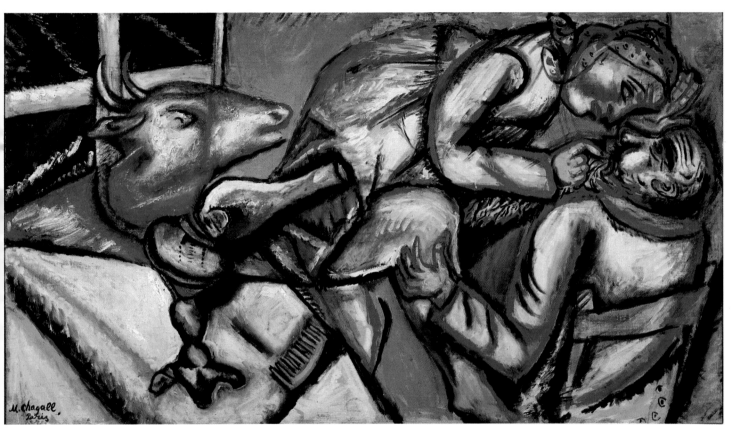

16 *Interior II* (1911)

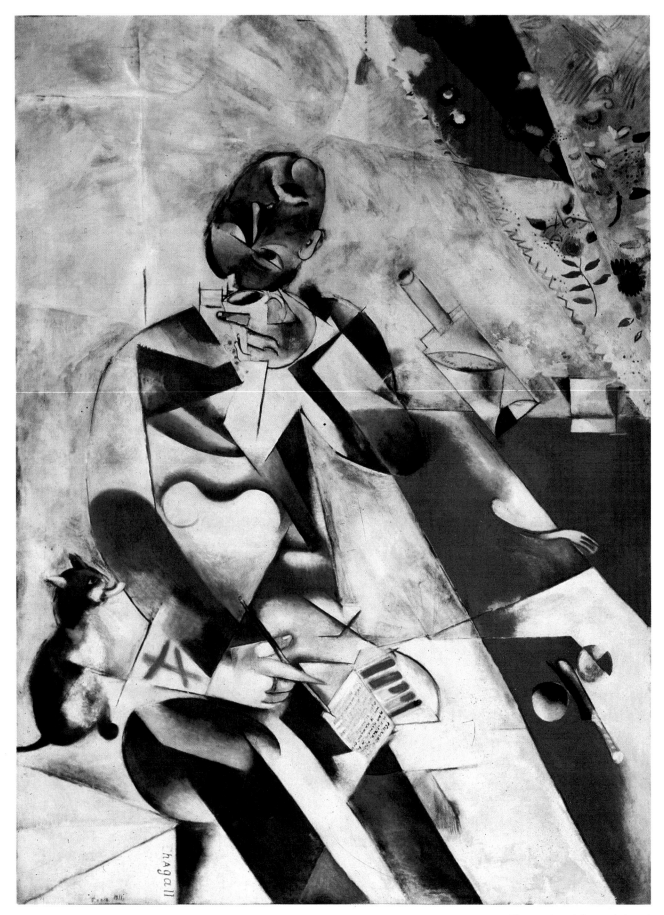

20 *Half Past Three (The Poet)* (1911)

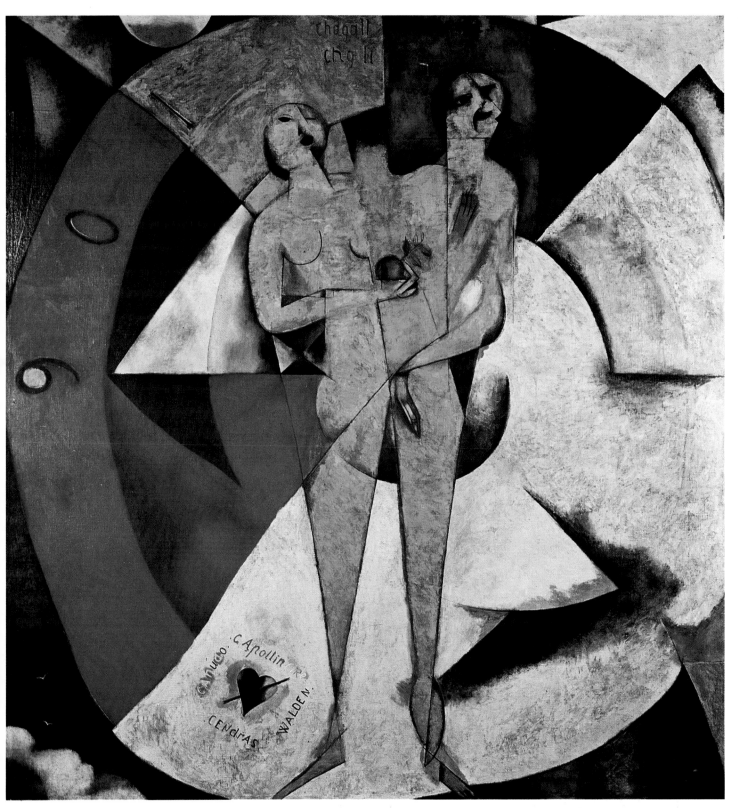

22 *Homage to Apollinaire* (1911–12)

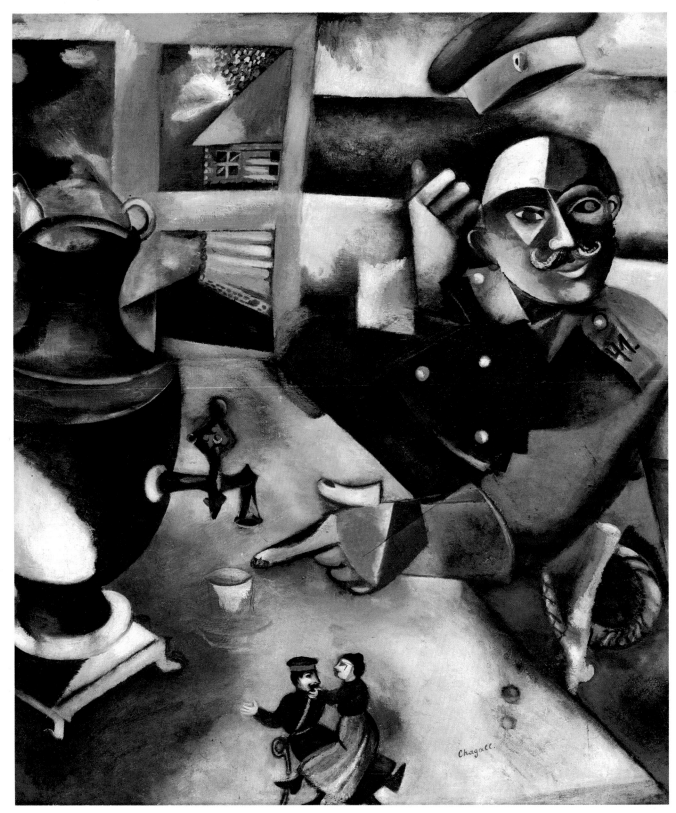

24 *The Soldier Drinks* (1911–12)

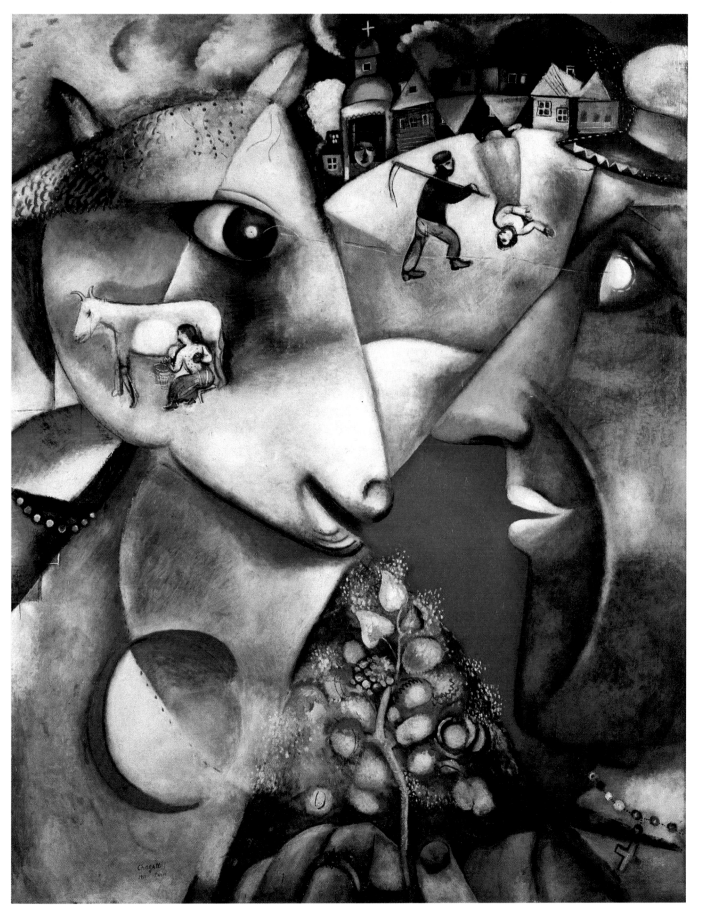

19 *I and the Village* (1911)

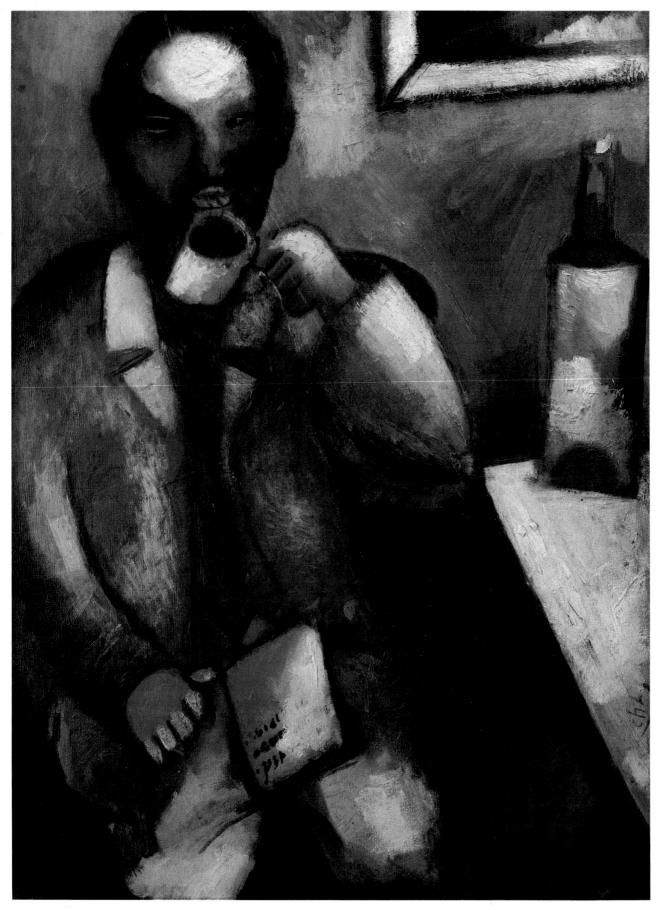

21 *The Poet Mazin* (1911–12)

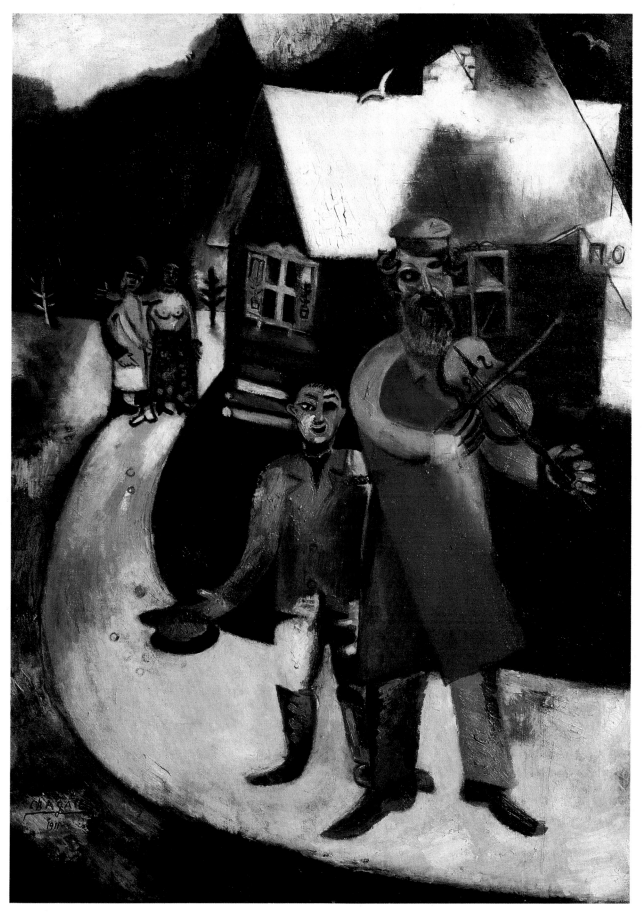

36 *The Violinist* (1911)

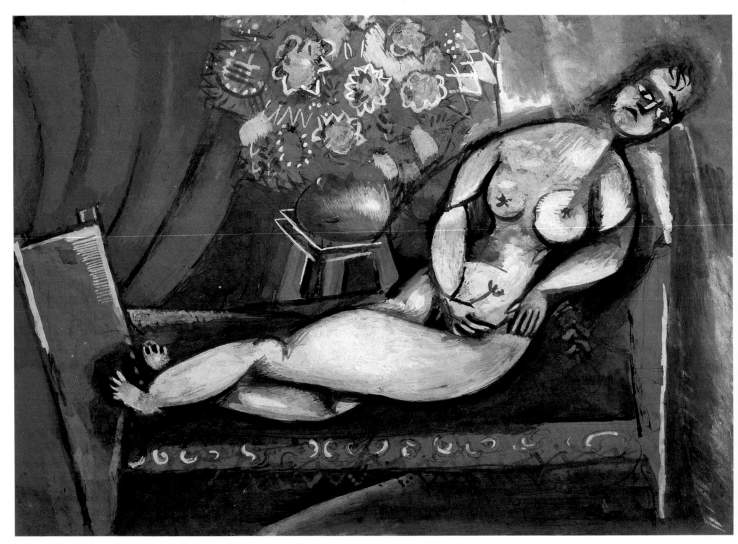

17 *Reclining Nude* (1911)

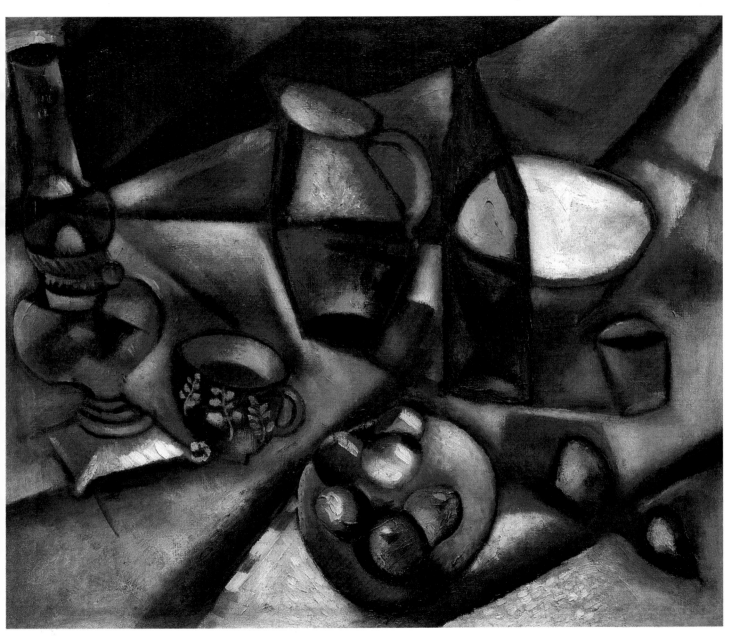

25 *Still-Life* (1912)

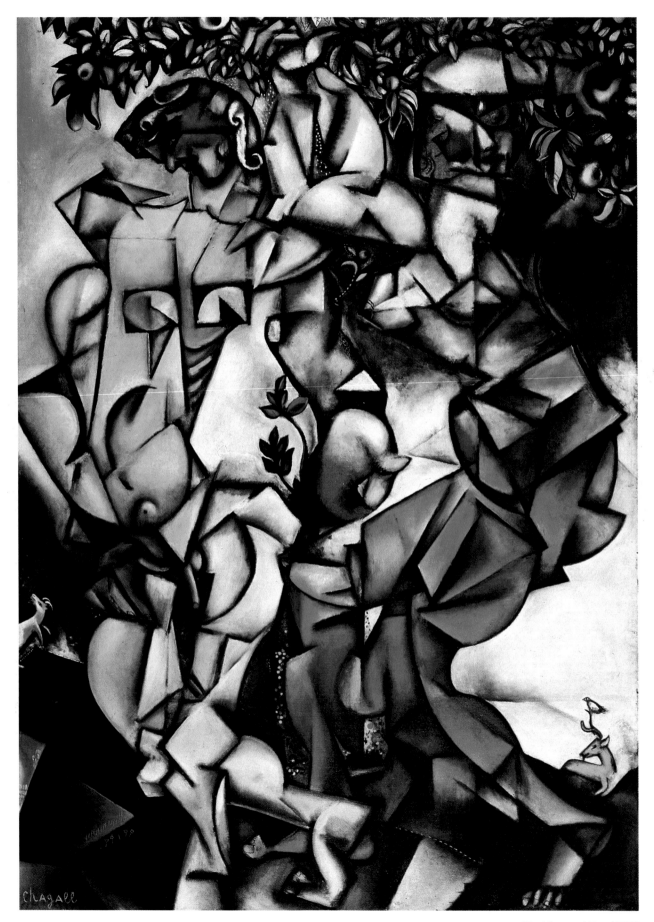

26 *Adam and Eve* (1912)

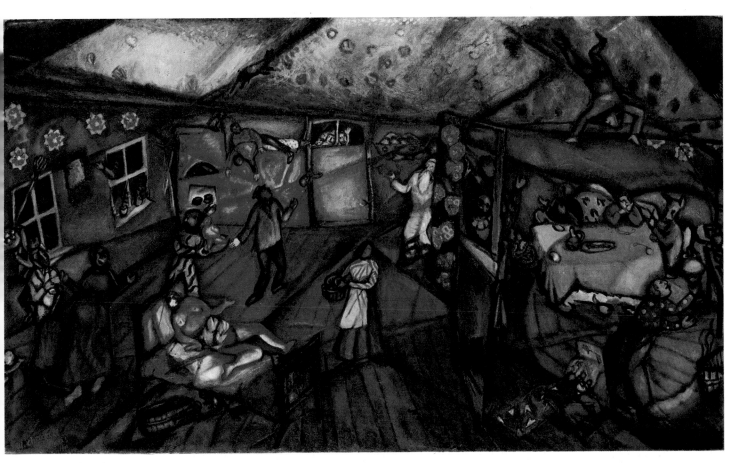

18 *Birth* (1911)

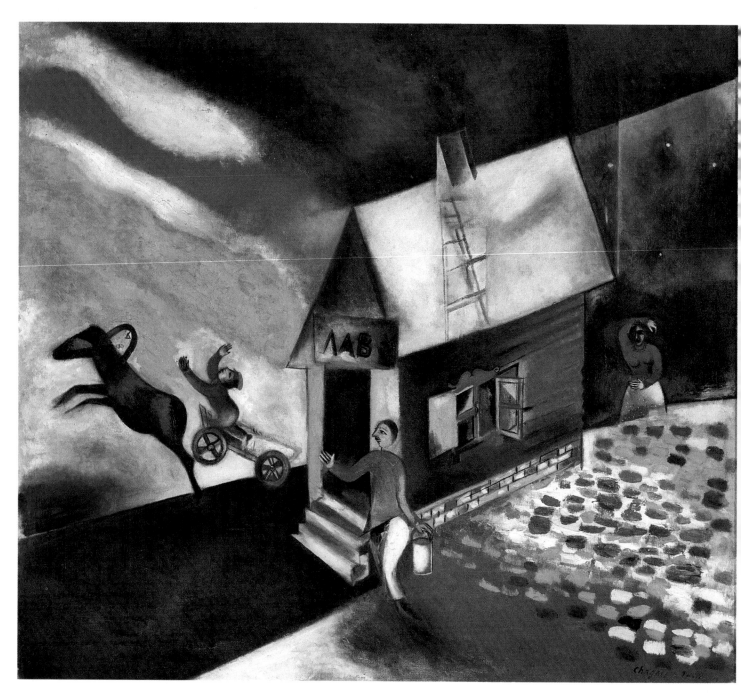

35 *The Flying Carriage* (1913)

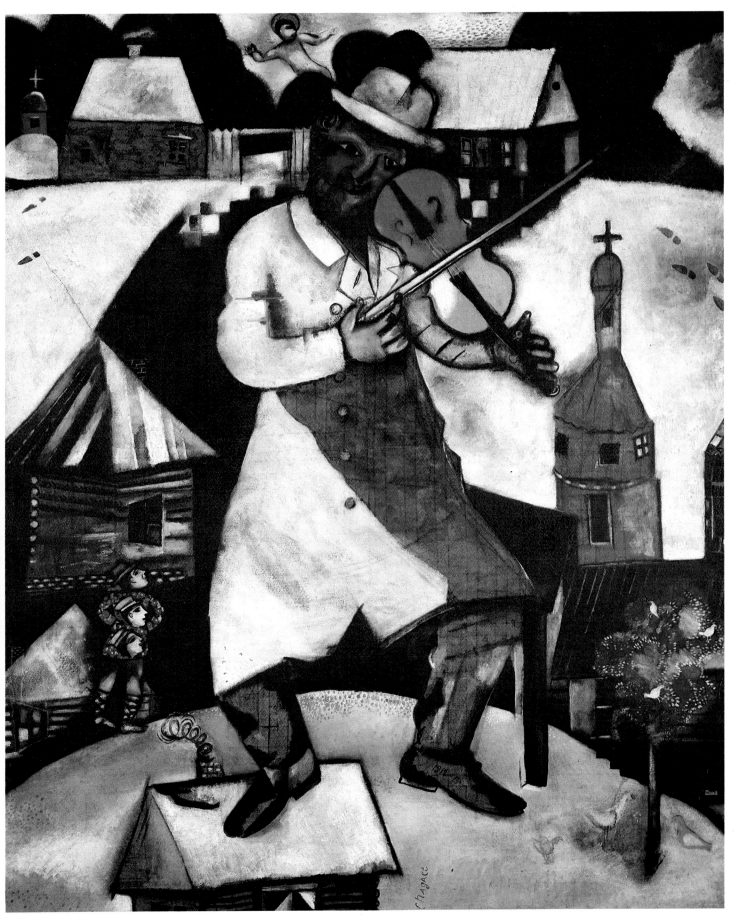

34 *The Fiddler* (1912–13)

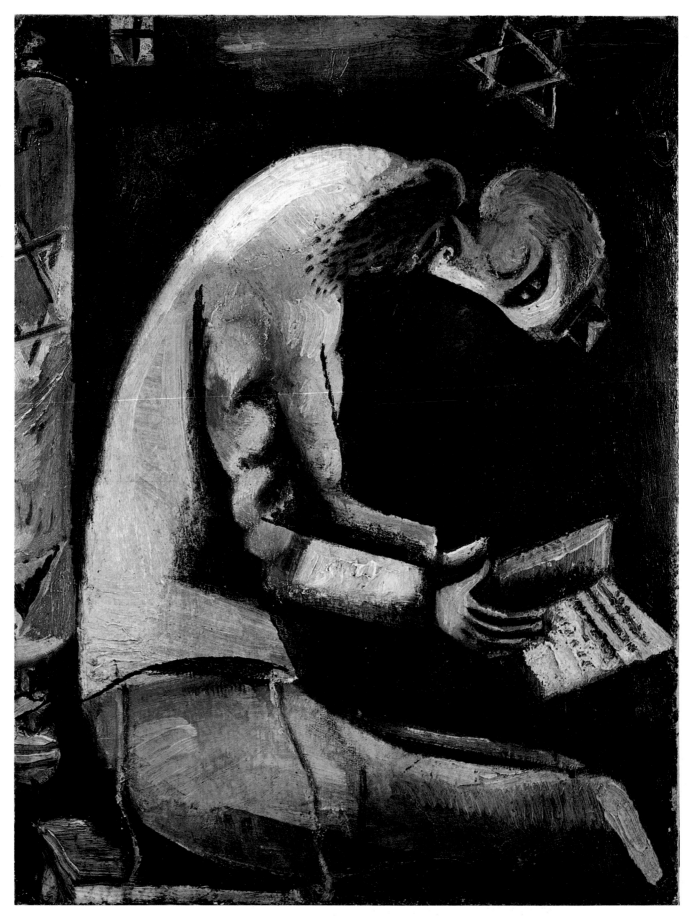

32 *Jew at Prayer* (1912–13)

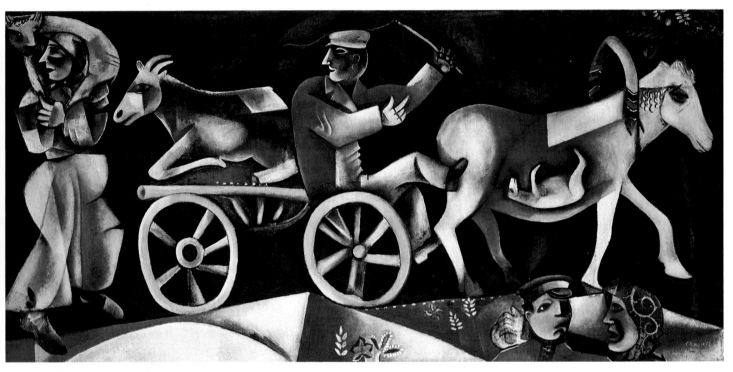

28 *The Cattle Dealer* (1912)

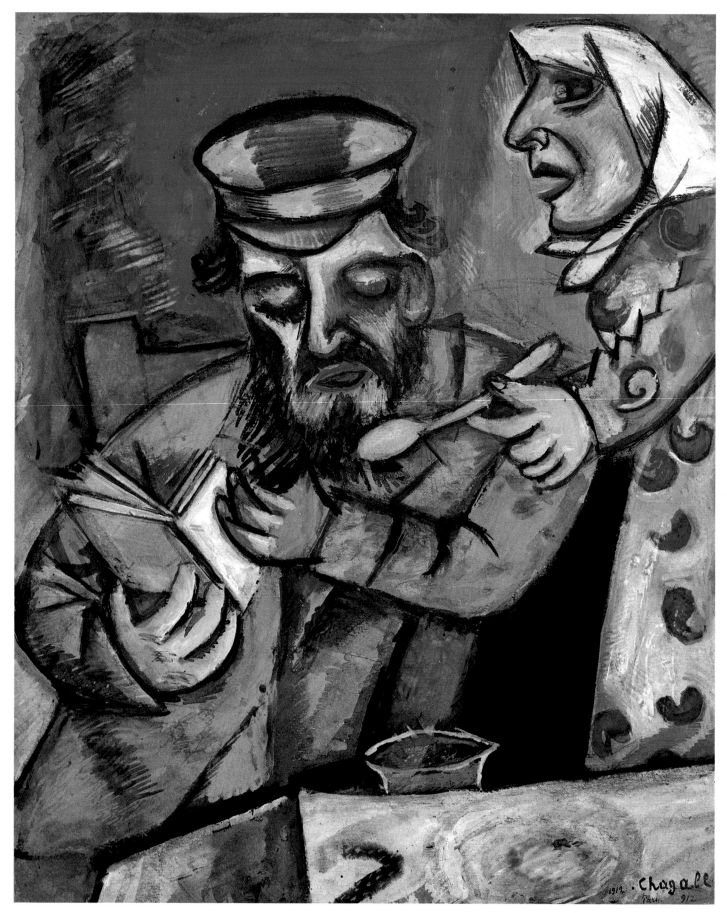

30 *The Spoonful of Milk* (1912)

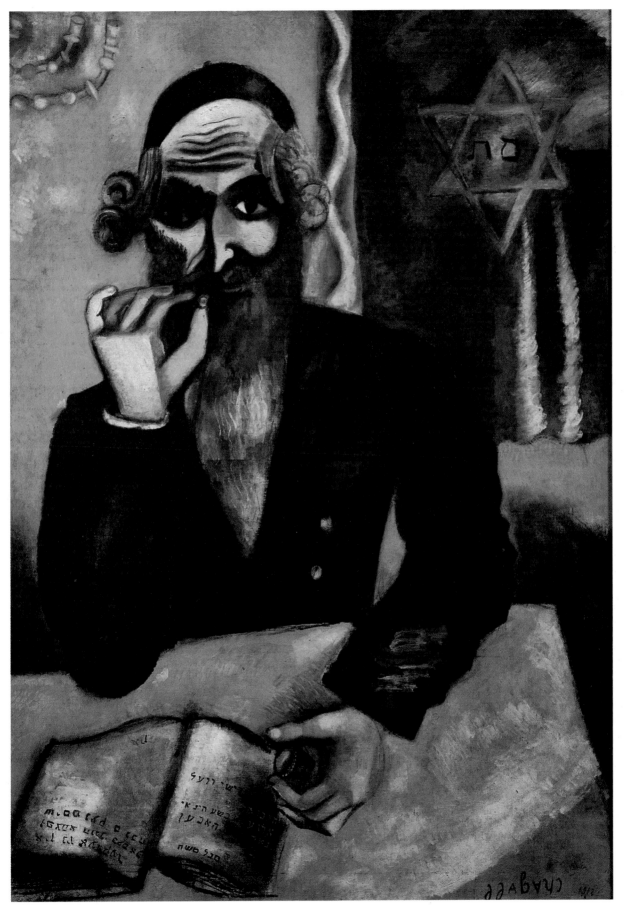

31 *The Pinch of Snuff* (1912)

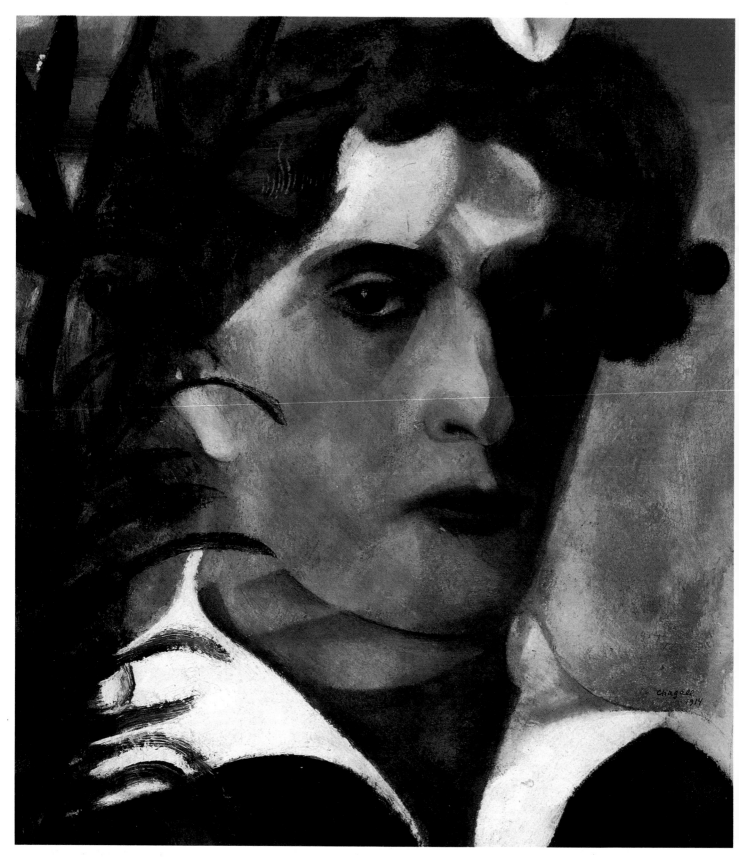

41 *Self-Portrait* (1914)

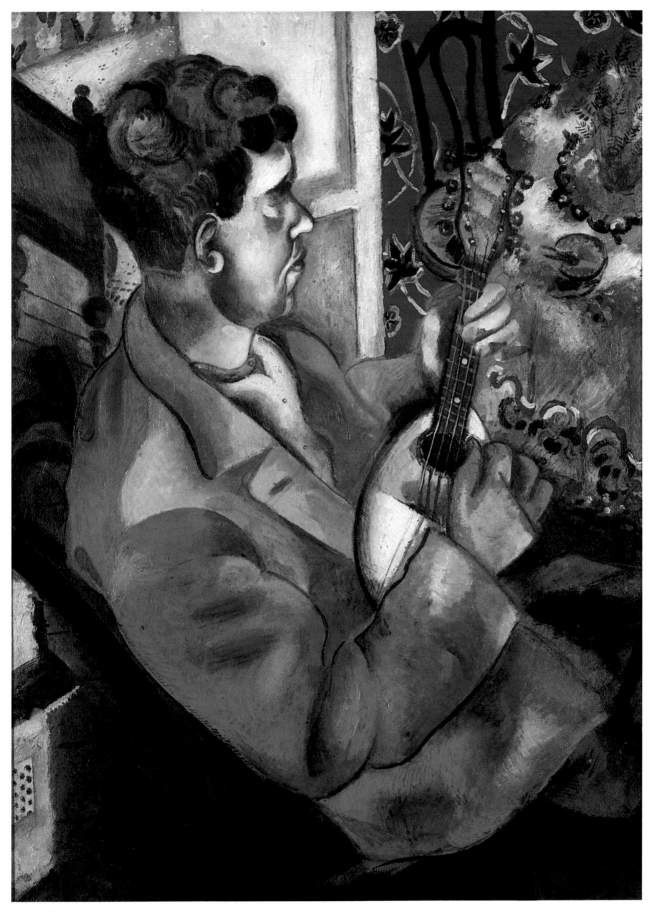

39 *David in Profile* (1914)

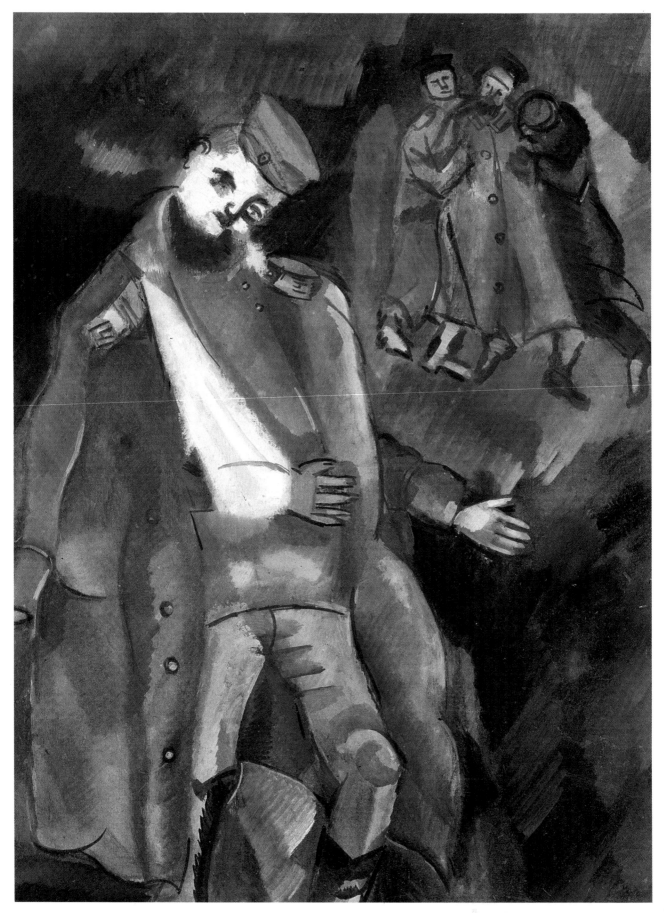

37 *Wounded Soldier* (1914)

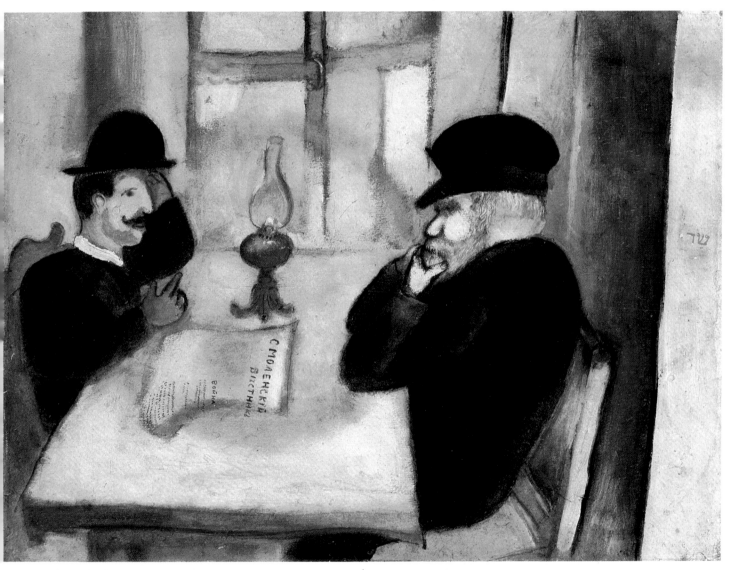

42 *The Smolensk Newspaper* (1914)

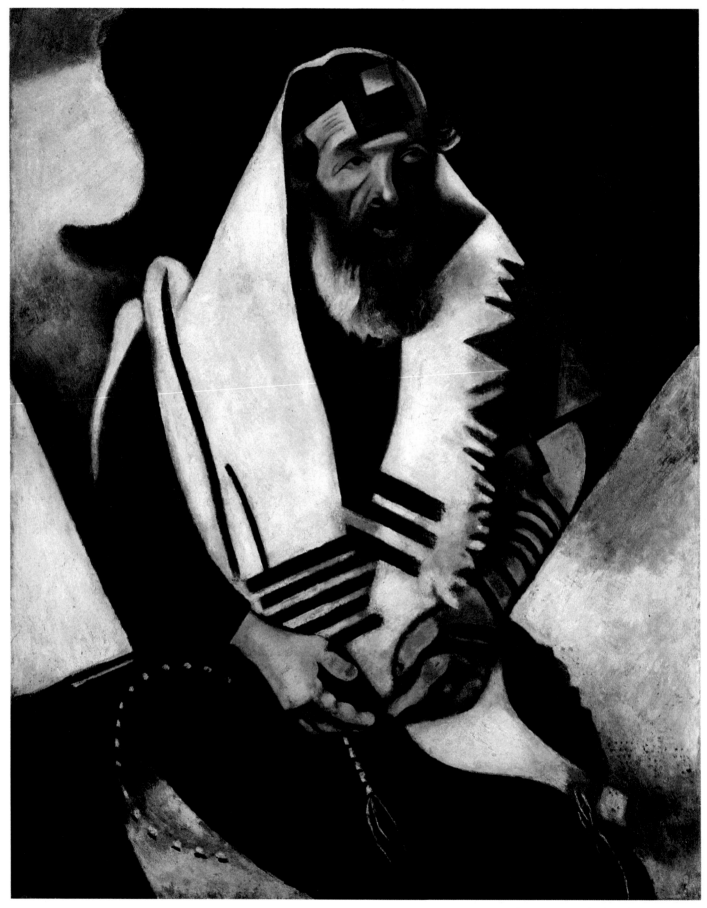

43 *The Praying Jew (Rabbi of Vitebsk)* (1914)

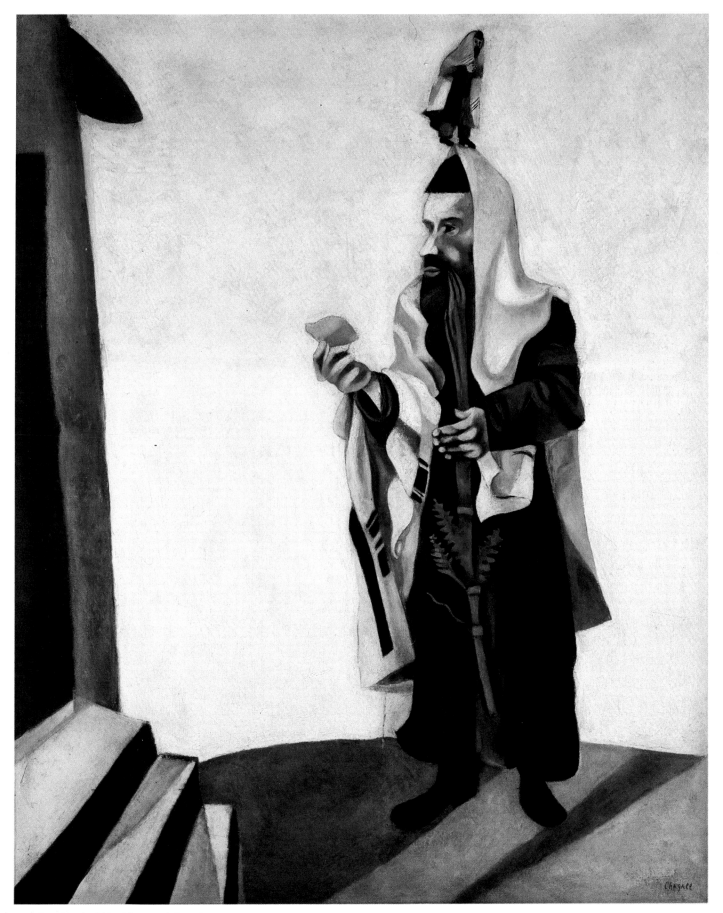

45 *Feast Day (Rabbi with Lemon)* (1914)

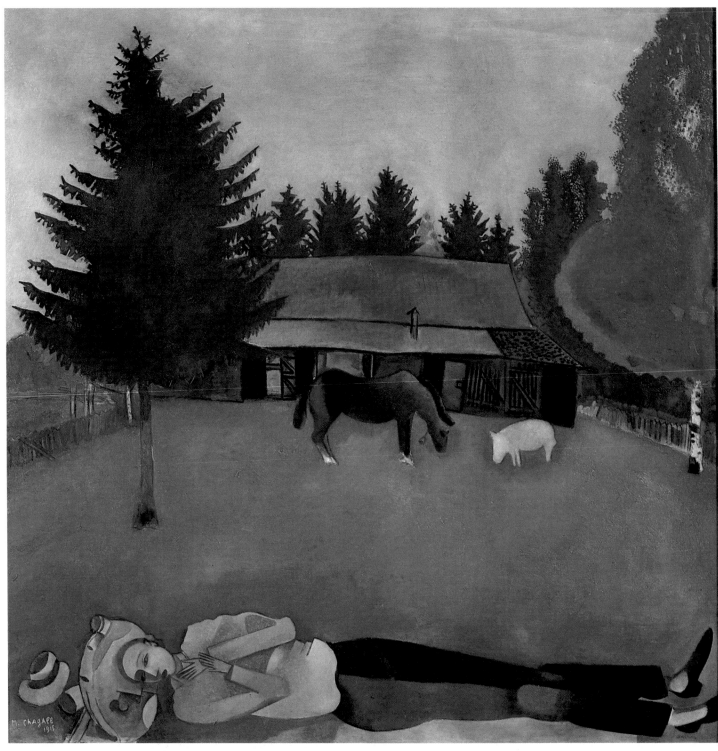

49 *The Poet Reclining* (1915)

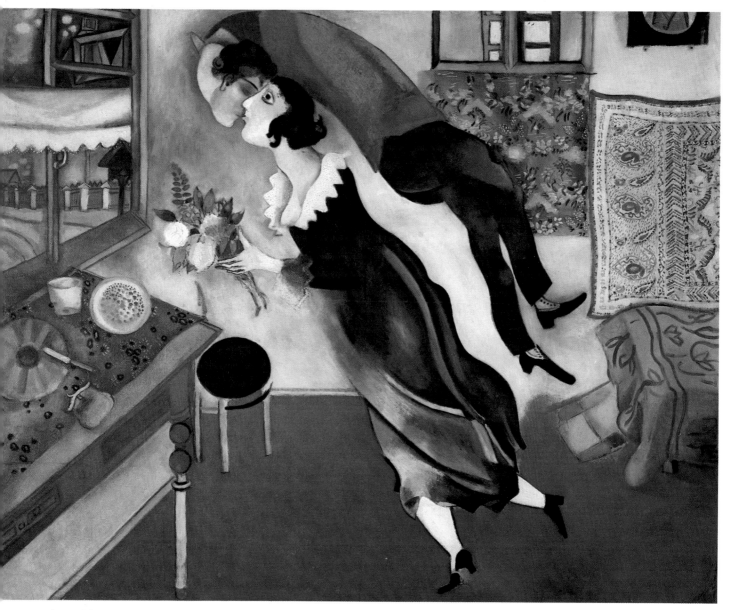

48 *The Birthday* (1915)

50 *Visit to the Grandparents* (1915)

52 *Purim* (*c.* 1916–18)

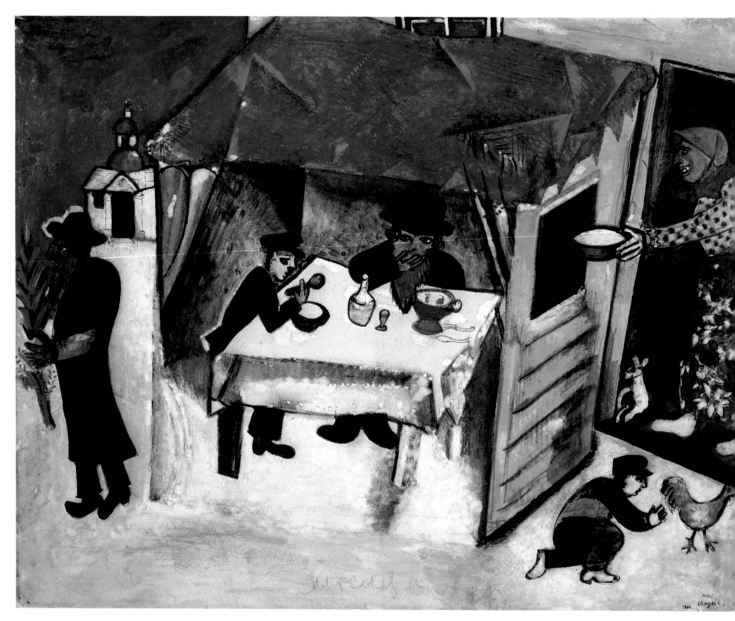

51 *The Feast of the Tabernacles* (1916)

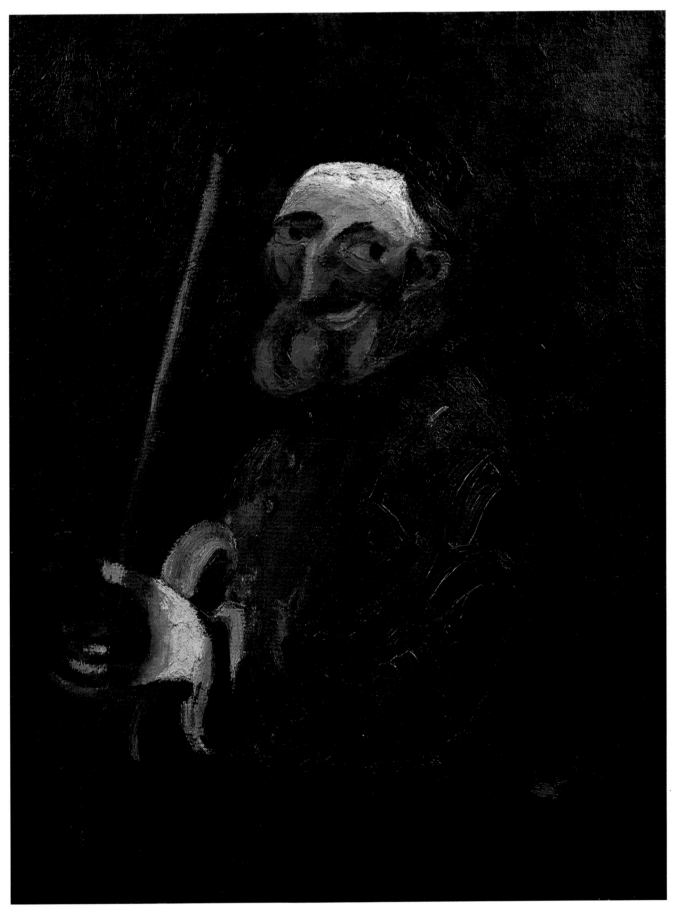

58 *Musician with Violin* (1919)

56 *The Red Gateway* (1917)

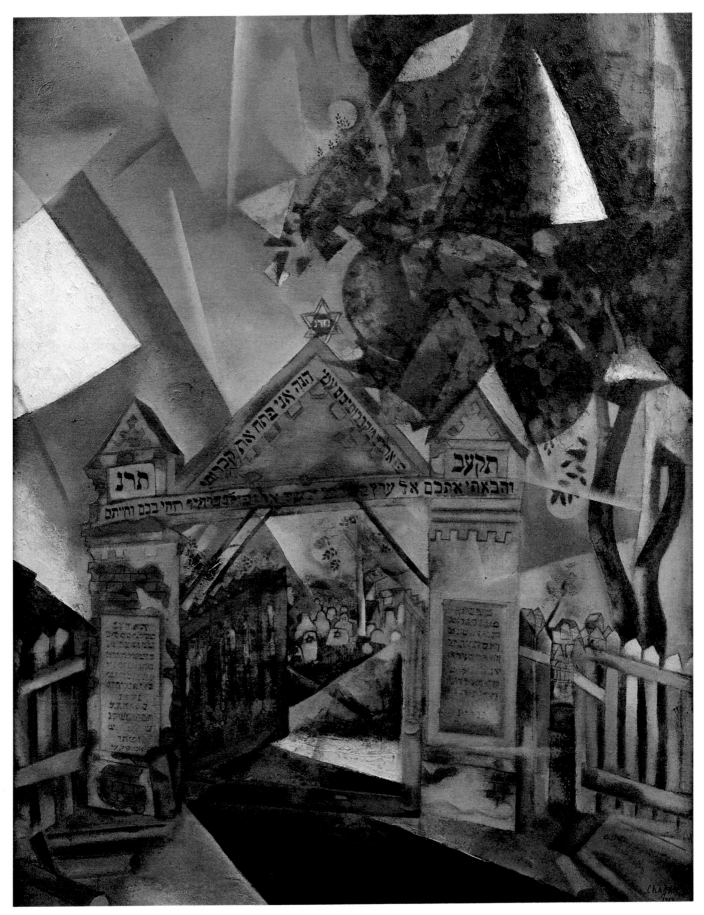

55 *Cemetery Gates* (1917)

54 *Vitebsk: from Mount Zadunov* (1917)

53 *Bella with a White Collar* (1917)

60 *The Painter to the Moon* (1917)

62 *Composition with Goat* (1917)

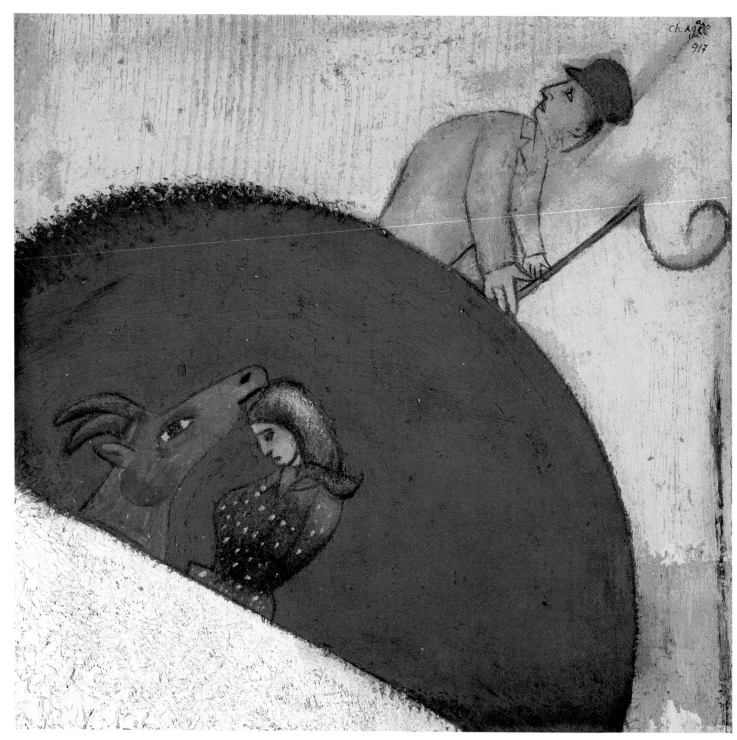

59 *Peasant Life (The Stable; Night; Man with Whip)* (1917)

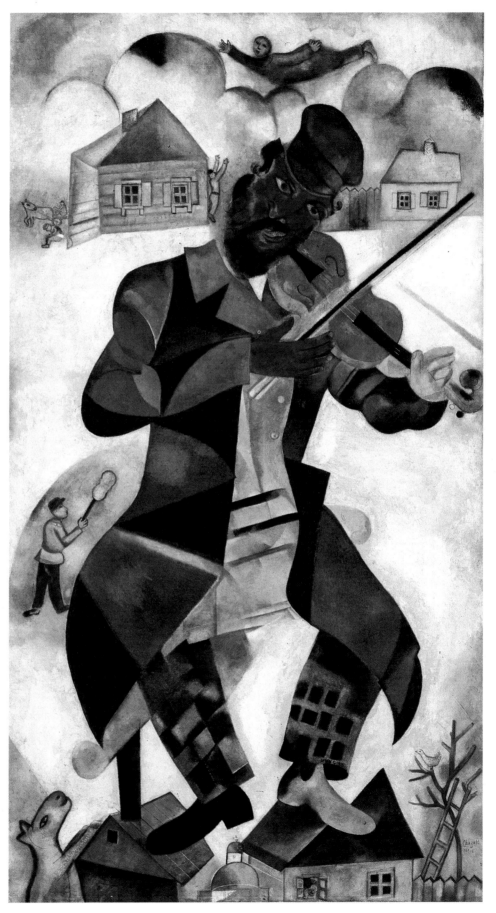

64 *Green Violinist* (1923–24)

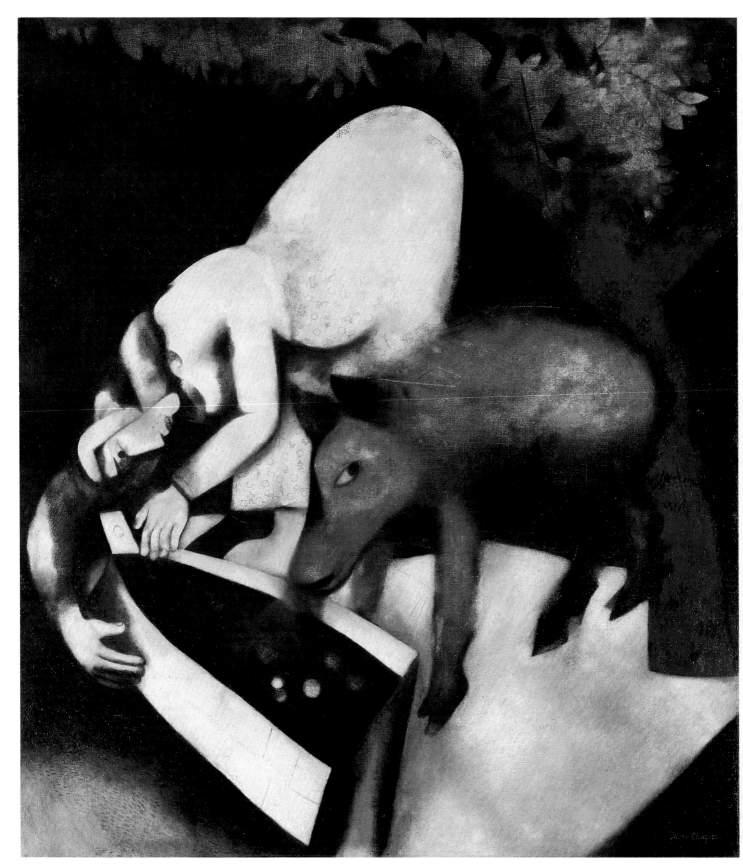

68 *The Watering Trough* (1925)

74 *Lovers with Flowers* (1927)

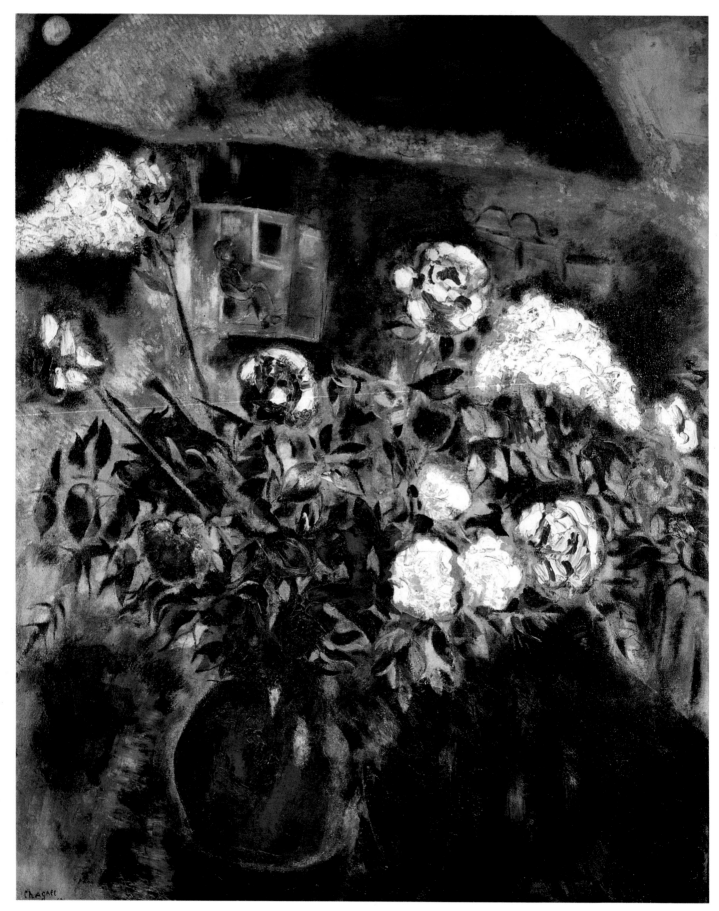

70 *Peonies and Lilacs* (1926)

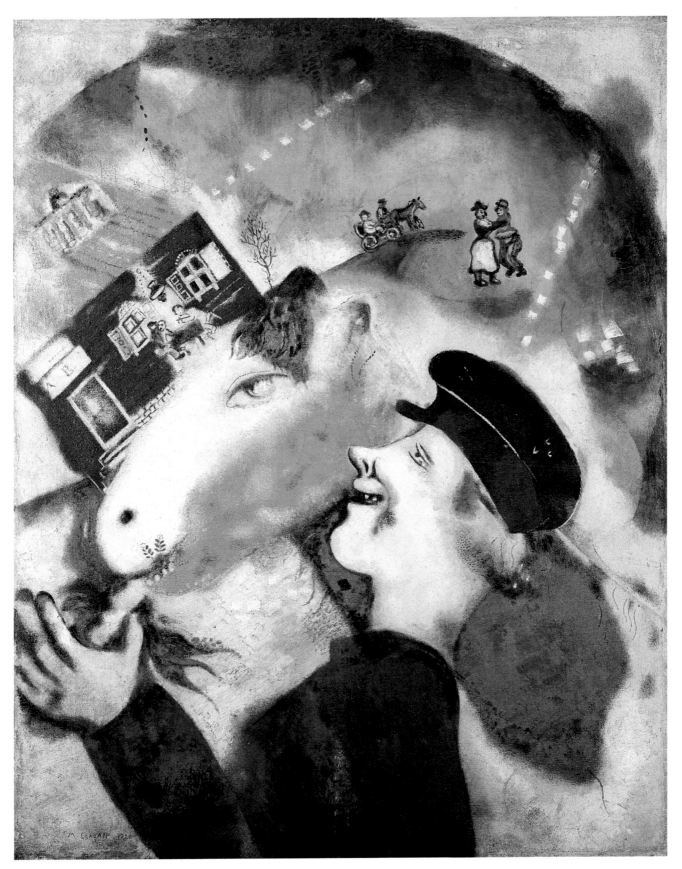

69 *Peasant Life* (1925)

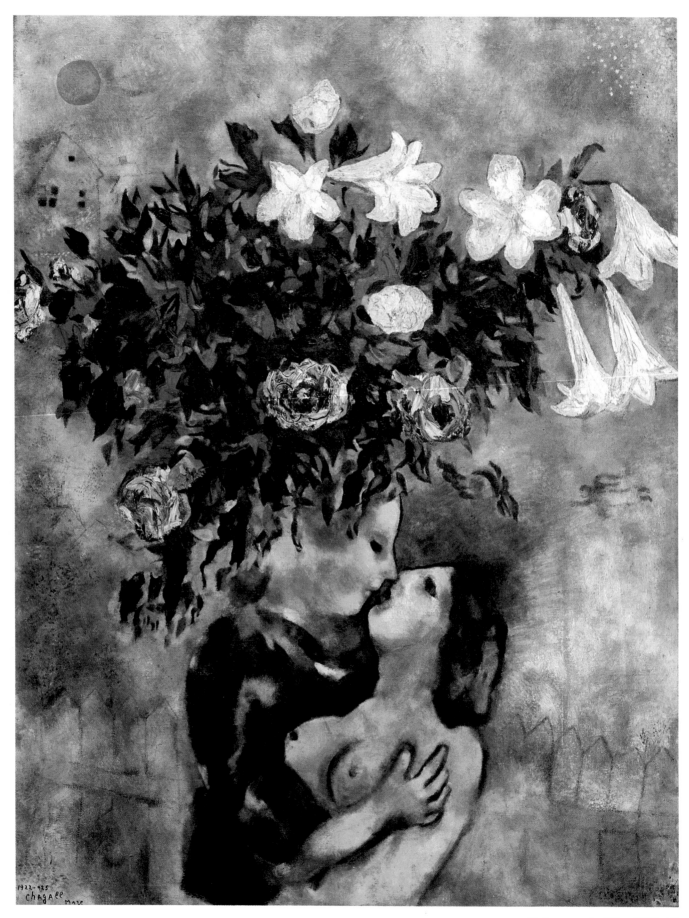

67 *Lovers under Lilies* (1922–25)

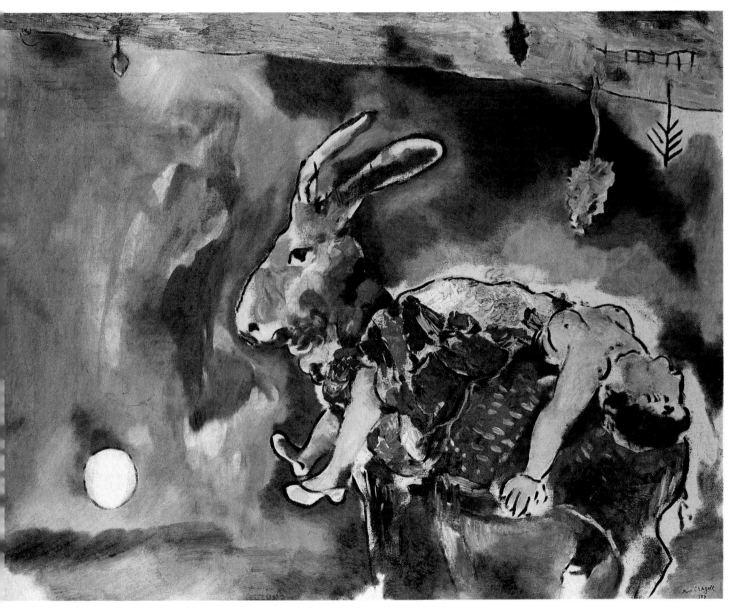

73 *The Dream* (1927)

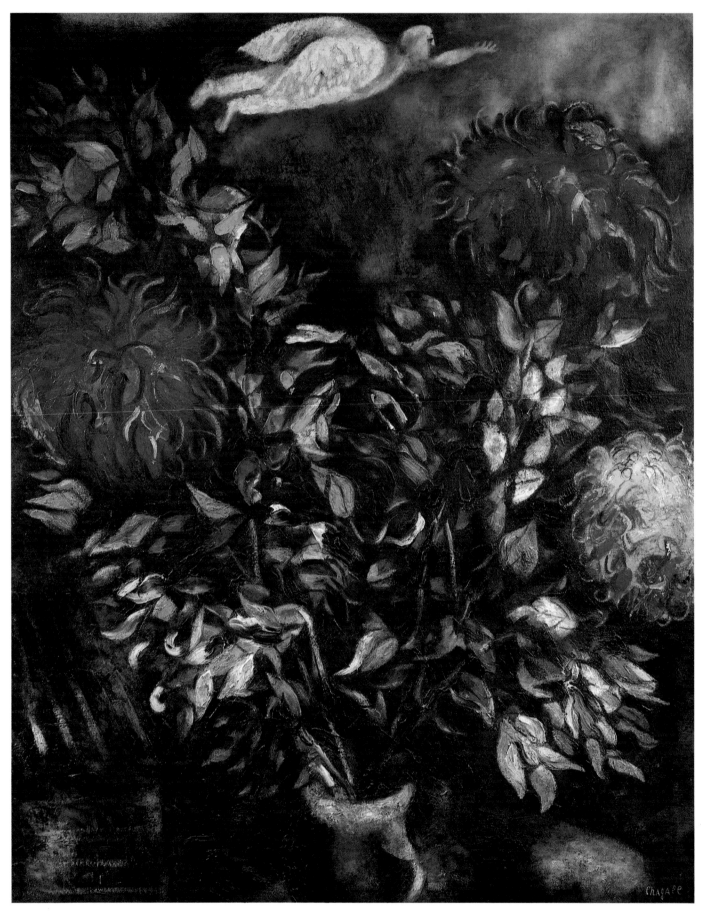

72 *Chrysanthemums* (1926)

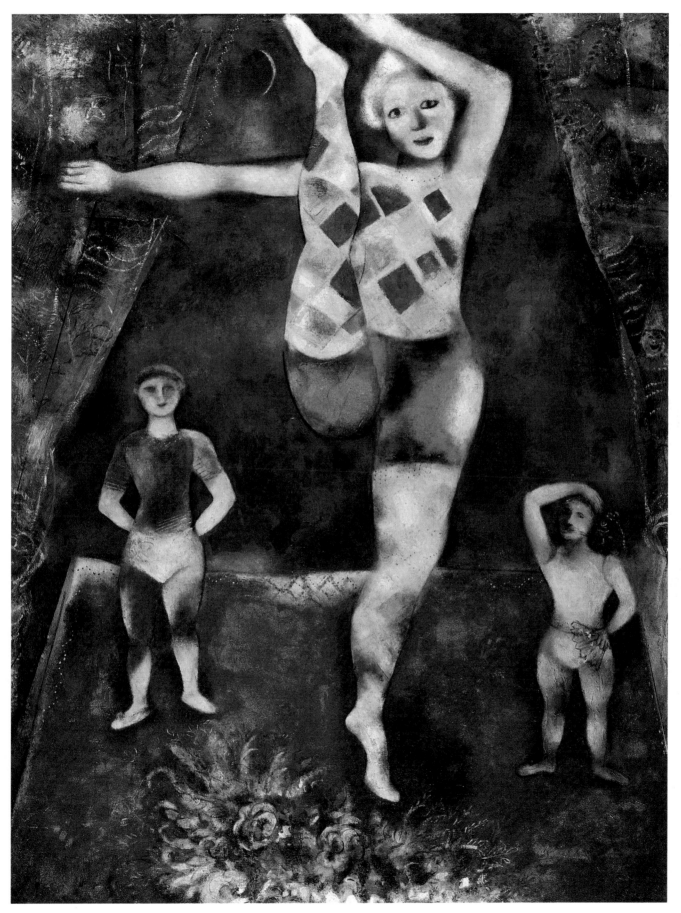

71 *The Three Acrobats* (1926)

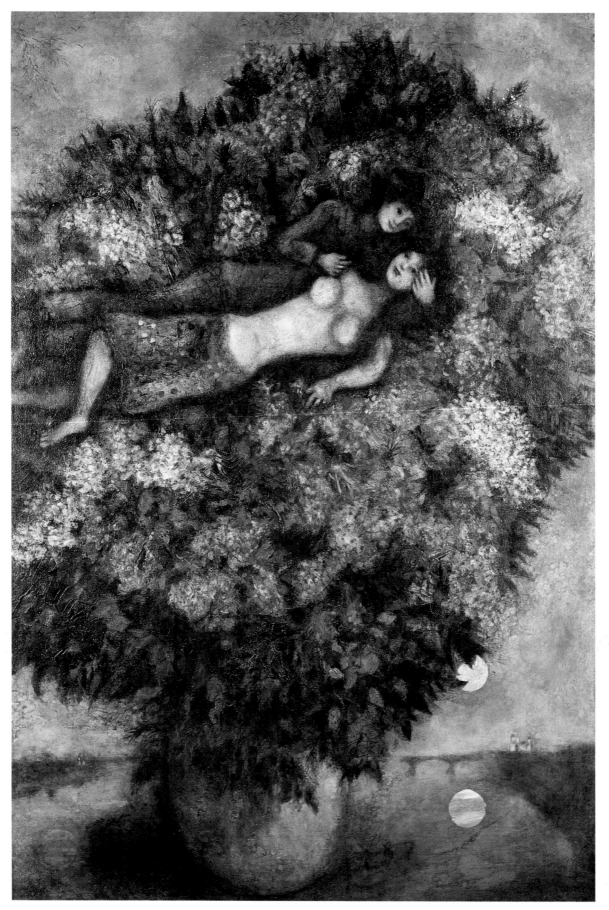

77 *Lovers in the Lilacs* (1930)

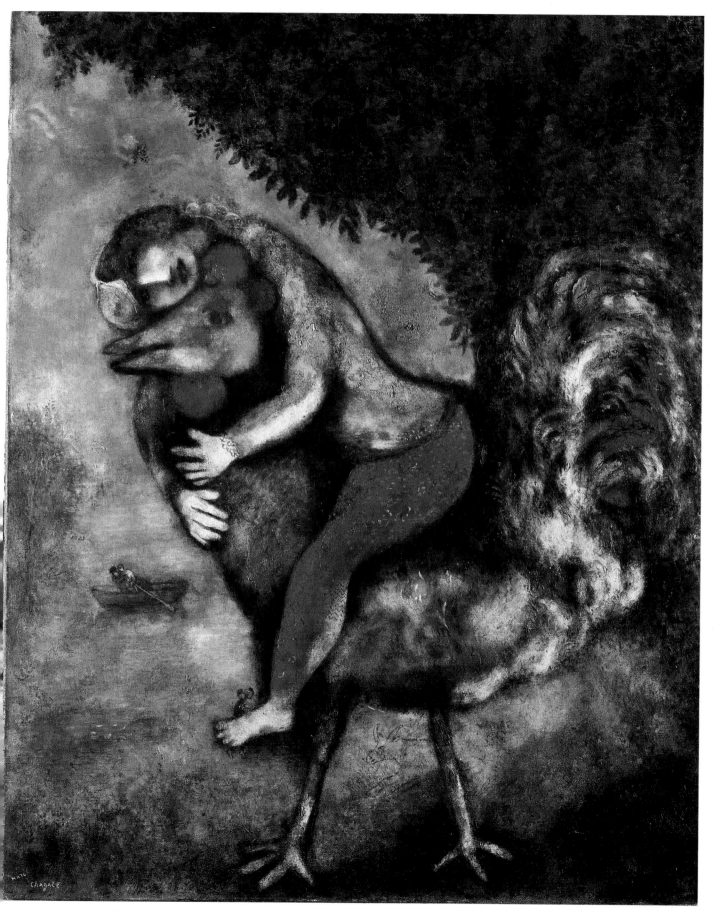

75 *The Rooster* (1929)

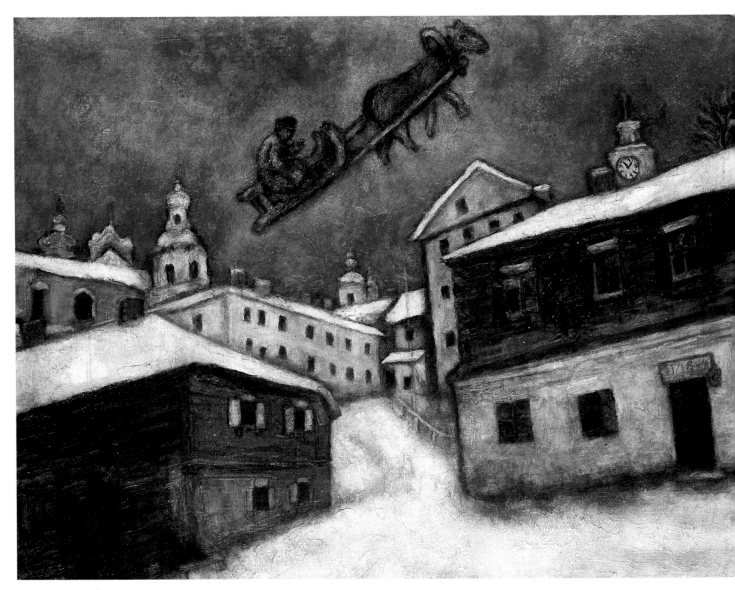

76 *Russian Village* (1929)

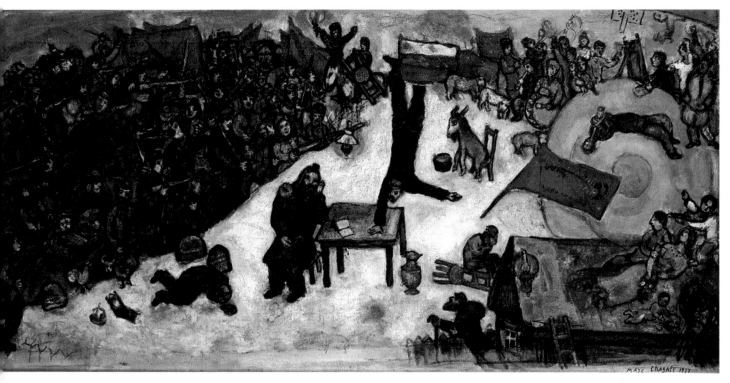

80 *The Revolution* (1937)

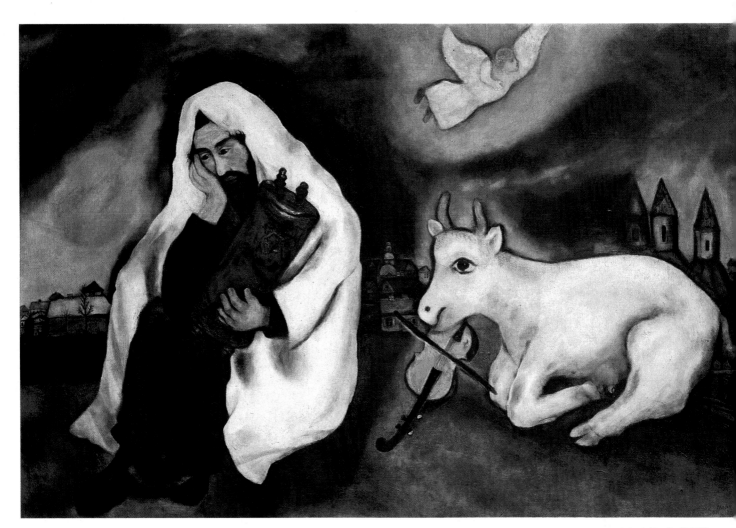

79 *Solitude* (1933)

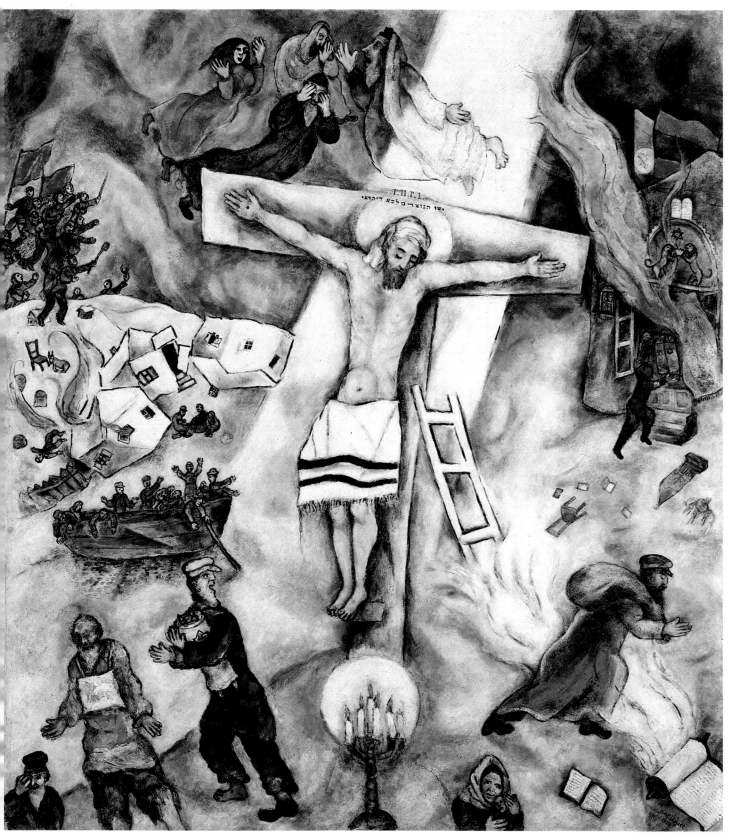

81 *White Crucifixion* (1938)

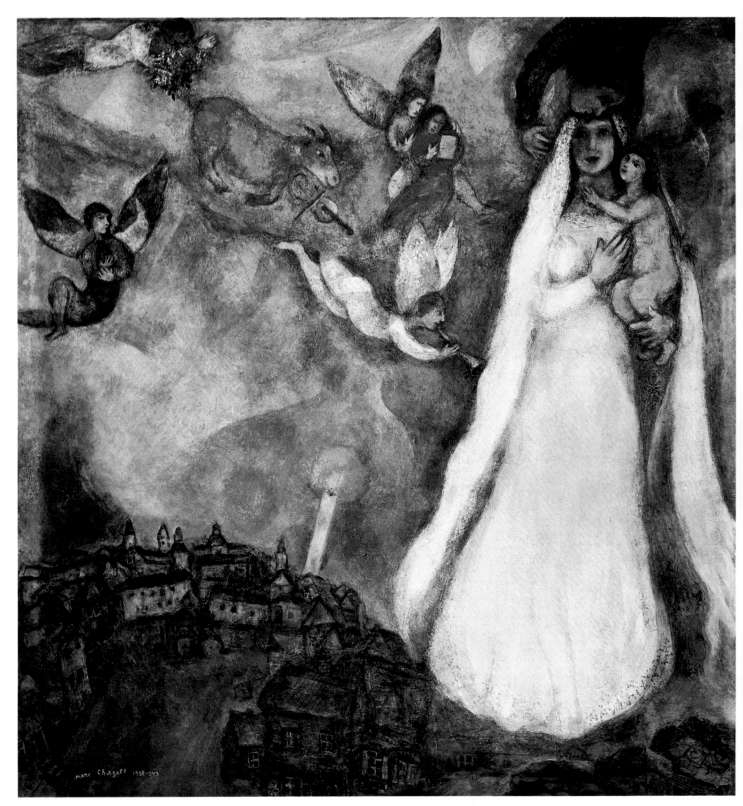

83 *Madonna of the Village* (1938–42)

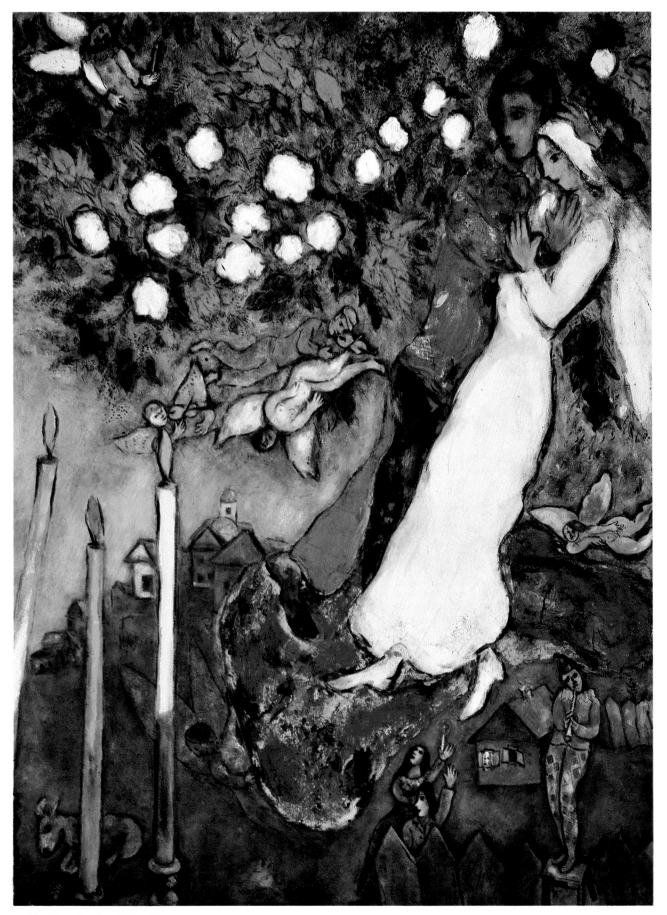

82 *The Three Candles* (1938–40)

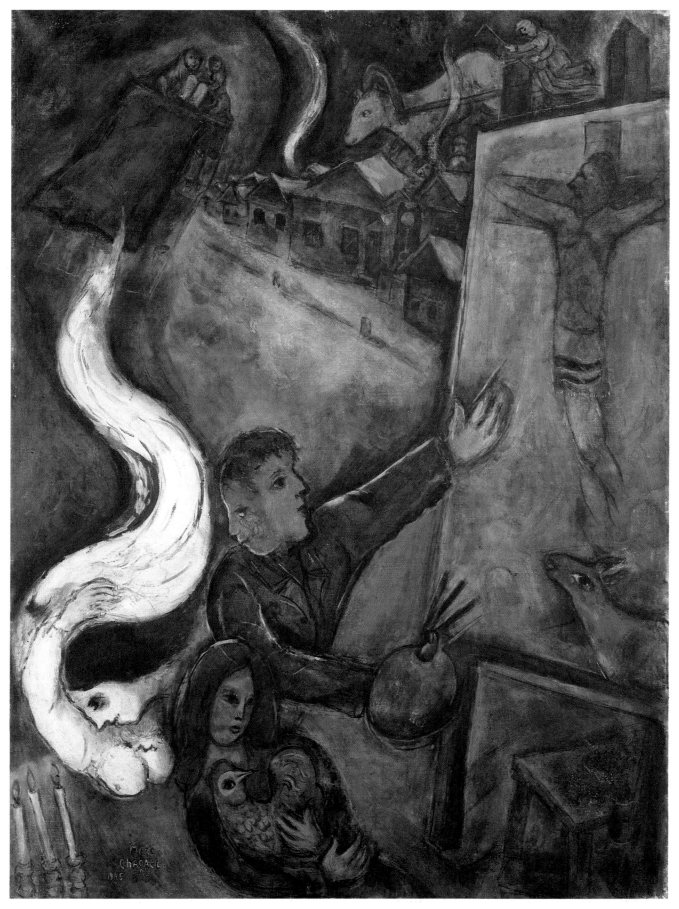

87 *The Soul of the City* (1945)

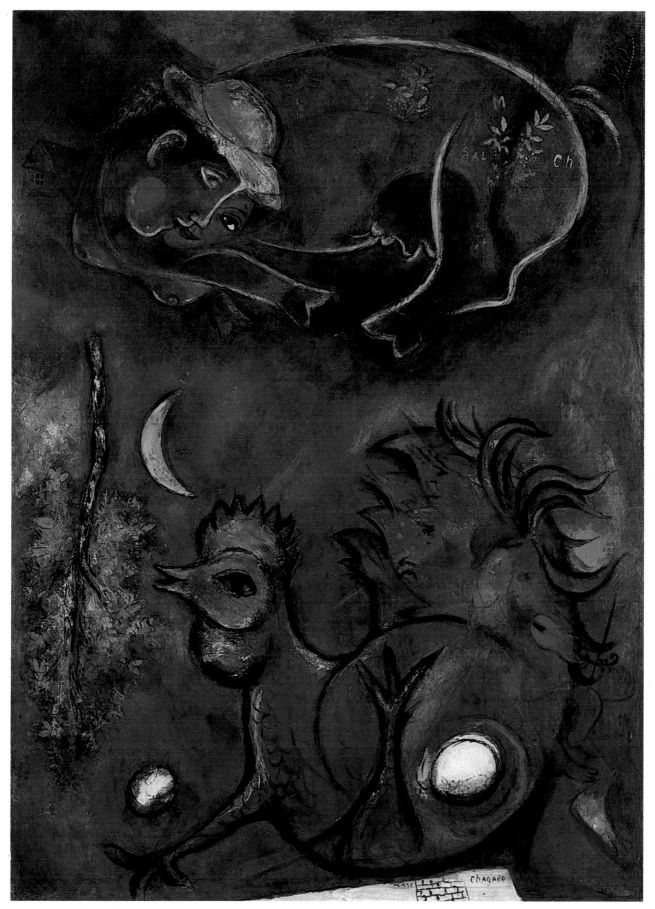

85 *Listening to the Cock* (1944)

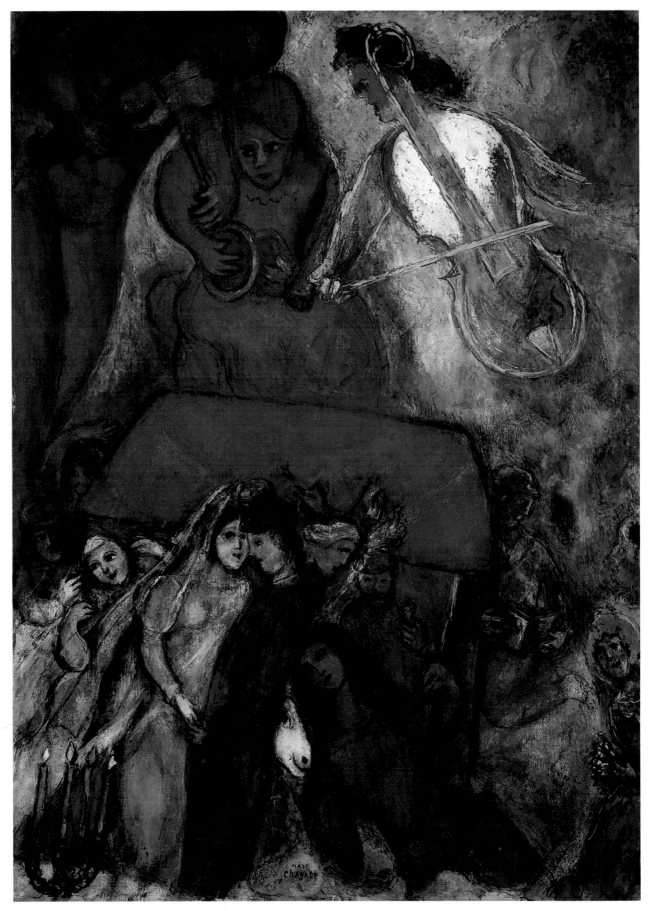

86 *The Wedding* (1944)

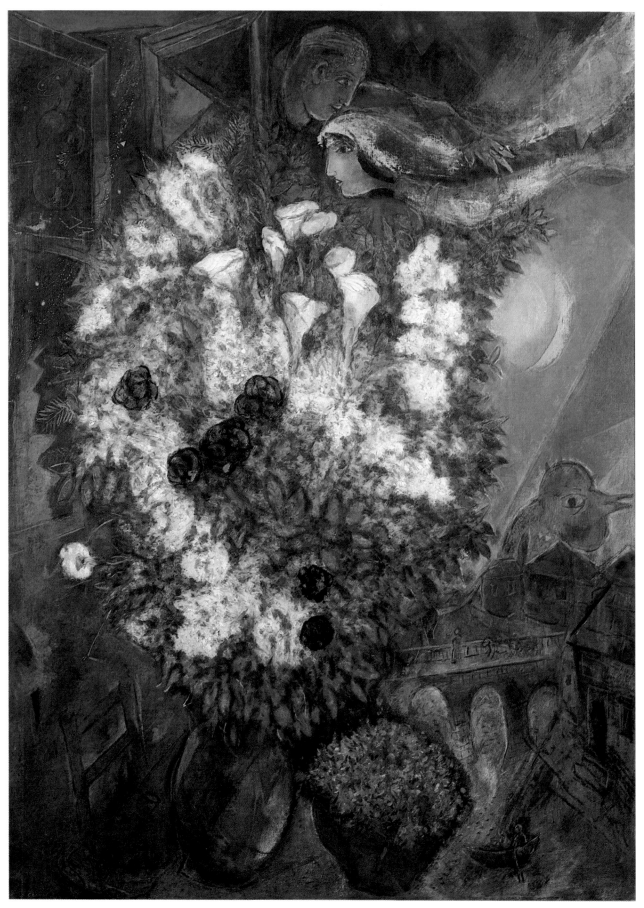

90 *Bouquet with Flying Lovers* (c. 1934–47)

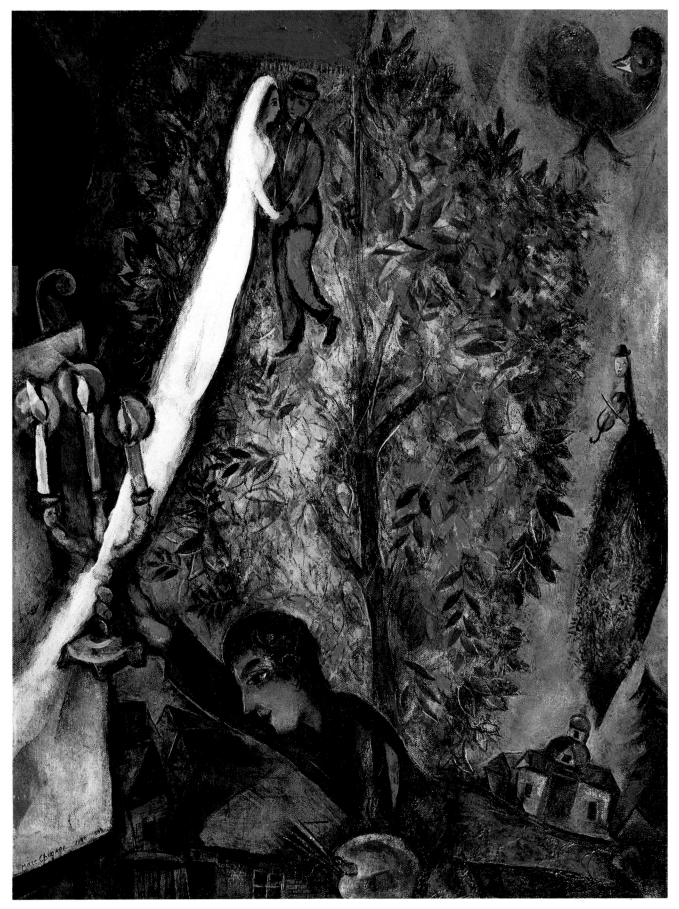

92 *The Tree of Life* (1948)

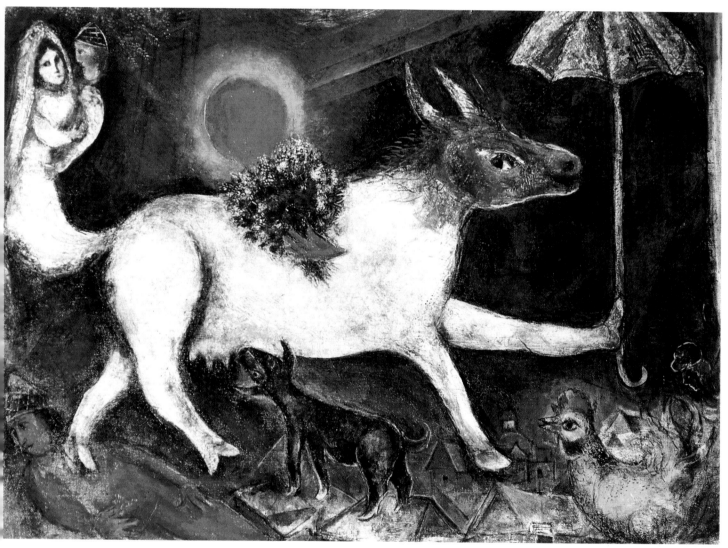

89 *Cow with Parasol* (1946)

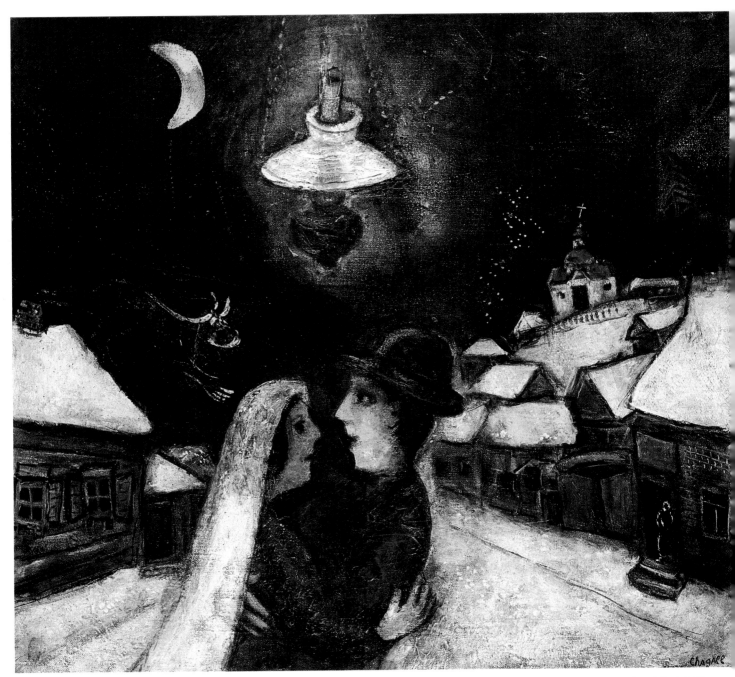

84 *In the Night* (1943)

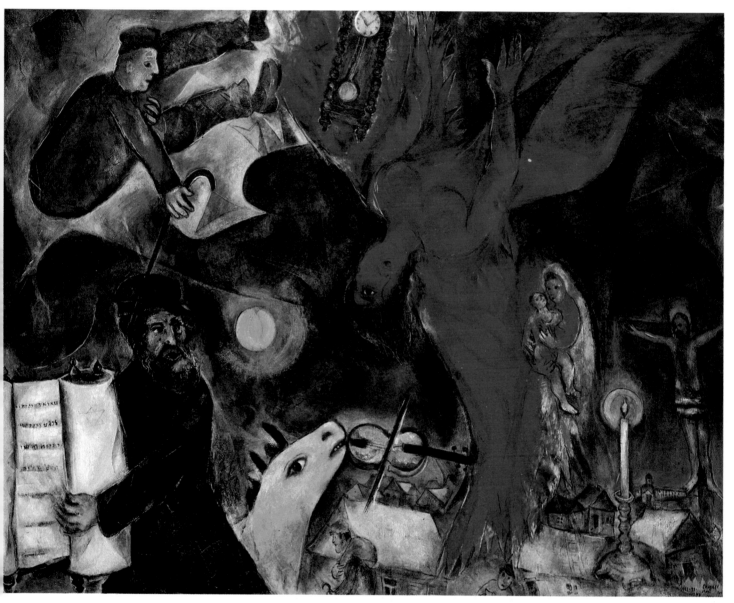

91 *The Falling Angel* (1922–33–47)

123

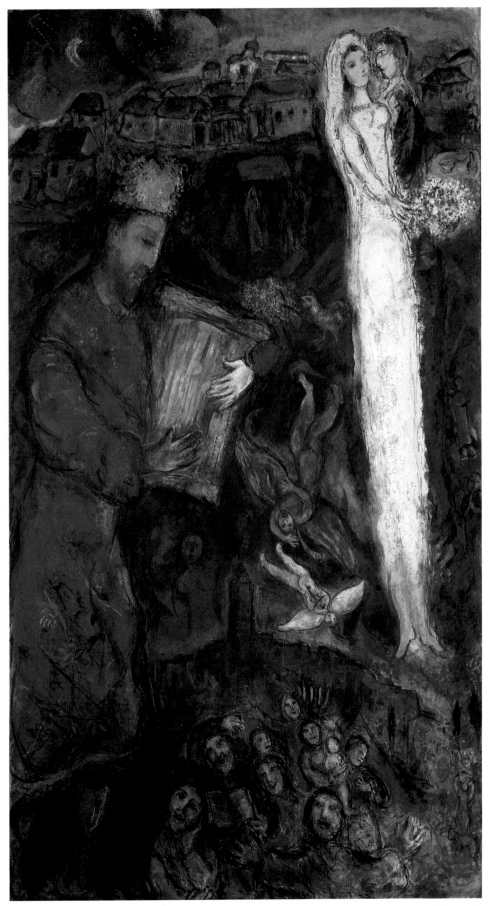

103 *David* (1962–63)

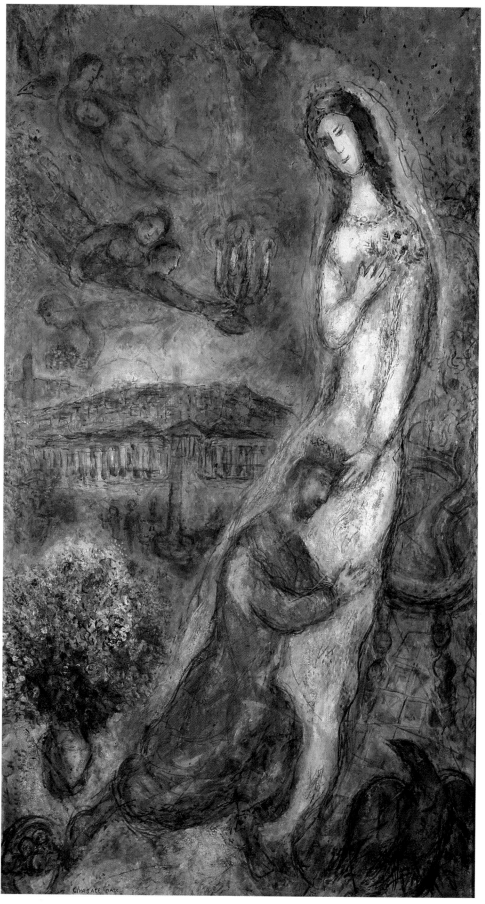

104 *Bathsheba* (1962–63)

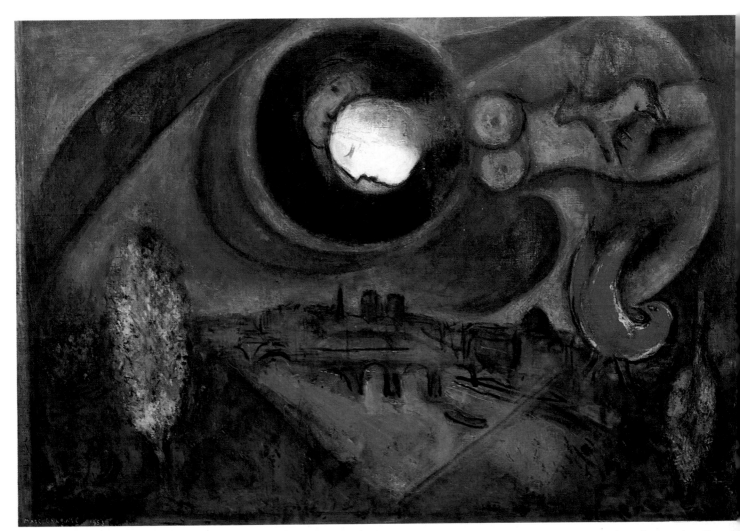

95 *Le Quai de Bercy* (1953)

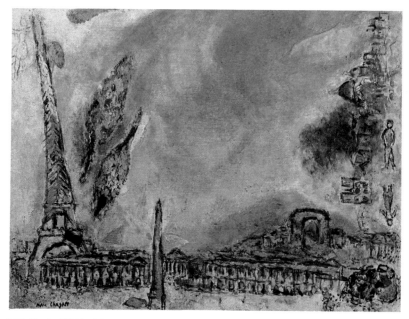

102 *Paris* (1962–63)

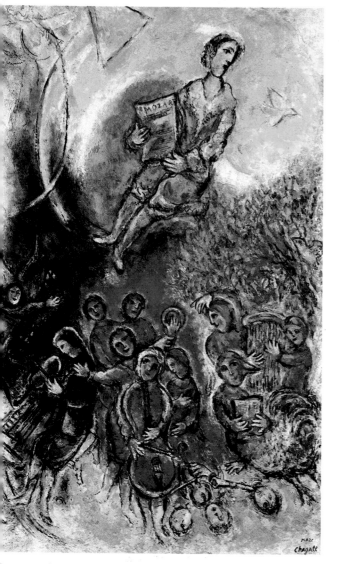

1 *Music* (1962–63)

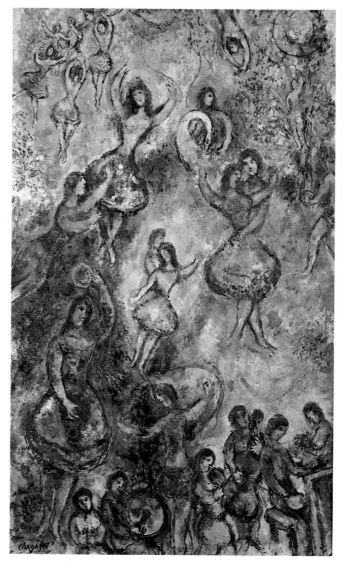

100 *Dance* (1962–63)

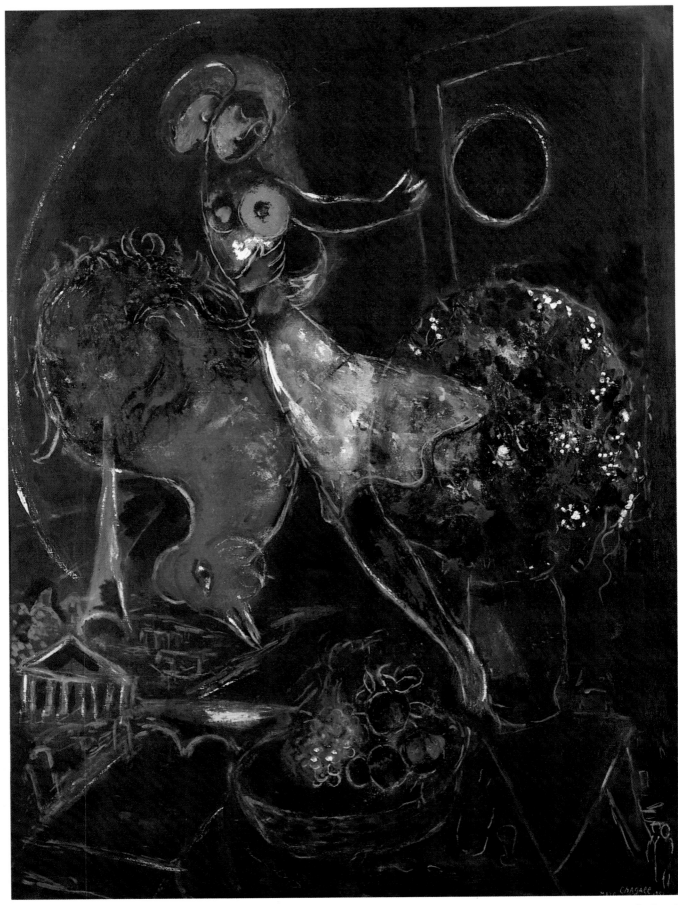

94 *Night* (1953)

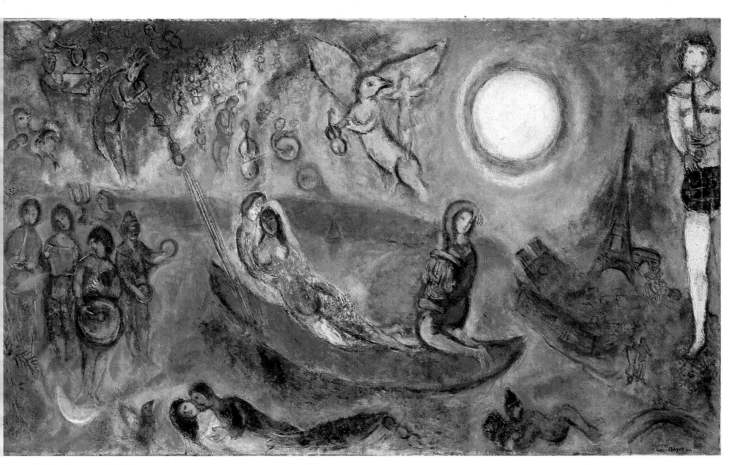

98 *The Concert* (1957)

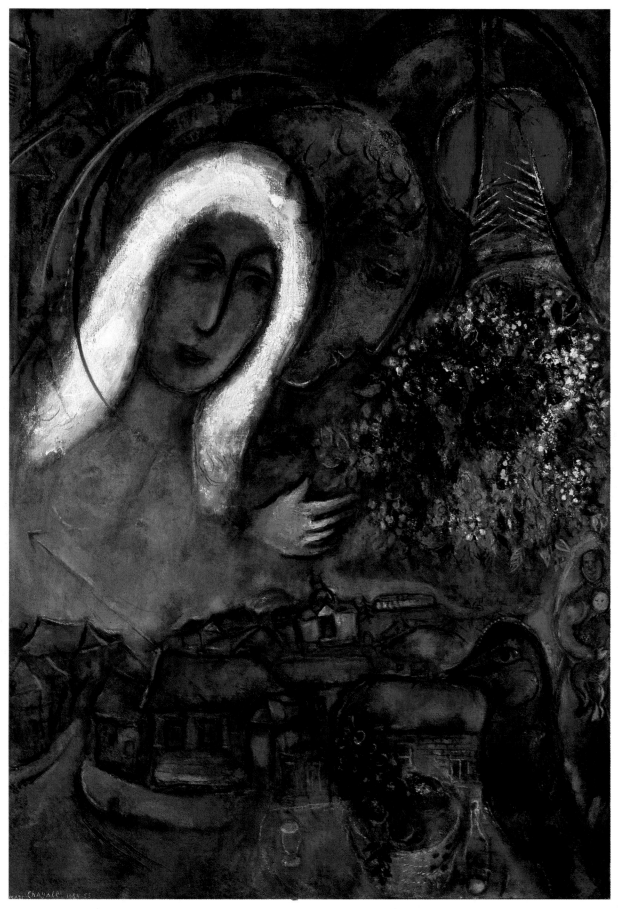

97 *Le Champ de Mars* (1954–55)

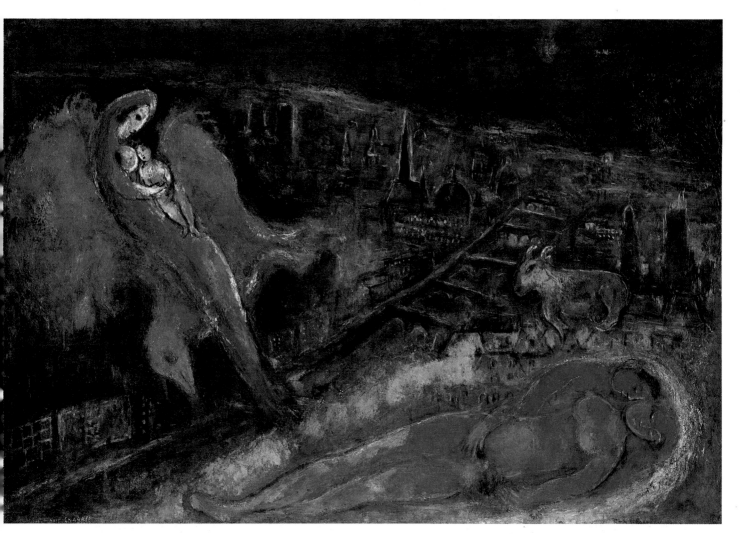

96 *Bridges over the Seine* (1954)

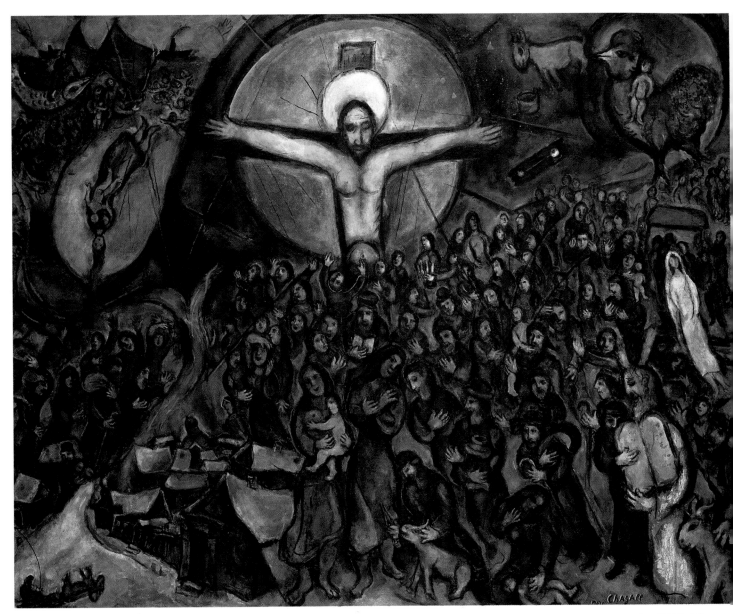

105 *Exodus* (1952–66)

132

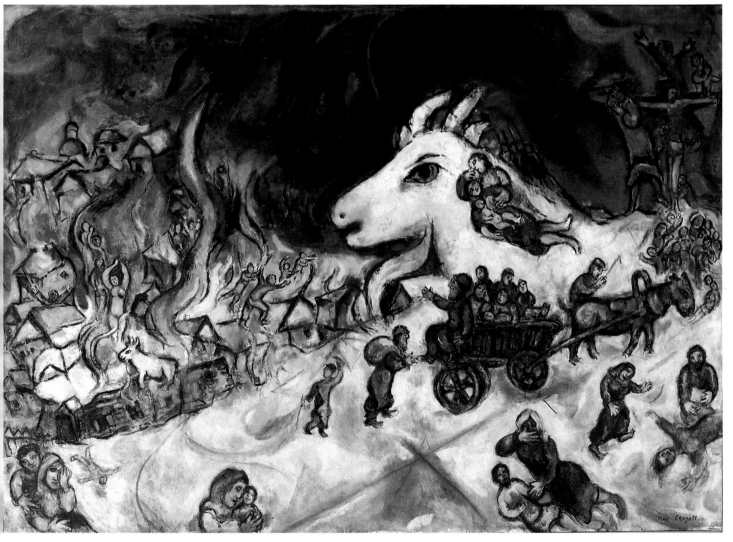

107 *War* (1964–66)

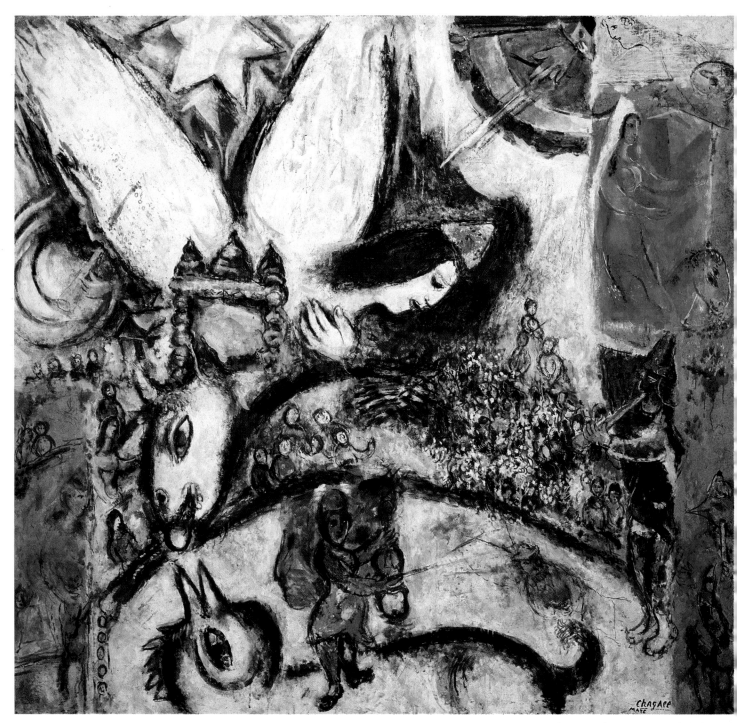

110 *The Large Circus* (1968)

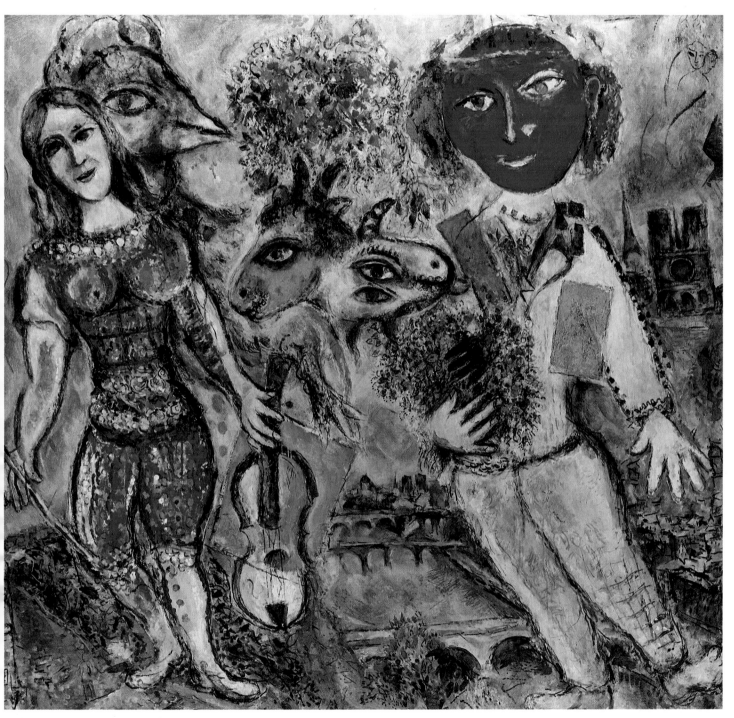

109 *The Players* (1968)

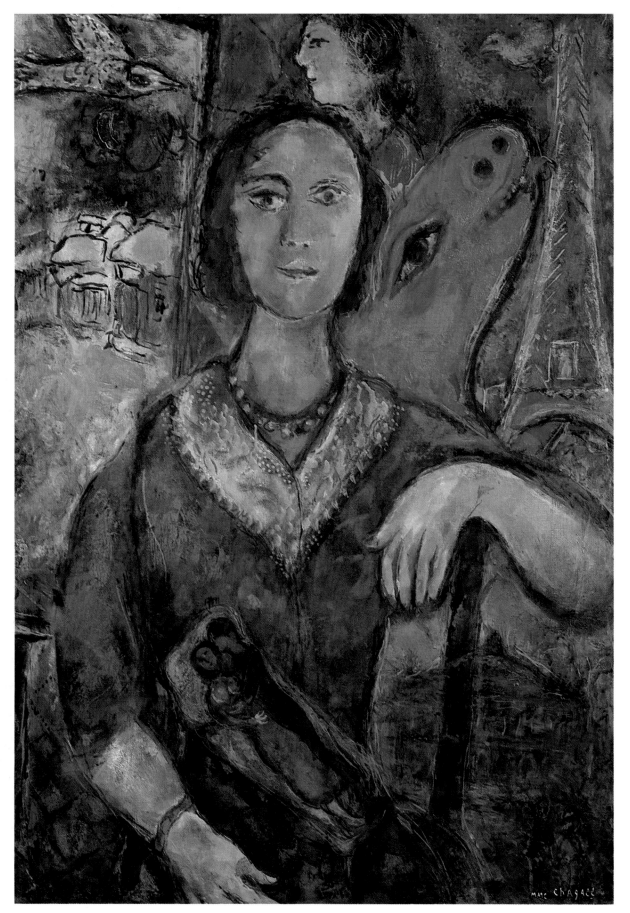

108 *Portrait of Vava* (1966)

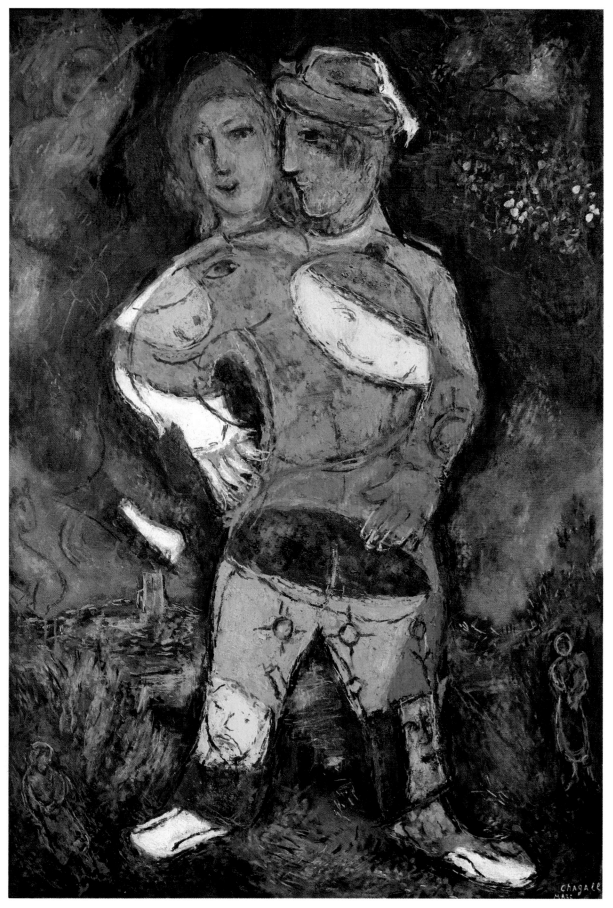

112 *The Walk* (1973)

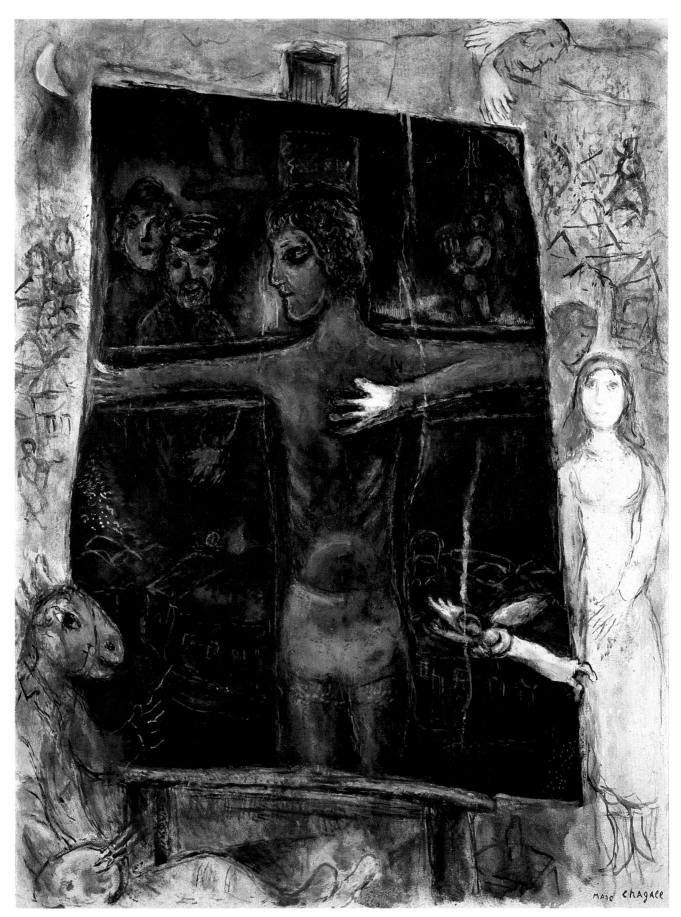

111 *In Front of the Picture* (1968–71)

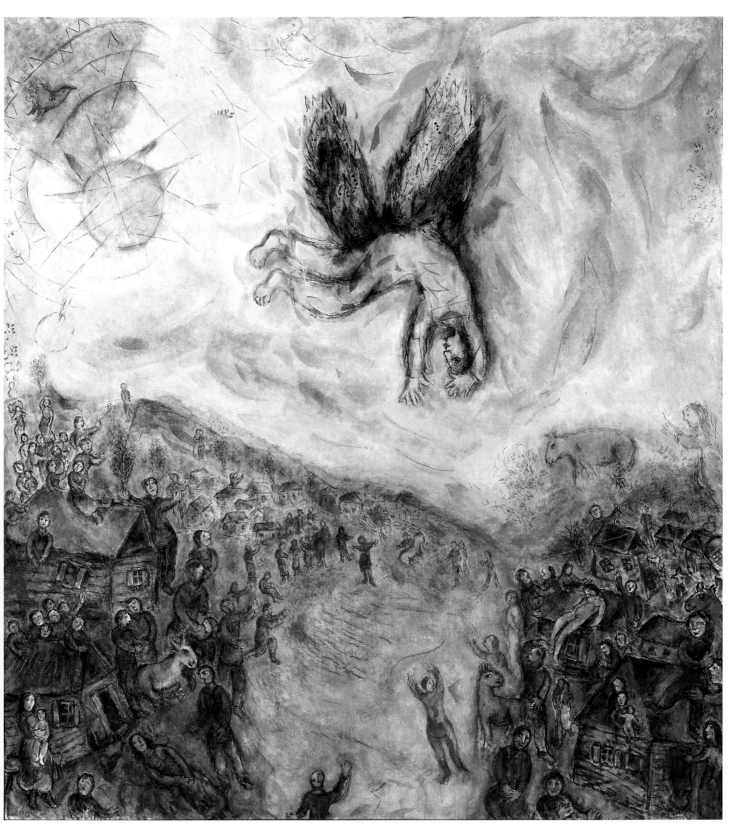

115 *The Fall of Icarus* (1975)

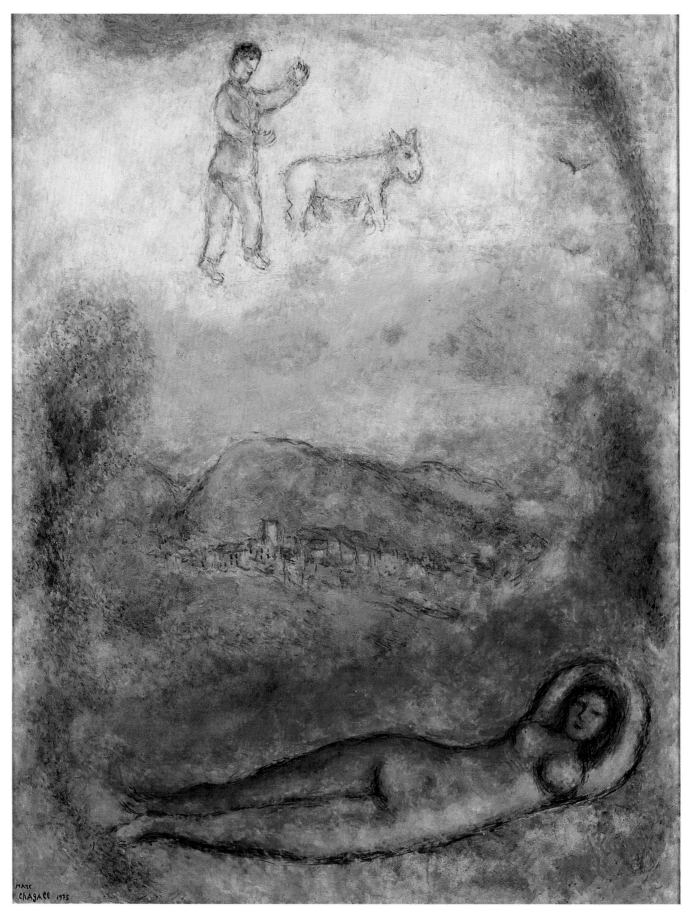

113 *Rest* (1975)

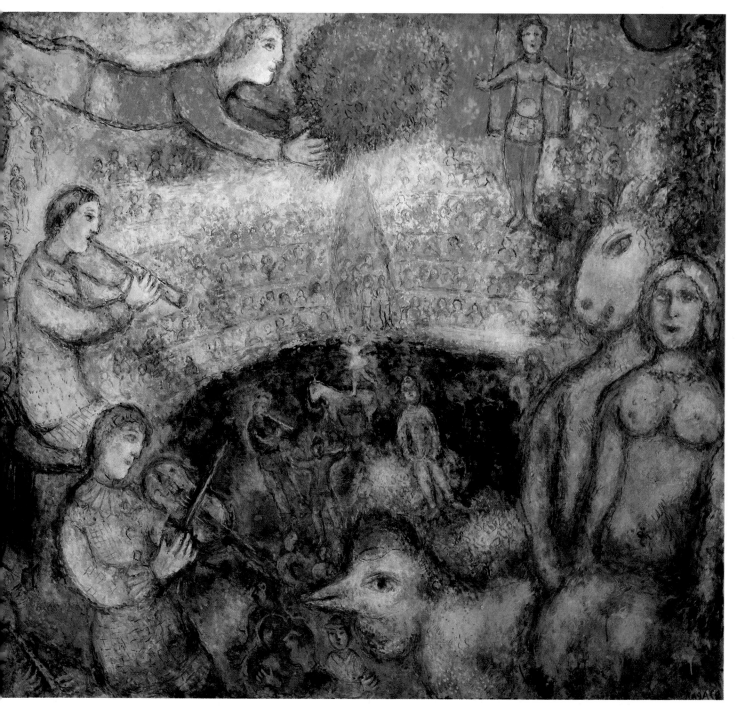

121 *The Grand Parade* (1979–80)

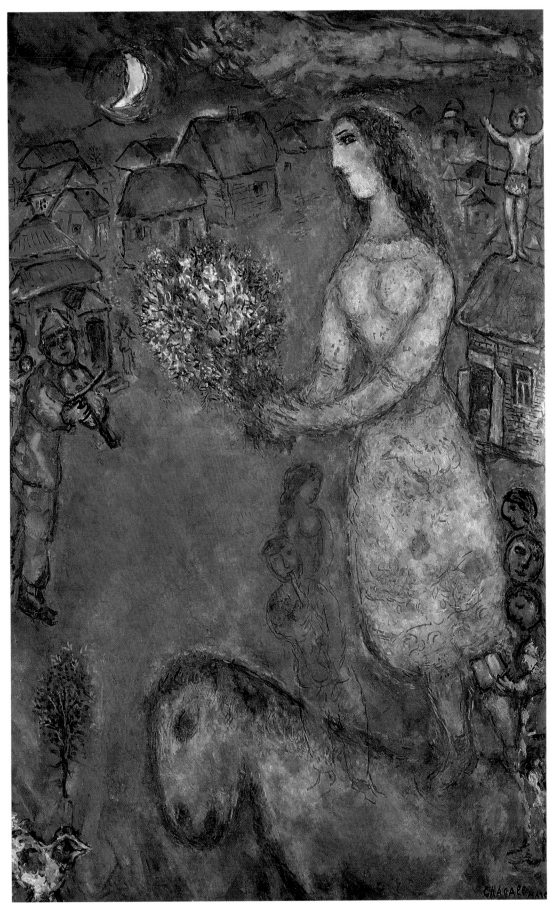

117 *Fiancée with Bouquet* (1977)

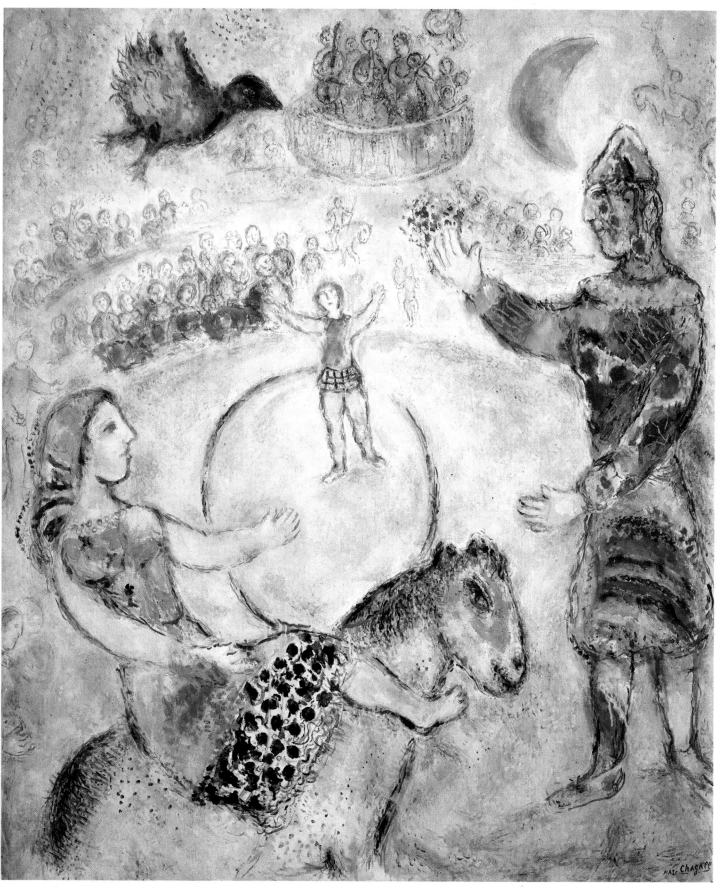

116 *The Large Grey Circus* (1975)

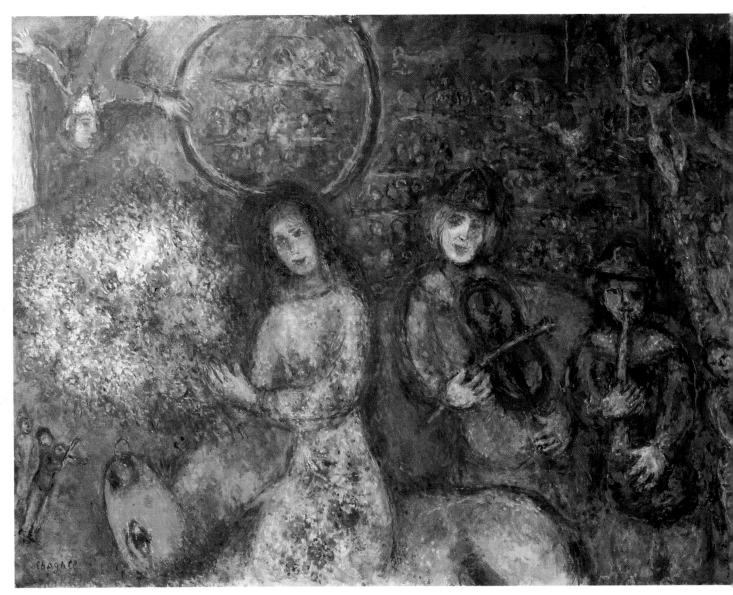

120 *Musicians* (1979)

144

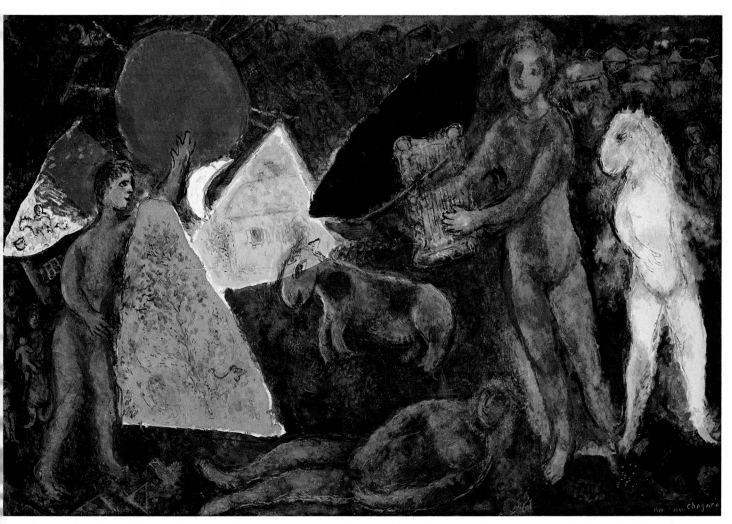

118 *The Myth of Orpheus* (1977)

122 *Peasants by the Well* (1981)

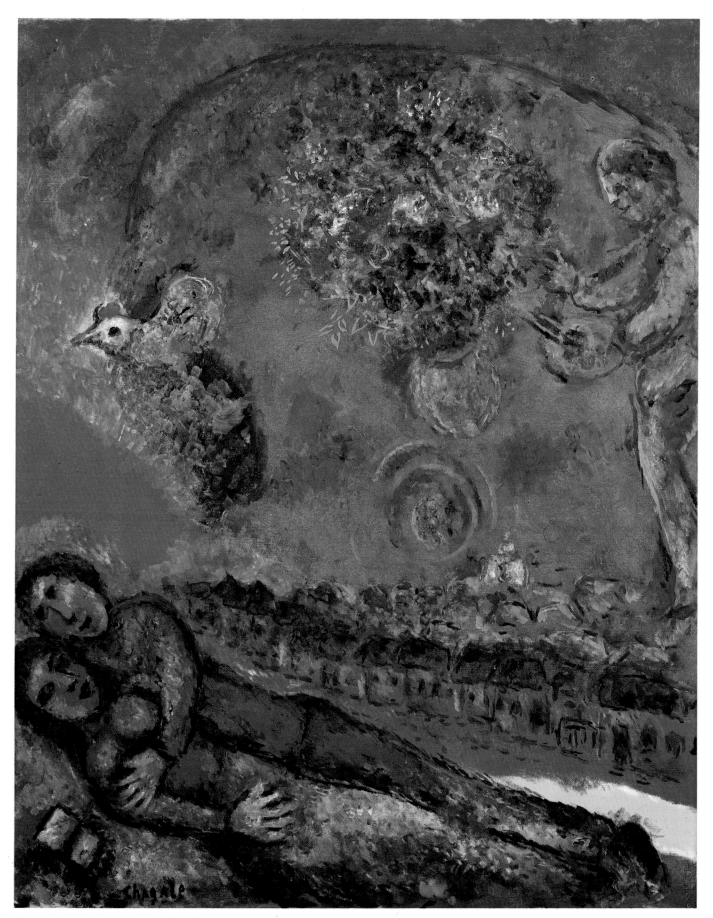

123 *Couple on a Red Background* (1983)

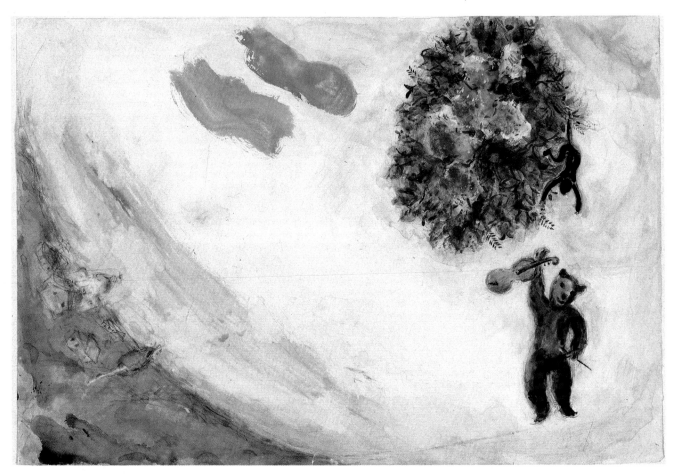

129 *The Carnival* for *Aleko* scene II (1942)

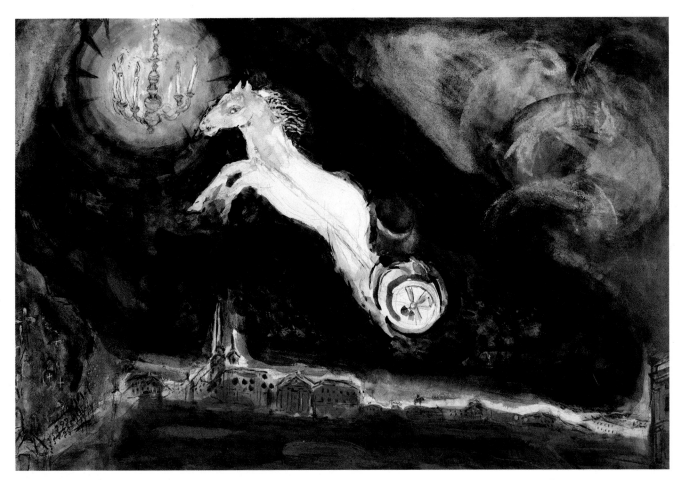

127 *A Fantasy of St Petersburg* for *Aleko* scene IV (1942)

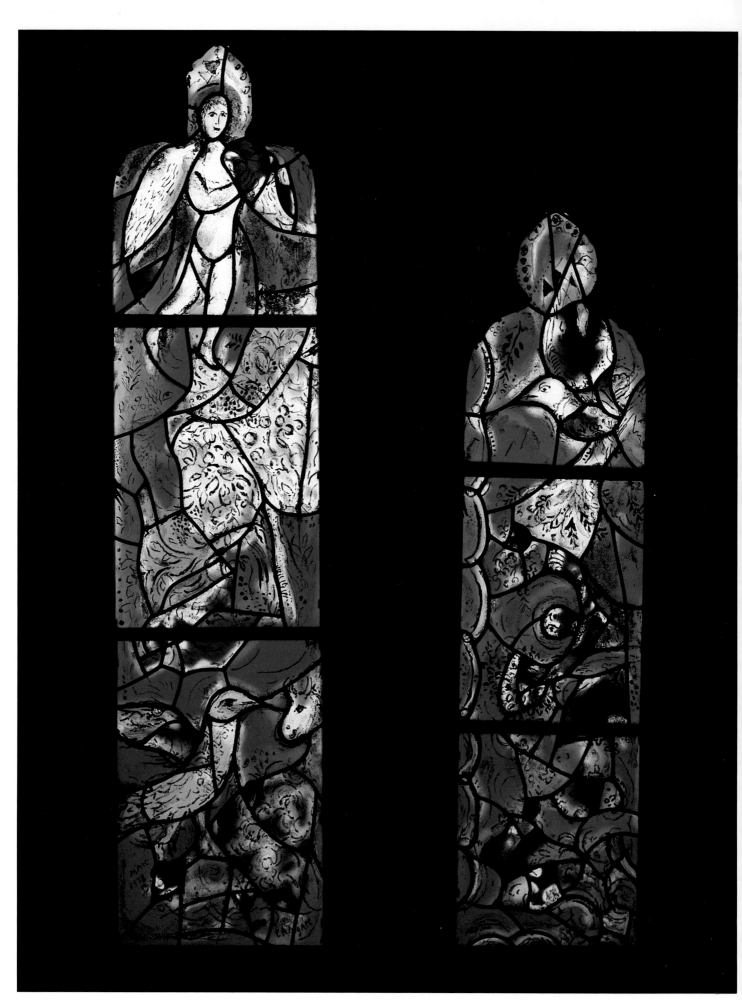

149, 150 All Saints Church, Tudeley, Kent: Two windows for the north side of the chancel (1978)

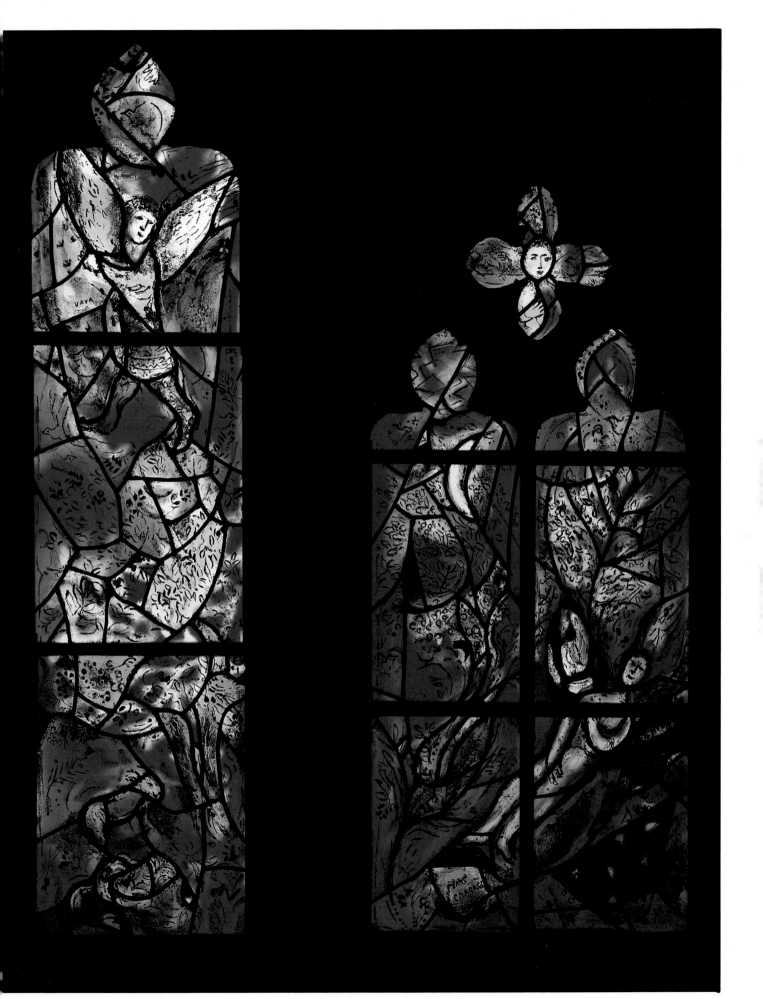

151, 152 All Saints Church, Tudeley, Kent: Two windows for the south side of the chancel (1978)

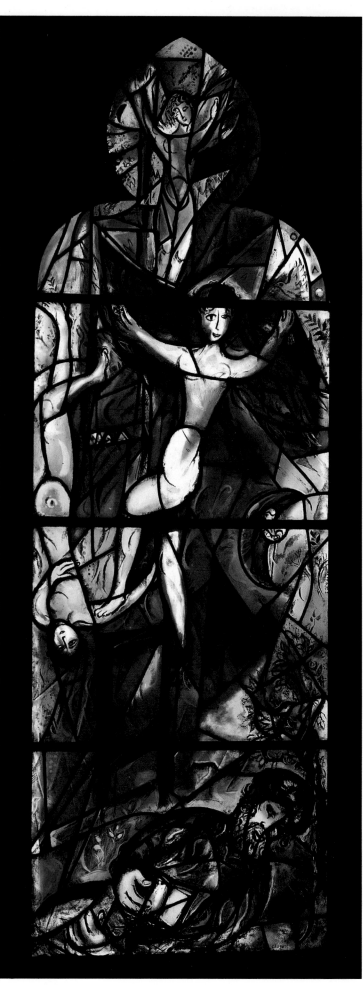

141 Metz Cathedral: Jacob's Dream, trial window (1962)

All the phrases about so-called 'pure art' and about bad 'literary' art have quite easily led to the very shaky positions of these last years. Lack of 'humanism' in art—don't be afraid of that word—was a sinister presentiment of a sinister present. The example of the great schools and the great masters of the past teach us that a true and genuine quality in painting are not in harmony with the antihuman tendencies displayed in certain works of the so-called 'avant-garde' schools.

Before the war of 1914, I was accused of falling into 'literature'. Today people call me a painter of fairy tales and fantasies. Actually, my first aim is to construct my paintings architecturally—exactly as the Impressionists and Cubists have done in their own fashion and by using the same formal means. The Impressionists filled their canvases with patches of light and shadow; the Cubists filled them with cubes, triangles, and cones. I try to fill my canvases in some way with objects and figures treated as forms . . . sonorous forms like sounds . . . passionate forms designed to add a new dimension which neither the geometry of the Cubists nor the patches of the Impressionists can achieve.

Chagall, from a speech at Holyoke College, 1943, published in English translation in *The Works of the Mind* ed. R. B. Heywood, Chicago, University of Chicago Press, 1947, pp. 34, 35.

St Petersburg

1907–10

Often overlooked, the years which Chagall spent in St Petersburg as an art student were of the first importance in shaping his outlook as a Russian artist. From these years there survive portraits of himself and his family (Cat. 4, 5) in varying styles which indicate some of his artistic interests; several of them must have been painted on his visits to his home town, Vitebsk. In addition, a number of oil-paintings of narrative subjects demonstrate his precocious talent as a highly individual artist. These form a major series of pictures of themes which, although not altogether unusual at the time, are treated in a distinctive and original manner. They point to a certain background in St Petersburg, for a change of direction took place in those years amongst writers who were closely connected with artists. In particular, the poet Blok and the philosopher Ivanov were influential, as is discussed here in individual catalogue entries (Cat. 10, 27) and in 'The Russian Background' (p. 34); they belonged to the Russian Symbolist movement which was especially strong in the capital.

In the West today, most of the general knowledge of Russian avant-garde art of these years is centred on Moscow-based artists, many of whom had exhibited at the Symbolist Blue Rose exhibition in 1907. Although Chagall would not have visited that Moscow show (for as a Jew he was unable then to travel freely in Russia), a picture like his *Birth* (Cat. 10) of 1910 can be seen as his reaction to the stylised and mystical treatment of the subject by that earlier group of artists. Indeed the factual approach in Chagall's narrative works, such as *Russian Wedding* (Cat. 9), point to a little-known literary counterpart: the symbolic realism of Andreev and Remizov. Chagall's work is by no means an illustration of the work of these writers, but it forms a visual parallel to their literary style. A similar approach is rarely to be found among contemporary Moscow artists (such as Larionov and Goncharova), and thus Chagall's pictures may seem totally unrelated to theirs. Nevertheless, it should also be seen in the context of the work of his teachers at the Zvantseva School (where he studied from late 1908 until 1910), particularly that of Dobuzhinsky, who is discussed in 'The Russian Background' (p. 33).

There is a further characteristic in Chagall's work from St Petersburg, which is entirely personal to himself: it can be connected with his Jewish background. *The Family or Maternity* (Cat. 8) displays a type of humour which would have been particularly appreciated amongst Chagall's enlightened Jewish patrons. It was largely due to their encouragement and generosity that this boy from Vitebsk was enabled to remain in the capital, for in those days a Jew from the Pale of Settlement (the limited areas where Jews were permitted to live) needed a permit to change his place of residence. Chagall at one time acquired this by nominally working as a footman to a wealthy Jewish household.

There came a time when he wanted to experience at first hand the new art of France which he had seen so far only in reproduction. He asked his painting teacher, Bakst, to allow him to paint scenery for the ballet *Narcisse* (planned for the 1911 season of Diaghilev's 'Les Ballets russes'). However, although Bakst evidently allowed him to try, his attempts did not prove satisfactory and it was finally his patron, Max Vinaver, who agreed to pay his fare and a monthly sum sufficient to enable him to go to Paris.

1 reproduced in colour on p. 52

1

Young Girl on a Sofa (Mariaska) 1907

Jeune fille au divan (Mariaska)

Oil on canvas
$29\frac{1}{2} \times 36\frac{1}{2}$ in/75 × 92·5 cm
Private Collection

Against a harmoniously arranged setting, Chagall has persuaded his young sitter to pose for this striking portrait. He has carefully arranged her head against a cool background, leaving only a small interval of grey before exploiting the coloured wall-covering. On this he has painted a bouquet of contrasting green leaves with flowers of a similar but deeper hue, whose warmer tones set off the girl's pale skin. He has further arranged a patterned material to form a dark foil with a gently curving silhouette. While these contours suggest a Whistlerian approach, the girl's figure is unexpectedly awkward, her pose conveying immaturity and innocence: Chagall has intentionally distorted the arrangement of her crossed legs, exaggerating the gaucheness of a child. For if 'Mariaska' is an affectionate name for his youngest sister Marussia, she would have been about six years old in 1908, the date Meyer gives to this portrait (p. 75). The jaunty hat, perched on her head, is rather like the soft beret that the artist sports himself in *Self*

Portrait with Brushes of 1909 (Cat. 4). Perhaps he encouraged his sitter by allowing her to dress up in his own cap.

The picture was no doubt painted the year that Chagall entered Bakst's school, but he still relies on the black outlines which Bakst discouraged his pupils from using. It makes an interesting counterpart to *The Artist's Sister (Mania)* (Cat. 5) of 1909, where the light background behind the girl is completely covered by a pattern. In that portrait he seems to have had difficulty depicting his sister's hands: in this earlier one he has picked one of the flowers from the vase and given it to his model to hold, so that it both provides a colour accent against her dark dress and allows him to avoid representing her hands. The portrayal of the legs is furthermore completely generalised, which adds an affectionate note as well as suggesting the naïvety of youth.

2

Village Fair 1908

La kermesse

Oil on canvas
$26\frac{3}{4} \times 37\frac{3}{8}$ in/68 × 95 cm
Pierre Matisse Gallery, New York

This picture portrays a remarkable scene of activity in some small town or village street. The canvas is divided into three zones: the background is dominated by figures from a village fair, hence the title; the middleground shows a procession of mourners following a coffin; and in the foreground the incongruous figure of a harlequin is in the process of raising himself from the ground, holding a lamp in his right hand, which he lifts up as though better to light the mysterious events. The scene is set in a sunset glow against which two acrobats perform their feats.

On the left side of the canvas, silhouetted against the sky, is a man standing on his hands, while towards the right side is another acrobat, carrying a parasol; next to him is a typical fairground booth. Surprisingly, in the centre-left of the picture, a couple stand on a balcony decorated with a flag: the woman empties water from a bowl down into the street, as though the dismal procession below were not mourners wailing but drunkards disturbing the air with their shouts. This curious scene, composed of elements of gaiety and sadness, epitomises the wry humour of the artist, who throughout his life has seen the fairground as a paradigm of life on earth.

A similar subject had been explored in a new stage production, the winter that Chagall had arrived in the capital. It continued to be of interest, for the artist Sapunov made a painting of the décor in 1909 (reproduced in *Apollon*, 4, 1914). It was a one-act drama, *The Fairground Booth (Balaganchik)* written by Alexander Blok, whom Chagall described in *My Life* as 'a poet of rare and subtle talent' (p. 94). Blok had based his play on *commedia del'arte* characters and the entire plot entwines the real and the imaginary. As well as Pierrot, Harlequin and Columbine, the cast includes 'mystics' who comment on the action.

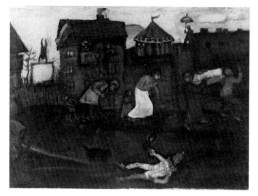

2 reproduced in colour on p. 54

However, 'the author' is given a part and at intervals he pushes his way onto the stage and begins to accuse the actors of distorting his intentions by dressing in clowns' clothes and acting out some legend instead of a 'real' play. Near the end, a clown tries to play a trick on a pair of lovers who retaliate by striking him on the head with a sword: cranberry juice runs out, parodying death; after feigning collapse, the clown runs off the stage.

Chagall's scene is like a tableau from a sequel to the play: his foreground clown takes the place of a prompter in his box, as it were holding up a single footlight to illumine the drama. His fellow entertainers are condemned continually to balance on the thin line which divides life from death. He has made a commentary on Blok's theme (itself borrowed from the puppet-shows traditionally played in the Lenten carnival season in St Petersburg): death is real, but who is death and when will he choose to come?

In this early narrative, Chagall takes a new approach to subject-matter in painting; he suggests a story, even one that contemporary viewers would have recognised, but he has made a vision of the human condition, poised somewhere between life and death, laughter and tears.

3

The Dead Man 1908

Le mort

Oil on canvas
$27\frac{1}{8} \times 34\frac{1}{4}$ in/69 × 87 cm
Collection of the artist

This astonishing picture is the culmination of a series of narrative compositions which Chagall completed in St Petersburg. It was shown at an exhibition, held in the offices of the journal *Apollon* in 1910 by pupils at the Zvantseva School (a cartoon is reproduced by Meyer, p. 28 with *The Dead Man* caricatured on the left).

In contrast to *Birth* (Cat. 10) the artist has chosen an outdoor scene, devoid of the crowd which presses its way into the room of that indoor fantasy. Here, the strangely evocative street lit by the breaking dawn, or by the white night of a northern summer, is peopled only by a mourning

woman, barely watching over the corpse. Round him, as V. Marcadé notices, are the customary candles, the symbol of his soul; it is not clear who is keeping watch over the body, day and night, so that the impure force, *Klipa*, cannot enter him, for until the local assembly of important Jews give their authorisation, he cannot be buried (p. 228).

In 1959 Chagall himself explained how the picture came about: at the home of a pupil to whom he gave painting lessons, he was struck by the strangely deserted street outside the window, and wondered how he could paint the air of desolation and impending tragedy. He realised the inadequacy of naturalistic methods but was repelled by literary allegory: 'How could I paint a picture, with psychic force but without literature? How could I compose a street as black as a corpse but without symbolism?' He has achieved his ends by treating the street rather in the way in which it was seen by masters of the Russian folk print (fig. 19). He has added over life-sized figures, whose actions unexpectedly jolt the viewer: the wailing woman, with her striking green and white clothes, leans away from the scene of disaster towards a figure escaping between the houses.

Behind her the road sweeper continues his task, apparently oblivious of the scene; likewise, on the roof, a fiddler, half-way between earth and heaven, unconcernedly makes his music.

Rational explanations might be proffered, beginning with quotations from *My Life* (pp. 65–6); yet the magic of the scene and its disturbing quality rest in its wholly illogical nature, which nevertheless, as in *Birth*, is contained by a remarkably geometric compositional structure. Although not a literary allegory, it is a symbolic painting, the 'real' symbol of death being more explicit here than in *Village Fair* (Cat. 2). That picture has been discussed here as a postscript to a play, but the dramatic quality of *The Dead Man* evokes the culmination of some drama—a Theatre of the Absurd many years before its time.

REFERENCES
V. Marcadé, *Le Renouveau de l'art pictural russe 1863–1914*, Lausanne, L'Age d'Homme, 1971; *Marc Chagall*, Musée des Arts Décoratifs, Paris, 1960, p. 128, quoted by Meyer, p. 64.

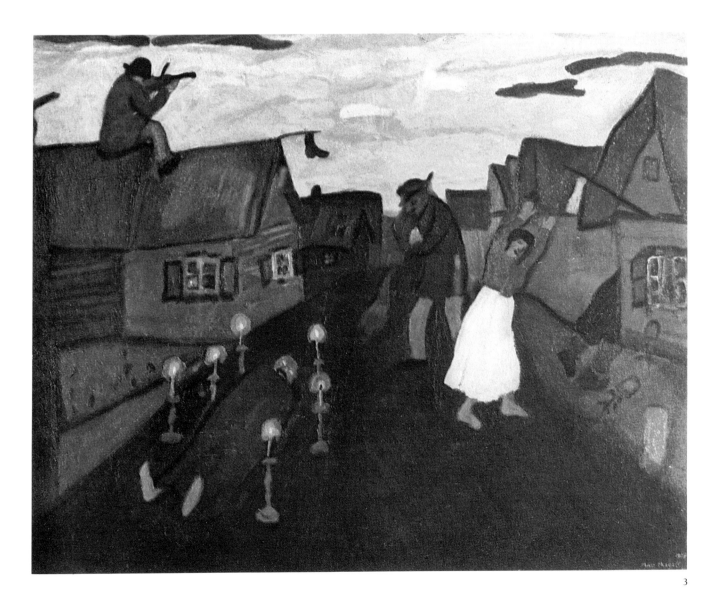

3

4 reproduced in colour on p. 49

4

Self-Portrait with Brushes (1909)

Autoportrait aux pinceaux

Oil on canvas
$22\frac{1}{2} \times 18\frac{7}{8}$ in/57 × 48 cm
Kunstsammlung Nordrhein-Westfalen, Düsseldorf

Chagall has modelled himself on some early seventeenth-century prototype, adding an ironic smile; his portrait is a study in black and grey, relieved by the white collar and flowers in the upper corner. The artist has suggested his métier by including three brushes, whose red, blue and yellow handles introduce a note of colour. He has used a coarsely woven canvas which gives an unexpected texture to the oil-painting. The young Chagall wears an extremely confident look as though he feels already established in his chosen profession. In *My Life* he recalled the difficulty with which he persuaded his mother and father to allow him to become a painter, and how from childhood he wanted to escape from the confining background of a provincial Jewish family, seeing the only way out through one of the arts.

It is difficult today to appreciate the cultural isolation of a young man from a tradition which was more renowned for music and literature than the visual arts. There were few painters from among the ranks of Jews, crowded into the eastern provinces of Russia. So the art world of St Petersburg must have come as a hard-won revelation to the young Chagall who, as a Jew, needed a permit to reside there. As well as attending art schools he visited the museums and a whole new world of the history of Western art was revealed to him. The self-satisfied expression on the young artists's face in this portrait is entirely justified, for by adopting the tradition of Western European art and beginning to master the idiom he had now progressed a long way from his schooldays when he had copied drawings from newspapers or anywhere that he could find them.

5

The Artist's Sister (Mania) 1909

La sœur de l'artiste (Mania)

Oil on canvas
$36\frac{5}{8} \times 18\frac{7}{8}$ in/93 × 48 cm
Museum Ludwig, Cologne

This picture belongs with several portraits that the artist made of members of his family, both before he left Russia for Paris and when he returned to Vitebsk in 1914 (see Cat. 7 and 11). He had a number of sisters who can be seen in family photographs taken at the time. The identification of the sitter as Mania was made by Meyer (cat. 20); she was a twin and celebrated her eleventh birthday in 1909. Unlike the larger portrait of his sister Aniuta (Cat. 11) or the study in black and white that he painted of Bella in 1909 (fig. 17), Chagall has made great play of contrasting patterns, which form an overall decorative device; especially vivid is the contrast of brilliant orange and blue.

This small portrait is more like a sketch than others by Chagall, and he has freely brushed in the blue pattern, giving it a dominant role in unifying the composition. The arrangement of the figure on the canvas is unusual: the portrait is a close-up, the frame cutting into the figure as though the artist were remembering the negatives which he was retouching in a photographic studio at the time.

5 reproduced in colour on p. 51

157

6 reproduced in colour on p. 57

6

Red Nude Sitting Up (1908)

Le nu rouge relevé

Oil on canvas
$35\frac{1}{2} \times 27\frac{1}{2}$ in/90 × 70 cm
Private Collection, London

Chagall rarely worked so closely from the figure as in this nude. Furthermore, it is unusual because he generally draws rather than models (as here). The picture is a study in brilliant crimson: the highlights on the girl's body are the lightest shade of pink, the forms are modelled in a deeper crimson, and the background is an even darker shade. This colour has been carried over the outlines so that the figure seems to be silhouetted in a striking way. The only contrast to the crimson is the patch of thin green paint, belonging to a flower-pot in the bottom right corner, near an apple distinctly outlined in blue. It is possible that the figure itself was originally treated with blue outlines in the same manner, and that the brilliant background colour was superimposed at a slightly later date. This seems all the more likely if, as Meyer says (p. 72), the nude was painted during the time that Chagall was still attending the Zvantseva school in St Petersburg. There he was taught oil-painting by Léon Bakst, who came on Fridays to criticise the students' work. Evidently he did not succeed in achieving the pitch of colour that he or his teacher wished for, since Chagall recalls a visit from Bakst once he had settled in Paris: '"Now," he said, "your colours sing" ' (*My Life*, p. 105). The crimson dominating this picture reappears in several strong paintings that Chagall made in Paris, particularly *Interior II* (Cat. 16).

Red Nude Sitting Up is one of two studies that Chagall painted from the same nude model, Thea Brachman, one of his circle of Vitebsk friends, who was studying at the time in the capital. 'Thea saw herself as a modern woman, an intellectual determined "in the service of art" to cast off middle-class inhibitions. Hence she was to outrage all the prudish ideas of Vitebsk by sitting in the nude for her friend' (Meyer, p. 72). Although there were opportunities to

draw from the nude at the Zvantseva school, Chagall apparently made this painting away from his teachers. The pose is certainly not that of a conventional life model: Meyer connects it with Gauguin's nudes, citing in particular the women in the foreground of *The Idol*, formerly in the collection belonging to Ivan Morozov. However, it is unlikely that Chagall had the opportunity to visit the famous collections of modern French art belong either to Morozov or Sergei Shchukin, for both were in Moscow and as a Jew he would have needed a permit to go there. As Meyer himself remarks, Chagall probably relied, like other students in St Petersburg, on the reproductions of Post-Impressionist pictures published in journals. Photographs of work by Gauguin were reproduced in the *Golden Fleece* (*Zolotoe runo*), 1, 1909 and *Apollon*, 11, Oct.–Nov. 1910.

7 reproduced in colour on p. 50

7

Portrait of the Artist's Sister (1909–11)

Portrait de la sœur de l'artiste

Oil on canvas
25 × 21 in/63.5 × 53.5 cm
Collection of Edward Albee, New York

This exhibition is particularly rich in portraits of the artist's family, but this is unlike the rest. Although not signed or dated, it is painted on the characteristic rough-textured canvas of the early Russian works and in the darker colour range which the artist then preferred. Compared with the decorative use of pattern in the portraits of Mania or Aniuta (Cat. 5, 11), this portrait includes a fully realised set of still-life motifs, arranged across the foreground. The flowers are particularly beautifully painted, so life-like that the individual blooms can be identified as roses. Furthermore, the artist has shown a plank table, using its lines as a perspectival device like the floorboards in *Birth* (Cat. 10). He has established a location, with the window firmly placed to one side, a device which became a favourite in pictures

such as *The Lovers* (private collection; fig. 2), or *The Soldier Drinks* (Cat. 24). But while in the last-named—which also shows a figure seated at a table—Chagall used the table-edge as a strong diagonal to divide the picture in two, here he has seen both table and sitter from a fully frontal point of view and even turned her book into the picture plane so as not to disturb the effect. It is all the more powerful because she is looking straight at the viewer. Of all the early portraits this must rank as the most unusual.

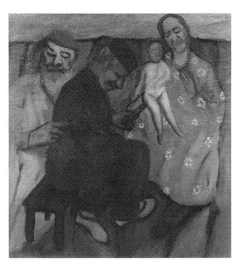

8 reproduced in colour on p. 55

8

The Family or Maternity 1909

La famille

Oil on canvas
$29\frac{1}{8} \times 26\frac{3}{8}$ in/74 × 67 cm
Private Collection

The strange group with its hierarchical composition, based on an inverted triangle, seem intent on the central figure, who is reading a book. To the right is a woman, swathed in a patterned robe, with a child perched on her knees like an emblem: on the other side is a bearded father. The smooth style of painting, the coarse canvas and the colours, link the picture with *The Holy Family* (Kunsthaus, Zurich; fig. 30) and the first version of *Birth* (Cat. 10), completed before Chagall left Russia. Aspects of these unusual compositions have been elucidated by the Israeli scholar Ziva Amishai-Maisels in terms of the Jewish in-joke. Thus the bearded child in *The Holy Family* literally illustrates a Yiddish saying, 'every Jewish child is born old', producing a child who, in terms of another Yiddish idiom, is 'debatably Jewish, debatably Christian'. A further Yiddish expression may explain the reversals and transformations: 'the other thing' is used colloquially to describe any Christian or un-Jewish element. So instead of 'They are selling pigs there', one would substitute 'They are selling the "other thing" there'. 'Thus the usual Christian elements have been switched: the

child sits not on the Virgin's knee, but on the "other thing", its father's knee. The Christ child is not a Christian child, but the "other thing", a Jewish little old man. Finally, John's symbol is not the symbolic lamb, but the primary "other thing", the unkosher pig.' (Amishai-Maisels, p. 80)

The Family or Maternity shares some of the ambiguities that can be found in *The Holy Family*; indeed, the subject was reproduced as '*Circumcision*' by Meyer (p. 74). But it has been pointed out more recently that in spite of the fact that the foreground figure might be a *mohel* reading the prayers before performing the circumcision (Meyer, p. 62), the identification is not self-evident, for the tools are missing and the child is on a woman's knee rather than that of the *sandak* or godfather. (In fact, a woman can be present at the

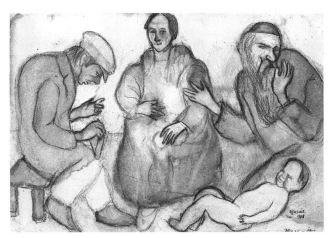

fig. 31 *Circumcision*, 1908 drawing (Private Collection)

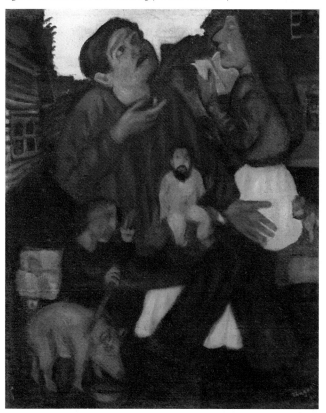

fig. 30 *The Holy Family*, 1910 (Kunsthaus, Zurich)

ceremony, but she is invariably a godmother, never the child's own mother.) If Chagall did intend the child's own mother in this picture, it could be a traditional 'Circumcision of Christ' in which Mary often holds the child. In that case, suggested by Amishai-Maisels, the bearded old man pointing to the *mohel* would be Joseph. She thinks that Chagall's choice of such a scene, symbolising the Jewishness of Jesus, would point to the artist's 'position between the Jewish and Christian world and to his attempt at this time to work out a peaceful compromise between them' (p. 79). Her interpretation is all the more plausible since a finished drawing by Chagall, including the same figures in horizontal format is far closer to a traditional 'Adoration of the Child' than to a 'Circumcision' (fig. 31).

Studying art in St Petersburg, the young Chagall immediately threw himself open to the tradition of Western art, much of it with Christian subject-matter, in the extensive collection of the Hermitage Museum. But he also admired the Orthodox tradition of ikon painting to be seen in the Russian Museum. The clash of Jewish and Christian traditions was one that had been written about in a highly sensitive way by the most famous recent Russian Jewish artist, the sculptor Antokolsky, whose letters had been published in 1905. Chagall says in *My Life* that his patrons in St Petersburg, 'dreamt of seeing me become the second Antokolsky' (p. 98).

It is noticeable that beginning in St Petersburg Chagall tackled conventional scenes of Christian iconography, such as his Crucifixion drawing (fig. 5), but he always gave them his own particular interpretation. In the case of *The Holy Family* it may be seen as a Jewish in-joke, but in *The Family or Maternity* it is more a question of coming to terms with his own position *vis-à-vis* the history of art.

REFERENCES
Z. Amishai-Maisels, 'Chagall's Jewish In-Jokes', *Journal of Jewish Art*, 5, 1978, pp. 76–93; for Antokolsky, see also her article, 'The Jewish Jesus', *ibid.*, 9, 1982, pp. 84–104.

9

Russian Wedding 1909

Le mariage russe

Oil on canvas
$26\frac{3}{4} \times 38\frac{1}{8}$ in/68 × 97 cm
Foundation E. G. Bührle Collection, Zurich

One of a group of narrative subjects, painted by Chagall before he left Russia for Paris, is this fine celebration of a Russian wedding procession. Unlike other outdoor scenes, such as *Village Fair* (Cat. 2) or *The Dead Man* (Cat. 3), this one is arranged in sharp diagonals, with the crowd moving down a hill towards the viewer, in a grouping reminiscent of those of Munch or Ensor. Some of the faces in Chagall's *Russian Wedding* are distorted in a similar way, though they are not as anguished as those of the Norwegian or the Belgian artist. Indeed, even if this connection can be made, the works of those artists can have been known to Chagall only

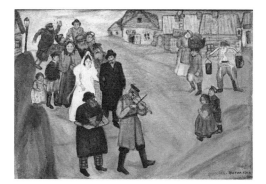

9 reproduced in colour on p. 58

in black and white reproduction, for his colour range is subdued compared with their strident colours. The manner of painting, using thin paint on a coarse canvas, is much closer to that of Gauguin, whom Chagall admired at the time: the small houses in the background are painted using the texture of the canvas to provide an imitation of thatched roofs.

As Valentine Marcadé has pointed out, the scene includes allusions to everyday life, and although the title is *Russian Wedding* the procession is led by a strolling fiddler, who would be invited to enliven the festivities of a Jewish marriage. Furthermore, a professional joker which she calls a *batkhn*, was included at such a celebration, to entertain the company with his stories, jokes and clowning: such a figure seems to be indicated by the curious posture of the prancing man who draws up the rear of the procession. He is cavorting near an illuminated street lamp which sheds a faint light on this vividly imagined scene.

REFERENCE
V. Marcadé, *Le Renouveau de l'art pictural russe 1863–1914*, Lausanne, L'Age d'Homme, 1971, p. 230.

10

Birth 1910

La naissance

Oil on canvas
$25\frac{5}{8} \times 35$ in/65 × 89 cm
Kunsthaus, Zurich

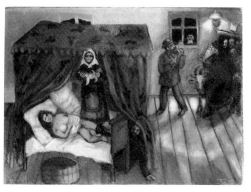

10 reproduced in colour on p. 53

This picture belongs with a series of narrative subjects, including death and marriage, which the artist painted in St Petersburg. The composition is severely frontalised, the midwife unaccountably standing next to the mother on the bed, which is turned to reveal a self-satisfied man, apparently hiding on the floor next to it. The canopy of a four-poster, with its geometric form, fills that part of the room. It is balanced by a dramatic scene in the background lit by an overhead lamp: a group of eager men push their way into the room, bringing a cow, while their leader seems to beg them to be silent. The cow intrudes in the masculine half of the composition just as the man under the bed curtain does in the feminine.

Chagall has depicted the room with foreshortened floorboards in the manner of a scene by van Gogh, whose *Le café de nuit* had been shown in Moscow in 1908 (at the Salon of the Golden Fleece: it was owned by the collector Morozov). But he has chosen a sombre palette and the manner of painting on the coarse canvas is more like that of Gauguin, whose work he said he admired at the time. Furthermore, the features of the women's faces are barely defined, which connects the picture to *The Holy Family* (fig. 30), but *Birth* is based much more closely on fact: Chagall's mother had regularly given birth and according to the artist, when she saw the picture she suggested that he add a bandage round the stomach of the newly delivered woman (*My Life*, p. 95). It was usual at the time for Jewish women to be girded with the band from the Torah scroll if labour was difficult. Furthermore, when a male child was born it was a popular custom for a vigil to be mounted every night. Friends and relations would gather at the home of the newborn to recite a prayer to protect the child from demons.

In choosing the subject and depicting it in a theatrical way and with a manner of composition that is almost classical, Chagall turned his back on a recent Russian celebration of birth. As a symbol of mystical union with the universe, it had been a popular theme for the avant-garde Blue Rose group, which had flourished in Moscow from 1906–08; even Malevich, under that influence, had painted his *Woman in Childbirth* of 1908 (George Costakis Collection, no. 478) which he treated in a purely stylised and symbolic way. Although it is very unlikely that Chagall knew that picture, he would have been acquainted with the Blue Rose aesthetic, for the poet V. Ivanov, who inspired the Group, lived in the same building as the Zvantseva school. But Ivanov's recent writing had stressed the need for an artist to adopt a more pragmatic approach to his symbols, by not using arcane references but 'real symbols'. He suggested using objects of everyday reality in order to 'enable us to become aware of the inter-relationship and the meaning of what exists not only in the sphere of earthly, empirical consciousness, but in other spheres too'. This quotation is from Ivanov's essay, 'Two elements in contemporary symbolism', first published in the journal *The Golden Fleece* in April and May 1908 (and reissued in the collection *By the Stars* of 1909). Ivanov even mentioned birth there: 'as a midwife eases the process of birth, so should [the artist] help things to reveal their beauty . . .', an image remarkably apt for Chagall's *Birth*.

REFERENCES
A. Zander Rudenstine (ed.), *Russian Avant-Garde Art, The George Costakis Collection*, London, Thames and Hudson, 1983; J. West, *Russian Symbolism: A Study of Vyacheslav Ivanov and the Russian Symbolist Aesthetic*, London, Methuen, 1970, pp. 50–51.

11 reproduced in colour on p. 56

11

Portrait of the Artist's Sister (Aniuta) 1910

Oil on canvas
$36\frac{1}{4} \times 27\frac{5}{8}$ in/92·5 × 70 cm
The Solomon R. Guggenheim Museum, New York

Aniuta was the eldest of Chagall's sisters, two years younger than himself, aged twenty in 1910 when he painted her portrait just before he left Russia for Paris. Compared with the contemporary portraits (Cat. 5 and 7), this is a large canvas; the pose is not unlike the portrait entitled *My Fiancée in Black Gloves* (fig. 17) of the year before. In this instance, however, he has given only the sitter's left arm that expressive position, a hand on hip and the elbow cut by the picture frame. He has here explored an area of light-coloured background round the figure, leaving a comparatively large pale area, dominated only by the silhouette. Although this is not very typical of Chagall's work, it is unusual in the context of the Russian portrait of those years for he has given less attention to *matière*—the brushmarks and surface of the canvas, which is a hallmark of so many conventional Russian portraits of the decade. Chagall took the canvas with him to Paris, presumably expecting to exhibit it, although the first time it is known to have been shown was at Der Sturm in the artist's one-man exhibition of June 1914.

REFERENCE
A. Zander Rudenstine, *The Guggenheim Museum Collection Paintings 1880–1945*, vol. I, pp. 54–56.

Paris

1910–14

fig. 32 Chagall in front of *The Studio, c.* 1911

Thanks to his years in St Petersburg, Chagall arrived in Paris with a considerable experience of the art world. He had already completed pictures such as *Birth* (Cat. 10), an outstanding technical and inventive achievement for a young man who was little more than twenty years old.

He was able to rent the studio of a painter-cousin of the writer Ilia Erenburg, letting the second room to a 'copyist' which helped to pay the rent. After one year he had leapt ahead both in imagination and the scale of his work, for he exhibited three works at the Salon des Indépendants of 1912. By the time that exhibition opened, Chagall had moved to a cheaper studio in La Ruche, near the slaughterhouses of Vaugirard. Other artists living there were predominantly from abroad (though Léger had stayed there in 1911). The atmosphere was cosmopolitan and bohemian. Chagall kept up his Russian connections by attending the studio which Le Fauconnier took over in February 1912 at a school named La Palette. (With his Russian wife Le Fauconnier attracted a number of Russian students, including Popova and Udal'tsova, in the winter of 1912–13.)

In his new studio Chagall embarked on an amazing series of paintings. He was recommended to the Salon d'Automne in 1912 by Le Fauconnier and Robert Delaunay and showed a now lost picture, *The Herdsman*; with *Golgotha* (see Cat. 27) and a new version of *The Dead Man* (now lost; see Meyer, cat. 66). A few months later he exhibited again at the Salon des Indépendants, where *Birth* 1911 (Cat. 18) was on view with *Adam and Eve* (Cat. 26). The latter reveals the influence of another teacher at La Palette, the Cubist-theorist, Metzinger. In March 1913, while that exhibition was on view, Chagall was introduced by the poet Apollinaire to the dealer Herwarth Walden, whose gallery in Berlin was an outstanding location for the exhibition of contemporary art. Walden invited Chagall to contribute to his First German

Autumn Salon, modelled on the Paris Salon d'Automne. The exhibition took place in September 1913 and was a truly international affair, including artists from fifteen countries. Chagall travelled to Berlin with his friend the poet Blaise Cendrars for the opening. In Berlin there were important pictures sent by the Munich Blaue Reiter group, including works by Kandinsky and Franz Marc. (Chagall's own paintings on view were his *Golgotha, Dedicated to my Fiancée*, fig. 33, and *To Russia, Donkeys and Others*, fig. 23.)

By the following year Chagall had achieved such prominence that his pictures were shown not only in Paris, but in several other European capitals. In the spring he showed *The Fiddler* (Cat. 34), *Self-Portrait with Seven Fingers* (fig. 8) and *The Pregnant Woman* (fig. 12), pictures which were subsequently exhibited in Amsterdam where they were bought by a collector. He also contributed to an exhibition in Brussels where he showed two decorative pictures of women in company with work by, amongst others, Giorgio de Chirico.

These works, named in exhibition catalogues and sometimes reproduced, give some idea of the probable course of Chagall's remarkable development in Paris. His meteoric rise to fame, with such outstandingly inventive paintings, would have given him a place in the annals of contemporary European art even if he had never returned to France. He worked out his own response, both to the Cubism of Picasso and Braque and to styles of those who were his personal friends.

Among them, priority must be given to Delaunay and his Russian wife, Sonia Delaunay Terk, and the poets who were their friends also. Blaise Cendrars deserves special mention; he was a young Swiss writer who had spent some time in St Petersburg. As well as creating a poem about Chagall, he apparently provided titles for a number of his paintings (including *I and the Village*, Cat. 19). Chagall moved in literary circles; in *My Life* he mentions André Salmon, Max Jacob, and Canudo (who edited *Montjoie!*) and a large circle of artists whom he met at gatherings at Canudo's home (p. 110). However, he reserved the epithet 'gentle Zeus' for Apollinaire, the poet and critic (with a Russian-born mother) who helped to promote the avant-garde in those years. He, too, dedicated a poem to Chagall, which was first published by Walden in 1914 on the occasion of Chagall's large one-man exhibition which was the climax of his years in Paris.

Chagall went to Berlin again for the opening of this exhibition, where he showed nearly all the major oil-paintings that he had completed in Paris, together with the *Portrait of the Artist's Sister Aniuta* (Cat. 11) which he had brought with him from Russia. There is no catalogue of this exhibition, but in 1923 Walden published his *Sturm Bilderbücher* no. 1 devoted to Chagall's work; this provides a record of some of the major pictures on view. Outstanding among these was *Homage to Apollinaire* (Cat. 22). But he also

showed a marriage of Cubism and traditional ikon painting in his profoundly Slav *I and the Village* (Cat. 19).

Moreover, it appears that during his last year in Paris he explored his relationship with his homeland, not simply by painting evocative scenes from provincial Russian life (for instance, *The Violinist*, Cat. 36). He began to rival the ikon tradition in his extraordinary *Pregnant Woman* and even referred to political events in an entirely original way, as in *The Fiddler* (Cat. 34). At the same time he painted *Lovers* (fig. 2), one of the most abstract pictures of his career, although, interestingly, he left it behind in Paris.

Chagall applied to the Russian consulate in Paris for a three-month permit to visit Russia after the opening of his exhibition in Berlin. He recalled in *My Life* that he wanted to go to his sister's wedding and to see Bella again (p. 115). Little did he know, when he set out on that fateful train journey across Poland to Vitebsk, that it would be nine years before he saw Paris again, or that he was saying goodbye to the work into which he had poured all his creative powers during those four fecund years.

(Adrian Hicken has helped with the catalogue entries in this section.)

12 reproduced in colour on p. 59

12*

The Model 1910

Le modèle

Oil on canvas
$24\frac{3}{8} \times 20\frac{1}{4}$ in/62 × 51·5 cm
Collection of Ida Chagall, Basle

According to Meyer, *The Model* was one of the earliest pictures that Chagall completed after his arrival in Paris, and he painted over an old picture which was cheaper than a new canvas (p. 95). The canvas reveals the thick underpainting which became a characteristic of the Paris work, but in this case the artist was still using the darker tonalities that for the most part he had preferred before he

left Russia. It must have been painted in Chagall's studio in the Impasse du Maine since the furnishings resemble those in the slightly later *Studio* (artist's collection; fig. 32). *Studio* is remarkable for its Matisse-like colour, with large areas of the room painted over in bright green, while in *The Model* Chagall has concentrated on patterns in the room, rather as he had done in *Portrait of the Artist's Sister (Mania)* (Cat. 5). Here he has begun to use a new approach to large areas of paint by applying it with broader brush strokes, thus achieving a new play with texture, partly achieved by the impasto underneath. Unusually, the model is herself engaged in painting a picture and this has given Chagall the opportunity to introduce more pattern into his canvas. This is a very interesting transitional work, linking his Russian colouring to the new painterly methods he developed soon afterwards in Paris.

13

Woman with a Bouquet (1910)

Femme au bouquet de fleurs

Oil on canvas
$25\frac{1}{4} \times 21$ in/64 × 53·5 cm
Collection of Helen Serger

The portrayal of this eager-faced woman is in direct opposition to the *Bride with Fan* (Cat. 14). *Woman with a Bouquet* may be slightly later than the date, 1910, which is given by the lender. The profile is strongly defined: it is more like that of the peasant in *I and the Village* (Cat. 19) than the style of other heads of the Paris period. The flowers in the vase which the woman clutches with her right arm are not recognisable botanic specimens: they are an excuse for a riot of colour. The paint is laid on with firm and sure brushstrokes, whose impasto gives the picture a glowing quality which reproductions fail to convey. The woman's mien suggests that she has supernatural properties: her face is filled with a visionary quality, a vision so sure that we can almost share it with her. She seems to see beyond the everyday world and to be lit up by the ecstasy of magic.

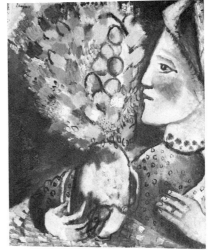

13 reproduced in colour on p. 61

14

Bride with Fan 1911

La fiancée à l'éventail

Oil on canvas
18⅛ × 15 in/46 × 38 cm
Collection of Pierre Matisse, New York

This small picture is unusual in Chagall's œuvre, being predominantly in two colours, white and blue. The quiet head of the girl is barely suggested, with her eyes modestly closed. She is given the symbol of a veil, with flowers, merely hinted, crowning her head; she apparently carries a fan, although her hand is not visible. The picture breathes stillness and submissiveness. However, it may once have looked rather different, for brighter colour shows through the white paint, especially in the fan which was formerly composed of ribs of colour, and the dress which was once also coloured. Likewise, pink paint under the veil suggests a different face. Nevertheless, the manner of painting is typical of Chagall's early period when he often reused old canvases which he could buy cheaply. He would then apply thick underpaint as can be seen here; over this impasto he would paint his composition with thinner paint. The rough undersurface may have been used for obscuring what lay beneath, but it has the effect of giving interest and texture to the surface of the new picture.

Although the handling of colour in the two pictures makes almost as strong a contrast as the subjects, *Bride with Fan* can be seen as a pair to *Woman with a Bouquet* (Cat. 13). The bride of the former may equally be an initiate, waiting for the revelation which lights up the face of the *Woman with a Bouquet*.

14 reproduced in colour on p. 60

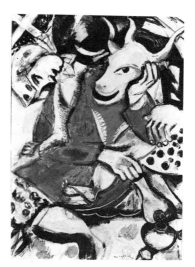

15 reproduced in colour on p. 62

15*

To My Betrothed 1911

A ma fiancée

Gouache, oil & watercolour over graphite on paper
24 × 17½ in/61 × 44·5 cm
Philadelphia Museum of Art; gift of Fiske and Marie Kimball

This gouache is closely related to the oil-painting *Dedicated to my Fiancée* (Kunstmuseum, Berne; fig. 33) exhibited at the Salon des Indépendants in March 1912 with the title, *La lampe et les deux personnes* (cat. 652). Apollinaire described it in his review as 'a golden donkey smoking opium', adding that the canvas had outraged the police, but 'a bit of gold paint smeared on an offending lamp made everything all right' (Apollinaire, p. 214). Since the lamp in the gouache is like the one in the oil, it must postdate it rather than be a study for it as it has not been touched up. The gouache was first exhibited in 1924 at the Galerie Barbazanges in Paris.

Chagall himself has confusingly referred to the incident at the salon in *My Life*, naming the painting as 'The Donkey and the Woman', rather than 'The Ox and the Woman', but perhaps confusion exists on account of a Yiddish proverb, 'If the ass had horns and the ox knew his strength, the world would be done for'. This fits the composition rather appropriately, for in the oil the woman's face appears more dead than alive, as though the ox did not know its strength. The surprisingly benign monster, his head resting on his hand, seems to be contemplating the vision of a dismembered woman's body, whose limbs are randomly distributed round the canvas. Her head is tipped over in a horrible manner, her blank eye sockets are gazing back at him. From her mouth issues a spittle-like substance, solidified breath: she is perhaps breathing memory, or even desire into the bovine mouth. In the oil her face is a superimposed mask like those worn by ancient Greeks in their dramas; in the gouache, this phenomenon is less pronounced.

It is said that the present evocative title, which was used when the oil was shown in Berlin in Autumn 1913, was

given by Chagall's friend, the poet Blaise Cendrars. He returned to France from a long absence abroad in July 1912 so he cannot have seen it in the Salon, which had closed in May. The director of the Bern Kunstmuseum, where the oil is now to be found, thinks that the lamp which is breaking in half at the bottom of the picture may have reminded Cendrars of the one which had caught fire and tragically burnt his fiancée Hélène to death several years earlier. Thus the poet may have identified himself with the musing monster, contemplating the terrible event. Of course this interpretation does not take into account the confusion over the previous naming of the animal as a donkey, nor the transformation of the offending opium pipe, so the original subject must still remain obscure. None the less, Chagall has described painting the picture as soon as he moved from the rather confined studio belonging to the painter Erenburg to bohemian quarters in La Ruche, where his neighbours were poets and painters. This ambience certainly freed him from a rather narrow background to one of avant-garde vitality, where he encountered a wide range of views that certainly broadened his subject-matter and approach. So it may be appropriate to make another, wider connection between Chagall's animal and a Late Dynastic representation of the Egyptian god Mont, who was identified by the Greeks as Apollo and whose bull-headed image is to be seen in the Louvre.

REFERENCE

G. Apollinaire, *Apollinaire on Art: Essays and Reviews 1902–1918* (ed. L. Breunig), The Documents of 20th-century Art, New York, Viking, 1972; S. Kuthy, 'A Marc Chagall *Rêverie*', *Berner Kunstmitteilungen*, 227, Jan./Feb. 1984, p. 5.

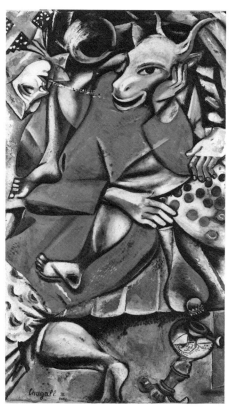

fig. 33 *Dedicated to my Fiancée*, 1911 (Kunstmuseum, Berne)

16 reproduced in colour on p. 63

16

Interior II (1911)

Intérieure II

Oil on canvas
$39\frac{3}{8} \times 70\frac{7}{8}$ in/100 × 180 cm
Private Collection

A pair of figures with a lamp connect this subject with two others that Chagall probably painted in close succession. The first is *Still-Life with Lamp* (fig. 36), a smaller canvas which could have been finished when the artist was still living in the Impasse du Maine. It also appears in *Dedicated to my Fiancée* (Kunstmuseum, Bern; fig. 33), one of the first pictures that he painted in his studio in La Ruche, to which he moved in spring 1912 (Meyer, p. 150). The subject of that oil is not unlike this, with the distorted glass lamp-chimney suggestively associated with a couple. But while the oil, *Dedicated to my Fiancée*, blazes with colour, much of it rendered in solid areas, the outlines in *Interior II* form an essential part of the composition and a great deal of the canvas is painted white. This gives the effect of a drawing transferred to canvas.

The subject is sometimes said to be a woman mounted on an old man. Her bare leg is clutched by him and she is bending intimately over his face, a symbolic line joining their necks. The two humans are crowded into the right half of the narrow canvas, restricted by the frame pressing upon them. In contrast, the left side is rather open, with the animal's head echoing the line of the woman's back, and the lamp chimney is parallel to those important horizontals. The whole composition is severely schematised by the extra lines which have been added partly to 'cubify' the picture surface. For instance, the red line which begins as part of the window frame cuts across the animal's head and continues on down into the lamp, forming a diagonal which counteracts the predominant horizontality of the composition.

According to Meyer (p. 147) *Interior II* was sent to Russia in December 1911 to be shown at the next 'World of Art' exhibition. The picture was exhibited in Berlin at Chagall's one-man-show at the Der Sturm gallery in 1914 and reproduced in the *Bilderbücher no. 1* published by the gallery in 1923. There the photograph is entitled *Intérieure I* and the title *Intérieure II* is given to the picture now known as *The Drunkard* (private collection, Caracas; fig, 41).

17 reproduced in colour on p. 70

17

Reclining Nude 1911

Nu allongé

Gouache on cardboard
9½ × 13½ in/24 × 34 cm
Collection of Mr & Mrs Eric Estorick

This small work represents in this exhibition a comparatively large number of surviving studies of the nude which Chagall made in Paris. The composition is loosely based on the type of a reclining figure with a repoussoir curtain which has a long history in Western art. In the recent past it had been treated by Manet in his well-known composition *Olympia* (Jeu de Paume, Paris). Chagall has placed the head of the figure on the right and included a still-life in the form of a vase of flowers. The stylisations of his figure approach those of Cubism, and the peculiar twisted shapes of the limbs are not unlike those adopted by his fellow countryman, Archipenko, whose sculpture *Venus* was shown in the Salon des Indépendants of 1912. (A contemporary photograph is reproduced by K. J. Michaelsen in a study of the early work.) However, a closer parallel for this drawing is *Femme nu* by Léger, a small pencil drawing executed in the winter of 1911–12, probably at the Académie de la Chaumière (Green, p. 31), where Léger and Chagall both went to draw from the nude.

In the current travelling exhibition, 'Marc Chagall, œuvres sur papier', there is a small sketchbook of these nudes. It was given by the artist to Blaise Cendrars some time between July 1912 and June 1914. The two pages on view there (cat. 19) show how Chagall often worked by making a relatively naturalistic sketch from the model, using well-defined sinuous lines, and then transformed it on the opposite sheet by reversing the pose and making formal alterations, primitivizing and cubifying at the same time. He apparently did not make Cubist studies directly from the nude and it is not certain that Léger did either. In Chagall's *Reclining Nude* the stylisations are very close to those of Léger's *Femme nu* and it has been said that Chagall knew Léger when he moved to 'La Ruche' (Sorlier, p. 236). Although Léger was no longer there then, there are other connections, for he visited the studio of Le Fauconnier and attended the soirées given by Gleizes and Metzinger. As Chagall was at Le Fauconnier's academy, there is every

likelihood that the two artists did meet; this gouache seems to indicate a point of contact, especially as both nudes are unusual in their respective œuvres.

REFERENCES
K. J. Michaelsen, *Archipenko: A study of the early works 1908–1920*, New York and London, Garland, 1977; C. Green, *Léger and the Avant-garde*, New Haven & London, Yale University Press, 1976; P. Provoyeur, *Marc Chagall, œuvres sur papier*, Centre Georges Pompidou, Musée national d'art moderne, Paris, June-October 1984; C. Sorlier (ed.), *Chagall by Chagall* (trans. J. Shepley), New York, Abrams, 1979.

18 reproduced in colour on p. 73

18

Birth 1911

La naissance

Oil on canvas
44¼ × 76⅛ in/112·5 × 193·5 cm
The Art Institute of Chicago; gift of Mr and Mrs Maurice E. Culberg

In spring 1913 Chagall exhibited this large version of *Birth* which is only very loosely based on his earlier one (Cat. 10). It was described in the catalogue of the Salon des Indépendants of 1913 as '*La naissance, coupe de maison*'. The extension of the title is vividly descriptive of this household scene, for he has raised the roof on a slice of life. Although the various compartments might suggest a Russian folk print as the starting-point, such a source—if it was used—is completely disguised by the composition, for Chagall has relied on triangles to organize the pictorial space. The result is a series of coloured areas which incidentally convey walls (muddy green), ceiling (a subtle blue), and floor (reddish brown) and give the composition credibility, so that the numerous anecdotal scenes do not disrupt the overall effect. The eye is led from one splash of deep pink to another without quite realising the number of activities taking place. The title gives pride of place to the terrifying nude who has just given birth to a small baby, precariously held by a woman in blue, but the picture encompasses several events in the same life. There is an embracing couple on the pink tiled stove in the background; on the left a woman is announcing some news, and on the right the same figure is holding up a lamp in horror, while an older child is on the floor nearby. Behind her some people seated at table include

one with features surprisingly like the animal in *Dedicated to my Fiancée* shown a year before (see Cat. 15). The scene is separated off by an extraordinary compositional device, a screen-like door with a magic curtain partly hiding an old man who peeps into the room.

Although *Birth* is as much Russian as Jewish, it seems to carry the fear that Adam's first wife, Lilith, the Queen of the Night, might come and kill the newborn child. In Jewish homes in those days, V. Marcadé says that a knife was put under the cushion of the woman in labour, a book of prayers at her feet, and over the bed, doors and windows were hung amulets, bought in the synagogue, to chase away bad forces and protect from all types of evil (p. 231). This scene looks more like the domain of Lilith.

In a strange way, with his remarkable picture including so many aspects of human life, Chagall was perhaps poking fun at a prevailing mood in avant-garde European circles, where sex was then being extolled as the single foundation for all that is divine in humanity, art, music and literature. Some Russian writers had emphasised the sanctity of sex though in Paris another view may have been better known. 'In the beginning was sex', began an article in 1910 in the magazine *Der Sturm*—it was so long that it had to run to two issues. Even though Chagall may not have been able to read the German for himself, no doubt the topic was discussed at La Ruche. In that context, his large picture with its overtones of magic would have seemed rather different than it does today. It must also have made a strange contrast to his *Adam and Eve* (Cat. 26), hanging in the gallery nearby.

REFERENCES
V. Marcadé, *Le Renouveau de l'art pictural russe 1863–1914*, Lausanne, L'Age d'Homme, 1971; S. Przybyszewski, 'Das Geschlecht', *Der Sturm*, 29 Sept. 1910, p. 243 (cited by R.-C. Washton Long, 'Kandinsky's Vision of Utopia as a Garden of Love', *Art Journal*, spring 1983, pp. 57–58).

19*

I and the Village 1911

Moi et le village

Oil on canvas
$75\frac{1}{4} \times 59\frac{1}{4}$ in/191 × 150·5 cm
The Museum of Modern Art, New York; Mrs Simon Guggenheim Fund

The title was given to this picture by the poet Blaise Cendrars, but it could well support a Russian title, *Mir*, which in historical times meant 'village community' as well as 'world', 'universe' and 'peace'. The life of the peasants who lived in such a community took its rhythm from the inexorable cycle of the seasons following each other in endless succession. This was the domain of the 'holy fool', where peasants and animals lived side by side and animal life was seen as the link between man and the universe; cows and horses were distinguished by name and the milker would expect a sign of recognition from her cow. It was a world where the expression 'there's no such thing' was

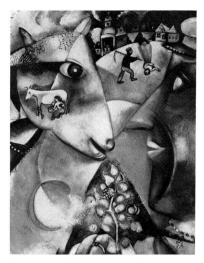

19 reproduced in colour on p. 67

never heard; instead, people would say 'who knows? There may be such a thing, there may not'.

Chagall's picture encapsulates this idealised view of that world: the wide-eyed peasant, a cross round his neck, faces the beast who also wears magic beads. Although their eyes are joined by a symbolic line, they look at each other across a universe, suggested by the quartered disc of the sun and its moon joining it at a moment of eclipse. Behind them lies the line of the earth, bordered by little houses, two of them upside-down like the peasant woman who seems to flee from a man. Are these figures harvesters in a segment of a picture of the four seasons, or does the peasant represent death, with a scythe on his shoulder? From the open doorway of a church behind him peers a large head, reminiscent of the symbolic heads in *Window at the Hairdresser's* (Tretiakov Gallery, Moscow; fig. 18), a small watercolour by Chagall's teacher, Dobuzhinsky, painted shortly after the street killings in the revolutions of 1905. Chagall's images of death are balanced by the flowering Tree of Life below (see Cat. 92).

By painting with an almost lacquer-like surface and choosing a background dominated by clear red, Chagall has alluded to the tradition of large ikons to be seen even today in the Russian Museum in Leningrad, which startle the viewer by the intensity of that colour. In April 1913, while Chagall's own paintings were hanging in the 'Target' exhibition in Moscow, there was a concurrent show of ikons and folk prints, organised by the same artists. In a review in the Parisian Russian-language newspaper, 'A letter on art' by Benois was cited. He affirmed that, in order to understand Cubists, one must travel via the ikon, and that, in order to understand ikons, one must travel via Cubism; he also predicted the advent of a new renaissance by the fusion of Byzantinism and modern research. The Moscow exhibition reviewed was organised by those same 'Donkeys' to whom Chagall had dedicated the large canvas, today in Paris, *To Russia, Donkeys and Others* (Musée national d'Art moderne, Centre Georges Pompidou; fig. 23). They were the painters and poets who through the summer of 1913 paraded in Moscow with drawings on their faces. In his ikon for a

modern day, Chagall has shown a cow with a drawing on its cheek, and in December 1913, Larionov and a friend explained 'Why we paint ourselves' in words which also aptly describe Chagall's a-logical approach: 'The telescope discerned constellations lost in space, painting will tell of lost ideas. / We paint ourselves because a clean face is offensive, because we want to herald the unknown, to rearrange life, and to bear man's multiple soul to the upper reaches of reality.'

Although *I and the Village* is inscribed 1911, it was not exhibited until 1914 in Chagall's one-man show in Berlin. As is remarked in other entries (Cat. 22 and 27), the disc—such a strong element in the original version of the composition— was an important feature of many of the pictures on view at the First Autumn Salon in Berlin in 1913. There, with Blaise Cendrars, he met Delaunay's German admirers, Macke and Marc, so he must have seen Marc's paintings of animals with cosmic symbolism. But Chagall's animals are different. Drawing on his Russian background, the *mir, I and the Village* is both human and universal: a confrontation of man and his animal, the sun and moon, red and green, upwards and downwards, even life and death. He has created a synthetic reality which still today invites questions of the world in which we live.

REFERENCES
Benois' letter in I. Ėrenburg, 'Russkoe narodnoe iskusstvo v Parizhe', *Parizhskiĭ vestnik*, no. 20, 17 May 1913 (cited by J. -C. Marcadé, 'L'avant-garde russe et Paris', *Cahiers du musée national d'art moderne*, 2, Oct.–Dec. 1979, pp. 174–83); I. Zdanevich & M. Larionov, 'Pochemu my raskrashivaemsĭa', *Argus*, Dec. 1913, pp. 114–18 (trans. J. Bowlt in *Russian Art of the Avant-Garde: Theory and Criticism 1902–1934*, New York, Viking, 1976, pp. 79–83).

20

Half Past Three (The Poet) 1911

Le poète, trois heures et demie

Oil on canvas
77⅛ × 57 in/196 × 145 cm
Philadelphia Museum of Art; The Louise and Walter Arensberg Collection

In a masterly way, Chagall has here exploited Cubist technical devices, fully integrating the figure and ground and painting *trompe l'œil* decoration on the curtain (upper corner) as though it were a collage element. He has done this without sacrificing his love of colour, though the present appearance of the picture is not as it used to be. The violet in the background was a fugitive colour which has deteriorated even since it was reproduced in 1946. It gave the composition more stability, as well as drawing attention to the distinction between the strongly coloured areas of blue and red and green and the shadowy, unreal space behind the poet himself.

Unlike most of Chagall's major oils dating from the latter part of his first stay in Paris, this picture has a variety of titles. As well as *Half Past Three* and *The Poet*, it has been

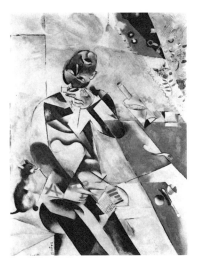

20 reproduced in colour on p. 64

called 'A Quarter to Five' and 'The Rendezvous'. The most obvious explanation for this is that it was never definitively named by the poet Blaise Cendrars, who provided titles for *Dedicated to my Fiancée, I and the Village* and *The Holy Coachman*. Those titles for *The Poet* which are associated with time may have been prompted by the three prongs of the fork and the five bars of colour on the open book, both of them seen as if on an imaginary clock face, whose centre would be the heart shape on the blue jacket. The final alternative, 'The Rendezvous', makes sense once the Cyrillic writing is deciphered, for it would seem to be an enigmatic love poem; only some of the words are legible: '— and only/ it seems to me I/ see—. every day I/ one and the same/ he—[she or it]—trembles/ —/ to you now'.

Meyer describes the subject as a sequel to the *The Poet Mazin* (Cat. 21), but he also sees in it the figure of the artist himself (p. 168). The latter is not unreasonable, considering that the artist wrote poems at the time and chose 'The Poet Reclining' as the title of a later self-portrait (Cat. 49). *Half Past Three (The Poet)*, however, is not entirely a solemn picture: inspiration may come from the bottle, leaning parallel to his sleeve and joined to it by an expressive arc. A devilish cat, its ears like small horns, licks the sleeve of the poet's writing arm: traditionally a symbol of foresight and insight as well as physical desire, the little animal is coloured the same shade of green as the poet's head, which is inexplicably rotated so that it points skyward.

The writer's pen is identical to the one in the artist's realistic drawing of Apollinaire in front of the Eiffel Tower (Meyer, p. 142). In that pencil drawing the poet's left ear is surrounded by a circular form; his head is slightly cocked as though he were listening to some music beyond the reach of ordinary people. It is tempting to see an analogy between this and the two circular forms above the head of *The Poet*, now so faded that they are difficult to distinguish. Originally these brushed the poet's green chin, extending the idea that he has been translated into some realm beyond that of everyday.

In spite of the possible connections to be made with any of the poets in the artist's circle of Parisian friends, the mood

of the picture reflects most closely that a-logism which contemporary Russian poets were trying to achieve in Moscow and St Petersburg during 1913. As Chagall sent pictures to the avant-garde 'Target' exhibition of April that year, it cannot be ruled out that he received news of their attempts to create a new language for poetry and painting, although this would suggest a later date for this picture. On stylistic grounds it must surely post-date *Adam and Eve* (Cat. 26), first exhibited in Paris in March 1913. At all events, in *Half Past Three (The Poet)* Chagall has set out a new way of combining Cubism with colour in a spirit imbued with that Russian 'non-sense' which the Parisian-based artist has been able to transform into a truly inventive pictorial language.

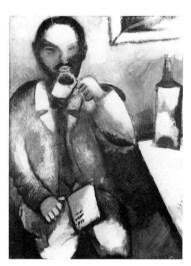

21 reproduced in colour on p. 68

21

The Poet Mazin (1911–12)

Le poète Mazin

Oil on canvas
$28\frac{3}{4} \times 21\frac{1}{4}$ in/73 × 54 cm
Private Collection

During his early years in Paris, Chagall enjoyed the company of a number of writers and dedicated some of his most ambitious pictures to them, for instance, *Homage to Apollinaire* (Cat. 22) and *Half Past Three (The Poet)* (Cat. 20). Although more modest in scale, this picture is unique amongst known oils, as it is named for the poet Mazin. (Surprisingly, there is no individual portrait recording the artist's friendship with the poet Cendrars, and only drawings as likenesses of Apollinaire, despite the fact that both dedicated poems to Chagall.)

Mazin is here represented in a manner which permits the viewer quite easily to grasp the essential character of the minor poet, although the portrait cannot be described as a likeness. The artist has taken pictorial liberties which he had not allowed himself before leaving Russia, when he had made portraits of his sisters Mania and Aniuta (Cat. 5, 11).

Even his *David in Profile* (Cat. 39), made when he returned in 1914, is decorative rather than deformed like the features of the hapless Mazin. Yet the poet's face is not seen as a caricature in a way that the artist was a little later to see his own (see fig. 38): Mazin is entirely original, prefiguring only the neo-primitive treatment which Chagall developed for the hermaphrodite in *Homage to Apollinaire*. There is a plausible connection to be made between the expression of the head there and here, but the colours and handling are quite unalike. The additional impasto, creating an even thicker paint surface than is customary in Chagall's pictures of this date, may, however, be an afterthought, for the signature on the table to the right and the writing on the book have been partly covered up. Of all the artist's pictures of this period, this seems the closest he came towards Expressionism. Yet when it is compared with a small contemporary gouache, a *Man with Cat* (Museum Ludwig, Cologne; fig. 34) who may be connected with *Half Past Three (The Poet)*, the figure of the poet Mazin is in a stronger, more restrained mode, for it lacks the deliberate savagery of Chagall's most Expressionist themes.

Strangely, one of the closest analogies that can be found for the powerful head is the contemporary *Portrait of Diego Rivera* by Modigliani (Galerie Beyeler, Basle), painted when that Italian was still in La Ruche, experimenting with different styles (before he found the one by which he is best known). But both owe a debt to the expressive features of the players in Matisse's large canvas *Music*, which, with *Dance* was commissioned by the Moscow collector Shchukin: both had caused a sensation at the Salon d'Automne in 1910.

REFERENCE
A Barr, *Matisse, His Art and His Public*, London, Secker & Warburg, 1975, pp. 132–38

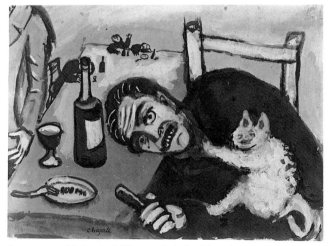

fig. 34 *Man with Cat*, 1911 (Museum Ludwig, Cologne)

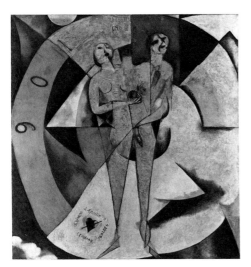

22 reproduced in colour on p. 65

22

Homage to Apollinaire (1911–12)

Hommage à Apollinaire

Oil, gold and silver powder on canvas
78¾ × 75⅝ in/200 × 189·5 cm
Stedelijk Van Abbemuseum, Eindhoven

This was the largest picture on view at Chagall's one-man exhibition, held in Berlin at Walden's Der Sturm gallery in June 1914, where it was shown in public for the first time. Its title, *Homage to Apollinaire, Walden, Cendrars, Canudo*, has more recently been abbreviated to the present form. It undoubtedly represents a climax of invention amongst the wealth of Chagall's compositions on view then and now.

The subject is a mystic hermaphrodite, a single trunk divided to suggest Adam and Eve (since the left arm, attached to the female torso, holds an apple). Chagall had depicted Adam and Eve in their two separate states in a major Cubist-style work (Cat. 26) shown in the Salon des Indépendants of 1913, when Apollinaire had introduced the artist to Walden. In spite of the date, 1911, now attached to *Homage to Apollinaire*, it seems unlikely that it was completed in time even for the First German Autumn Salon of 1913, since the dealer would surely have included it there. This is all the more likely since a prototype for the picture is to be found in four large sculpto-paintings by Chagall's friend Delaunay which the artist saw on his visit to that exhibition. One of these unusual works, *Cheval, prisme, soleil, lune*, (fig. 11) is known today only in a photograph and shows a neo-primitive horse in front of a universal cosmic disc.

In this riposte Chagall has integrated his own esoteric figure with a disc composition, which carries within it multiple levels of meaning. Amongst other things, his disc can be seen as the conjunction of planets, a colour wheel, a clock; he gives naturalistic references: an orange sun, glimpsed in the top corner; clouds with birds, bottom left; and intersecting coloured quarterings below the right arm of the figure. No doubt many more interpretations were intended by the artist, whose theory of symbols, suggested

under *Calvary* (Cat. 27), had a broader base than the more limited symbolism of Delaunay. The hermaphrodite itself, after its primary reading as Adam and Eve, can also be seen as an alchemical marriage or the hands of a clock.

Further symbolism is suggested by the dedication to the poets Apollinaire and Cendrars, the dealer Walden and the editor of *Montjoie!*, Canudo, with the four names arranged round a pierced heart, colour-coded in such a way as to draw attention to puns on the four elements: the *aire* of Apollinaire suggests air; the *wald* of Walden, earth; *do* in Canudo makes the French sound *d'eau*, indicating water; the poet Cendrars had adopted his pseudonym for its connection with the fire of *cendres*. Chagall's own name is written in the centre of the picture above the heads of Eve and Adam: first his surname in French (repeated without the vowel 'a'), then 'Marc' in two alphabets, the first and last letters in the roman and the intervening letters in the Hebrew. In *My Life* Chagall commented on the play on letters in Hebrew, 'I already know that "a" with a line below it makes "o",' (p. 48), so his signature must have cabbalistic significance.

Some contemporary viewers might have drawn a connection with lectures by the Anthroposophist Rudolf Steiner. In Munich in 1910 he had given a widely discussed cycle of lectures on *Genesis* using individual Hebrew letters to stand for powers of creation and making liberal use of Hebrew words. Reading the creation story backwards in time from the moment when Eve had been formed from one of Adam's ribs, he had nominated prior stages of creation of the universe, a progressive evolution of the four elements. Steiner's imagined 'picture of an immense cosmic globe, composed of weaving elements of water, air or gas and fire . . . which splits apart into a solar and telluric element . . . [which is] the expression of the spiritual' (p. 13) seems remarkably apt, particularly as he envisaged the countenances of Spiritual Beings revealing themselves. He further taught that separation into 'male' and 'female' came late in time; at the sixth 'day' all human beings had a bodily nature in common (p. 133). Much of this symbolism is present in Chagall's picture.

Cabbalistic symbolism is suggested for the hermaphrodite by some appropriate words from the *Zohar*: 'When is "one" said of a man? When he is male together with female and is highly sanctified and zealous for sanctification; then and only then he is designated one, without mar of any kind'. This section continues with a eulogy on the union of man and wife, as well as that of God and the patriarchs and the Community of Israel. However, the very nature of Chagall's approach to symbols, his deliberate choice of 'real' symbols (see Cat. 27) such as the hermaphrodite, allows multiple references to be suggested in *Homage to Apollinaire*. The concept and image of the hermaphrodite had also had associations with alchemy, where the hermaphrodite symbolised the 'great work', the mystical transposition of the essence of an entity. That this interpretation was additionally implied here is suggested by the artist's use of gold and silver powder for the figures and background.

In 1973 Chagall returned to the hermaphrodite, treating it in a more resolved manner in *The Walk* (Cat. 112), where the human nature of the creature is fully defined. Here in

Homage to Apollinaire he has suggested figures in the process of becoming differentiated, the male from female, with their mask-like heads singing some unutterable language celebrating the division of night and day, of life on earth at its inception.

REFERENCES
Zohar, The Book of Splendor (ed. G. G. Scholem), New York, Schocken Books, 1949; R. Steiner, *Genesis*, London, Rudolf Steiner Press, 1959.

23*

The Ferris Wheel 1911–12

La grande roue

Oil on canvas
$25\frac{5}{8} \times 36\frac{1}{4}$ in/65×92 cm
From the estate of the late Sir Charles Clore

fig. 35 Paris, *La Grande Roue et la Tour Eiffel*, postcard

This unusual picture follows the motif so closely that it is almost certainly based on a contemporary postcard such as fig. 35; it is restricted to two surprising colours, acid lemon and green. Both factors suggest that it was painted late in 1912 at the time when Delaunay was using the same Paris landmarks from the Exposition Universelle of 1889 and 1900 for the background of *L'équipe de Cardiff* (Musée d'art moderne de la Ville de Paris), of which he sent a large sketch to Berlin for an exhibition in January 1913 (Stedelijk Van Abbemuseum, Eindhoven). Although Delaunay made a

practice of using photographs, in this instance the motif seems to have fascinated other artists in his circle including Diego Rivera, whom Chagall knew in La Ruche. (Rivera used the wheel for the background of his *Portrait de M. Best*, exhibited at the Salon des Indépendants in 1913.)

Chagall's view is not identical with the postcard; he has turned the wheel into the picture plane and perhaps tried to express its movement by repeated coloured marks and the visual extension of the box-cars into space. More importantly for someone as poor in the French language as

23

he seems to have been at the time, he has made a verbal pun: he has left the 'S' off the expected word 'Paris', leaving PARI, meaning 'bet', instead. Delaunay used the same word, adding 'MAGIC PARIS' to his sketch, *L'équipe de Cardiff*, which Dorothy King has associated with the Wheel of Fortune (p. 42). She has pointed out that Cendrars incorporated the same word in his long poem *La Prose du Transsibérien*, begun sometime early in 1913 and published in September. Although Cendrars did not provide the title 'The Ferris Wheel' for Chagall's painting, perhaps he contributed in a more direct way by suggesting that Chagall include the pun. The picture marks the entry of 'modern' subject-matter into the painter's œuvre, which he used afterwards in a more poetic way, for instance in *Paris through the Window* (Solomon R. Guggenheim Museum, New York).

REFERENCE
D. King, 'The Delaunay School, 1912–14', unpublished CNAA dissertation for the City of Birmingham Polytechnic, 1977.

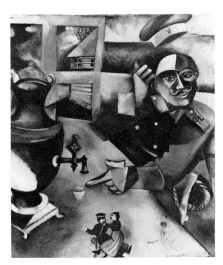

24 reproduced in colour on p. 66

24*

The Soldier Drinks (1911–12)

Le soldat boit

Oil on canvas
43 × 37¼ in/109·1 × 94·5 cm
The Solomon R. Guggenheim Museum, New York

Chagall had no experience of military service himself, but he has described this subject as a reminder of the Russo–Japanese war of 1904–05 when soldiers were billeted on private families. Aged seventeen at the time, the experience of having soldiers living in his house made a strong impact on his imagination. He has further rejected any interpretation that the soldier is drunk—suggested by Waldemar George in 1959. The artist also spoke of the figures in the foreground as a general expression of the mood of the painting.

In the Guggenheim Collection Catalogue, where these remarks by Chagall are recorded (see Cat. 35), Angelica Rudenstine describes the small couple as dancing figures; however, they seem more like a pair of lovers, the woman seated on the soldier's knee, both of them awkwardly on the ground. This is the case in a tiny gouache study (formerly in the collection of Mrs Ogden Stewart, London; Meyer, cat. 109), where the expression on the soldier's face is very much more caricatured; he holds his pointing finger in the stream of water from the samovar. In that vivid gouache, the window behind the samovar does not show an explicit view, but curiously abstracted shapes, one of them perhaps a close-up of the sun. In the oil-painting, although the main compositional lines remain the same, the figure is more hierarchical with stylisations in the face which are a little like those in the *Self-Portrait with Seven Fingers* (fig. 8). The soldier has a rather unexpected air of musing and concern: he seems to point with his right-hand thumb to the house through the window. That is menaced by a hot red which lights up the blackened night—a combination which Chagall used to suggest war in *The Newspaper Vendor* (see Cat. 44). Here there are two interlocking themes, expressed by the courting couple with their tiny scale in contrast to the enlarged samovar, facing the soldier across the table rather as the bovine head faces that of the peasant in *I and the Village* (Cat. 19). Moreover, it is possible to see a progression from the *Self-Portrait with Seven Fingers* (first exhibited in March 1914), with its pairing of views of Vitebsk and Paris, and the artist and the picture on the easel. The sequence continues in *The Soldier Drinks*, with its pairing of samovar and soldier: it even has a related structure, for the tipped plane now doubles as floor and table. A third picture is *I and the Village*, although there the two profiles are drawn closer together, and the motifs at top and bottom of the canvas are linked by the device of interlocking circles. On these grounds it seems reasonable to see in these pictures a later, rather than earlier, Paris style, for *The Soldier Drinks* was first shown in late spring 1914 at Der Sturm, as was *I and the Village*. While it might seem strange to put forward the idea that Chagall moved from more generalised scenes like *Birth* (Cat. 18) and *Adam and Eve* (Cat. 26) and even *Golgotha* (fig. 6) to more precise ones like these, this is the order which is borne out by the record given by exhibition catalogues of the time.

REFERENCE
W. George, *Les Artistes juifs et l'école de Paris*, Algeria, 1959, p. 23, cited in A. Zander Rudenstine, *The Guggenheim Museum Collection: Paintings 1880–1945*, vol. I, New York, The Solomon R. Guggenheim Museum, 1976, p. 59.

25 reproduced in colour on p. 71

25

Still-Life (1912)

Nature morte

Oil on canvas
$24\frac{3}{4} \times 30\frac{3}{4}$ in/63 × 78 cm
Collection of Mr and Mrs Eric Estorick

Chagall rarely painted a conventional still-life but this is one of two surviving from his years in Paris. The other, now lost, is reproduced by Meyer (p. 107); it carries the date '12–4', interpreted by Meyer as 1912–14, and it seems unlikely that this more cubist *Still-Life* preceded it. This picture shares the palette and geometric schema of the second version of *Birth* (Cat. 18, first exhibited in January 1913), though, being on a much smaller scale, the composition is more lucid and the colours are brighter and more translucent. One of the motifs is a lamp like the ones in earlier pictures, including the *Still-Life with Lamp* (fig. 36), where it is intimately associated with humans. Here it is exploited for its dual role as elegant

fig. 36 *Still-Life with Lamp*, 1910 (Private Collection; photograph Galerie Rosengart, Lucerne)

form and source of light; indeed, some of the main structural lines radiate from within its glass chimney. Although the light is rendered in a non-naturalistic way, it is none the less consistent with the quality of illumination such a lamp would give, looming out of velvety darkness. Chagall later recalled painting at night by such light (*My Life*, p. 103). Although this seems a straightforward picture, it may hide further meaning for the artist, who, speaking of the Cubists in 1927, made the rather cryptic remark, 'Still-life was deformed , following research into the third and fourth dimensions' (Raynal, p. 94).

REFERENCE
M. Raynal, 'Marc Chagall', in *Anthologie de la Peinture en France de 1906 à nos jours*, Paris, Montaigne, 1927.

26 reproduced in colour on p. 72

26*

Adam and Eve 1912

Adam et Eve

Oil on canvas
$63\frac{1}{4} \times 42\frac{7}{8}$ in/160·5 × 109 cm
St Louis Art Museum

Under the title *Couple sous l'arbre (1912)* this picture was exhibited in spring 1913 at the Salon des Indépendants (cat. 556). In a review in *L'Intransigeant*, Apollinaire named the subject more precisely: 'Chagall's *Adam and Eve*, a large decorative composition, reveals an impressive sense of colour, a daring talent, and a curious tormented soul'. His other canvas on view was *Birth* (Cat. 18) a reworking of an earlier Russian theme (see Cat. 10). In contrast, *Adam and Eve* is a stylistic development related to the large-scale figure compositions which Parisian Cubists had sent to previous exhibitions, especially Metzinger's *La femme au cheval* (fig. 9) shown a year before. Metzinger taught at the Académie de la Palette which Chagall attended, and there is a marked similarity in the stylisations of heads, hands, breasts and feet adopted by Chagall in *Adam and Eve*: a photograph of Metzinger's painting was reproduced in

October 1912 in *Du Cubisme*, of which he was joint author. But unlike Metzinger, or other Cubists, Chagall has silhouetted the two figures and the tree between them against plain background areas of muted colour, blues, white and purple which suggest a sky. Furthermore, he has indicated a low horizon, with quirky little animals, one on each side. This goat and stag with a little bird on its antlers, must surely have had some symbolic meaning.

With its sweeping curved forms and surprising colours, including an unexpected green and yellow like the *Ferris Wheel* (Cat. 23), Chagall's *Adam and Eve* has many of the characteristics which Apollinaire described as Orphist in the review quoted above: 'This school groups together painters with quite different personalities, all of whom have, in the course of their investigations, arrived at a more internal, less intellectual, more poetic vision of the universe and of life. Orphism was not a sudden invention; it is the result of a slow and logical evolution from impressionism, divisionism, fauvism, and cubism. Only the name is new.' (Apollinaire, p. 284.) Of the artists he named in this review, most, including Chagall, were invited and accepted the invitation to contribute to the First German Autumn Salon the same autumn, which Apollinaire described as the first Salon of Orphism.

Although this picture seems to stand apart from others by Chagall, it was preceded by the now lost painting, *The Herdsman*, exhibited in the Salon d'Automne of 1912 and no doubt followed by *Half Past Three (The Poet)* (Cat. 20). In subject *Adam and Eve* prefigures the large *Homage to Apollinaire* (Cat. 22).

REFERENCE
G. Apollinaire, *Apollinaire on Art: Essays and Reviews 1902–1918* (ed. L. Breunig), The Documents of 20th-century Art, New York, Viking, 1972.

27

Calvary 1912

Le Calvaire

Gouache
$18\frac{3}{4} \times 23\frac{1}{4}$ in/47·5 × 59 cm
The Museum of Modern Art, New York; The Joan and Lester Avnet Collection

This finished study for the large painting *Golgotha* (fig. 6), belonging to the same museum, shows a group of figures arranged in the manner of a traditional Crucifixion, with an

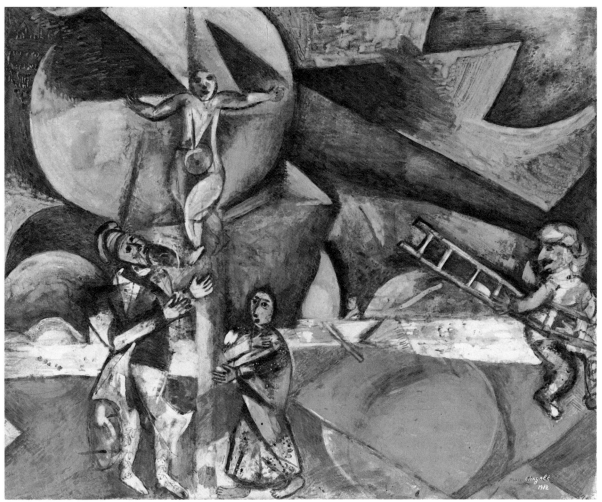

27

additional figure in a boat in the background, and, to the right, a small figure running off with a ladder. When the oil was shown in Berlin at the First German Autumn Salon in 1913 it was called *Dedicated to Christ*, and the designation *Golgotha* no doubt stems from a line-drawing shown at Chagall's one man exhibition in Berlin in 1914 (fig. 5). There used to be another oil-painting of a Crucifixion by Chagall, dating from the same period; it is now lost but it was related both to the ink-drawing and the versions in New York, (Meyer, p. 197).

It is necessary to mention all the versions as the Crucifixion was clearly an important subject for Chagall at the time and the theme has continued to fascinate him. While priority is sometimes overstressed by art historians, the dating of *Golgotha* is of considerable interest. As can be seen even from this colour study with its discs, if the oil was shown in the Salon d'Automne of 1912, Chagall anticipated a compositional device widely used in 1913, particularly by his friend, Robert Delaunay. Indeed, such disc compositions became intimately associated with the art movement 'Orphism' named by Apollinaire (see Cat. 26). In the absence of photographs of the Salon of 1912, the only evidence rests on a review in the Russian journal *Apollon*, in which Tugendkhol'd wrote: 'In the other picture, *The Crucifixion*, I liked very much the figure of Judas running away with a ladder. It was full of sharp expression'. Since all Chagall's versions include Judas and a ladder it seems impossible at present further to clarify which one was on view.

With its unexpected, child-like figure on a cross, *Golgotha* invites interpretation and Avraham Kampf has attempted to explain the subject by pointing to connections with themes in Yiddish literature at the turn of the century. He sees the river in the background not merely as representing a physical barrier which kept Jews in a ghetto, but also symbolic of the movement of enlightenment which spread througout Eastern Europe at the time. He names the writer Serafim, whose Benjamin the Third wanted to 'cross the river' to reach Israel where he hoped to eat dates and figs from the trees, and join the three lost tribes of Israel. Chagall's warm landscape in the background of *Golgotha* reminds Kampf of such a country: the child on a cross, set by a river, represents a generation of young Jews who went out into strange countries, into strange cultures and who were therefore considered lost by their elders (the figures at the foot of the cross). Such an interpretation broadens the base from which Chagall's novel Crucifixion scene can be considered.

However, an even more generalised interpretation may be appropriate, and even intended. For in Russian books and articles, including 'Two elements in contemporary symbolism', published in the art journal *The Golden Fleece* (in April-May 1908; see Cat. 10), a theory of 'realistic' Symbolism had been put forward by the poet V. Ivanov (whose 'Wednesday evenings' had taken place in the same building occupied by the Zvantseva school, attended by Chagall before he left St Petersburg for Paris). Ivanov had denied that symbols were exclusive and designated a particular idea: rather, he asserted that each conveys every possible level of meaning. But to create a 'cosmogonic' myth,

a 'real' symbol must be used by the artist: for instance, citing a snake as an example, he linked it symbolically with 'earth, incarnation, sex, death, sight, knowledge, temptation, enlightenment'. Likewise, the sun could be used as a potent symbol, but it was not enough to use only its secondary manifestations, such as sunlight or a golden colour; the 'real' sun must be cited. Additionally, Ivanov wrote about the quest of the soul for God, using imagery from both Western and Oriental sources, equating Christ with the Eros of Dionysian myth; he had explored the latter in *The Hellenic Religion and the Suffering God* (1903–04).

In this light Chagall's *Golgotha*, under the title *Dedicated to Christ*, would be the artist's transformation of a particular 'real' symbol into a more general one, implying every intervening shade or nuance. Thus the moment of reconciliation between God and man, ascribed by Christians to the Crucifixion of Jesus, could have been adopted in this picture as a schema for encompassing all myths of a suffering god. The artist has generalised the concept (embodied in its more usual form in his drawing) and replaced the figure by that of a child, flanked by magical-looking personages: he has added a reference to a Charon-like figure in his boat, perhaps waiting to see if he can row the soul to the Underworld. 'Judas running away with a ladder' could be interpreted as an attempt to break the pathway between heaven and earth.

Furthermore, the suffering of the artist in his symbolic role as seer (a theme as dear to Blok, see Cat. 2, as to Ivanov) is indirectly implied here, for a poem by Chagall's friend Cendrars, 'Portrait', dedicated to the artist in 1913, includes the lines: 'Christ / He's Christ himself / He passed his childhood on the cross' (*Dix-neuf poèmes élastiques*).

REFERENCES
IA. Tugendkhol'd, 'Osennĭ salon, 1912g', *Apollon*, 1, January 1913, p. 40; A. Kampf, 'Marc Chagall, an insight into this artist's symbolism through a study of the images of his Jewish background', *The Student Zionist*, February 1951, pp. 11–17; J. West, *Russian Symbolism, A Study of Vyacheslav Ivanov and the Russian Symbolist Aesthetic*, London, Methuen, 1970; B. Cendrars, 'Portrait' (trans. John Dos Passos), in J. J. Sweeney, *Marc Chagall*, New York, The Museum of Modern Art, 1946.

28

The Cattle Dealer (1912)

Le marchand de bestiaux

Oil on canvas
38 × 79in/97 × 200·5cm
Öffentliche Kunstsammlung, Kunstmuseum, Basle

A procession of man and woman with their domestic animals is here composed like a sequence of music: alternating horizontals and verticals create a rhythm of visual chords on a long and narrow canvas. It makes an interesting contrast with a second painting, which like this one was first exhibited at Walden's Der Sturm gallery in spring 1914. For in *I and the Village* (Cat. 19) Chagall used concentric and interlocking circles in a close-up confrontation of a peasant

28 reproduced in colour on p. 77

and what Chagall himself called a cow. In later versions of both compositions, made in the early 1920s, the insistence on geometric structure is not so pronounced (see *I and the Village*, Cat. 65; the later *Cattle Dealer* is in the collection of the artist); precise rhythms were evidently more important to the artist in the early Paris period.

The ordered arrangement in *The Cattle Dealer* is matched by colour articulations, leading the eye from left to right and then back again, aided by the strict profiles of the dealer and his wife. These hierarchical heads, joined to torsos seen in a frontal view, may remind the viewer of some frieze from ancient Egyptian times, transformed into a traditional Russian subject of peasants apparently driving their animals to market. In the foreground are two more peasants in close-

up, the scold, a little less angular than the one in *The Spoonful of Milk* (Cat. 30); she seems to berate her son, who stares fixedly into space. Although it might be tempting to 'read' the picture as a story, especially the slightly less formal finished study included in the exhibition, 'Marc Chagall, œuvres sur papier' (cat. no. 39), it is by no means a legend, but rather a symbolic picture of the rhythmic cycle of rural life. The artist has set out the relationship between man and nature, joined in a never-ending continuity.

As has been mentioned elsewhere (see Cat. 19), Chagall must have known contemporary work by Franz Marc, whose animals more often interact solely with nature; they come from another tradition; a dream of a return to nature, freed from human intervention. *The Cattle Dealer*, on the other hand, shows Chagall's insistence on the association of animals with man, to whom they remain subservient. Like man, they play a role as actors in the picture, accepting their fate, unlike the strident woman of the foreground who vainly shouts aloud. Animals do man's bidding: they pull the cart, provide the milk, they live or die according to man's will. Yet these humans, who may seem to be like God, are themselves locked in this cycle, so beautifully suggested by the turning golden wheels.

REFERENCE
Marc Chagall, œuvres sur papier, Paris, Centre Georges Pompidou, Musée national d'Art moderne, June–October 1984 (reproduced in colour on p. 56).

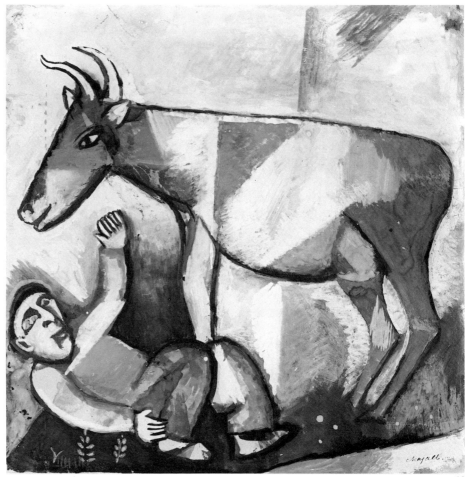

29

29

Man and Cow (1912)

L'homme et la vache

Gouache on paper
$10\frac{1}{2} \times 10\frac{5}{8}$ in/26·5 × 27 cm
Öffentliche Kunstsammlung, Kupferstichkabinett, Basle

This exemplary gouache, painted on brown paper, belonged
to the wife of Herwarth Walden, who bought for her own
collection many of the works from Chagall's two exhibitions
held at the Der Sturm gallery in spring 1914; so this work
can reliably be said to have been exhibited between April
and July of that year. Superficially it is a representational
composition of a patient cow standing beside a man lying on
the ground, raising a hand with five fingers. Both are drawn
with blue outlines, but the colours are filled in with an
abstract pattern of right-angled and equilateral triangles
together with rectangles. These colours are extremely strong
and non-naturalistic, with each half of the composition
dominated by a colour: the left, including the man, being
more blue than the right, where the bitter-lemon yellow of
the background is predominant. The colours are applied in
small parallel brushstrokes, in a way similar to a technique
used by the Impressionists, which was continued by other
Modernist painters as well as Chagall. Furthermore, large
areas of the blue underpainting in this gouache were covered
(at the time) with lighter colours, mainly mixed greens—a
characteristic of another remarkable gouache by Chagall in
the Print Room in the Kunstmuseum, Basle, *Fighting under
the Moon* (Inv. 1942.437).

In *Man and Cow*, Chagall has indicated some connection
between the human and the animal by a light green 'halo'
round the man's head, repeating the colour in a vertical line
of dots falling downwards like rain onto the cow's muzzle.
The same colour recurs in beautifully naturalistic leaves in
the foreground, as well as in three carefully positioned spots
of green paint to be seen in two places in the foreground.
The significance of these marks is unclear, although similar
ones crystallise into the rosary-like necklace worn by the
cow in *I and the Village* (Cat. 19).

The conjunction of man and animal becomes the subject
of Chagall's important picture *The Cattle Dealer* (Cat. 28),
also in the Basle Kunstmuseum. Whereas the artist Franz
Marc (whose work Chagall saw at the First German Autumn
Salon in September 1913) used animals for their expressive
alternative to human-beings, Chagall in both these works—
and others—celebrates the symbiotic relationship between
man and his domestic beasts.

30

The Spoonful of Milk 1912

La cuillerée

Gouache on paper
$15 \times 12\frac{1}{4}$ in/38 × 31 cm
Private Collection

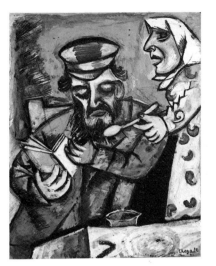

30 reproduced in colour on p. 78

The subject of this work, whose scale defies the forcefulness
of the imagery, is particularly poignant for those of the
Jewish faith. An old man is seen buried in his book, no
doubt celebrating one of the great fast days of the religious
year. But a ruling permits the breaking of the injunction that
food may not pass the lips from sunrise to sundown, in cases
of ill-health or decrepitude. So here, the old man is suffering
the humiliating necessity of receiving a spoonful of milk,
which in some instances may have to be forced down the
throat. The attitude of the woman is that of the concerned
wife, who—with her open mouth—seems to remonstrate
with her husband, trying to pull him back from the depths
of contemplation, for he is engrossed in his holy book. The
subject, therefore, is an unpleasant, but human, reference to
the weakness of old age and its inability to continue to keep
the customs of the faith. But compared with the very small
couples in the oil paintings of the period (see, for example
The Soldier Drinks, Cat. 24), Chagall has used the gouache,
with its brilliant colouring, as the means to explore human
relationships in close-up.

31

The Pinch of Snuff 1912

La prisée

Oil on canvas
$50\frac{3}{8} \times 35\frac{1}{2}$ in/128 × 90 cm
Private Collection

There is a small gouache of this subject (today in the Dial
Collection, Meyer cat. 128) and a second version in oil in the
Kunstmuseum, Basle. The oil in this exhibition was first
shown in Chagall's one-man exhibition at Der Sturm in
Berlin in June 1914, and differs in one important respect
from the small gouache: the Star of David in the background
of each contains letters, that in the Dial Collection signifying
'Life', whereas in the oil versions they signify 'Death'. The
writing on the pages of the open book in front of the figure
(who has been variously identified as a rabbi and a scribe)

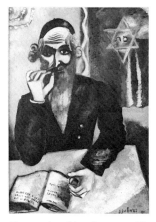

31 reproduced in colour on p. 79

is in Yiddish; early photographs show that there were
originally more words, but some of them have since been
painted out. The only words which can be read easily are
the artist's name which is written in reverse order, 'Segal,
Moshe', the surname preceding the first name. The present
title of the work might refer to a traditional saying, 'It's not
worth a pinch of snuff', which in turn may be the basis of
a story by I. L. Peretz entitled 'A Pinch of Snuff'. Chagall
illustrated that author's 'The Magician' (published in 1917
by Kletskin in Vilna) and it seems likely that another oil
painted in Paris, *The Holy Coachman* (Private Collection;
fig. 45) is based on 'Bontshe the Silent', probably the best-
known story by Peretz.

'A Pinch of Snuff' is about the Rabbi of Chelm, who at
the end of his life was discovered by Satan to have lived
such an exemplary life that no sin blotted the ledger of living
souls. Provided he did not kill the rabbi, Satan was given
permission to tempt him, 'Since it is written that no man is
pure in virtue and free of sin . . .'. But Satan's temptations
misfired, and his devils could find no way of making the
rabbi sin: they tried unsuccessfully to bribe him and even
Lilith was unable to beguile him. However, her visit proved
the rabbi's undoing, for she noticed that he had a snuffbox:
'When her fragrance had reached his nostrils, he had taken
a pinch'. And that was how a devil finally succeeded in
trapping this rabbi of Chelm, because on his evening walk,
he usually took a pinch of snuff before turning back at a
particular tree. The devil moved the tree further away,
causing him to walk too far and to fail to return at the
appointed hour on the eve of the Sabbath. The moral, in the
mouth of a youthful devil was, 'They're on guard against
temptations that rage, but unprepared for the strength of
quiet needs'.

Chagall's rabbi, taking his pinch of snuff with the word
'death' inscribed nearby, could only be connected with the
story by someone who knew it, so it is not an illustration,
merely a reminder. With its hierarchical composition and its
cryptic signs, it points towards the series of Jews that he
painted from the life on his return to his home town (see
Cat. 43).

REFERENCE
I. L. Peretz, 'A Pinch of Snuff' in *Selected Stories* (trans. R.
Bercovitch), London, Elek, 1974, pp. 58–64.

32

Jew at Prayer (1912–13)

Le Juif en prière

Oil on canvas
$15\frac{3}{4} \times 12\frac{1}{4}$ in/40×31 cm
The Israel Museum, Jerusalem

Although Chagall is best known for the faithful pictures
which he made of Jews after he returned to Vitebsk in 1914,
the subject was established in Paris, as may be seen here and
in *The Pinch of Snuff* (Cat. 31). This tiny picture is far more
stylised than that one, or *The Praying Jew*, which was
certainly painted in Russia from the life (Cat. 43). Here, the
artist has given an idea of the holy man who is so carried
away by his incantations that he has lost all personal
identity. Sitting on his prayer stool, he bends over his holy
book—of which the writing has been largely crossed out—
and which he barely needs to look at, for he knows the
words so well. Above his head is the Star of David, that
pentacle which was a magic sign in the Middle Ages; behind
him, the case of the Torah Scroll is covered with cabbalistic
devices.

In *My Life* Chagall has described how 'Day after day,
winter and summer, my father rose at six o'clock in the
morning and went off to the synagogue./ There he said his
usual prayer for one dead soul or another' (p. 28); then
again, 'Papa is all in white./Once a year, on the Day of
Atonement, he looked to me like the prophet Elijah./ His face
is a little yellower than usual, brick-red after the tears./ He
wept unaffectedly, silently, and in the right places./ Not one
extravagant gesture./ Sometimes he would give a cry: "Ah!
Ah!" turning towards his neighbours to ask them to keep
silent during the prayer, or to ask them for a pinch of
snuff. . . . All day long I hear "Amen! Amen!" and I see
them all kneeling' (pp. 43–44). In this strange representation
the artist seems to grope towards the devotion of those close
to him as a child.

Unlike most of the Paris pictures, the style is devoid of
Cubist tendencies, though, with its distortions of the head
and folds in the sleeves, it is one of the most expressionistic
oil-paintings which he made at the time.

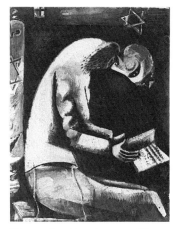

32 reproduced in colour on p. 76

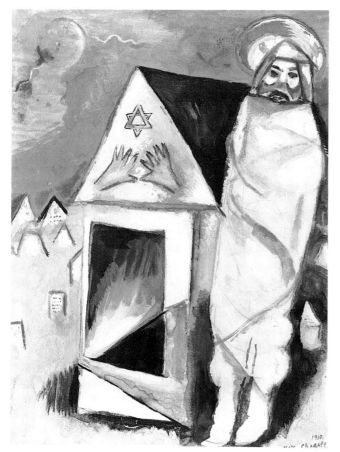

33

33*

Resurrection of Lazarus 1910

La resurrection de Lazarre

Gouache on paper
$8\frac{1}{4} \times 11$ in/21 × 28 cm
Philadelphia Museum of Art; The Louis E. Stern Collection

The *Resurrection of Lazarus* remains as a record of an idea
which was taken no further, unless one counts the paintings
of Jewish cemeteries, for instance Cat. 55, which Chagall
made in 1917. This small gouache is unlike them, however,
because it contains the alarming figure of Lazarus,
apparently just risen from the open tomb beside which he
is standing. His mournful-looking face is closely connected
with the neo-primitive heads of the figures in *The Violinist*
(Cat. 36).

Space in the composition is treated in a non-naturalistic
way and the other graves are only alluded to by the briefest
of outlines around white patches covered by illegible red
dots, presumably representing inscriptions. The centre of
the composition is dominated by the open tomb, whose
façade is made up of a series of congruent triangles which
extends onto the figure. This device seems to connect the
space in which Lazarus is now standing with the grave, a
reminder that Lazarus has just crossed from one world to
another. The idea is carried further by the position of the
sun which acts as a halo behind his head, and the moon with

a face in the opposing corner. The anthropomorphism of the
moon is supported by the curious squiggles which can be
interpreted both as moonbeams and the moon's long hair.

The whole picture is drawn with the blue outlines
characteristic of Chagall's gouaches of this time. The colours
are restricted to an emerald green, ultramarine blue, a light,
acid yellow and touches of red. This range of colours,
together with the division of the composition into three
sections, of which the central one resembles a window, is a
reminder of the pictures of Chagall's friend Delaunay, who
in 1912 began his series of *Window* compositions. In a
fascinating study on Apollinaire, G. Noszlopy has called the
Window a 'stylistic and iconographical device which
suggests simultaneous experience of internal and external
space' (p. 62). While Chagall painted other pictures which
utilise this device, here he adopts a variation in the form of
the open tomb. Instead of reviving experiences inside and
outside the studio, he has attempted to convey various
realities which are only too familiar to each of us. One reality
is dominated by the sun, the light of day, in which Lazarus
is now standing; another is dominated by the moon, shining
onto the graves where the dead sleep. But the third,
unknown mode, between day and night, between life and
death, is suggested by the open tomb from which Lazarus
is supposed just to have returned. The picture is clearly an
allegory, belonging with other religious subjects like
Golgotha (fig. 6). The source is the New Testament but
Chagall has reminded the viewer that the story concerns a
Jew by placing a Star of David and the 'hands of Levi' as
emblems on the tomb. Paradoxically and no doubt
intentionally, both signs have other meanings: this star,
formed from interlocking triangles, is an old magic formula,
adopted by Jews only in the nineteenth century; the hands,
for Jews representing a priestly blessing placed on the grave
of a priest (*kohen*), resemble those prehistoric hand prints
found in cave paintings, publicised by the Abbé Breuil in
1911. As is so often the case, Chagall has here made a picture
with extended levels of meaning.

REFERENCES
G. T. Noszlopy, 'Apollinaire, Allegorical Imagery and the Visual
Arts', *Forum for Modern Language Studies*, IX, no. 1, Jan. 1973; H.
Alcadé del Rio, H. Breuil, L. Sierra, *Les cavernes de la région
cantabrique*, Monaco, 1911, fig. 106.

34

The Fiddler 1912–13

Le violiniste

$74 \times 60\frac{5}{8}$ in/188 × 158 cm
Stedelijk Museum, Amsterdam, dienst verspreide Rijkskollekties;
donated by P. A. Regnault

For many viewers this violin player standing with one foot
on the roof and the other on a little hillock will evoke the
long-running musical 'The Fiddler on the Roof'. The special
quality of the violin is described in evocative words by
Sholom Aleichem Stempeni, in his book on Jewish life: 'In
this sad song one hears the groan or lamentation of the soul.
In these marvellous and enchanted sounds flow the nostalgia

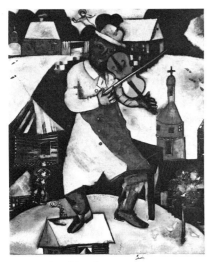

34 reproduced in colour on p. 75

of past youth, dead love, lost liberty' (p. 123). However, as in so many of Chagall's pictures conceived in La Ruche, the immediate impression of a simple fantasy of Russian rural life is deceptive, for there are many additional references. The houses in the background and the church tower in the foreground suggest memories of Russia, as does the musician himself. He was present in *Russian Wedding* (Cat. 9) and is featured in *The Violinist* (Cat. 36), where his setting is more specific. Here he has a green face: the same colour as *The Poet* (Cat. 20)—both are seen '*à travers la verte*', a contemporary slang expression indicating inebriation. Yet heads of gods—especially Osiris—were also painted green by ancient Egyptians as a token of resurrection, and other pictures have been linked with this mythology here, (see Cat. 15 and p. 36).

The Fiddler has a new ingredient, for it is painted on a white tablecloth with a checked pattern. Chagall has reinforced this built-in grid, apparently by ruling along the woven lines. Furthermore, behind the player's head he has allowed the areas of black and white to meet as though they formed a chequer board. He has thus shared a fascination for a favourite device of French artists of the time—but not in order to suggest movement as Delaunay was supposed to have done in *La Ville* (Musée d'art moderne, Centre Georges Pompidou)—according to an article in *Der Blaue Reiter*. Nor has he used it as a decorative device as Metzinger did in 1912 in his *La Danseuse au café* (Allbright Knox Gallery, Buffalo). Instead, he has literally painted part of a chessboard, the subject of a Cubist painting of 1912 by Marcoussis (*Le Damier*, Musée d'art moderne, Centre Georges Pompidou). Automatically the grid prevents the viewer's eye from reading a traditional perspective view, and, as Jean Clair has suggested, artists used the chessboard at that time to try to reveal a fourth dimension.

While that concept may be inappropriate here, Chagall has certainly wished to convey more than the present moment in time. For the small person with three heads placed one below another, is related to Dobuzhinsky's *Window at the Hairdresser's*, discussed in 'The Russian Background' in relation to the political uprisings in Russia in 1905 (fig. 18 and p. 33). The same abortive revolution had produced a

fiddler-hero, who had played his violin while leading marching workers through the streets (see Cat. 36). Thus Chagall's *Fiddler* functions on many levels—contemporary viewers might even have remembered the playing of Le Douanier Rousseau, or the violinist in Matisse's panel *Music*. But since with this *Fiddler* at the Salon des Indépendants of 1914, they could see Chagall's astonishing *Pregnant Woman* (fig. 12) and *Self-Portrait with Seven Fingers* (fig. 8), they certainly marvelled at the originality of this imaginative Russian artist.

REFERENCES
Sholom Aleichem Stempeni, *La vie juive*, St Petersburg, 1903 (quoted by V. Marcadé, *Le Renouveau de l'art pictural russe, 1863–1914*, Lausanne, L'Age d'Homme, 1971); A. Barrère, *Argot and slang, a new French and English Dictionary of the cant words, quaint expressions, slang terms and flash phrases used in the high and low life of old and new Paris*, London, Hugo's Language Institute, 1906; E. von Busse 'Robert Delaunay's Methods of Composition', in *The Blaue Reiter Almanac*, (ed. W. Kandinksy and F. Marc), documentary edition ed. by K. Lankheit, London, Thames & Hudson, 1974; J. Clair, 'L'échiquier, les modernes et la quatrième dimension', *Revue de l'Art*, no. 39 1978, pp. 59–68.

35

The Flying Carriage 1913

La calèche volante

Oil on canvas
$42 \times 47\frac{1}{4}$ in/106·7 × 120·1 cm
The Solomon R. Guggenheim Museum, New York

Although this is the title by which the painting is now known, it was reproduced in *Sturm Bilderbücher* no. 1 as *Landschaft* (*Landscape*) and has subsequently been named *The Burning House*. When Angelica Rudenstine was preparing her exhaustive catalogue of oil paintings at the Guggenheim Museum, she invited her colleague Margit Rowell to visit Chagall to discuss his paintings. He 'identified the scene as a peaceful one, in which the predominant emotion is ecstasy, not panic or fear: "C'est calme, mon tableau, rien ne brûle. C'est la grande extase"' (p. 61).

The Flying Carriage of the title is a magic vehicle with no shafts, rising into the air near an unbridled horse wearing a typical Russian collar with bell (like the one in *The Cattle Dealer*, Cat 28). The other figures in the richly coloured scene seem only dimly aware of the event; a man continues

35 reproduced in colour on p. 74

to carry his bucket near the doorway of the shop (identified by the sign *lav*, short for *lavka*, meaning 'shop'). A woman, hidden from their sight—as well as partially from ours— raises her arm over her head as though to shield herself from the brilliance of day: her own section of the picture is a starry night sky. This suggests one interpretation of the subject, for traditionally the sun god rises in his chariot: the subject was brought to the fore by the publication of a new Russian language journal in Paris in November 1913, named *Gelios*, the Russian orthography for 'Helios' (the Greek sun god). On the cover was a neo-primitive design by I. Lebedev, showing a charioteer with his steeds inside a flaming sun (fig. 22). Chagall's charioteer with his single rearing horse, near a Russian village shop, is unlike the cover design, although his colours are a reminder of the section devoted to Russian Folk Art at the Salon d'Automne of 1913. This was discussed in an article in *Gelios* with photographs of three-dimensional objects, including toys and embroideries. Their vivid colours would have struck Chagall anew after his three years in Paris.

A different connection was made by Rudenstine, who noted a similarity between the motif of the flying carriage and Byzantine or medieval representations of Elijah's Ascension into Heaven. When Chagall was asked about this in 1974, he 'responded positively' (p. 62). It may be added that the theme was a favourite among ikon painters, and a detail from a sixteenth-century ikon now in the Tretiakov Gallery, Moscow, is surprisingly close, although there the Prophet is looking downwards to Elisha, to whom he is handling his cloak. (In II *Kings*, II, 11–13, it is related that there appeared chariots, and horses of fire which separated them, and Elijah was carried up in the whirlwind to heaven.) But once again Chagall has not followed a story precisely: he has simply placed his figures in such a position that it is possible to read into the picture any one of a number of interpretations.

Meyer suggested a third interpretation, seeing it as a 'Burning House' with the 'astral powers, sun and moon, in opposition . . . Between them stands the house of man, forever burning yet never consumed' (p. 204).

Chagall has here used a precise symbol (a 'flying carriage') but he has presented it in a way which permits the viewer to interpret it in any number of ways. If he has used sources as a starting-point, he has transformed them in his unique way. His friend Cendrars was working on a book on Redon during 1913 (which remained unpublished), though he almost certainly read Redon's words: 'I cannot be denied the credit of giving life to my most unreal creations', and his description of his own originality 'in causing improbable beings to live in human fashion according to the laws of the probable'. These words seem equally appropriate to Chagall.

REFERENCES
Sturm-Bilderbücher I/Marc Chagall, Berlin, Der Sturm, 1923; A. Zander Rudenstine, *The Guggenheim Museum Collection Paintings 1880–1945*, vol. I, New York, Solomon R. Guggenheim Museum, 1976; IA. Tugendkhol'd, 'O russkom narodnom tvorchestve v salon d'automne', *Gelios*, I, November 1913; Redon cited without source, J. Selz, *Odilon Redon* (trans. E. Hennessy), New York, Crown, 1979, p. 21.

36 reproduced in colour on p. 69

36

The Violinist 1911–4

Le violiniste

Oil on canvas
$37\frac{1}{4} \times 27\frac{1}{4}$ in/94·5 × 69·5 cm
Kunstsammlung Nordrhein-Westfalen, Düsseldorf

The subject is one that Chagall often returned to: he made several versions of a single player and incorporated a violinist in many pictures. Here the player dominates a rural scene, accompanied by a boy who holds out his cap in a gesture of appeal. The couple in the background may remember a wedding day, for a strolling fiddler always played at Jewish weddings. Chagall himself had learnt the instrument, and has always remained a music-lover, often playing records while he paints.

The Violinist is dated '1911–4', indicating that it belongs to the artist's time in Paris. During those years an Estonian musician was playing his violin at emigré, fund-raising concerts. An article written by Lunacharsky about Eduard Sõrmus appeared in the Russian-language Paris newspaper in November 1912, explaining how this revolutionary musician had led street demonstrations in 1905. (Sõrmus once told Lenin that he wanted to help free the proletariat with his violin.) Thus Chagall's picture functions on several levels to those familiar with its background; yet it can also stand alone, acting through the power of colour to evoke emotion. The violinist, with his red coat stylised into a single plane and his arm reduced to a sweeping arc, more eloquent than realistic, is not so much a 'real' person as a means of transcending everyday life. This was a device which Chagall used also in *Orpheus* (fig. 7) and *The Lovers* (fig. 2), finished, like this picture, shortly before he left Paris for Berlin.

REFERENCES
A. V. Lunacharskiĭ, *Parizhskiĭ vestnik* no. 47, 23 Nov. 1912 (cited by R. C. Williams, *Artists in Revolution*, London, Scolar, 1977, pp. 53, 210 n. 50.).

Russia and Berlin

1914–23

Chagall's visit to Russia was intended to be of three month's duration, but was prolonged indefinitely by the outbreak of the First World War. Stranded back in provincial Vitebsk, his most significant achievement was to marry his sweetheart, Bella. The realities of his early life appearing now in a new light gave rise to *The Praying Jew* (Cat. 43) and *The Newspaper Vendor* (Cat. 44). Although a more factual account of everyday life than the pictures he had left behind in Berlin and Paris, the new ones do not fit the tradition of Russian Realism: their quality is rather '*surnaturel*', a term coined by Apollinaire in Paris (see *The Feast Day, Rabbi with Lemon*, Cat. 45). This element contributes a completely different flavour to his work included in contemporary avant-garde Russian exhibitions (see 'The Russian Background', pp. 37ff.).

1917 was the momentous year of upheaval and change in Russia, with the Revolution of February followed by the October victory for the Bolsheviks, commemorated a year later in Vitebsk when Chagall, as Commissar for the Arts, organised a grand celebration. Opening an art school and founding a museum, and at the same time working on stage designs, he found time to paint views of the city, like *Red Gateway* (Cat. 56) and the poignant *Cemetery Gates* (Cat. 55).

Although on a small scale, *Homage to Gogol* (Cat. 61) and, especially, *Composition with Goat* (Cat. 62) reveal his serious consideration of the changing order of revolutionary art. They reflect the conflict which arose when Malevich arrived at the Vitebsk art school and proceeded to preach an art devoid of figures. A most important commission, to paint huge canvases for the State Jewish Kamerny Theatre, allowed the Chagalls to leave for Moscow and resulted in *The Green Violinist* (Cat. 64), while the small but significant *The Dream* (Cat. 63) gives an idea of another style which the artist used at the time.

The physical strains of the revolutionary years had been hard for the family (for a small daughter had been born—see *Bella with a White Collar*, Cat. 53). In 1921 they lived in a colony near Moscow, established by artists and writers to look after orphaned young people. Yet, for an artist with an international reputation, teaching fifty pupils was no viable future; neither were the schools of Moscow, at that time torn by arguments about the future of art. In common with other idealists, he sought permission to leave for the West: his feelings of uncertainty and desire for change are found in *My Life*, written in 1922; in visual form, they are seen in *Oh God* (Cat. 57).

In 1922 Chagall left the Soviet Union via Kaunas, where he exhibited pictures which he had brought with him, going on to Berlin, where his wife and daughter joined him. There they spent a year, during which the artist became embroiled in a legal case against Walden, who had continued to show Chagall's pictures at Der Sturm through the war years: many had been sold and the artist needed compensation. More importantly, Chagall learnt etching, a technique which resulted in some remarkable prints (see Prints section). This skill permitted him to return to Paris to undertake commissions which extended the basis of his art and brought about a flowering of ideas, nourishing his creativity for the decades to come.

fig. 37 Chagall at work on a sketch for a mural for the State Jewish Kamerny Theatre, Moscow, 1920–21

37

Wounded Soldier (1914)

Le soldat blessé

Watercolour and gouache on cardboard
$19\frac{1}{4} \times 14\frac{7}{8}$ in/49 × 38 cm
Private collection

This exceptional work reveals a different side of Chagall from the one to be seen in the large oil-paintings that he had left in Berlin, or from the studies from life which he began in Vitebsk in the same year (for instance, *David in Profile*, Cat. 39, or *The Praying Jew*, Cat. 43). On a small scale, he has

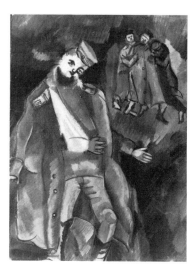

37 reproduced in colour on p. 82

captured the realities of war in a reminder of the wounded soldiers who must have been a familiar sight in Vitebsk, a city which has always been connected with the eastern defences of Russia. Using a range of unexpectedly drab colours, the artist presents his stricken soldier, his arm now in a sling, holding out his hand to a memory of his wounding when he had been supported by two friends in a moment which he cannot forget.

In formal terms, the handling of the background with parallel strokes which knit the surface together, is curiously like a nude by Braque which had been exhibited and then reproduced (in the *Golden Fleece* journal, no. 2–3, 1909). But the style may have been filtered through a series of pictures of soldiers that Larionov had painted during and after his year of military service (1910–11). In 1912 at least two had been used for postcards made by transfer lithography (figs. 20, 21), which Chagall may well have known.

This picture, one of a series (see Meyer, cat. 210–18), is in marked contrast to the propaganda posters, mock-folk prints, published in the winter of 1914 by other artists, or the *Mystical Images of War*, a series of heroic images published as a portfolio of lithographs by Goncharova.

REFERENCES
Zolotoe runo, 2–3, 1909, p. 20;
N. Goncharova, *Voĭna: misticheskie obrazy voĭny*, Moscow, Kashin, 1914.

38

Leave-Taking Soldiers 1914

Les adieux des soldats

Pencil, ink on brown card
9 × 14 in/22·6 × 36·2 cm
Kunstmuseum, Basel

During the First World War Chagall made a number of images of Russian soldiers, but whereas he relied on paintstrokes and colour gradations in *Wounded Soldier* (Cat. 37) to convey a feeling of the hopelessness of war, here he has restricted himself to black and white. That poignant moment when loved-ones must part is visualised through facial expression, which was far less important in *Wounded Soldier*.

It is fascinating also to compare *Leave-Taking Soldiers* with an earlier gouache made in Paris, *The Spoonful of Milk* (Cat. 30), which, in a different way, is full of feeling. There the woman's face is reduced to a series of sharp and even cruel lines: conflict is expressed through harsh, bright colours.

Since the late nineteenth century colour had been popularly thought to be a therapeutic agent, but in *Leave-Taking Soldiers*, perhaps to reflect the finality of war, Chagall relied on black ink with white highlights, increasing the telling conjunction of man and woman by constricting the imagery in a lunette-like shape. This suggests another reason for the use of black and white, which is confirmed by the careful corrections, applied with white. For although no known book includes illustrations of soldiers by Chagall, this is one of a number of drawings which would appear to have been intended for reproduction. Other drawings, though not of soldiers, were printed, for instance those for the fable *The Magician* by I. L. Peretz (Vilna, Kletskin, 1917; see Meyer, cat. 251, 252). Chagall's graphic work is discussed in the section of this catalogue devoted to prints (pp. 259ff.), but this fine drawing shows the artist's mastery of a medium suitable for simple printed reproduction before he began to explore the richness of conventional graphic techniques.

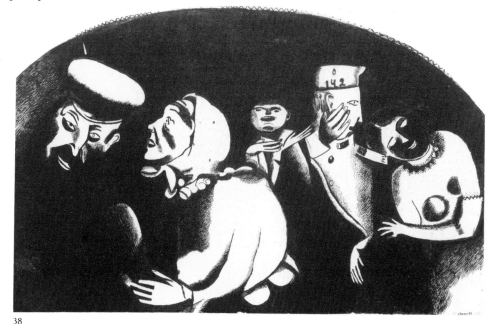

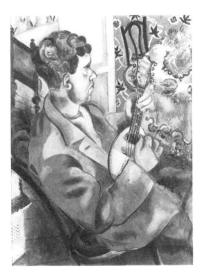

39 reproduced in colour on p. 81

39

David in Profile (1914)

David de profil

Oil on paper, fixed on board
$19\frac{5}{8} \times 14\frac{3}{4}$ in/50 × 37·5 cm
The Art Museum of the Ateneum, Helsinki

When Chagall returned to Vitebsk in summer 1914 he
painted a number of portraits and studies of his immediate
family. His younger brother, David, was twenty-two and
suffered from tuberculosis; he went subsequently to the
Crimea, where he died. Chagall remembered him fondly:
'My brother. I could do nothing. Tubercular. The cypresses.
Far away from us all. Decline. / But before, we used to sleep
in the same bed' (*My Life*, p. 33).

Chagall painted several studies of his brother from
different angles and for this one he has chosen to show him
playing the mandolin with his chair tipped backwards, so
that the figure in his colourful green jacket divides the
canvas diagonally in two. The artist has exaggerated the
unhealthy hue of the face using a purple to contrast with
the green and extending the colour oppositions by
juxtaposing the red patterned wallpaper of the room
beyond. The adjoining rooms are cluttered with objects: a
patterned curtain hangs beyond the bed and there is another
design on the tablecloth, making the pictorial space busy to
the eye. This perhaps reflects Chagall's interest in Matisse's
La chambre rouge, 1908 (Hermitage, Leningrad), which was
then in the collection of Shchukin in Moscow and was
reproduced early that year in a fine colour reproduction in
the journal *Apollon* (1–2, 1914, p. 60).

40*

The Artist's Sister 1914

La sœur de l'artiste

Oil on canvas
$31\frac{1}{8} \times 18\frac{1}{4}$ in/79 × 46·5 cm
Collection of Ida Chagall, Basle

When he returned to Vitebsk in 1914 Chagall painted most
of his oils on cardboard, so this is a rare example of a work
on canvas from this time. He has used the coarse weave of
the canvas to give an added texture, and, by using thinly
applied paint, he has made the uneven fibres a decorative
feature. This is particularly apparent in the area of the
blouse, where it contributes its own pattern to the
embroidery on the white material.

The portrait was reproduced with the title *Lisa at the
Window* in 1952: Lisa was the twin sister of Mania, whose
portrait Chagall had painted shortly before he left Russia in
1910 (see Cat. 5). Lisa was aged fifteen in 1914 and her

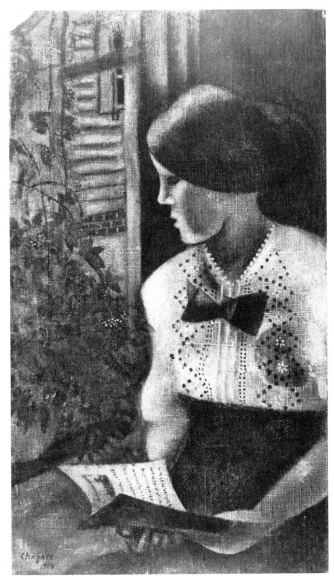

40

brother has beautifully captured the thoughtful melancholy of an adolescent girl, with her open book, sitting near an open window blocked by a vase of spring-like flowering twigs. The wall of the house across the street shares the same pink colour as her arm, as though she were poised to go out into the world, but uncertain what it holds for her.

REFERENCE
'Marc Chagall: die russischen jahre', *DU: Kulturelle Monatsschrift*, 22nd year, July 1952, p. 25.

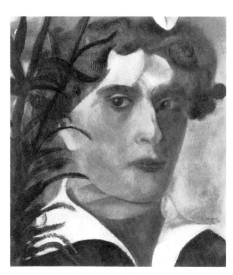

41 reproduced in colour on p. 80

41

Self-Portrait 1914

Autoportrait

Oil on paperboard
$11\frac{3}{4} \times 10\frac{1}{2}$ in/30 × 26·5 cm
Philadelphia Museum of Art; The Louis E. Stern Collection

This is one of a series of self-portraits which the artist painted after his visit to Russia in June 1914 had been prolonged indefinitely because of the outbreak of war. He has adopted a confident, traditional approach akin to the *Self-Portrait with Brushes* (Cat. 4). The present version anticipates a trend that became fashionable among the Parisian avant-garde in 1917, but was not unknown among Russian avant-garde artists (for instance, Filonov's portrait of his sister of 1915, State Tretiakov Gallery, Moscow). In Chagall's case, the experiments that he made in a number of styles while he was again living in Russia may have been triggered off by the discomfort of realising that his achievements of the past few years were now all trapped abroad, for he had left all his pictures at the Der Sturm gallery in Berlin or in Paris. But his natural curiosity was no doubt another contributory factor. In Berlin he had probably visited the huge retrospective exhibition of the work of Van Gogh, held in Paul Cassirer's gallery in May and June. (He left Berlin on June 14.) There he would have seen many self-portraits in varying styles, though one cannot

ignore the influence of the classical art in the Berlin museums as a further stimulus.

The colours are subdued, in dark tones reminiscent of the range favoured by seventeenth-century artists. Relief is given by the green leaves which run across his head, doubling as a laurel crown. (As there is the tip of a white flower over his forehead, the plant is most likely a lily.)

Self-Portrait shows the young man completely sure of the position that he had carved out for himself in the international art world. Here is no small-town boy made good, but an artist, fully confident of his own powers to create an image of himself by which he would like to be known. In 1929 a Belgian art magazine, *Sélection*, devoted an issue to the work of Chagall. The *Self-Portrait*, dated 1915, was reproduced opposite another from 1914, which then belonged to the collector, Kagan Chabchai (fig. 38). The two make a striking opposition, the classicism of the present one against the caricatured features in the other—in the vein of *The Pinch of Snuff* (Cat. 31). It is not surprising that Chabchai should have chosen the earlier version for his projected museum of contemporary Jewish art, rather than this: while Chabchai's portrait expresses the cunning playfulness of Chagall, the Philadelphia *Self-Portrait* catches him in a particularly serious moment, as he chose to see himself then, in the heroic tradition of Western art.

REFERENCE
Marc Chagall, *Sélection: Chronique de la vie artistique*, VI, Anvers, Sélection, 1929, pp. 94, 95.

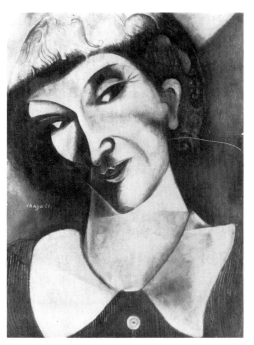

fig. 38 *Self-Portrait*, 1914 (collection of Charles im Obersteg)

42 reproduced in colour on p. 83

42

The Smolensk Newspaper 1914

La gazette de Smolensk

Oil on paper on canvas
15 × 19⅞ in/38 × 50·5 cm
Philadelphia Museum of Art; the Louis E. Stern Collection

This small picture is filled with messages. The piece of
newsprint which gives it its title bears only one legible
word, other than 'Smolensk News'. That word is *voina*,
'war'. The newspaper lies on the table between two men of
very different styles. The old man on the right is holding
his beard and meditating deeply, while the younger man
opposite pushes up his bowler hat and raises his finger,
though he is apparently not speaking. The two figures, each
in his own way, seem to react to the word 'war'. For them
both, war is a terrible event, but for the old Jew, himself
past the age for active service, perhaps the history of his
people in Russia preoccupies him. (During the nineteenth
century Jewish boys had often been seized from their
families and forced to enter the Russian army, humiliated,
and converted by force to Christianity.) For the other man
across the table, dressed in a Westernised style, his hair cut
short, who has already, at least superficially, relinquished
the closed Jewish society and allied himself with Russia, the
army and war lie ahead of him. As well as this contemporary
interpretation of the subject-matter of *The Smolensk
Newspaper*, its composition, two seated figures shown in
profile, is a reminder of a version of *The Cardplayers* painted
by Cézanne (reproduced in the journal *Apollon*, 6, 1910,
p. 89). In spite of the fact that Chagall's two men are neither
smoking nor playing cards, they seem to be related to
Cézanne's timeless figures, who contemplate forever the next
move in a game. It may be that Chagall saw two men like
these sitting at a table in front of a window as they are
shown here. But it is impossible for a Western viewer,
familiar with masterpieces of the last hundred years, to avoid
making the connection with Cézanne's figures.

REFERENCE
V. Lvov-Rogachevsky, Chapter v, 'Forced Military Service' and
Chapter xii, '1905 and After' in *A History of Russian–Jewish
Literature* (ed. & trans. A. Levin), Ann Arbor, Ardis, 1979.

43

The Praying Jew
(Rabbi of Vitebsk) (1914)

Le juif en prières

Oil on canvas
41 × 33 in/104 × 84 cm
Museo d'arte moderna, Venice

This composition is very likely the earliest of Chagall's series
of Jews of 1914–15, because the background retains the
patterns which are to be found in *The Lovers* (fig. 2), one
of the last pictures that he had painted before he left Paris
in June 1914. Compared with that picture, with its mask-like
heads, he has adopted a naturalistic style for the face of the
old man, who was painted from the life. 'Another old man
passes our house. . . . He comes in and stands discreetly by
the door. . . . "Listen", I tell him, "have a little rest. Sit
down. Like that. You don't mind that do you? Have a rest.
I'll give you twenty kopecks. Just put on my father's prayer
clothes and sit down."/Have you seen my portrait of the old
man praying? That's him.' (*My Life*, pp. 118–19).

By restricting the colours to the black and white regalia
of an orthodox Jew at prayer, Chagall has created a marriage
of realism and abstraction, using the black bands of the
traditional prayer shawl (*tallit*) as structural elements of the
composition. He has given the shawl a stylised serrated edge
on the right, continuing some of the lines of the leather
thongs which hold in place the phylacteries (the small
leather boxes containing words from the scriptures, written
on parchment). The one on the forehead complements the
geometric lines below.

Chagall repeated this composition almost line for line a
number of times. The earliest version is in the Obersteg
collection in Switzerland, painted on cardboard; the oil on
canvas in The Art Institute of Chicago is dated 1923, and the
one in the Museo d'arte moderna in Venice was purchased
in 1928, from the Venice Biennale of that year. On that
canvas the signature is accompanied by the inscription, 'N.2
Paris'.

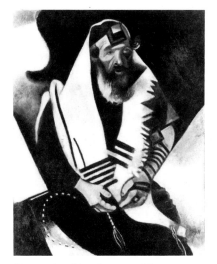

43 reproduced in colour on p. 84

The haunting image was almost certainly exhibited in Russia at 'The Year 1915', where the first entry in the catalogue under Chagall's name is *Black and white*. This would have been the Obersteg version, which was bought by the collector Kagan Chabchai, who was then hoping to set up a Russian museum devoted to Jewish art.

44

The Newspaper Vendor 1914

Le marchand de journaux

Oil on canvas
$38\frac{5}{8} \times 30\frac{3}{4}$ in/98 × 78 cm
Private Collection

Strangely, the landscape in this powerful picture is very close to the view in *Over Vitebsk* (Cat. 46), though the vendor must be standing, as it were, across the road, close to the paling fence on a level with the lamp-post, which appears here on the right side. But where the wall of the house beyond the fence in *Over Vitebsk* is blank, the one here is shown with a figure just visible in a window; and while the figure striding over the houses has been equated with a saviour, the newspaper seller seems full of foreboding.

There is a related pencil study for the picture, reproduced by Meyer (p. 251). It consists of the head, evidently drawn from life, with, below the beard, the tops of the newspapers. One of them bears the single word 'VOINA', meaning 'war'. The drawing is on grey paper, and in the oil Chagall has used the colour in association with red and black to convey the

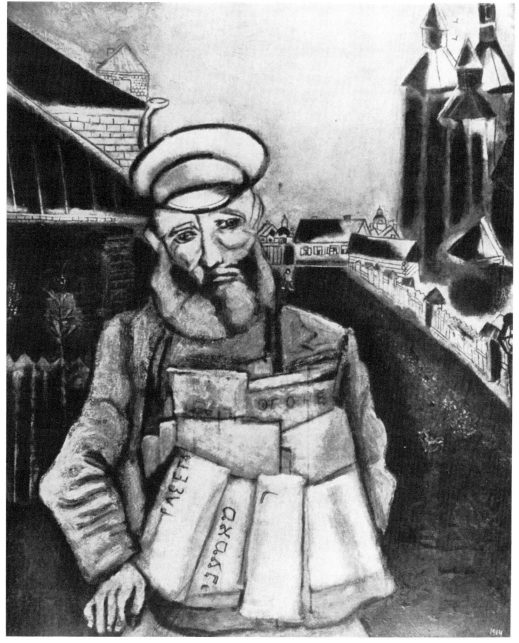

44

menace of the war, removing the word itself and replacing it with names of newspapers. Even then he has chosen the simple Cyrillic, 'GAZETA'—'newspaper'—juxtaposed with a Hebrew title. Surprisingly, the only other writing is a part of the word '*Ogonek*', the name of a St Petersburg journal which carried reviews of art exhibitions. Moreover, the vague forms of the newspapers, with their overlapping geometric shapes and letters and parts of letters, draw a strange analogy with a Cubist construction, whether by Picasso or by the avant-garde Russian, Tatlin (who exhibited on his own for the first time in May 1914). In his inimitable and forceful way, Chagall has drawn attention to divisions among the ranks of artists, inviting comment upon the making of art as well as of news and, even, of war.

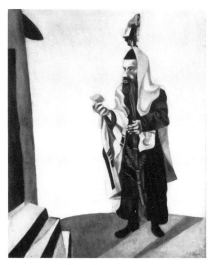

45 reproduced in colour on p. 85

45

Feast Day (Rabbi with Lemon) (1914)

Jour de fêtes

Oil on canvas
$41 \times 33\frac{1}{8}$ in/104×84 cm
Himan Brown

Feast Day is a faithful replica of the original of 1914 (now in the Nordrhein-Westfalen collection, Düsseldorf). It has one notable difference, for the violet colour has badly faded in the first version, and is here preserved. In his right hand the rabbi holds an *etrog*, a lemon, and in his left the *lulav*, a palm branch, to which are tied a branch of myrtle and willow. This identifies the feast of the title with *Succot*, the Feast of Tabernacles, which Chagall presented in another form in 1917 (see Cat. 51). The Feast is first mentioned in *Leviticus* XXIII, 40, 'On the first day you shall take the fruit of citrus trees, palm fronds, and leafy branches, and willows from the riverside, and you shall rejoice before the Lord your God for seven days'. The artist has added a touch of fantasy in the *doppelgänger* perched on the rabbi's head. Dressed slightly differently and lacking the ritual emblems,

the 'other' faces away from his host as though reluctant to celebrate the Feast. Or maybe he simply represents 'another', the one who 'gets on my back': Chagall's symbol is a potent myth with multiple possible interpretations. Another paradox in the scene is the doorway on the left: the harvest thanksgiving feast is associated with a temporary building, a tabernacle, but the artist has introduced a permanent doorway to suggest frontiers of different realities, as he had with the open door of the tomb in *Resurrection of Lazarus* (Cat. 33). However, he has adopted a quite different style here, with no suggestion of the fraternisation with Cubism that had occupied him in Paris.

Surprisingly, *The Rabbi with Lemon* is like a reinterpretation of some early Renaissance saint from an Italian painting, his *etrog* and his *lulav* replacing the insignia associated with traditional representations of a Christian saint. The prayer shawl (*tallit*) and long garment give him the timeless air of a figure in some fresco by Giotto, or perhaps Piero della Francesca. (As books on art like the series *Klassiker der Kunst*—monographs with excellent photographs and details of historic artists—were available before 1909, it is unnecessary to ask whether the artist 'knew' such work, even though it may seem surprising that he adopted such a realistic approach.)

Fantasy is here combined with apparent realism to create a supernatural effect; indeed, the poet Apollinaire had already dubbed Chagall's work *surnaturel* (*My Life*, p. 114). The term was explained in an editorial article in the periodical *Les Soirées de Paris* in May 1914, just before Chagall left Paris. It was couched in the form of a defence of Apollinaire as a *Fantasiste* and told the reader: 'Supernaturalism . . . is a superior naturalism, more sensitive, more lively and more varied than the former . . .'. The article, signed by the pseudonym Jean Cerusse—a pun on the editors' names—also included the assurance that although people had not recognised 'reality' in Apollinaire's poetry, they ought to realise that he was attempting entirely natural poetry with no artificiality: 'what seems in it most fantastic is often most true'. The article ended, 'Nothing is beautiful except truth', a motto which Chagall might be said to be illustrating in this fantastic but 'real' picture.

One version of *Feast Day* was exhibited in Paris at Chagall's show at the Galerie Barbazanges in 1924, the year of the Foundation Manifesto of Surrealism, which Apollinaire had originated with his more ambiguous term *surnaturel*. But Chagall decided not to be counted amongst the Surrealists, because he disliked their insistence on automatism, although he felt that Surrealism confirmed the basic trend of his art (Meyer, p. 334). Throughout the 1920s and 1930s his own fantasy remained closer to the original definition of the *surnaturel* which is encapsulated in this painting, originating in 1914.

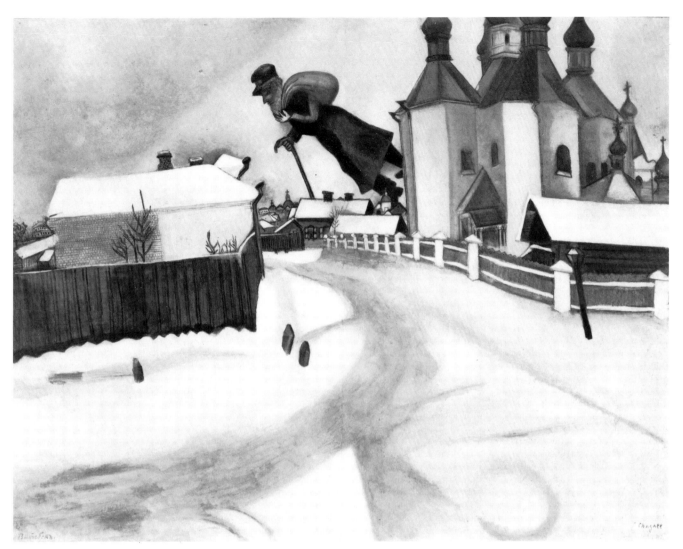

46

46

Over Vitebsk 1914

Au-dessus de Vitebsk

Oil on card on canvas
28¾ × 36½ in/73 × 92·5 cm
The Art Gallery of Ontario, Toronto; gift of Sam and Ayala Zacks

The subject is one to which Chagall returned several times, but this version appears to be the first, painted in oil on cardboard, a medium frequently used by the artist after his return to Vitebsk in June 1914. The view is the Iltych church: a close-up of the same scene appears through the window in *The Birthday* (Cat. 48), painted shortly before Chagall's wedding in July 1915. Bella wrote: 'That summer you had a room of your own, remember? It wasn't far from your parents' house, and you'd rented it from a policeman . . . It was on a corner, by a long wall enclosing a convent standing in a large garden' (*First Encounter*, p. 227).

The crossroads in *Over Vitebsk* is covered by snow, with marks where carts have dirtied it creating a pattern in the light-coloured expanse of paint, a reminder of the much less

realistic style which Chagall had explored before he left Paris. Here, however, the emphasis is on a naturalistic rendering of the local scene, so the appearance of an old man in the sky is all the more unexpected. With his quietly resigned, yet strong face and the sack over his shoulder, he is as much a part of the landscape as a tree or a factory chimney: indeed, his walking stick echoes the angle of the street lamp in the foreground right.

This is not the first time that Chagall had painted an over life-size figure hovering in the sky, for *To Russia, Donkeys and Others* (Musée national d'Art moderne, Centre Pompidou; fig. 23) includes a witch with her head completely detached from her body, staring into a sky blackened by an eclipse. But the appearance of the strange being in that fantastical composition is hardly comparable with *Over Vitebsk*, where the old man could have been shown on a smaller scale walking along the street, though he would not then have attracted attention as Chagall has caused him to do.

What is the meaning of the figure? In his study of the artist, Isaak Kloomok reminded his readers of a common Yiddish expression 'he walks over the city', describing a

beggar that goes from door to door begging. He says that many Yiddish-speaking people identify the subject with that phrase and tells of the persecution, discrimination and restrictions which were the lot of Jewish people in eastern Europe. He identifies Chagall's figure as 'the eternal wanderer, the Jew without a country . . . tossed into the air to fall down somewhere, God knows where . . .' (Kloomok, p. 37). But this pessimistic interpretation loses sight of other associations, also suggested by Kloomok in an earlier chapter, in which he speaks of the religious life of Jews in communities 'of the not-distant days' and tells of the importance of Elijah. The prophet still comes uninvited if one is deserving of his favour : 'at any time of great need to bring succour and salvation—though one may not recognise him, for he comes in all kinds of disguises . . . a sack on his shoulder, in which he brings his gifts when material aid is wanted' (p. 5).

Chagall's bearded figure with a stick and a bundle on his back reappears many times in his later work as a motif in scenes of persecution of the Jews, for instance *The White Crucifixion* (Cat. 81) and *War* (Cat. 107). To the present author, the figure always seems closer to Elijah in a saving role than to one of despair. The interpretation noticed also by Allyn Weisstein (p. 42) is confirmed by Chagall, for describing the custom at the Passover Seder of opening the door to let in the prophet Elijah, he wrote: 'But where is Elijah in his white chariot?/Is he still waiting in the courtyard, perhaps, to enter the house in the guise of a wretched old man, a hunchback beggar, with a pack on his back and a stick in his hand?/"Here I am, Where is my glass of wine?"' (*My Life*, p. 45).

REFERENCES
I. Kloomok, *Marc Chagall: His Life and Work*, New York, Philosophical Library, 1951; A. Weisstein: 'Iconography of Chagall', *Kenyon Review*, vol. XVI, 1(Winter) 1954, pp. 38–48.

47

Study for Birthday 1915

Pencil, pen and ink on paper
9 × 11½ in/23 × 29 cm
The Museum of Modern Art, New York; gift of the artist

This is a preparatory drawing for the central figures of *The Birthday* (Cat. 48). It shows Chagall's typical flowing style with a pencil: in a remarkably fluid series of lines he concentrates on establishing the relationship between himself and his fiancée. They form the right side of a triangle, of which the left consists of a table, treated as a plane in steep recession in order to balance and anchor the two figures and create a classical composition. The drawing is squared up, but the lines have been added in ink, possibly in 1923 when Chagall made a replica of *The Birthday* now in the Solomon R. Guggenheim Museum (the circumstances are described in detail by Angelica Rudenstine in her catalogue, pp. 69–73).

REFERENCE
A. Zander Rudenstine, *The Guggenheim Museum Collection Paintings 1880–1945*, vol. I, New York, The Solomon R. Guggenheim Museum, 1976.

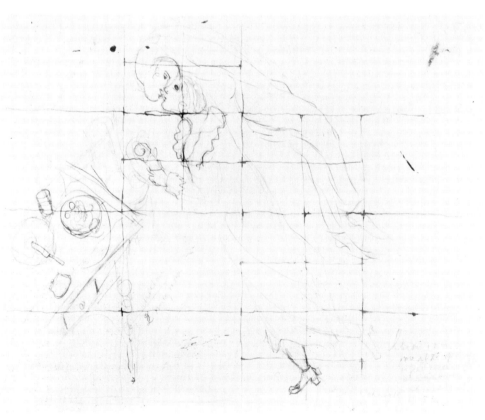

47

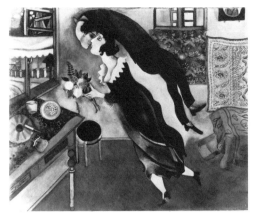

48 reproduced in colour on p. 87

48

The Birthday (1915)

L'anniversaire

Oil on canvas
$31\frac{3}{4} \times 39\frac{1}{4}$ in/80·5 × 99·5 cm
The Museum of Modern Art, New York

A vivid account of the genesis of this picture is to be found in the memoirs of Chagall's wife, Bella, dedicated to Marc in 1939. 'The Birthday' is the final chapter of *First Encounter*, where she describes a visit to the artist's room: 'although I don't know how I did it, I did somehow find out the date of your birthday' (p. 224). She tells how she ran to the outskirts of Vitebsk to pick flowers, went home and gathered all her bright scarves and silk squares and even the coloured quilt from her bed, before putting on her best dress and hurrying across the town to Chagall's room. After his initial surprise, she remembers him rummaging among his canvases and putting one on the easel. '"Don't move" you said, "Stay just like that."' Although this suggests that the whole painting was done very spontaneously and quickly, there is a pencil study (a gift of the artist to the Museum of Modern Art) with slight variations (see Cat. 47).

Whereas the drawing establishes the magical relationship of the hovering figures and indicates the detailed elements of the still-life on the table, the role of the table itself has become less important in the oil. For instead of being based purely on a triangle, the final composition depends on the balancing of the diagonals on the left by additions on the right, where the bed and shawl above it have been added. Likewise the area above the table has been enlivened by a window. The view outside provides links with other paintings: it is a close-up of *Over Vitebsk* (Cat. 46) and *The Newspaper Vendor* (Cat. 44). *The Birthday* also has connections with *The Lovers* (fig. 2), with its red table below a window with another view of Vitebsk. But in the present picture of a very specific occasion, the artist and his fiancée have materialised out of the realm of hope and imagination of the earlier *Lovers* into a 'real' space, in spite of the 'impossible' position of the artist. Instead of the the two masks of *The Lovers*, the features of the ecstatic couple are rendered in a recognisable manner.

Here Chagall has captured the anticipation and vision of his fiancée, gazing out with her staring eyes, to where as she says, 'Through the window a cloud and a patch of blue sky called to us. The brightly hung walls whirled around us. We flew over fields of flowers, shuttered houses, roofs, yards, churches '(*First Encounter*, p. 228). Thus she also recalls later developments of the theme, where the artist and his bride hover above the town in *Over the Town* (State Tretiakov Gallery, Moscow; fig. 25) or she soars up into the air in *The Walk* (State Russian Museum, Leningrad) painted about a year afterwards.

49

The Poet Reclining 1915

Le poète allongé

Oil on millboard
$30\frac{3}{8} \times 30\frac{1}{2}$ in/77 × 77·5 cm
The Trustees of the Tate Gallery, London

The figure lying on the grass with his head leaning on an artist's palette is that of Chagall himself, but *pentimenti* suggest that there may once have been a second figure alongside. He has said that the picture was painted in Russia during the honeymoon which followed his marriage to Bella Rosenfeld in July 1915. In *My Life* he wrote of the days after his wedding: 'Alone together in the country at last./ Woods, pine-trees, solitude. The moon behind the forest. The pig in the sty, the horse outside the window, in the fields. The sky lilac' (p. 123).

The elongated figure exactly fits the base of the canvas, as though it were a framing device. The same idea is to be found in *Madeleine au bois d'amour* painted by the French Post-Impressionist artist, Emile Bernard, in 1888. In a very similar range of colours, a single figure lies on the ground in a rather more heavily wooded landscape, wearing a blue dress and pensively looking into the space in front of her. Madeleine was the saintly sister of the artist, much loved by Gauguin whom Chagall admired.

Chagall has painted himself here in the role of poet, but perhaps he wanted to be seen in the tradition of his own people. He had grown up in the sect named Hasidim, which

49 reproduced in colour on p. 86

had given him a pious but happy background. One of the famous Hasidic teachers, Rabbi Nachman of Bratzlav, said: 'Each tongue of grass has its own tune. It is beautiful to hear the field of grass sing. When you pray in the open field the grass and the flowers enter into your prayers and give them power to ascend to heaven' (Kloomok, p. 5).

Soon after he painted *The Poet Reclining* Chagall began to illustrate a short story by the Yiddish writer, I. L. Peretz. Kloomok recalls that when Peretz wanted to describe the fields in early spring, he said with the Talmud: 'You can sense how behind each blade of grass there stands an angel and urges it on: grow! grow!' (p. 5).

There is a curious tension between the body of the artist lying rigid on the ground and the remainder of the landscape, tranquil and bathed in evening light, with the animals feeding peacefully in the background. The poet himself is alert, listening perhaps to some words of inspiration which come to him from another world, or from the angel who makes the grass grow. Leaving aside such poetic interpretations, the style which Chagall has adopted for his own figure, with its modified return to a type of Cubism, can be related to contemporary work by Natan Al'tman, best known for his portrait of the poet Anna Akhmatova, dating from 1914 or 1915. Today in the Russian Museum, Leningrad, it has many of the characteristics of the gentle Cubism which Chagall reintroduced into his own work, probably in the middle of 1915. A similar combination of Cubism and naturalism is found in *Vitebsk: from Mount Zadunov* (Cat. 54).

REFERENCES
R. Alley, *Catalogue of the Tate Gallery's Collection of Modern Art Other than Works by British Artists*, London, The Tate Gallery, 1981, pp. 110–11; I. Kloomok, *Marc Chagall, His Life and Work*, New York, Philosophical Library, 1951.

fig. 39 *Sketch for the Baby Carriage*, 1916–17 (collection of Ida Chagall, Paris)

50 reproduced in colour on p. 88

50

Visit to the Grandparents 1915

Pen, indian ink and wash
$18\frac{1}{4} \times 24\frac{1}{2}$ in/46·5 × 62·5 cm
Private Collection, London

This exquisite pencil drawing has unusually restrained colour added in wash. Accents are given by the purple skirt of the grandmother, the contrasting orange in the doorway and the mellow straw-coloured perambulator, which relieve the black and grey; a little splash of orange on the loaf of bread gives the finishing touch.

Visit to the Grandparents is related to the *Sketch for the Baby-carriage* (belonging to Ida Chagall; fig. 39), which was preparatory to a mural for a secondary school in Petrograd (see Cat. 51). But *Visit to the Grandparents* is altogether more informal, with the grandfather stretching out his arms and the grandmother throwing the child up into the air in a gesture of joyful recognition, echoed by the curiously stylised figure near the window. There are delightful touches such as the cat playing with the wheel of the pram and the little pullet standing on the shelf above the bread oven. This is an altogether charming work with none of the severity of the sketch for the mural.

51

The Feast of the Tabernacles 1916

La fête des tabernacles

Gouache
$13 \times 16\frac{1}{8}$ in/33 × 41 cm
Private Collection; courtesy of Galerie Rosengart, Lucerne

Like *Visit to the Grandparents* (Cat. 50) and *Purim* (Cat. 52), this theme is related to a commission which Chagall received early in 1917 to provide murals for a secondary school attached to the chief synagogue in Petrograd (Meyer, p. 246). The celebration of this feast, essentially a harvest thanksgiving, is beautifully described by Bella in her vivid accounts of her childhood. For the feast, held at the time of a harvest moon, a temporary lean-to or tabernacle (*succot*) was built behind the house. 'A cart loaded with pine

branches drove into the yard . . . The planks of the walls were up and nailed together, but the roof was still open and the sky peered in. My brothers climbed up ladders and stood on chairs to pass the branches to one another, waving them about like the *lulav*, or palm branch, used in the holiday celebrations. . . . The branches were piled so thick no star could shine through. A cool twilight reigned within. Only through the chinks in the walls could a few rays of light struggle in. /In the middle of the booth a long table was installed, with benches on either side. The floor was just bare earth, and the legs of the table and benches stuck in the damp ground, which clung to our shoes' (*First Encounter*, p. 67). She goes on to tell of the ceremonial meal which her father and brothers ate there, with the food passed in through a hatch in the side, for no women could join in.

Chagall has depicted two men in the lean-to and the version on show has lost the roof of branches which can be seen in another, described by Meyer as the sketch for the mural (Meyer, cat. 257). In the present gouache the serving woman passing the food is stylised in a similar way to the woman in the foreground of *Purim* (Cat. 52). As there are indications for colours written in Cyrillic on the drawing, it would seem as though this was also a preliminary study for the murals.

51 reproduced in colour on p. 90

52

Purim (c. 1916–18)

Pourim

Oil on canvas
$19\frac{7}{8} \times 28\frac{1}{4}$ in/50·5 × 72 cm
Philadelphia Museum of Art; The Louis E. Stern Collection

Like *Feast of the Tabernacles* (Cat. 51) and *Visit to the Grandparents* (Cat. 50), *Purim* is related to the commission for murals for a secondary school attached to a synagogue in Petrograd. This version on canvas may date from a later period, although with its emphasis on the silhouette and the wide expanse of background colour it is probably related to an earlier project for the mural. The final version for that commission, a work on paper, is today in the collection of

52 reproduced in colour on p. 89

Ida Chagall; this is simplified and formalised, and has fewer details than the oil exhibited here. These details are didactic: they convey both the original account in the Book of Esther of *Pur*, the casting of lots for the destruction of the Jews which is remembered in the feast, and also beautifully illustrate Bella's memories of the celebration of Purim in her childhood. On the right of the picture sits the market stall-keeper, who, in her account, used to urge the children to hurry up and choose their Purim sweetmeats, made in the form of dolls, or little horses and fiddles. The child is nearly out of sight in Chagall's picture, but Bella's tall thin boy, Pinya, who offered to deliver the Purim presents, is to be seen striding across the middle of the canvas. '"Here are the Purim gifts, Pinya, don't run with them, will you?"' (*First Encounter*, p. 125). Children exchanged gifts, taking one from the plate (carried by Pinya) and putting another in its place. In the foreground is the old woman, wrapped in a large shawl, who, at the end of Bella's story, brings a yellow sugar horse as carefully as if it were a new baby: 'A strange woman, like someone out of the madhouse. Had she really once been my brother Isaac's nurse?' (op. cit., p. 130).

But Chagall has introduced a more serious note in the background. On a blue banner-like form rides a horseman. Is he another Purim gift, or is he one of the mounted couriers, riding on horses from the royal stables, who took the writ of King Ahasuerus granting permission to the Jews in every city to unite and defend themselves? Do the strange figures in the upper left of the picture, apparently on poles, represent the sons of Haman who after Queen Esther's intervention were hung up on the gallows? Following this story of the Jewish Queen and her brave Uncle Mordecai, we read: 'This is why isolated Jews who live in remote villages keep the fourteenth day of the month Adar in joy and feasting as a holiday on which they send presents of food to one another'. (*Esther*, IX, 19)

On the eve of the Bolshevik revolution, when these murals were planned, the time of modern pogroms was barely over. In *My Life*, Chagall tells of how he had himself been stopped in Petrograd and had narrowly escaped with his life (p. 132). To the pupils of the school his vision of *Purim* would have evoked both joy for their history and hope for the present time.

REFERENCE
Book of Esther, *The New English Bible*, London, Collins World, 1970.

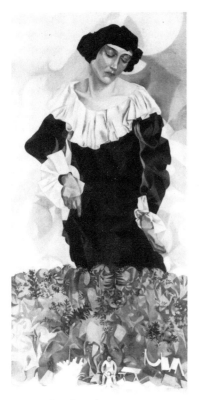

53 reproduced in colour on p. 95

53

Bella with a White Collar 1917

Bella au col blanc

Oil on canvas
58⅝ × 28⅜ in/149 × 72 cm
Collection of the artist

This marvellously inventive composition is an evocation of
the artist and his family on some rural occasion, probably
inspired by their weeks in a dacha in the summer of 1917.
Chagall has begun with a touching full-length portrait of his
wife, in the style and colouring of *The Vision* of the same
year (Ministry of Russian Culture, Leningrad; reproduced in
colour in *Marc Chagall*, p. 57). In that vision the artist was
greeted like Tobias by an angel who shares his human scale.
In this picture his wife looks downwards on a domestic
scene: the artist is guiding the first footsteps of their small
daughter Ida in the foreground below. The woods are like
the stylised trees of *Vitebsk: from Mount Zadunov* (Cat. 54),
but here there is evidence of outdoor living—the bench and
table, and curious shapes, which suggest both a hammock
beside an easel and references to the Hebrew alphabet.

 Although on a smaller scale than *Double-Portrait with
Wineglass* (Musée national d'Art moderne, Centre Georges
Pompidou), the effect is of a monumental composition. With
only three main colours, Chagall has achieved a magical
freshness which remains unrivalled.

REFERENCE
Marc Chagall: Rétrospective de l'œuvre peint, Saint-Paul, Fondation
Maeght, 1984.

54

Vitebsk: from Mount Zadunov (1917)

Vitebsk, vue du Mont Zadunov

Oil on canvas
24½ × 32½ in/62 × 82·5 cm
Private Collection

This landscape, apparently painted *sur scène*, combines two
distinct stylistic approaches typical of Chagall's Russian
work. The buildings of Vitebsk seen in the distance in
sombre colours, with the dark green foliage overhead, are in
a style belonging to his return to Vitebsk from Paris, when
he carried out a number of views from nature. In this
exhibition, *The Poet Reclining* (Cat. 49) shows rather similar
colouring, though there the foliage is painted with less
fidelity. That picture combines a naturalistically painted
landscape with a foreground figure in a different style, just
as *Vitebsk: from Mount Zadunov* includes areas of emerald
green foliage rendered in a far more stylised way. Indeed,
that green and, above all, the comical little figure sitting
reading under a parasol outlined on the grass near the tree-
trunk, link this view with the imaginative woodland scene,
Bella with a White Collar (Cat. 53). Although the Chagalls
returned to Vitebsk in 1917, it was not until November,
when the woman in this view would certainly not have
needed a sunshade. There is a touch of wit in this picture,
for where the tree-trunk touches the ground a pair of men's
legs and shoes can be seen. The rather naïvely painted town
makes a dramatic contrast with the more assured landscapes
painted on the outskirts of Vitebsk in the following years,
but this is a precious document in Chagall's œuvre, for he
has rarely attempted such a wide perspective from nature at
any time in his life.

54 reproduced in colour on p. 94

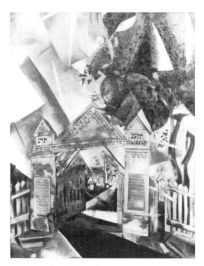

55 reproduced in colour on p. 93

55

Cemetery Gates 1917

Les portes du cimetière

Oil on canvas
$34\frac{1}{4} \times 26\frac{7}{8}$ in/87 × 68·6 cm
Private Collection

'Prophesy, therefore, and say to them, These are the words of the Lord God: O my people, I will open your graves and bring you up from them, and restore you to the land of Israel. You shall know that I am the Lord when I open your graves and bring you up from them, O my people. Then I will put my spirit into you and you shall live, and I will settle you on your own soil, and you shall know that I the Lord have spoken and will act, This is the very word of the Lord.' These words (from *Ezekiel*, XXXVII, 12–14) are written over the gateway into the Jewish cemetery by Chagall. They are not usually found in such a place and must surely signify the profound problems facing his people in Russia, not only after the Revolution (when the Jews looked forward to a new future), but in the turbulent history of relationships between Russians and Jews, with the problem of pogroms and possible emigration to Palestine, the Land of Israel, in the nineteenth century.

On the gateposts there are notices which have not been deciphered because they have proved illegible. They also bear the dates 1812 on the right and 1890 on the left; the latter date is repeated within the Star of David above the pediment. Whatever the precise connotations (for Jews) of these dates, Chagall's *Cemetery Gates* is a memorial to all those who had died in the Pale of Settlement, the sixteen provinces of Russia to which Jews were restricted before the revolutions of 1917. Although many had died in pogroms in the nineteenth century as well as our own, many also died fighting for the Bolshevik revolution, which they hoped would give them a new role in society. In 1921 the artist lived in a Jewish colony outside Moscow, where a number of writers and artists attempted to provide a new start for young people who had been orphaned and needed

encouragement to take their place in society. Although *Cemetery Gates* is dated 1917, in style it appears later than, for example, *The Red Gateway*.

With his surprising choice of biblical reference, Chagall's picture conveys the anxiety expressed in 1881 by the writer Levanda: 'People and events are pushing us toward a realm of shadows, for we are deemed "superfluous" people for whom there is supposedly insufficient room in the homeland, and who are cramping the indigenous population which already is hard pressed. But let our circumstances change even slightly for the better, let us cease to feel that the soil is burning beneath us and disappearing from under our feet, and we are convinced that the very same dreamers who have described so attractively the picture of an independent Palestine—a galvanised mummy—would sing along with many Russian Jews: "I'm a Russian, and I love my country".'

REFERENCES
The New English Bible, Collins World, 1970; Levanda, unidentified quotation in V. Lvov-Rogachevsky, *A history of Russian Jewish Literature* (ed. & trans. A. Levin), Ann Arbor, Ardis, 1979, p. 152.

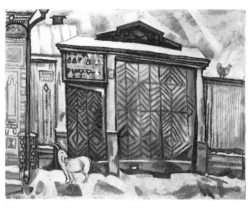

56 reproduced in colour on p. 92

56

The Red Gateway (1917)

Le portail rouge

Oil on cardboard
$19\frac{1}{2} \times 26$ in/49·5 × 66 cm
Staatsgalerie, Stuttgart

Like so many of Chagall's pictures, this apparently straightforward street scene includes a number of signs for the initiated. The gateway is decorated with a red abstract pattern which makes a dramatic focal point; it also makes a pun on the purely geometric painting favoured by the Suprematists (led by Malevich), who were then working in Moscow. Above the slightly open gate are apparently cabbalistic signs which could be read as a form of amulet to ward off the evil eye, and next to it is a sign with the wording *'dom'*, meaning 'house' in Russian. But the innocuous view is loaded with further symbols, for incongruously in the roadway is a goat, and perched up on

the right side is a chicken. These animals featured in a story-book published in 1917 (by Kletskin in Vilna) with illustrations by Chagall, described as two stories in verse by Der Nister, 'With the Rooster' and 'With the Little Goat'.

These animals cannot be in *The Red Gateway* by chance, for they have such a clear meaning for Jews as symbols of the Day of Atonement. (This was the feast when the sins of the people of the Lord were expiated, originally—in *Leviticus* XIV—on the head of a goat, who was then taken far out into the wilderness; after the destruction of the Temple in Jerusalem the goat was abandoned and a rooster or hen was adopted instead.) Perhaps this picture was intended for a proposed Jewish museum of art, for in 1917 Chagall was actively involved in the promotion of Jewish artists.

With its flavour of folk art combined with magic, this red gateway provides ready-made decoration. A year later the artist, in his role as Commissar of the Arts, added another note to the street scenes of Vitebsk. He organised a 'Red Festival' to mark the first anniversary of the Bolshevik revolution, using 15,000 m. of red bunting in a celebration that was later criticised as a mystic and formalistic bacchanal (Meyer, pp. 266, 605 n. 13).

57*

Oh God 1919

O Dieu

Oil, tempera, crayon and distemper on cardboard
$22\frac{3}{4} \times 18$ in/58 × 46 cm
Philadelphia Museum of Art; The Louis E. Stern Collection

This unusual work, dated on the surface 1919, is closely related to other representations, presumably of the artist himself: one is to be found on the wrapper of the first monograph on Chagall, published in Moscow in 1918 (fig. 27). But this composition also refers closely to the figure of *Half Past Three (The Poet)* (Cat. 20), though the artist has renounced Cubist stylisations, preferring the neo-primitive characteristics of *The Poet Mazin* (Cat. 21). Gone too, are the bottles and glasses; instead, the background is like some school blackboard on which are inscribed the Cyrillic words —OKH BOZHE— joined to a cluster of buildings by little crosses which stream upwards from a phallic-looking dome.

This was the period when Chagall seems to have enjoyed some poems by Baudelaire, for he borrowed the title *Anywhere out of this World* for another figure (private collection, Switzerland; fig. 26), who contemplates his fate in much the same way as Baudelaire questions his own soul in the poem. Furthermore, Chagall entitled another work *En Avant!* (fig. 29), following a line found in Baudelaire's related *Le Voyage*, a poem which seems also to have inspired *Oh God*. Perhaps it is fanciful to suggest that the helpless figure crying 'Oh God' echoes the lines: 'chattering mankind drunk with its own wit, as crazy today as it was in the past, shrieking to God in its insane agony, O thou my likeness, my master, I curse Thee'. In Baudelaire's poem, these lines follow from: 'several religions like our own, so many ladders

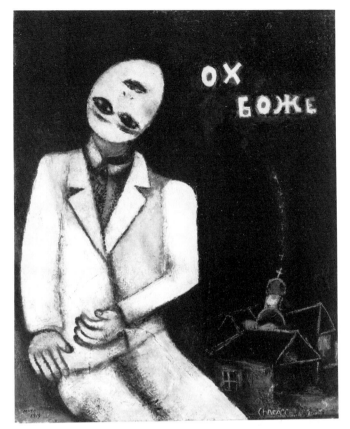

57

to heaven;' and continue with the homily: 'stay, if you can stay: go, if you must', afterwards bewailing the fate of the Wandering Jew. The picture is certainly not an illustration, but in mood it matches Baudelaire's. No doubt Bella provided the artist with such readings, though earlier references may have been made by Chagall: for instance, the cat inspiring *Half Past Three (The Poet)* (Cat. 20) may allude to another favourite theme of Baudelaire.

REFERENCE
'Anywhere out of this world' [*sic*], 'Le Voyage', 'Les chats ("Les amoureux fervents")', French text with English translation in *Baudelaire*, introduced and ed. by F. Scarfe, Penguins, Harmondsworth, Middx, 1964 (reprint), pp. 190, 182, 82, respectively.

58

Musician with Violin (1919)

Avec un violon

Oil on cardboard
$24 \times 18\frac{1}{2}$ in/61 × 47 cm
The Tel-Aviv Museum; gift of Mr Leffmann, Florence, 1958

Exceptional in this exhibition is this example of a little-known type which Chagall developed, probably not until 1921. That is the date of the touching picture of his father in a related style (Meyer, p. 317) which commemorates his accidental death in that year, when he was knocked down by a lorry at his workplace (*My Life*, p. 145). In that picture,

Chagall flattened the schematised face by painting it with a loaded brush, which echoes in a remarkable way his reaction to this sad loss. In *Musician with Violin* he has used a similar expressionistic treatment of the face and jacket, so better to convey the mobility of the features of the smiling fiddler. The facial characteristics are related to those of the rabbi in *The Pinch of Snuff* (Cat. 31), though he was barely breaking into a smile while the present figure is grinning broadly.

The expressive features reflect the many drawings which Chagall made in 1920–21 for costume designs for the Sholom Aleichem playlets for the opening of the State Jewish Kamerny Theatre in Moscow. (Many of these are reproduced in *Œuvres sur papier*, 1984.) There he caught the essence of the individual characters, as though the experience of working at first hand on a theatrical performance enabled him to invent a completely original style based on the mobility of the actors' faces rather than on caricature.

A further characteristic of *Musician with Violin* is Chagall's extraordinary use of paint — the impasto and the strong contrast between the highlights of the forehead, the hand and the profile of the violin, and the dark background and clothes of the player. In painterly terms this is equivalent to the exploration which Chagall had been making with black ink on white paper, which he used for illustrations of Yiddish stories in 1917 (see Cat. 56). Those were printed in collotype, which allowed only an overall difference between black and the colour of the paper. But Chagall began to experiment with different graphic techniques in 1923, when he made several drawings with a lithographic crayon, including two recently published, which are based on the same model as the violin player (*Œuvres sur papier*, 1984, cat. 93, 94). In one in particular the artist explored texture by using the crayon on its side; here he has worked with an equivalent fancy, with his brush loaded with paint.

REFERENCE
Marc Chagall: Œuvres sur papier, Paris, Musée national d'Art moderne, Centre Georges Pompidou, June–October, 1984, cat. 82–89, 93, 94.

58 reproduced in colour on p. 91

59 reproduced in colour on p. 98

59*

Peasant Life (The Stable; Night; Man with Whip) 1917

Vie de paysans

Oil on board
$8\frac{1}{4} \times 8\frac{1}{2}$ in/21 × 21·5 cm
The Solomon R. Guggenheim Museum, New York

With its numerous titles, this work has proved difficult to interpret; the man with the whip is related to the driver in *The Cattle Dealer* (Cat. 28), and the woman with her cow is not unlike the figures there, but the association of the figures with the partial hemisphere is more like the 'edge of the world' suggested in *I and the Village* (Cat. 19) or in the later *Peasant Life* of 1925 (Cat. 69).

Chagall has treated the man and woman as though they were elements of a Cubist collage, and although he has painted the triangle in the left corner up to the edge of the milkmaid and her cow, he has created the illusion that they are covered up by the geometric shape. In turn, these figurative elements are placed on top of the semicircle which hides part of the man with a whip. Thus abstract shapes and likenesses are combined, as a comment on contemporary 'non-objective' paintings by Suprematists, particularly those of Malevich. (For instance, several of Malevich's compositions in the book *Suprematism: 34 Drawings*—a series of lithographs printed at the art school in Vitebsk in 1920—consist of parts of circular forms, with overlapping quadrilaterals.) No doubt Malevich expected the viewer to be affected by the power of abstract colours and shapes, whereas in *Peasant Life* Chagall has combined geometric forms with people, producing a hybrid picture in which emotions can clearly be depicted.

60 reproduced in colour on p. 96

60

The Painter: To the Moon (1917)

Gouache and watercolour on paper
12½ × 11¾ in/32 × 30 cm
Collection of Marcus Diener, Basle

Although lacking the dramatic colour of *Homage to Gogol* (Cat. 61), in several ways *The Painter: To the Moon* makes a pair to that drawing. Both show the artist occupying an absurd position, which fills the pictorial space in a dramatic way. While he holds a laurel wreath and bows in the first, here he wears the wreath himself and bends over backwards in a parody of the ecstasy expressed in the earlier *The Holy Coachman* (private collection; fig. 45): in 1919, Chagall adapted that figure for the décor for a proposed production of Gogol's play, *The Gamblers*, also known as *Card Players* (Los Angeles County Museum; fig. 40).

Although the date of *The Painter: To the Moon* was given by Angelica Rudenstine as 1917 (p. 85), in composition it is closely related to the surviving sketches for the Gogol plays and so seems more likely to have been produced in spring 1919, the date of that commission, or, on account of its more

fig. 40 *Card Players*, 1917 (Los Angeles County Museum of Art)

'painterly' handling, shortly before. The unusual shape seems to be intentional: the floral curtain is folded to fit the rounded edge, and the tiny village scene occupies a semicircle in the centre of the bottom edge, emphasising a somewhat surprising resemblance to a fan.

REFERENCE
Russian Avant-Garde Art: The George Costakis Collection (ed. A. Zander Rudenstine), London, Thames & Hudson, 1981.

61

Homage to Gogol 1917

Hommage à Gogol

Watercolour on paper
15½ × 19¾ in/39·5 × 50 cm
The Museum of Modern Art, New York; acquired through the Lillie P. Bliss Bequest

Meyer describes this work as either a backdrop or a curtain which Chagall was commissioned to design in spring 1919 (p. 289). He was invited to provide sketches for two plays by the nineteenth-century writer, Gogol, *The Gamblers* and *The Marriage*, for the Hermitage Studio Theatre in Petrograd. He had already provided a set for an avant-garde play in the capital: it had been directed by Evreinov and performed in the Comedians' Halt Cabaret in 1916: on that occasion Chagall had enlarged his picture *The Drunkard* (fig. 41) for use as a backdrop. This time the commission was for a classical play, but Chagall once more approached it in an unconventional way.

In his *Homage to Gogol* Chagall has placed a jet black figure with a stylised silhouette on a brilliant golden yellow background. (This is related to the background of *Double Portrait with Wineglass*, now at the Centre Pompidou, which dates from 1917–18, but there the sky was reworked in 1925.) Since the words read 'To Gogol from . . . Chagall', the figure bowing like an actor to his audience at the end of a performance is understood as the artist himself. He is shown in an exaggerated posture which neatly fills the space. At first glance it looks as though the figure has been cut out and glued on instead of being painted, because the lines are sharply drawn as if with rough cuts from a pair of scissors: the jagged lines contrast with the smooth curve of the upper body.

Chagall has chosen a dramatic pose suitable for a theatre work: he balances a tiny church on his foot, in ridicule or affection; he is carrying a laurel wreath, but, paradoxically, looks as though he is tripping up instead of offering it to Gogol. Altogether, the lighthearted work seems completely unlike a backdrop, though it would have made a striking curtain. (A decorated curtain was often provided for Russian stage productions: this would greet the audience and set the theme of the play.) The mood may reflect the experimental nature of the Hermitage Studio Theatre, which was founded on the initiative of the Director, Meyerhold. The only productions that were realised took place in 1919 under the direction of the artist Annenkov, who put into practice ideas

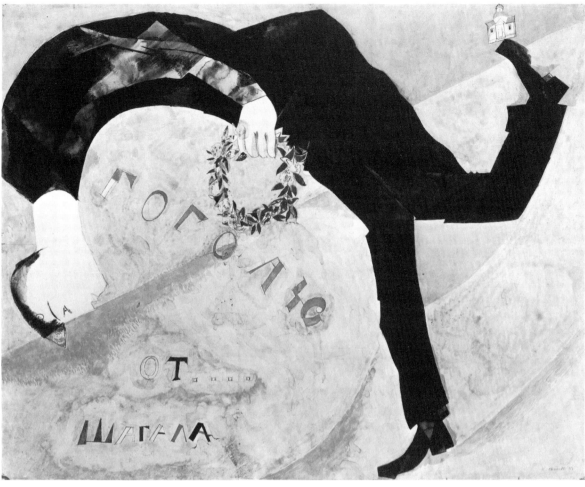

61

from the Italian Futurists' manifesto of Variety Theatre (1913), especially point number 15: 'the Variety Theatre destroys the Solemn, the Sacred, the Serious, and the Sublime in Art with a capital A'.

REFERENCE
F. Deák, 'Two Manifestos: the Influence of Italian Futurism in Russia', *The Drama Review*, vol. 19, no. 4 (T–68), December 1975, p. 89.

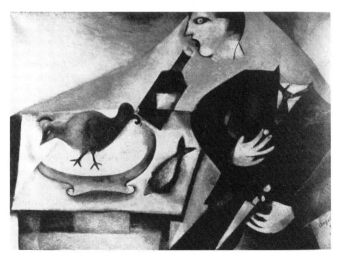

fig. 41 *The Drunkard*, 1911–12 (private collection, Caracas)

62

Composition with Goat 1917

Composition à la chèvre

Oil on cardboard
$6\frac{1}{2} \times 9\frac{1}{2}$ in/16·5 × 23·5 cm
Collection of Dr Franz Meyer, Switzerland

While Chagall was making designs for the theatre between 1919 and 1921, he explored the power of illusion on the stage. Stylised theatre, connected with the art of the conjurer, is vividly suggested by one of his designs, to which *Composition with Goat* can be related. This is a sketch for the décor of Sholom Aleichem's play, *The Lie* (now in the artist's collection and reproduced in colour in *Marc Chagall: Œuvres sur papier*, 1984, p. 128). In the sketch, a screen near a conjurer's box hides a figure so that only his legs are showing. In the *Composition with Goat* a man's two feet emerge just below a plane (rather than a screen) which also hides most of the goat. Other details connect this work with a scene design which was probably made at the time: the small bare tree as well as the goat occur in a *Sketch for the set of Gogol's Inspector General* (artist's collection; Meyer, p. 286). Interestingly, that sketch also features the little dots and dashes used to enliven the bare yellow plane in

199

62 reproduced in colour on p. 97

wittily parodies the concern with *faktura* or texture (to be
seen in the impasto on the black plane and the bare card of
the unpainted one). Further, he has used flat areas of colour
as though they were elements of a Cubist collage, but added
a line below the bare plane to transform it into something
three-dimensional, a reading exaggerated by the feet and the
diagonal 'wall' or screen below. Thus Chagall has used this
unusual surface for a witty commentary on contemporary
Russian art.

REFERENCES
Marc Chagall: Œuvres sur papier, Paris, Centre Georges Pompidou,
Musée national d'Art moderne, June-October 1984; C. Lodder,
Russian Constructivism, New Haven & London, Yale, 1983.

Composition with Goat. This detail is one which Chagall was
to use to great effect when he began etching in Berlin in
1923; the broken line has remained an unusual characteristic
of his drawing style ever since.

Franz Meyer, who owns *Composition with Goat*, rejects the
date written on it, preferring one between 1920 and 1922.
He connects it with an even more non-representational
collage in the artist's collection (fig. 42), which includes a
fragment of the invitation to the opening of the exhibition
of Chagall's murals for the Jewish State Chamber Theatre. As
that took place in summer 1921, both collage and, by
connection, this *Composition with Goat*, must be later.

In view of the discussions that were taking place in
Moscow at that time about the nature of 'Composition' and
'Construction' as well as the disagreements about Realism
and Non-objective art (discussed at length by Christina
Lodder in her study, *Russian Constructivism*), Chagall's
Composition with Goat exemplifies his own position. It
represents his commitment to Jewish art: the goat appears
in nearly all his contemporary work (even as the dominant
motif on the curtains for the Jewish State Theatre) and no
doubt served as a symbol (see Cat. 56); but this painting also

63*

The Dream 1920

Le rêve

Pencil, ink, gouache, gold and gold-leaf on paper
$12\frac{5}{8} \times 17$ in/32 × 43 cm
The Solomon R. Guggenheim Museum, New York

This is one of the most finished works on paper in this
exhibition; the precise lines and silhouettes give no evidence
of second thoughts on the part of the artist, and the
composition is carried through in a deliberate way. It is
closely related to one of the murals which Chagall made for
the State Jewish Theatre (probably between November 1920
and its opening in May 1921), entitled *Love on the Stage*, now
in the State Tretiakov Gallery, Moscow (reproduced by
Meyer, p. 281). On a very small scale *The Dream* shares with
this large panel (measuring about nine feet by eight) a form
of Cubist-based construction, though in *The Dream* various
details such as the woman's hands are more precisely drawn,
as befits its size. The woman's figure here is, as it were,
reconstructed from the elements of some Cubist collage;
these are brought back from that abstract stylisation into an
arrangement which makes the woman more readable. Her
dress is suggested by the fascinating device of a pattern
transferred from real lace—the artist soaked lace in gold
paint and applied it to the surface and then pulled it off
again. The use of lace makes a very interesting comparison
with *At the Seaside, Panel* by A. V. Lentulov, which had
been shown at 'Contemporary Russian Painting' in Petrograd
in 1916, where Chagall had been a fellow exhibitor. In that
picture Lentulov had attached real tassels along the edge of
a woman's dress, and in others he had stuck on a lace
border; his method was described in 1917 by the critic
Tugendkhol'd, who contrasted the style (which Lentulov had
named *'ornéisme'*) with French art. The appliqués, he wrote,
'are pasted on, not according to some "symbolic" plan as in
Picasso's spiritualism but just the way you'd expect a
Russian, a Muscovite and a peasant to do it: literally and
materially, just where they should be—around the neck and
underneath the skirt'. Chagall has metamorphosed
Lentulov's realistic application by abstracting it and turning
it into a decorative device for *The Dream*.

fig. 42 *Collage*, 1920 (collection of the artist; photograph
Jacques Faujour, Centre Pompidou, Paris)

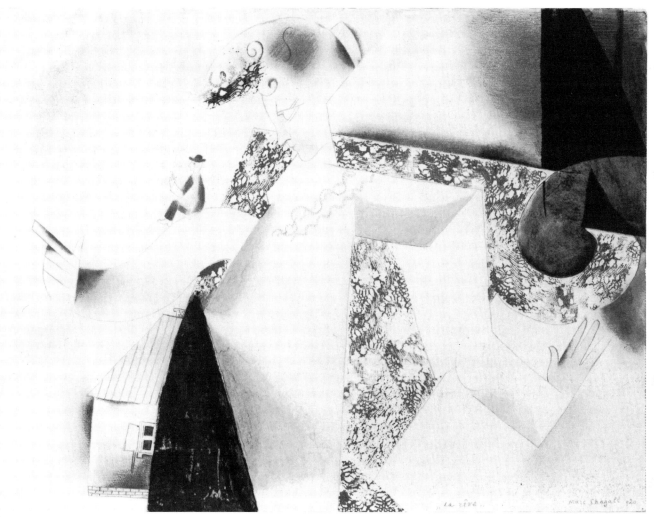

63

Chagall was not averse to studying the work of others and transforming any stylistic devices which might appear of use to himself. Thus, at about the time he began work on the Jewish theatre project, the Moscow artist Stepanova noted his interest in a current exhibition of her own work and that of Rodchenko. Her diary entry for 20 November 1920 reads: 'Chagall is often at the exhibition. . . . Today he told Anti [her pet name for Rodchenko] that he would love to learn a little more about what we're doing—'Won't you open your cook-house to me'', he said'.

REFERENCES
M. Frost, 'Marc Chagall and the Jewish State Chamber Theatre', *Russian History*, vol. 8, parts 1–2, 1981, pp. 90–107; IA. Tugendkhol'd, 'Pis'mo iz Parizha', *Apollon*, 1, 1917, pp. 70–71 (trans. S. G. Dzhafarova, 'Aristarkh Vasilievich Lentulov', *Seven Moscow Artists 1910–1930*, exhibition cat. Galerie Gmurzynska, Cologne, April-July 1984, p. 177); V. Stepanova, 'Diary entries on the xixth State Exhibition', loc. cit., p. 260.

Berlin

Chagall's work made in Berlin in 1922–23 is represented in this exhibition by etchings and lithographs which are to be found in the separate section headed 'Prints and Books' on pp. 258–74.

France

1923–41

The second period that Chagall spent in France can be divided into two halves, roughly coinciding with the end of the 'roaring twenties' and the beginning of political events which led to the outbreak of the Second World War. The opportunity to return to Paris was given by his old friend the poet Blaise Cendrars, who wrote to Chagall in Berlin telling him that Ambroise Vollard wanted to meet him to discuss a commission for book illustrations. In August 1923 Chagall received a French visa and by early 1924 he was settled with his family in a studio in the Avenue d'Orléans. Vollard allowed him to choose any book to illustrate, and Chagall picked Gogol's *Dead Souls* (see Prints section, Cat. 153–88). While he was working on the etchings, Chagall painted replicas and new versions of work that he had made in Russia, for which he had acted as courier for the current owner, the collector Kagan Chabchai. Many can be seen in a photograph of the artist with his wife and daughter in their studio (reproduced by Meyer, p. 34).

During his first year back in Paris Chagall received visits from Max Ernst, Paul Eluard and Gala, inviting him to join the Surrealists at the time when they issued their First Manifesto. But although Chagall's work had been saluted so early by Apollinaire as '*surnaturel*' (see Cat. 45), he chose not to ally himself formally to the younger artists who seemed to him too obsessed with the method and technique of automatism (making works of art by relying wholly on chance). Rather, he renewed his friendship with Robert Delaunay and his Russian wife Sonia, and the two families were often together. So although Chagall's 'a-logism', his magical juxtapositions of unlikely images, remained a feature of the new oils that he worked on in the 1920s (for example *The Watering Trough*, Cat. 68), there flooded back into his work a renewed joy in colour, as in *The Rooster* (Cat. 75), prompted in part by Delaunay's continuing interest in colour theory. The juxtaposition of humans and animals was also connected with a new commission from Vollard to illustrate the *Fables* of La Fontaine, for which Chagall first of all made gouaches.

From 1927 onwards Chagall was recognised as a leading painter of the *École de Paris*, an accolade that persisted for many years (even after his return to Paris in 1948). As the 1920s drew to a close a new mood becomes apparent in Chagall's work (for instance, *Russian Village*, Cat. 76), reflecting his continuing contacts with Russia—1927 saw a visit to Paris by the Moscow Yiddish theatre with Granovsky's players led by the actor Michoels; in 1930 Chagall helped find a theatre for the director Meyerhold's Paris tour. Thus he was kept fully informed of political changes in the USSR and the new policies for art. In Paris itself, his financial position became less secure, with the cancellation of a contract from the dealer Bernheim-Jeune leaving him financially dependent on the commissions which Vollard continued to offer him. The commission for illustrations for *The Bible* resulted in his first journey to Palestine, where he was present in 1931 for the laying of the foundation stone of the Museum of Tel-Aviv. He found the visit very moving: 'The air of the land of Israel makes men wise—we have old traditions' (Meyer, p. 385).

Whereas life in the 1920s for Chagall had been characterised by his discovery of French landscape, with frequent visits first to Normandy and then the south of France, in the 1930s he travelled further afield in Europe, visiting Amsterdam and Spain, seeing the work of Rembrandt, Velazquez, Goya and El Greco. These experiences resulted in a new monumentality in the artist's work, to be seen here in *White Crucifixion* (Cat. 81). This picture can also be seen as a political statement which Chagall made as a result of visiting Poland in 1935 for the opening of the Yiddish Institute in Vilna: he went there because it was the closest he felt he could go to Vitebsk, but he found himself overcome with a sense of anguish for Jews in the restricted ghettos of Poland. At this time Chagall was also moved to attempt to encapsulate his political experiences in a monumental canvas, *Revolution* (see Cat. 80), in response to the growing number of intellectuals and artists in France who became Communists as a result of the Spanish Civil War.

Chagall had taken French citizenship in 1937 and was loath to leave his adoptive country on the outbreak of war in 1939. However, he moved south away from Paris, and when the Vichy government began to enforce laws against Jews in 1941, he accepted the invitation from the Museum of Modern Art in New York to leave for the United States, after he had been arrested and imprisoned for a short time in Marseilles. Although Chagall's paintings are often enjoyed solely for their imaginative fantasy, in the 1930s they began to reflect the political uncertainties of the times, in spite of retaining familiar subject-matter such as the lovers in *The Three Candles* (Cat. 82).

fig. 43 Photograph of Chagall painting *Solitude* (Cat. 79) in August 1934

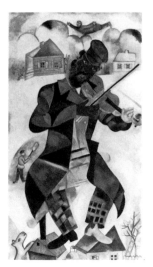

64 reproduced in colour on p. 99

64*

Green Violinist (1923–24)

Violiniste

Oil on canvas
78 × 42¾ in/198 × 108·6 cm
The Solomon R. Guggenheim Museum, New York; gift of Solomon R. Guggenheim

This outstanding picture shows a popular musician whom Chagall saw as the forerunner of the contemporary actor (*My Life*, p. 161). It is related to a canvas which he painted in 1920–21 for the auditorium of the State Jewish Kamerny Theatre in Moscow (now Tretiakov Gallery, Moscow), which it closely resembles, though lacking the stylisations of the clouds and background. Furthermore, this version is slightly wider to the left, allowing an extra figure driving a horse to enter the background, and the little violinist next to the seated player is significantly lower, taking away the flowing lines which join the houses at the base of the original composition to those at the top, in a remarkable serpentine curve.

Speaking of this picture in 1974, Chagall emphasised the importance of a violinist for Russian villages, where there were no orchestras, museums or paintings, and he represented all the arts. Moreover, the ladder resting against the tree alludes, he said, both to Jacob's ladder (see Cat. 141) and to Chagall's desire always to be high up as a child (Angelica Rudenstine, p. 78).

Green Violinist is also related to the earlier *Fiddler* (Cat. 34) but while Chagall has repeated the elements of a village, as befits a large wall-painting he has removed the intervening buildings, increasing the area of the snow-clad village square. Furthermore, the stylisations of the vivid purple coat are now, paradoxically, more Cubist than those of the earlier picture. Another player is to be found in *The Violinist* (Cat. 36) and attention has been drawn in that entry to the revolutionary Estonian who had led the workers through the streets in 1905, playing his violin. In *The Fiddler* the curious device of the figure with three heads superimposed one on

the other, which occupies the place given to the little violinist in the later versions, has here been connected with the 1905 uprisings. Significantly, the story of the Estonian violinist had been told by Lunacharsky in the Russian-language Paris newspaper, but, now that the Revolution had taken place and Lunacharsky was the Commissar for Education and Enlightenment, such a reference was no longer needed. Likewise, the agonised expression of the flying figure in the sky in the early picture is here replaced by a rejoicing one.

REFERENCE
A. Rudenstine, *The Guggenheim Museum Collection Paintings 1880–1945*, vol. 1, New York, The Solomon R. Guggenheim Museum, 1976, pp. 74–78.

65

I and the Village (1923–24)

Moi et le village

Oil on canvas
21¾ × 18¼ in/55·5 × 46·5 cm
Philadelphia Museum of Art; gift of Mr and Mrs Rodolphe M. de Schauensee

This smaller version of an earlier composition (Cat. 19) can be seen in a photograph of the artist and his family, taken in the studio in the Avenue d'Orleans into which they moved early in 1924 (Meyer p. 34). On the walls can also be seen some of the pictures that Chagall had brought with him from Russia. Nearly all the variants are similar in size to the original and it is strange that Chagall recreated *I and the Village* on such a different scale (the first version is over six foot high by five wide).

In reducing the composition, Chagall loosened the structure by emphasising the diagonal division of the canvas, instead of the disc of the earlier version. The strong

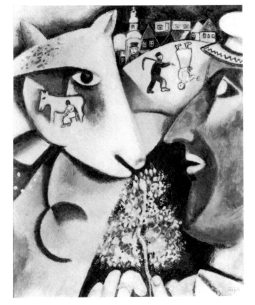

65

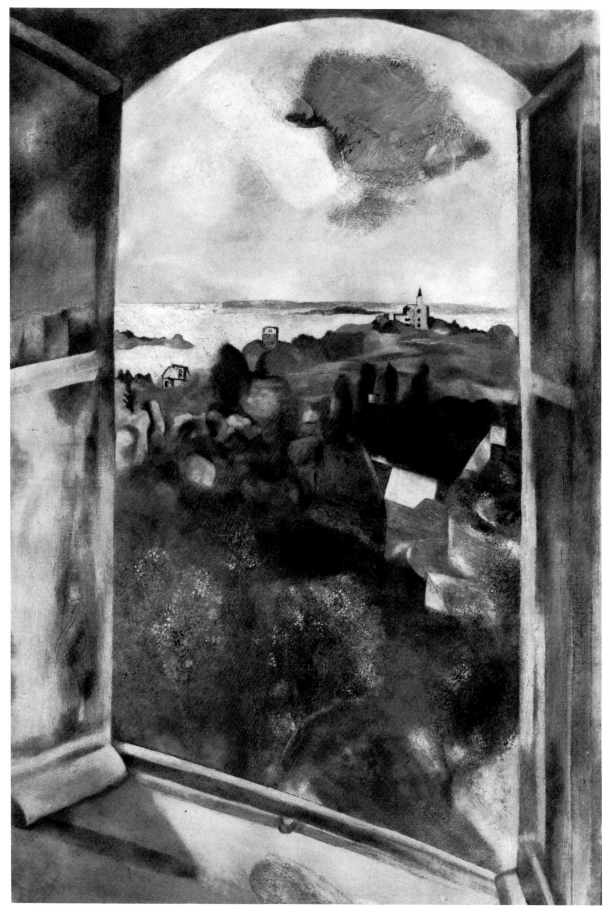

circular rhythm of the larger painting allowed an
interpretation of four seasons (see Cat. 19) which is less
obvious here. Indeed, the subtle change in the mouth of the
animal alters the force of the encounter. Unlike *The Birthday*
Chagall did not have the original picture before him when
he made this version, as it was one of the paintings he had
left in Berlin in 1914. Thus he was evidently working from
a photograph, possibly from *Sturm Bilderbücher 1* of 1923.

66*

The Window (1924)

La fenêtre sur l'île de Bréhat

Oil on canvas
39 × 28¾ in/99 × 73 cm
Kunsthaus, Zurich; gift of G. Zumsteg to the Vereinigung Zürcher
Kunstfreunde

In June 1924 the Chagalls spent a month on the island of
Bréhat off the north Brittany coast where the artist painted
this picture from a top-floor window. It shows a cluster of
houses on a promontory jutting into the sea, with a
lighthouse in the distance to fix the eye; the sky is bathed
in a soft northern light. In a conversation with the critic,
Florent Fels, the following year, Chagall said: 'I want an art
of the earth and not merely an art of the head'—a
description which fits this view, with its stone circle next
to the farm. An 'art of the earth' is not the same as an art
of the eye, and this view is not like a landscape painted by
the Impressionists. Chagall's is an experience of the
landscape as much as a visual representation, with
generalisations—such as the lack of detail in the farmyard—
which give the impression that the houses are wedded to the
land, the counterpart of the nearby Menhirs. Furthermore,
the landscape is tamed: it is controlled by the framing device
of the inward-opening French windows. They reveal just so
much of the landscape as the artist has wanted to show from
the very high viewpoint, which reduces the detail of the
room in which he stands.

 Although he had used a window in several early pictures,
this composition is surprisingly close to one painted by
Matisse, *Paysage vu d'une fenêtre, Tanger* (Pushkin House,
Moscow; Barr, p. 386) in early 1912, which had belonged to
the Moscow collector Ivan Morozov. Chagall is much more
likely to have seen this work in Moscow in 1920–21 than
earlier in his career. Yet unlike that view by Matisse there
are no flowers in vases on Chagall's windowsill, to act as a
link between indoors and out, which, in Matisse's picture,
make the viewer feel secure within. Rather, Chagall has
emphasised the ambiguity of external and internal in man's
environment, using the window as a paradox, recalling the
door in *Resurrection of Lazarus* (Cat. 33) or *The Feast Day*
(Cat. 45).

REFERENCES
F. Fels, *Propos d'artiste*, Paris, 1925, quoted by Meyer, p. 337; A.
Barr, *Matisse, his art and his public*, London, Secker and Warburg,
1971.

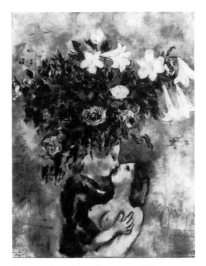

67 reproduced in colour on p. 104

67

Lovers under Lilies 1922–25

Les amoureux aux lys

Oil on canvas
46⅛ × 35 in/117 × 89 cm
The Evelyn Sharp Collection

This picture, with its overt sensuality, is totally unexpected
in Chagall's œuvre. In 1929 it was reproduced by Fierens
with the title *Le baiser* (*The Kiss*) and the date 1927. It shows
two figures embracing near a fence, with little houses and
a small figure like an angel, barely outlined on the softly
coloured background. The composition is ambiguous, for
while at first glance the lovers appear to be under a tree, the
foliage and flowers are the peonies and lilies of a large
bouquet normally associated with a still-life. Thus the still-
life doubles as a tree, or, alternatively, the lovers are a vase
for the flowers. The poetic composition is touchingly pretty,
but it avoids the sentimentality that this description might
suggest.

 The method of painting is interesting, for most of the paint
is very thinly applied, the background is composed of mixed
colours with the suggestion of a village scene outlined on it
in thin mauve paint. Likewise, the figures themselves are
painted as though they were porcelain; the flowers, by
contrast, are encrusted with thick impasto. The combination
of thin background painting with added impasto is to be
found in a number of Chagall's other pictures of the 1920s,
especially *The Dream* (Cat. 73). The particular incongruity of
this scene and its illogical character are typical of his poetic
approach which was parallel to, but unlike, the fantasies of
contemporary French Surrealists.

REFERENCE
P. Fierens, *Marc Chagall*, Collection Les Artistes Nouveaux, Paris,
Crès, 1929.

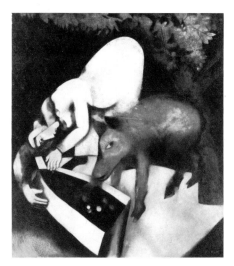

68 reproduced in colour on p. 100

68*

The Watering Trough (1925)

L'auge

Oil on canvas
39¼ × 34¾ in/99·5 × 88·5 cm
Philadelphia Museum of Art; The Louis E. Stern Collection

This surprisingly forceful and irrational composition of a
single woman with an animal marks a change in the artist's
work of the mid-1920s. He painted the slightly larger first
version (Meyer, p. 326) after his return to France from
Berlin, when he felt thoroughly settled in his adoptive
country. The picture is contemporary with a lithograph of
the same subject, of 1925 (Cat. 162). The clear-cut silhouette
of the peasant woman's dress and the playful echo of her
figure with that of the pig can be seen as a direct result of
Chagall's experiments with white and black. It is as though
in his etchings he had discovered a new imaginative force
and a reservoir of artistic invention. Now that he was
returning to oil-painting, he needed to curb his unbounded
exuberance and reinstate some of the forcefulness that he

had achieved before 1914 with such images as *The Holy
Coachman* (fig. 45).

Meyer has said that the composition of *The Watering
Trough* is based on an early version in gouache dating from
1912, today in the Stedelijk Museum in Amsterdam (p. 341).
However, although that gouache is reproduced in Theodor
Däubler's book on Chagall, published in Rome in 1922, the
photographs in the book are not confined to works dating
from before 1914. So it cannot be ruled out that the gouache,
entitled there *Le breuvage* ('The Drink'), may have been a
new work in Russian idiom that the artist began soon after
he left Russia in 1922. Indeed, the face of the peasant
woman, both in the gouache and more especially in the two
versions in oil, is closest in style to a black and white
drawing entitled *Abduction* and dated 1920 (fig. 44).

The subject of *The Watering Trough* conveys a wry
humour. The woman, bending so seriously over the trough,
seems to attempt to prevent the small animal from tipping
it over; her seriousness is matched by the humourous glance
of the little pig, who looks slyly out of one eye. There are
few differences between the two versions in oil, one being
the presence of a plucky little rooster in the foreground of
the larger version. This version also has an unexpected
glowing, green background, while the smaller one, on view
here, has a purplish one. This striking difference in colour
between the two oils, which are in turn unlike the less
stylized gouache, indicates that the artist's interest in the
properties of colour was renewed after his long stint of work
with black and white.

Nearly all the double versions of pictures which Chagall
made between 1923 and 1925 are repeats or smaller forms
of his existing work (see *I and the Village*, Cat. 19, 65) and
it is rather strange that in this instance he made two versions
of a new subject comparatively close together, but it gives
some idea of the importance he attached to this irrational
invention, so much in the spirit of the Surrealist movement
of which he was being seen as a precursor. However, after
the publication of the manifesto of Surrealism, Meyer
records that Chagall refused three personal invitations to ally
himself formally with the group of writers and artists
(p. 334): they seemed to him both too cerebral and too
involved with the unconscious. *The Watering Trough* reveals
his own personal irrational approach.

REFERENCE
T. Däubler, *Marc Chagall*, Rome, Valori plastici, 1922.

fig. 44 *Abduction*, 1920 (collection of the artist; photograph Jacques Faujour,
Centre Pompidou, Paris)

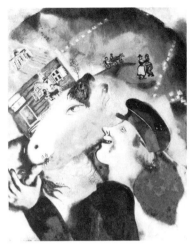

69 reproduced in colour on p. 103

69*

Peasant Life 1925

Vie paysanne

Oil on canvas
39¾ × 31½ in/101 × 80 cm
Albright-Knox Art Gallery, Buffalo, New York; Room of
Contemporary Art Fund, 1941

Peasant Life, dated 1925 by the artist, has been seen as a
remake of *I and the Village* (Cat. 19) from the first Paris
period. But although Chagall made new versions of that
subject in oil and in gouache in the 1920s, *Peasant Life* is
only superficially related to the theme: whereas in *I and the
Village* the animal and the peasant confront each other, in
this picture the jaunty human profile overlaps the neck of
the horse or donkey. The composition of the earlier picture
is made up of interlocking segments of circles, but, although
the curve of the background hill is common to both pictures,
the tipped-up house is treated here as if it were an element
in a Cubist collage: Chagall has overlapped the major forms,
treating them like some abstract composition which relies on
a sequence of coloured areas; he has used only four colours
(with white) in the order ochre, terracotta, green, repeated
on a blue and white ground. This device is a development
from the much more abstract *Composition with Goat* (Cat. 62)
in which rectangles doubled as screens to occlude parts of
outlined animals and figures. Some of the same stylisations
are repeated in *Peasant Life*, where the peasant's hair is
executed with repeated tiny dots, as are the horse's mane
and trees, barely indicated behind the house. The same
broken line is found in his contemporary prints, made as
illustrations to Gogol's *Dead Souls* (Cat. 165–72).

 The writer cannot have been far from the artist's mind,
for against the house wall he has shown those same figures
round a table with a lamp overhead that he had used in a
proposed curtain for a production of Gogol's stage play, *The
Gamblers* (see Cat. 61). While the picture is not an
illustration in the same precise way as the etchings for *Dead
Souls*, it evokes that classic tale. It is translated into an

expressive pictorial idiom, almost musical in conception,
with its colour harmonies and small white squares creating
their own 'music' for the dancing peasants, or suggesting the
sound of bells. Chagall echoes Gogol's question, as
appropriate in 1925 as in 1841: 'And you, Russia of mine—
are not you also speeding like a *troika* which nought can
overtake?... Whither, then, are you speeding, O Russia of
mine? Whither? Answer me! But no answer comes—only
the weird sound of your collar-bells. Rent into a thousand
shreds, the air roars past you, for you are overtaking the
whole world, and shall one day force all nations, all empires
to stand aside, to give you way!' (last paragraph of part I
of *Dead Souls*).

REFERENCE
N. V. Gogol, *Dead Souls* (trans. D. Hogarth), Everyman's Library,
London, Dent, 1943, p. 206.

70

Peonies and Lilacs 1926

Pivoines et lilas

Oil on canvas
39⅜ × 31½ in/100 × 80 cm
Perls Galleries, New York

Chagall has painted flowers throughout his career, but in the
1920s, when he re-established himself in France, flowers
seem to have provided a kind of stability. In this picture,
the flowers are an evocation of time gone past, for in the
background, a figure is sitting at the open window in a
moonlit Russian night. There is a surprising amount of bare
canvas behind the effectively rendered flowers, with thick
impasto and firm brushstrokes contrasting with the thinner
paint behind. The combination is similar to that of *The
Dream* (Cat. 73) and very different to the handling in
Chrysanthemums (Cat. 72). *Peonies and Lilacs* also makes an
interesting contrast with *Peasant Life* (Cat. 69), a much
stronger evocation of a Russian theme, with its brilliant
yellow adding a raucous note. This flower piece is far more
romantic in conception, it also gives the viewer an
opportunity to study the way that Chagall's technique
changed and developed during the 1920s in Paris.

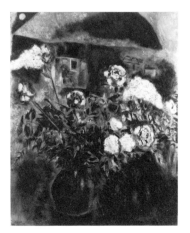

70 reproduced in colour on p. 102

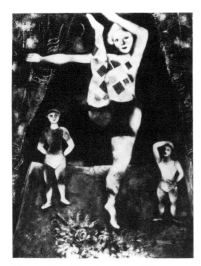

71 reproduced in colour on p. 107

71

The Three Acrobats 1926

Les trois acrobates

Oil on canvas
46 × 35 in/117 × 89 cm
Private Collection

The earliest circus subject chosen by Chagall was *The Three Acrobats*. In a daring movement, mid-way between a pose from the ballet and a gymnastic feat, the female acrobat comes forward to take her applause. At her feet lie bouquets of flowers; behind her are the two strong men, awaiting their turn to perform. The smaller, with the figure of a wrestler, has a tiny monkey on his shoulder and, incongruously, carries the artiste's fan.

In 1927 Chagall's patron, Ambrose Vollard, booked a box at the Cirque d'Hiver, where the artist accompanied him to the performances so that he could make a set of prints on circus themes. This picture appears as a prelude to that commission, which was carried out in a set of preliminary

72 reproduced in colour on p. 106

gouaches where the paint is laid on thickly in crude but effective marks. Here, however, the acrobats are painted with rather thin oil, in a range of colours close to those that Chagall was using when remaking earlier work, for example *I and the Village* (Cat. 65). But while that composition relied originally on a series of interlocking discs, here he has divided the background with a purple rectangle which recedes towards a mysterious blue. By placing the female acrobat so much in the foreground he has drawn attention to her role of figuration on a background, almost as abstract as the squares and triangles of the Russian Constructivists. Yet any such connection is quickly dispelled by the inventive device of the marks on the stage curtains—which even include the cheeky head of a clown on the right. These freely roaming lines and dots are close to those in the etchings for *Dead Souls* (see Cat. 167), completed in 1925.

Finally, the picture evokes an unexpected note of shyness, as though the heroine in her remarkable green trunks and multicoloured tights is amazed by her own achievement. Chagall has often used a theme from the circus as a paradigm of life (see Cat. 2) and he has imagined this girl from the point of view of a lover as much as of an artist.

72

Chrysanthemums (1926)

Les chrysanthèmes

Oil on canvas
36¼ × 28⅜ in/92 × 72 cm
Perls Galleries, New York

In this striking close-up, Chagall has caught the brilliance of autumn flowers, adding a note all his own—a little winged figure which hovers overhead. According to Klaus Perls, the picture was painted in Paris for sale, a fact which explains its flamboyant sureness of touch and the decisive representation of the blooms. This is the mature work of an artist, who by 1927 was a leader of the so-called School of Paris (*École de Paris*). He was given a 'Portrait' in the influential Paris art magazine, *L'Art Vivant*, which ends with an interview with the writer Jacques Guenne, who asked Chagall what had been the most important changes which he had seen in European art when he returned to Paris after nearly ten years away. The artist replied: 'It was agreeable to record the triumph of Expressionism in Germany, the birth of the Surrealist movement in France and the appearance on the screen of Charlie Chaplin. He is seeking in the cinema what I am attempting in my painting. Charlot is perhaps the single artist of today with whom I can agree, without having to pronounce a single word.'

With *Chrysanthemums* Chagall, like an acrobat, balances on a tightrope of art: with one false move he would fall into banality; with another, he would destroy the fragile unity of the picture surface.

REFERENCE
J. Guenne, 'Portraits d'artistes, Marc Chagall', *L'Art Vivant*, no. 72, 15 December, 1927, pp. 999–1010.

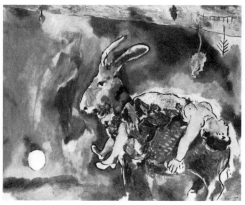

73 reproduced in colour on p. 105

73

The Dream 1927

Le rêve

Oil on canvas
$31\frac{7}{8} \times 39\frac{3}{8}$ in/81 × 100 cm
Musée d'Art moderne de la ville de Paris

This picture has been described as a figure on a rabbit
(Meyer, p. 356), but to the present author the animal seems
to be a donkey, with large floppy ears. He is a mythical
figure, strayed perhaps from Shakespeare's *A Midsummer
Night's Dream*, where Bottom was turned into a donkey by
Oberon's magic. Or maybe he was suggested by Lucius
Apuleius, who was changed into a 'miserable ass'. Chagall
has captured the essence of a dream by placing the oversize
animal with his ravished burden (not unlike a parody of the
Rape of Europa) to one side of the canvas and allowing the
moon and the landscape to change places.

The Dream takes place in a fantastical world of blue sky,
where the upside-down landscape has small trees dropping
from above. Chagall had often placed individual and paired
motifs the 'wrong' way up in his earlier pictures, for
instance in *I and the Village* (Cat. 19). 'Direction' had also
fascinated him when Walden had hung *The Holy Coachman*
(fig. 45) on its head in his Berlin gallery in 1914 and Chagall
had liked the effect, so it has been hung that way ever since.
Here in *The Dream* the whole composition could be read
either way up which likewise contributes to its dream-like
quality. He has continued to disregard direction in the act
of painting in later years (in a film made in the early 1950s
he worked on a gouache from all directions, turning it as he
applied the paint).

In *The Dream* he has used the area of blue as though it
were a strange country of the imagination. The colour stops
short of the figure leaving a white space round most of the
outline, except for the girl's feet kicking into the expanse
of sky. The thinly painted blue areas contrast with the
woman's skirt which is rendered in large brushstrokes with
very thick impasto, in pink, green and red: the landscape
is treated in the same way. This treatment of the paint
surface is similar to that of *Lovers under Lilies* (Cat. 67) and
is freer than other 1920s pictures of single figures with an

animal, such as *The Rooster* (Cat. 75).

Chagall painted *The Dream* when he was beginning work
on the commission to illustrate La Fontaine's *Fables* (Cat.
173–80), which may account for the hint of a story in the
theme. However, as is so often the case in his work, the
particular is generalised in such a manner that one enjoys
rather than interprets. If there is any message in *The Dream*
it is like the moral drawn by an early translator in his
introduction to Apuleius's *The Golden Ass*, who saw the
fable as 'a figure of man's life, [which] toucheth the nature
and manners of mortal men, egging them forward from their
asinine form to their human and perfect shape, beside the
pleasant and delectable jests therein contained . . .'
(Adlington, p. 20).

REFERENCE
Introduction, *The Golden Ass of Lucius Apuleius in the translation
by William Adlington*, London, The Navarre Society, n.d.

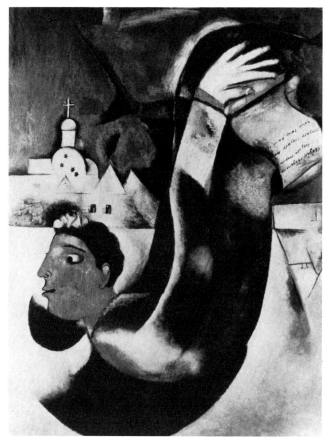

fig. 45 *The Holy Coachman*, 1911–12 (private collection)

74 reproduced in colour on p. 101

74

Lovers with Flowers 1927

Les amoureux aux fleurs

Oil on canvas
39⅜ × 34⅝ in/100 × 88 cm
The Israel Museum, Jerusalem

This evocation of a summer day contrasts with the more playful *Lovers under Lilies* (Cat. 67). Although the ingredients are similar, the mood is very different: the artist has here stressed the closeness the lovers feel for each other on a visit to the French countryside. The Chagalls had spent some months in the Auvergne in 1926, and a real place is indicated by the device of verticals and horizontals behind the figures, suggesting a fence or a window. The principal difference between this and *Lovers under Lilies*, however, is in the handling of paintwork. Here, generous brushmarks are used to block in the figures and background, a technique which probably derives from the large number of gouaches which Chagall had painted in the Auvergne. He has retained some of the more delicate style of the earlier pictures for the faces, which are subtly modelled to convey the dappled light shining through the flowers. As in *Lovers under Lilies*, the cut flowers double as a bush or tree, but whereas in the earlier picture the figures could be read as a delicately painted china vase, here the scent of the red and cream roses is so strongly suggested that it seems to pervade the picture and match the oneness of the pair.

In the 1920s Chagall invented many ways of showing the different aspects of human love, often exchanging one of the figures for an animal (*The Dream*, Cat. 73 or *The Rooster*, Cat. 75) but *Lovers with Flowers* evokes the companionship of a lasting relationship.

75

The Rooster (1929)

Le coq

Oil on canvas
31⅞ × 25⅝ in/81 × 65 cm
Thyssen-Bornemisza Collection, Lugano

Chagall's approach to the subject of a single figure and an animal here is quite different from that in *The Watering Trough* (Cat. 68), *The Dream* (Cat. 73) or his illustrations for La Fontaine's *Fables* (Cat. 173–80). The figures can be identified more precisely by the longer title, *Le coq et l'arlequin*, with the subtitle, *quadrichromie*, given by Raïssa Maritain in her book on Chagall of 1948. Leaving aside the slightly earlier date (1928) that she gives, the longer title clarifies the subject-matter and treatment of *The Rooster*. The harlequin, a female figure more like an equestrienne, is embracing the bird in such a way that the silhouette of her back and head exactly complements his jaunty stance; it is, indeed, possible simply to see the outline as a single figure. The closeness of the two main figures is reflected by the pair of human lovers in the little boat in the background.

A modern viewer may equate the picture with the more recent well-known ballet, *La fille mal gardée*, which features giant feathered birds. But for Chagall, the rooster no doubt held a symbolic place. As Meyer has pointed out, the figure of the cock has for thousands of years 'played a part in religious rites as the embodiment of the forces of the sun and fire. This symbolic meaning still lingers on in Chagall's works, where the cock represents elementary spiritual power' (p. 380). Thus the sensuous and sinuous body of the harlequin holding the bird so tenderly can be seen as a marriage of the female moon and the masculine sun.

Such symbolism is reflected in the use of colour. The subtitle, *quadrichromie*, meaning 'four-colour' and the use of strong elementary colour-oppositions in determined relationship to each other, reflect the renewed friendship of Chagall with Delaunay. In the autumn of 1927 the two artists had driven to the south of France and visited Collioure, the

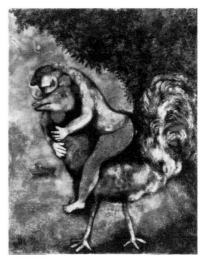

75 reproduced in colour on p. 109

seaside town so loved by Signac and the Fauves in the first decade of the century. Delaunay had taken a leading role in exploring colour in those years before 1914 when Chagall had been part of his circle.

In *The Rooster* the use of red and yellow, applied in thick impasto on the thinner greens and blues, gives the viewer an added dimension of colour, compared with the superficially far more striking *The Watering Trough* (Cat. 68), where the exaggerated linear quality and the witty oppositions give an irrational flavour. Because of the oppositions, the viewer here takes in the properties of colour on a more unconscious level; they influence his relationship with the images in a subtler way. *The Rooster* provides a key to a great deal of Chagall's later work, for it marks the beginning of the colour 'chemistry' which he developed most fully in pictures painted after the Second World War (see 'France 1948 onwards', p. 223).

REFERENCE
R. Maritain, *Chagall ou l'orage enchanté*, Geneva, Trois Collines, 1948.

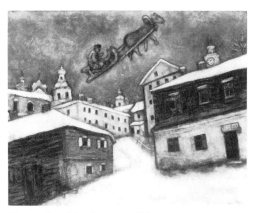

76 reproduced in colour on p. 110

76

Russian Village (*c.* 1929)

Le village russe

Oil on canvas
$28\frac{3}{4} \times 36\frac{1}{4}$ in/73 × 92 cm
Private Collection

This has been identified by Ida Chagall as a painting given to a wealthy travel-agent friend in lieu of a fare for Chagall and Bella's first trip to Palestine, which they made in 1931. A similar view is to be seen in *Girl on Horseback (Violin music)*, dated 1929 (Meyer, cat. 538): it is thought to be Vitebsk and is unusually realistic, suggesting a postcard view or a painting by Utrillo. It is rendered in the colours of a midwinter day with a leaden sky. The figure in his sleigh has been displaced from the steep snowy road and flies through the sky as though this were his true domain. Chagall has achieved the effect by using a rigid system of diagonals which look as though they follow the traditional rules of perspective, so the viewer reads the scene

naturalistically. Receding lines are arranged in steep angles which carry the eye up the snowy hill in the centre. The structure of this composition is so logical that the final line, that of the sledge, makes 'sense' to the eye, even though the mind is afterwards surprised at having 'agreed' to something so illogical as a sledge being driven above the town. Here lies the imagination of Chagall: even more than Redon he is able to cause 'improbable beings to live in human fashion according to the laws of the probable' (see Cat. 35).

Russian Village makes an interesting contrast with *Over Vitebsk* (Cat. 46), where the whole view seems to share the fantasy of the displaced figure; here it has been much more closely integrated into the composition. Chagall used the figure on a sleigh again later many times, for instance in *Soul of the City* of 1945 (Cat. 87).

77

Lovers in the Lilacs 1930

Les amoureux aux lilas

Oil on canvas
$50\frac{3}{8} \times 34\frac{1}{4}$ in/128 × 87 cm
The Richard S. Zeisler Collection, New York

Chagall here continues a theme of lovers and flowers which was initiated by the small bouquet which Bella holds in *The Birthday* of 1915 (Cat. 48). He brought it to fruition in the 1920s, with such paintings as *Lovers under Lilies* (Cat. 67) and *Lovers with Flowers* (Cat. 74). Here he has taken a still-life and married it with a franker approach to the lovers in one of his most explicit memories of days as a young lover by the River Dvina in Vitebsk (seen most recently in *Couple on a Red Background*, 1983 (Cat. 123).

By choosing lilacs, Chagall has distilled the quintessential mood of an early summer's night when the young couple share the fragrance of the flowers with a tenderness born of inexperience. He has displayed the fullness of the young woman's breasts, making a beautiful analogy with the moon and its reflection in the water below. Thus in a restrained but sensuous way, he has alluded to night and the age-old

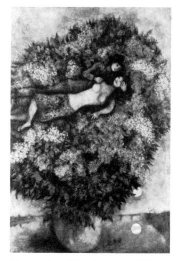

77 reproduced in colour on p. 108

idea that the moon dominates love and woman. The youthful lover shyly explores the other side of life; he is fully clothed for he has strayed here from the realm of the sun and daylight (which in other pictures is symbolised by a rooster).

A vase of flowers appears again in *The Lovers* of 1936, the first stage in the evolution of *Bouquet with Flying Lovers* (see fig. 47 and Cat. 90). The conjunction is one that particularly appeals to Chagall, a bouquet of cut flowers being the archetypal gift for a lover to bring. Yet cut flowers are ephemeral: through man's artifice their beauty is arranged momentarily. So in these themes the artist reminds us of the impermanence as well as the ecstasy of human love.

78

The Wailing Wall 1932

Le mur des lamentations

Oil on canvas
$28\frac{3}{4} \times 36\frac{1}{4}$ in/73×92 cm
The Tel-Aviv Museum; gift of the artist, 1953

This is one of a series of oils which the artist made on his first visit to Palestine in 1931. All are factual records of the scenes which he witnessed, and which he found profoundly moving. Interestingly, he had travelled via Egypt, where he had visited Cairo and the Pyramids, so his encounter with the land of the Prophets followed his first-hand experience of a land of ancient mythology.

In a curious way, this impressive view of the Wailing Wall in Jerusalem brings home the antiquity of these blocks of stone which were put in place by faithful people glorifying

the God which Jews, Christians and Mohammedans worship there today. At that time, the Pyramid builders were still devoted to the worship of sun and moon gods. Since Chagall is a twentieth-century artist, his work reflects his own widespread interests and often includes references to other religions and mythologies which have also shaped the history of Europe. But on his visit to Palestine, by his own record, he discovered the powerful reality of the old traditions of his own people in the present. In this picture he has shown the faithful praying at this most illustrious shrine, the remains of walls of the Temple of Solomon, in a moving representation. The artist visited Palestine in preparation for illustrating the Bible, and the experience of walking in this ancient Holy Land affected his approach to that commission (etchings from the Bible are included in this exhibition in Cat. 181–88).

79

Solitude 1933

Solitude

Oil on canvas
40×66 in/102×169 cm
The Tel-Aviv Museum; gift of the artist, 1953

Chagall made the small version of this composition (Meyer, p. 391) in 1933, just two years after his first visit to Palestine. According to Meyer (p. 384) he had decided to go there to experience the landscape of the ancient Jews before beginning work on a commission to illustrate the Bible (see Cat. 181–88). In the Holy Land he made some finished

78

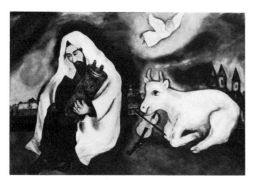

79 reproduced in colour on p. 112

sketches strictly after the motif, views of synagogues and outdoor scenes. This context makes the apparently illogical juxtapositions of *Solitude* all the more remarkable.

On a dark background in the open air sits a Jew, holding a Torah scroll. His head rests in his other hand; in the sketch his eyes are closed, in the present version he is gazing pensively at the ground. A large white garment, which serves to protect the figure from the elements, provides a sharp silhouette against the surrounding dark colours. Nearby, Chagall has painted a white heifer with golden horns juxtaposed with a golden violin and bow, both of which are clearly symbolic. Eloquent words of Sholom Aleichem Stempeni are appropriate to the musical instrument: 'You can compare the heart in general and the Jewish heart in particular to a violin with several strings'. The *Dictionary of the Bible* links the heifer with Israel, citing a verse from the Book of Hosea: 'Since Israel has run wild, wild as a heifer' (*Hosea* IV, 16): the artist has chosen a tamed animal with an angel hovering over its head. In the background distant buildings, generalised in the sketch, take shape as twin towers and domes of churches in Vitebsk (recognisable from earlier pictures) together with low roofs of some rural landscape. All suggest that the pious Jew is imagining Israel from far away. By giving the picture to the museum in Tel-Aviv, the artist has brought his home town there, adding, perhaps, a hope expressed in the continuation of the same verse from Hosea: 'and will the Lord now feed this people like lambs in a broad meadow?'

In the years since his childhood Chagall had, of course, added some of the myths of other religions to his stock of memories. His use of a cow may suggest to some the holy animal of the East, as well as that innocent victim of the butcher's knife whose lowing had troubled Chagall's nights in his Paris studio in La Ruche (*My Life*, p. 103). But any connections the viewer brings to the picture will not alter its innate, mythical quality, which remains unaffected by particularisations. Chagall's images are essentially generalised and timeless; he has succeeded in creating his own religious art, imbued with a sense of the divine but wider than any one faith or creed.

REFERENCES
Sholom Aleichem Stempeni, *La vie juive*, St Petersburg 1903, p. 123; J. Hastings, *Dictionary of the Bible* (2nd edn, rev. F. Grant & H. Rowley), Edinburgh, Clark & Scribner's Sons, 1963.

80

The Revolution 1937

La révolution

Oil on canvas
$19\frac{3}{4} \times 39\frac{3}{8}$in/50 × 100 cm
Collection of the artist

This small oil version records a monumental canvas which Chagall worked on in the latter part of the 1930s, finally cutting it up into three parts in 1943. As Meyer records (pp. 412–13), Chagall attempted to encompass his experience of the Russian Revolution at a time when in Paris most intellectuals were supporting the Communists in the Spanish Civil War. While Picasso painted *Guernica*, symbolically portraying the suffering of innocent villagers in modern warfare, Chagall wanted to fix the paradoxical nature of revolution on canvas. He chose the format that he had already used for his huge paintings for the foyer of the Moscow State Jewish Theatre in 1920–21, and he derived the central figure, Lenin himself, from the clowns in one of that series (which he had kept alive by making a replica at the time, surviving canvases reproduced by Meyer, cat. 751, 752). But in *The Revolution* the clown is in deadly earnest: Lenin symbolises his turning the values of the world upside-down. On the right a red flag falls across a disc which doubles as a sun or a trampoline; round it musicians, lovers and the painter himself are celebrating an idealised freedom, to which Lenin is pointing.

On the opposite side, the world is in turmoil: revolution is taking place, with soldiers and people with sticks threatening those about them. A dead figure has fallen onto the central arena, a stage incongruously lit by a hanging lamp. Nearby a praying Jew, holding a Torah scroll, is leaning on his elbow at Lenin's table, but in meditation like his counterpart in *Solitude* (Cat. 79). Here, given this central position, he seems to ponder the freedom the Jews obtained as full citizens after the Bolshevik Revolution in Russia.

In the same year that he dated this sketch Chagall himself took French citizenship, an event perhaps linked with the growing persecutions in Nazi Germany. For in 1937 Hitler ordered all work by modern artists to be removed from museums and some of Chagall's pictures were sold in the auction of work by 'degenerate' artists.

In *The Revolution* Chagall has attempted to portray the difficulty of trying to reform society while preserving the liberty of the individual.

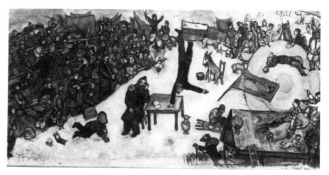

80 reproduced in colour on p. 111

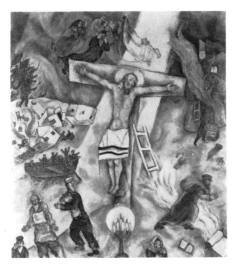

81 reproduced in colour on p. 113

81

White Crucifixion 1938

La crucifixion blanche

Oil on canvas
61 × 55 in/155 × 139·5 cm
The Art Institute of Chicago; gift of Alfred S. Alschuler

This culminating picture of the 1930s was begun while Chagall was working on *The Revolution* (Cat. 80). Although *White Crucifixion* is not at first glance a political painting, it is far more complex than its traditional counterparts and offers a commentary on contemporary history. The canvas includes many events; its form is related to that of an Eastern ikon, although the artist has dispensed with the separate compartments of an Orthodox ikon and used the grey background to unify the disparate scenes. All are dominated by the calm figure on the cross, an image from the Western tradition.

That a painter preoccupied with his own Jewish upbringing should depict the Crucifixion may seem incongruous, but he was following a precedent in Russian art: letters from the Jewish sculptor Antokolsky, published in St Petersburg in 1905, vividly describe the conflicts of a faithful Jew in a Christian society. 'For several weeks now I have been working on "Christ", or as I call Him "Great Isaiah"./Jews may have renounced Him, but I solemnly admit that He was and died as a Jew for truth and brotherhood . . . The Jews think I'm Christian and the Christians curse me for being a dirty Jew (*zhid*). The Jews rebuke me: why did I do "Christ", and the Christians rebuke me: why did I do "Christ" like that?' (Stasov, pp. 70–71 and 489).

In this picture Chagall demonstrated his sensitive and passionate care for suffering Jews, identifying Jesus of Nazareth as one of them. His central figure is a point of stillness amid intense activity. Soldiers, male and female, rush in from the upper left, from the sky as well as from behind a hill, arms aggressively outstretched, carrying two red flags and weapons of all kinds. They are attacking

houses of a schematic Vitebsk, which have been pushed over like toys: flames pour from one, someone is tumbling off a roof. Nearby, those made homeless by war are sitting on the ground. This is not the only disaster: on the other side is a scene of religious tragedy. A synagogue is burning, with flags identifying the aggressors behind it (in a photograph published in 1939, swastikas appeared on the soldier's armband and the flag above the ark, *Cahiers d'Art*, 14, nos 5–10, p. 152). The façade carries a relief of two lions, traditional motifs on an eastern European synagogue. But in this Crucifixion scene their significance as Christian iconography need not be overlooked, for lions are the emblem of St Mark, so the artist has introduced his own, westernised name; he has included himself, not in the form of a self-portrait, but as a lion, firmly attached to the threatened synagogue.

Chagall is not the only Jewish artist in the twentieth century to have adopted the Crucifixion as a poignant reminder of the suffering of Jews. In a most interesting article Ziva Amishai-Maisels has traced the history of the 'Jewish Jesus'. Discussing *White Crucifixion*, she has suggested that it was directly inspired by specific events, the *Aktion* of 15 June 1938 (when fifteen hundred Jews were taken to concentration camps), the destruction of synagogues in Munich and Nuremberg in June and August, and the pogroms of the same year. The picture was originally more specific than it is now, for before overpainting, the old man at the lower left had '*Ich bin Jude*' (I am a Jew) written on the plaque which he wears round his neck. When it was first exhibited in Paris in February 1940, Chagall's countryman, Benois (who shared memories of pogroms in St Petersburg) saluted it in a review: 'This painting was undoubtedly conceived in suffering . . . It is clear that this vision was provoked by the events of the last years, especially by that untranslatable horror which has spread itself over Chagall's co-religionists.'

Chagall has presented his Christ as the symbol of the suffering of Jewish people; however, since for many this figure is the symbol of the central divine figure of the Christian religion, he introduces a confrontation. This is embodied in the small, overloaded ship, with survivors of this holocaust pointing to the figure on the cross. Looking at this figure, who radiates a quietness and peace superlative in twentieth-century art, one has to ask with any Jew, why are Christians watching while the world kills Jews? Perhaps Chagall did not set out to ask this question directly, but his picture asks it itself.

REFERENCES
Letters to Stasov, Rome, 31 March 1873 & Paris, 8 January 1883, in V. V. Stasov, *Mark Matveevich Antokolskiĭ*, St Petersburg, Wolf, 1905, cited in English in Z. Amishai-Maisels, 'The Jewish Jesus', *Journal of Jewish Art*, 9, 1982, pp. 84–104; A. Benois, 'Les Expositions: Chagall, œuvres récents', *Cahiers d'Art*, 15, nos 1–2, 1940, p. 33.

82

The Three Candles (1938–40)

Les trois cierges

Oil on canvas
50¼ × 38 in/127·5 × 96·5 cm
Private Collection

The theme of lovers with flowers is here treated in a far more energetic composition whose sombre tonality matches its mood. It makes a contrast with another picture of a bride but with a Christian title, *Madonna of the Village* (Cat. 83). *The Three Candles* can be seen as its Jewish counterpart, for the bride and groom are mysteriously standing on a marriage canopy, held up by small angels. Amongst the angels is a violinist, a traditional player at Jewish weddings, and immediately behind the three candles lies a heifer, a symbol of Israel which appears in *Solitude* (Cat. 79). But the picture is loaded with further symbolism for it was painted in the two years before the Chagalls left France for the United States, at a time when their own future and, more especially, the future of their friends and relations in faraway Vitebsk, must have seemed unsure. There is bewilderment on the faces of the newly married couple with a lifetime before them, as they contemplate the tapers that had been part of so many religious festivals of their youth. This picture expresses the hopes and fears of any newly married couple as well as reflecting the reaction of the painter to an anxious moment in history.

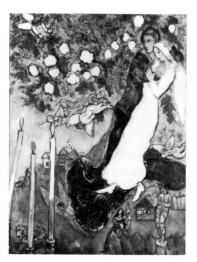

82 reproduced in colour on p. 115

83

Madonna of the Village 1938–42

La madone du village

Oil on canvas
40¼ × 38½ in/102 × 98 cm
Thyssen-Bornemisza Collection, Lugano

After Chagall had painted his *White Crucifixion* (Cat. 81), it

83 reproduced in colour on p. 114

should come as no surprise to find him tackling a Madonna and child, another religious theme from the Christian tradition. Once again, he treats a familiar subject in a totally unexpected manner: the over life-sized Madonna holds a child but she is clad in the clothes of a bride; she hovers next to a collection of buildings which are as much like some small town in France as Chagall's native Vitebsk. Indeed, this Madonna seems to belong to the Western Church, where a sacred statue may be borne aloft through the streets on a feast-day.

A closer look at the picture reveals that it is divided into three distinct zones: above the two angels hovering in the blue sky is a yellow realm of the imagination. From it a human figure reaches down and tenderly touches the head and veil of the Madonna with his cheek and hand. This yellow mythical country includes a heifer with a violin which has escaped from another of Chagall's fantastic compositions, *Solitude* (Cat. 79). In the corner a floating figure offers a bouquet. Only in the middle background is a spiritual note again suggested by the candle which doubles as a star or the moon. Thus the artist has used his inventiveness to shape a superficially simple picture with his own symbolism, so allowing a much wider interpretation of what might otherwise be a narrow theme. For example, the Christian image of the Madonna and Child was probably in the early history of the Church developed from various pagan cults which worshipped a female goddess. Centuries earlier, but under the aegis of a cult of Venus, the great Jewish symbolic love poem the *Song of Songs* was written, supposedly by King Solomon. Later in his life the bride of this poem held a special fascination for Chagall, evoked in this picture by the Madonna in her bridal array. In 1943 he said: 'Some people are wrongly afraid of the word "mystical", to which they give a meaning that is too religiously orthodox. We must strip this term of its obsolete and musty exterior and understand it in its pure form, exalted and untouched' ('The Artist', p. 33).

REFERENCE
Marc Chagall, 'The Artist' in *The Works of the Mind*, ed. Robert B. Heywood, University of Chicago Press, 1947.

The United States of America

1941–48

There were three strong influences on Chagall's art of this period, Russia, the theatre and the death of his wife. In some ways the arrival of the Chagalls in the United States must have given them a feeling of homecoming as much as of exile. Unlike the previous time when the artist had left France in 1914, on this occasion he was able to bring all the canvases from his studio, which allowed a continuity in his work. He and Bella lived mainly in New York where there was a thriving community of expatriate Russians, and the entry of the Soviet Union as an ally in the War removed a source of stress for the couple. In 1942 the artist renewed his old friendship with Russians who were sent by the Soviet Government on a cultural mission to New York: these were the actor Michoels from the State Kamerny theatre and the poet, Feffer. During the summer and autumn the artist saw them almost every day and was able to relive and revive his feelings for his native country. When Michoels and Feffer went back to Russia he sent with them a touching message: 'To my fatherland, to which I owe all I have done in the last thirty-five years and shall do in the future' (Meyer, p. 441).

In 1942 he was given the opportunity to work in the theatre for the first time since 1921. For six months he worked with the Russian choreographer, Léonide Massine, on the ballet *Aleko*, which is described in the theatre section (Cat. 126–39). Stage lighting effects brought a renewed interest in colour which is reflected in the oils of this period, for instance, *Listening to the Cock* (Cat. 85) of 1944. That year was marked by a personal tragedy when, on 2 September, Bella died suddenly from a virus infection. For thirty years she had been his constant companion, and with her great love of literature she had clearly enriched his inventive compositions. Chagall was unable to work for some time after this blow and the later pictures in this section nearly all commemorate his loss. However, in 1945 he received a second commission to design a ballet and then an invitation for a major retrospective, organised by Sweeney at the Museum of Modern Art in New York in 1946. This was followed by another invitation, for an important exhibition in Paris the following year. These exhibitions enabled the artist to complete a number of pictures which he had brought with him unfinished from Europe, and they also resulted in his bringing others to their final form, such as *Bouquet with Flying Lovers* (Cat. 90).

fig. 46 Chagall at work in his New York studio, *c.* 1945

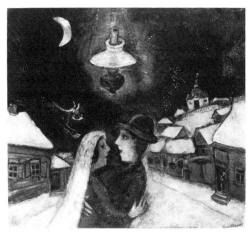

84 reproduced in colour on p. 122

84

In the Night (1943)

Dans la nuit

Oil on canvas
$18\frac{1}{2} \times 20\frac{5}{8}$ in/47 × 52·5 cm
Philadelphia Museum of Art; The Louis E. Stern Collection.

This small picture was originally nearly twice the size, it is reproduced by Meyer in its early form, cat. 602. When the artist completed the picture in 1943 he cut down the sky, leaving the lamp and the pair of figures below. But he brought the street scene into a closer relationship with the lovers, adding a veil for Bella and replacing an angel by a whimsical cow, barely outlined in the black night sky. Chagall has now imagined the scene as taking place in Vitebsk, with its characteristic church and shop doorway. The profiles of the lovers, though immediately suggesting the artist and Bella, are carried out in that caricature-like style which he had used so effectively in early pictures; it is particularly close to *Wedding* (State Tretiakov Gallery, Moscow) dated 1917.

In a persuasive article, Mira Friedman has connected *Wedding*, with its unusual style and imagery, with an unusual medieval painting of Joachim and Anna near the Golden Gate from the cathedral at Carpentras (Dipre, *Rencontre à la Porte Dorée*, Carpentras Museum) which she suggests that Chagall must have known at least in postcard form. (Incidentally, the town is also famous for its medieval synagogue, so it seems not unlikely that someone in Chagall's circle would have visited it.) But in this scene, originally called 'Under the Lamp', a type of hanging lamp which is included in so many of Chagall's early pictures (see *Birth*, Cat. 10) takes the place of the angel which had joined the lovers together in 1917. Paradoxically, it brings this street-scene indoors, as though the experience of the lovers allows them to inhabit their own world where, indoors or out, their experience of each other brings back their shared memories of the years in Vitebsk.

REFERENCE
M. Friedman, '"Le Mariage" de Chagall', *Revue de l'art*, no. 52, 1981, pp. 37–40.

85

Listening to the Cock (1944)

En écoutant le coq

Oil on canvas
$37\frac{1}{2} \times 29\frac{1}{4}$ in/92·5 × 74·5 cm
Collection of Katherine Smith Miller and Lance Smith Miller, Phoenix

This conceit marks a joyful return to the lighthearted theme of man and animal which Chagall had explored in the 1920s. But here, after his visit to Mexico, he has captured a kind of primitive exaltation which is new in his work. The canvas is roughly divided into two coloured areas dominated by the darkness of night and the red of dawn or passion. The composite figure of the lovers in the cow, nestling in the darkness on the ground near a little house, paradoxically appears to the viewer to be in the sky: they are far above the moon and a tree which unaccountably appears upside-down. No doubt they are awakened by the cock crowing in the foreground, in spite of the fact that he is about to lay another egg, to join the one so comically enclosing a little chick beside him. Furthermore, sheltering in his tail-feathers is a violinist, while the artist's name is written in disjointed letters on the rump of the cow, with a pattern of foliage. This decoration suggests one of the painted pottery animals made by Mexican folk-potters which Chagall must have seen when he was staying in Mexico City two years before when preparing the ballet *Aleko* (see p. 248).

Onto his own resonant fields of colour Chagall has placed recognisable forms, which tease the mind even as the eye enjoys the colour.

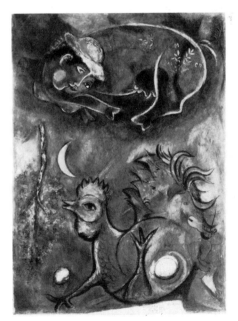

85 reproduced in colour on p. 117

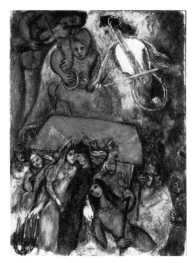

86 reproduced in colour on p. 118

86

The Wedding (1944)

Le mariage

Oil on canvas
39 × 29¼ in/99 × 74 cm
Collection of Ida Chagall, Basle

Chagall painted this picture in the year of the sudden death of his wife Bella. According to the artist, her last words were: 'My notebooks . . .'. In 1947 in an 'Afterword' for Bella's writings he remembered: 'I can see her now, a few weeks before her eternal sleep, fresh and beautiful as always, in our bedroom in the country. She was arranging her manuscripts—finished works, drafts, copies' (*First Encounter*, p. 346). After her death, her daughter Ida edited Bella's writings and this picture seems to encapsulate one of the stories from her mother's childhood. Entitled 'A Wedding', it tells how the little girl ran from her home one evening to the Reception Rooms nearby where, every night, a wedding was held. Bella describes this occasion of anticipation and joy in her usual vivid style. The climax is the meeting of the bride and groom, a young man who walked with hesitant steps, 'whose tall hat trembled with him. He drew near the whiteness of the bride. He seemed as scared of her as she of him. . . . A little red sky has been unfurled in the middle of the room, held up with long poles. The bride stood like a bright cloud in the middle of the dark floor. We hurried over and supported her from all sides. Almost fainting , she was led under the bridal canopy' (op. cit., p. 122). Chagall has caught the mood: the groom has just thrown back the bride's veil and is pressing against her in nervous anticipation, lit by the candles which burn in the foreground. Behind them, figures press forward with the red canopy, to raise it over the heads of the couple. But at the same time the canopy takes on an ominous look, casting a glow on all those around, and with its striking form divides the painting in two. Above it there emerge from the background three over life-size musicians, occupying the space traditionally reserved for beings from another world.

But these are no joyful angels who have strayed from a Botticelli Nativity, but rather some menacing harpies, more like the grotesque inventions of Goya. These give *The Wedding* an air of sinister foreboding, which is characteristic of Chagall's paintings of the 1940s. But unlike many of them, this picture is a celebration of colour: he has regained the strong feeling for brilliance found also in *Listening to the Cock* (Cat. 85) of the same year. The canvas is flooded with red, balanced by a calmer green and blues, the three areas working against each other and bathing the figures with their radiance. He has borrowed a theatrical device, where coloured lighting is used to pick out various parts of a stage backdrop. He had already had experience of such lighting in his work for the ballet *Aleko* (Cat. 126–39), and he was to explore it again the following year with his décor for *Firebird*, of which the climax is a more joyful red wedding scene.

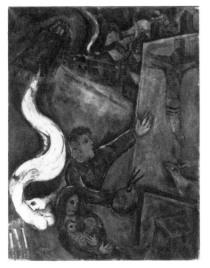

87 reproduced in colour on p. 116

87

The Soul of the City 1945

L'âme de la ville

Oil on canvas
42⅛ × 32 in/107 × 81·5 cm
Musée national d'Art moderne, Centre Georges Pompidou, Paris

The sombre colours of this painting belie the urgency of its subject-matter. The artist has depicted himself in the centre, painting a large Crucifixion. Although the picture within a picture might be expected to include the colours from his palette, he has kept it in shades of grey (except for the vivid blue of the animal). Likewise, the village behind shares the same level of reality—or unreality—by virtue of its similar dark and gloomy tones. Colour is introduced in the artist's purple jacket and the contrasting green of his second, Janus head. That head is looking at the apparition of Bella, or the Bride, who streams down like a comet from a pulpit dominated by the Tables of the Law and flanked by traditional lions painted in grey. From these falls red

drapery, next to the Torah Scroll. In the sky is the trail of another comet, a white, serpentine line which streams down into the houses; another, less clear, doubles as a plume of smoke. Nearby is a flying sleigh, a familiar motif going back at least to the end of the 1920s when Chagall painted *Russian Village* (Cat. 76). Dominating the foreground is another woman, or perhaps another side of the first, clasping a little rooster to her chest.

The juxtapositions in *Soul of the City*, the double-headed artist, the two forms of the woman, the dying man with the frightened doe, and the pairing of colours, suggest that the artist wanted to convey the dichotomies of life, the tension between the spiritual and the sensuous. The crucified figure, traditionally the emblem of Christianity, which Chagall has used a number of times to stand for the noblest suffering of human kind, marks one form of spirituality. The bride, streaming down from the emblems of the Jewish law, with her eyes fixed firmly on the three candles, represents both the spiritual side of mankind and Israel as the bride of God. The human form of the artist with his green head, and the sensuous woman in the foreground, betray the dualism which is present in the whole of life. The movement in the diagonal left half of the picture is counterbalanced by the cross-like formation of the human protagonists in the centre (the artist's outstretched arm is continued in the line of Bella's head).

The Soul of the City, loaded with anguish and with its wealth of imagery, forms a strong contrast both to *The Three Candles* (Cat. 82) of 1938 and *The Tree of Life* (Cat. 92) of 1948. It marks a period of turmoil in Chagall's personal life, following the death of his beloved first wife. But the immediate events in the life of the artist reflected in this picture are less important than its underlying message of the tensions and dichotomies that exist, if unrecognised, in the life of everyman.

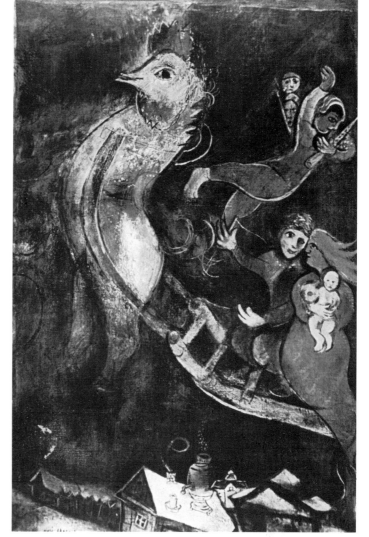

88

88*

The Flying Sleigh 1945

L'attelage volant

Oil on canvas
$51\frac{1}{8} \times 27\frac{5}{8}$ in/130 × 70 cm
Collection of the Abrams Family

Like *Listening to the Cock* (Cat. 85), *The Flying Sleigh* is a fantasy of lovers with a mythical bird, but here the couple with a newborn child fly up into the black sky, drawn by a bird-headed horse. They are greeted by a figure clothed in blue, who is joined by mysterious peering heads. All this takes place in silver moonlight which reveals a cluster of snow-covered houses huddled together below. The same magic which draws the fantastic procession through the air enables a roof to double as a table-top, to support that emblem of Russian life, the samovar. While most of the canvas is painted in black, the woman's figure glows with a brilliant red as her partner reveals the mystery of the night sky.

While the subject is like a dream, the composition is astonishing; there is no suggestion of spatial depth, the figures are simply deployed on the relatively uniform surface. Chagall has often spoken of his pictures as 'abstract'; here he has demonstrated what he means, since the representational elements are arranged on the surface in a series of arabesques and silhouettes which parallel the triangles and circles of other artists. Yet, because the rhythm and movement is conveyed by recognisable forms, Chagall reaches the senses as well as the eye: above all, the way that he physically manoeuvres the paint gives an added sensibility to the picture.

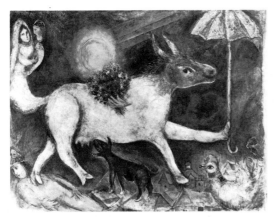

89 reproduced in colour on p. 121

89

Cow with Parasol (1946)

La vache au parasol

Oil on canvas
$30\frac{1}{2} \times 41\frac{3}{8}$ in/77·5 × 106 cm
Richard S. Zeisler Collection, New York

For many people this picture will epitomise the fantasy of Chagall. He imagines a contented cow who, absurdly, carries a parasol to protect herself and her calf from the incandescent sun. No matter that she strides over the rooftops with one foot on an uncomplaining clown, nor that the sweeping line of the bridal dress doubles as an unlikely tail; no matter, even, that her head has turned a wondrous blue, nor even that the bridal bouquet is held against her rump by a magic hand or glove. This takes the place of the expected ribbon or bow, and with its brilliant orange, it flames with the passion of the sun.

This is indeed a folkloric picture, full of wit and surprising touches of humour. Though seen in profile, the expression of the cow is a knowing one—she looks at the viewer with her single eye almost as enigmatically as a Mona Lisa. Yet there is something earthy and primitive in the head; it seems to be related to a mask which the artist had used for a character in the ballet *Aleko* (Cat. 133). He had been fascinated by folk-art on his visit to Mexico (where the costumes for *Aleko* had been made): the effect could be seen in *Listening to the Cock* (Cat. 85) and he has captured a similar spirit here.

Seen in the context of Chagall's earlier work, the subject has a precedent in the picture dedicated *To Russia, Donkeys and Others* (Musée national d'Art moderne, Paris, fig. 23), with its cow on the rooftops. This was featured in a small retrospective held in New York in 1941 and in the larger one at the Museum of Modern Art in 1946. So the more jovial approach in *Cow with Parasol* can be seen as a reconsideration of the subject. But while the new composition reflects a new experience of primitive art forms, the animal in the earlier picture played a profound role in the realisation of an ancient myth: her sun had been fully eclipsed and, instead of a bridal pair, there hovered a wizard or witch-like figure in the blackened sky. There the cow

suckled a child as well as her calf—a role given in ancient times to the Egyptian god Hathor (see p. 36). It is quite likely that the artist himself had forgotten that connection, more relevant in the heady days of his first visit to Paris than in 1946, but, none the less, the present picture is clearly not devoid of symbols. He has included the cockerel, an ancient symbol of the sun, and placed the cow—a moon and female symbol—between the sun and its own masculine symbol, repeating the pairing of the bride and groom nearby. The artist insists that 'one must not start with the symbols but *arrive at them*' (Meyer, p. 138), and therefore interpretations of this or any other picture should not take the place of the viewer's enjoyment of Chagall's special gifts with colour and imagery.

90 reproduced in colour on p. 119

90

Bouquet with Flying Lovers (c. 1934–47)

Bouquet aux amoureux volants

Oil on canvas
$51\frac{3}{8} \times 38\frac{3}{8}$ in/130·5 × 97·5 cm
The Trustees of the Tate Gallery, London

This picture went through a number of changes before arriving at its present state between 1944 and 1947. A photograph (fig. 47) shows the first version with the large vase of flowers and two heads appearing above it as though their bodies were hidden in the lilies and lilac. Flying through an open window beside them is a cupid or cherub, an idea that Chagall had used several times in the 1920s. The picture was radically changed after the death of Bella in September 1944, although an X-ray photograph has been taken by the Tate Gallery which shows the original state of the picture underneath (when it was entitled *The Lovers*). In the present state, the window framing a bird's-eye view of a village street has gone, replaced by a larger view of Vitebsk, now in the same space as the lovers. Instead of kissing each other, the heads are newly painted, with the head of the artist hovering over Bella and his left arm

outstretched, stroking her flying black hair which is covered by a bridal veil. This image, together with new features in the revised composition, is found in a picture of 1944 with the same motifs, called *Cock in the Night* (reproduced by Maritain, p. 166).

The imagery comes from Chagall's décor for the ballet *Aleko*, especially the first act (Cat. 128). There the disembodied heads of Aleko and Zemphira are shown on a blue background. In *Bouquet with Flying Lovers* this motif has been married to the existing still-life. The moon glows below the lovers in a shaft of light into which the figure of Bella has been partly absorbed; the peaceful roofs of the little town of Vitebsk can be seen below, with the rather menacing head of the cock, perhaps announcing the dawn. On the river there is a boat with one or two figures in it, like the one in the backdrop for the third act of *Aleko* (Cat. 134). However, in *Bouquet with Flying Lovers*, altered after Bella's death, it also serves as a reminder of the age-old symbol of rowing the soul across the river separating this life from the one beyond.

Chagall himself stated in front of the picture in January 1953: 'Say that I work with no express symbols but as it were subconsciously. When the picture is finished, everyone can interpret it as he wishes'.

REFERENCES
Raïssa Maritain, *Chagall ou l'orage enchanté*, Geneva, Trois Collines, 1948; R. Alley, *Catalogue of the Tate Gallery's Collection of Modern Art Other than Works by British Artists*, London, The Tate Gallery, 1981, pp. 112–14.

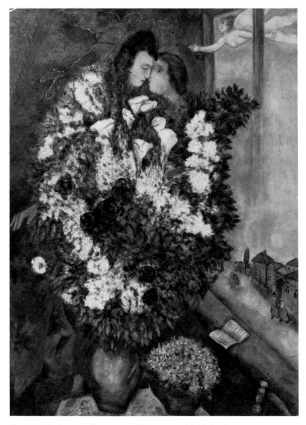

fig. 47 *The Lovers*, first state of *Bouquet with Flying Lovers*, 1936 (photograph Pierre Matisse Gallery, New York)

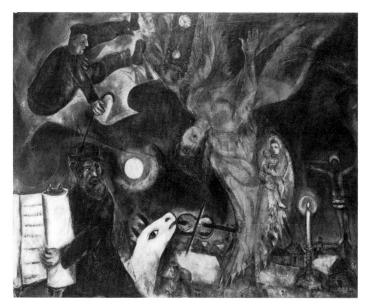

91 reproduced in colour on p. 123

91

The Falling Angel 1923–33–47

La chute de l'ange

Oil on canvas
$58\frac{1}{4} \times 104\frac{3}{8}$ in/148 × 265 cm
Kunstmuseum, Basle; extended loan

This is a picture which preoccupied the artist over a long time: the old man and the angel are present in the earliest version, recorded by a tiny sketch on paper barely ten inches by thirteen (Meyer, cat. 369). In its second state additional figures were added, the younger man in the sky, the clock, a village, the cow's head with violin and a single candle, and the older man now held the scroll open (Meyer, cat. 613). The present state has a mother and child and a small crucifix added on each side of the candle; the fence has gone and the village has been brought into the foreground, with a small figure with a sack on his back in front of the houses. The sky has been darkened on the right, making that contrast of red and black which gives the picture such a fateful look.

The line of the angel's wing, sweeping downwards in its perilous fall, is echoed by the curved back of the old Jew; the pronounced curve of the younger man's body likewise echoes the brilliant red silhouette of the angel's body, and is balanced by the craning head of the calf below. These parallel curved coloured shapes set up a series of diagonals, so that it would be possible to draw a geometric schema of this composition which holds together in an altogether convincing way. The eye is attracted by the contrast of the red of the angel of darkness and the purple of the man of religion, and by the blue and gold of the man and animal symbolising the more human aspects of this strange allegory. Meyer has seen a 'parallel between the cosmic catastrophe of the angel's fall and the course of recent history. The angel is fire from heaven, a burning brand, an insatiable flame that

threatens the same forces of life' (p. 489). Haftmann sees it as 'a pictorial parable on the impact of the wrath of God, who nevertheless is still a loving God'. He also mentions that the artist had recently made the décor for the ballet *Firebird*, using similar colours on a large scale.

Although Chagall had attempted several large easel paintings during the 1930s he had been unable to bring them to completion (see *The Revolution* Cat. 80). Here he conquered his problems, carrying the viewer triumphantly into his baroque scale, which may terrify as well as astonish his viewer. Angels from hell as well as from heaven people the stories of I. L. Peretz as counterparts to the giants and fairies of Grimm and Hans Andersen. The writings of Peretz, however, are as apt for adults as for children, combining parable with myth in an uncanny way. Although *The Falling Angel* is not like any one of the Yiddish stories, it too draws a response from the viewer at many levels. Whatever the viewer may read into this painting, it cannot fail to awaken feelings of tragedy, counteracting a view of Chagall as simply the master of lighthearted fantasy.

REFERENCES
W. Haftmann, *Marc Chagall* (trans. H. Baumann & A. Brown), The Library of Great Painters, New York, Abrams, 1972, pp. 128–9; I. L. Peretz, *Selected Stories*, trans. R. Bercevitch, London, Elek, 1974.

92 reproduced in colour on p. 120

92

The Tree of Life 1948

L'arbre de vie

Oil on canvas
$38\frac{1}{4} \times 31\frac{1}{2}$ in/97 × 80 cm
Private Collection

Chagall has returned to a wedding scene in a mood far removed from the anxieties of the picture of 1944 (Cat. 86). Now the soaring couple are closer to the one in the décor of the final scene of the ballet *Firebird*, which he had designed in 1945. The picture is no doubt a reference to his

own wedding with Bella and it includes a reminder of the same story from her memoirs quoted in the catalogue entry for *The Wedding*. Earlier in the account, Bella had described the bride: 'What did she look like? / A bride was first and foremost a long white dress that trailed along the ground like something living, the whole covered by an airy veil. Through it, as through glass, the bride herself seemed far, far away' (*First Encounter*, p. 118).

In a *jeu d'esprit* Chagall has painted himself, his palette in his left hand, striding across the lower part of the canvas, like *Onward! (The Traveller)*, fig. 29, where he made a pun on his name, which in Russian comes from the verb 'to stride' (*shagat*). In his hand he carries a candlestick to illumine a canvas on his easel but he finds that the bride has soared up into the air, leaving only a few coloured marks there. Behind him are roofs, jostling together with the little church which signifies Vitebsk; further up on the right is a mysterious violinist who seems to have escaped from the ballet *Aleko*, where in one of the scenes, the dancers are weighed down by enormous branches. All these motifs are dwarfed by the vivid autumnal tree which gives the picture its title.

The original 'Tree of Life' is to be found in the Book of Genesis in the description of Paradise, where it was set by the Lord 'in the middle of the Garden of Eden', with the Tree of the Knowledge of Good and Evil, whose position in the Garden is not stated, though Adam and Eve were forbidden to eat its fruit (*Genesis* II).

Some commentators have inferred that the trees were identical, but there is a long tradition that the Tree of Life stands for immortality. Chagall evidently distinguished the one tree from the other, for in his later *Adam and Eve Chased from Paradise* (Musée National, Message Biblique Marc Chagall, Nice), he showed two trees, one uprooted, falling below the arm of the angel who dismisses the lovers, the other still standing gloriously covered with flowers. Its identity is surely the same symbol of immortality that he has painted here. This celebration of the tree of life has a quiet radiance unusual in Chagall's œuvre, perhaps marking the artist's recovery from the terrible blow he had sustained at the sudden death of his bride (cf. *The Soul of the City*, Cat. 87).

REFERENCE
J. Hastings, *Dictionary of the Bible* (2nd edn, rev. F. C. Grant and H. H. Rowley), Edinburgh, Scribner's Sons, 1963.

France

1948 onwards

This section of the Catalogue encompasses the artist's oil-paintings up to the present day, years which have led to his recognition as the greatest living artist. His permanent return to his adoptive country in 1948 heralded a period of consolidation and stability. He began to handle larger areas of canvas, at first because of chance opportunities, such as an invitation to provide wall-paintings for the Watergate Theatre in London in 1949. Then he devoted himself to a scheme of his own devising, a permanent pictorial memorial of the Bible (following the publication in 1956 of the illustrations which he had begun etching as long ago as 1931). Through the late 1950s and the 1960s he worked on monumental canvases illustrating the major stories of the Old Testament. These majestic themes, many of them with few figures and executed on a grand scale, pushed the subject-matter of Chagall's painting back into the mainstream tradition of Western art. When finally in 1972 they were gathered into the Musée National Message Biblique in Nice, they formed a landmark in twentieth-century art, not only by the scale and the masterly handling of colour, but also by the almost ecstatic conception of the subjects. By the terms of the bequest, these pictures remain permanently in the museum, and only a glimpse of this aspect of Chagall's major works of this kind can be shown in an exhibition. However, there are secular counterparts, such as the monumental canvas, *War* (Cat. 107) of 1966 and the great mythological *Fall of Icarus* (Cat. 115) of 1975.

It is remarkable that in the last twenty-five years Chagall has also embarked on a totally new career—he has become the most famous stained-glass artist of our day. The examples shown here, necessarily on a small scale, convey a little of the freedom with which he has approached the medium, allowing colour its full rein. These experiments bore fruit in the easel paintings of the late 1960s and 1970s, where the artist achieved new intensities of colour. But even in the 1950s his renewed excitement with colour following his return to France can be seen in a series of pictures of Paris, with striking black backgrounds, for instance, *Night* (Cat. 94). With *The Concert* (Cat. 98) of 1957 he established a new poetry of colour.

Since the early 1950s Chagall has used the word 'chemistry' to indicate the processes of artistic creation, that is everything that happens to the material substance under the artist's forming hand. He has said: 'I never cross the threshold of an exhibition if my eyes encounter an impossible "chemistry"' (Meyer p. 542). In the 1950s, he often spoke of Monet as a master of this 'chemistry', 'because in his encounter with the visual every brushstroke stemmed from the absence of prejudice. Monet's "colour" was so vigorous that he could even do without "drawing". His eye did not dwell on details but on the compenetration of light

fig. 48 Marc Chagall photographed in Vence, *c.* 1956

and matter, on the "chemistry" of nature for which he created an equivalent in his painting. Thus Chagall's admiration of Monet tallied with his determination to grapple with the elemental still more directly in his own painting.' (Meyer p. 544; see further pp. 542–45).

In recent years Chagall has continued to experiment with a variety of styles. While *War* is a culmination of themes from the 1940s (albeit executed with a new freedom of surface organisation), *The Players* (Cat. 109), executed two years later in 1968, marks an experiment with geometric coloured areas used to heighten the range of colours and prevent the fully modelled figures from advancing out of the picture plane. Although this evidently did not satisfy him, for he forthwith reduced their volumes, he has subsequently invented new ways of marrying figure and ground. He has used a subtle mixture of colours to anchor the forms, sometimes relying on a technique rather similar to that of the Pointillists (of the earliest years of this century), but often creating original effects as in *Don Quixote* (Cat. 114) of 1975 or *The Fall of Icarus* (Cat. 115) of the same year. In many of these pictures Chagall's handling of paint is an important part of the work: the picture surface is as rewarding as the imagery.

Above all, the oils of this period convey the artist's sheer enjoyment of painting. In his own words he may sum up the positive characteristics of this long period of active tranquillity: 'Love of all the world is the most important thing, and liberty. When you lose liberty, you lose love' (quoted by J. Marshall, 'A Visit with Chagall', *Arts*, 30, April 1956, p. 11).

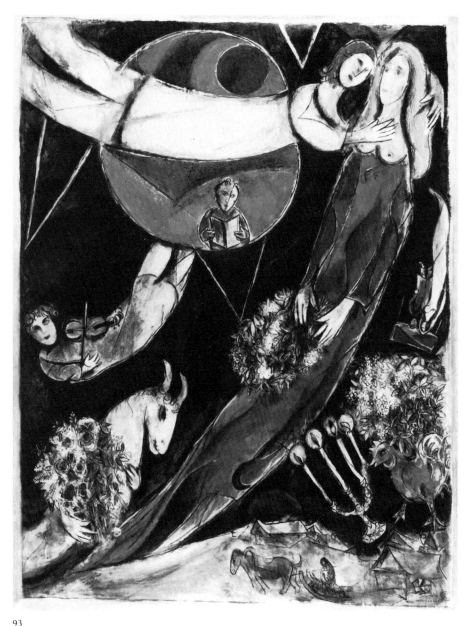

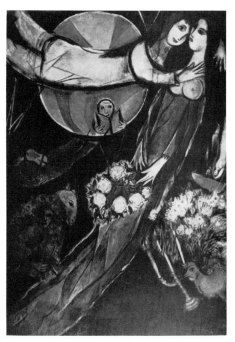

fig. 49 *The Red Sun*, 1949 (collection of the artist)

93

Red and Black World (1951)

Un monde rouge et noir

Gouache on paper
$83\frac{1}{2} \times 65$ in/213×165 cm
Stedelijk Museum, Amsterdam; lent by the artist

This work on paper is a cartoon for a tapestry which was never executed. It is based on an oil-painting of 1949 called *The Red Sun* (fig. 49), although the faces in the present version are more generalised and the village scene at the bottom edge rendered in greater detail.

The bold handling and the large scale are new in the artist's œuvre. Meyer describes how Chagall spent the spring of 1949 in the south of France where he worked only on large gouaches. At this time he took a new dealer in Paris whose larger exhibition space encouraged the artist to

work on a broader scale. In addition, he met the two founders of the Watergate Theatre who were wintering at Cap Ferrat, and he offered to paint murals for this London venture; these he completed shortly before he made *Red and Black World*. (They are reproduced by Meyer, pp. 505, 513 and recorded in London by two very small replicas in the collection of the Tate Gallery.) It shares with them the sweeping lines which are ideally suited for such monumental works, as are the simplified forms in few colours on a unified background. Having conquered the problem of scale by the completion of *The Falling Angel* (Cat. 91) and confined himself to the picture surface in *The Flying Sleigh* (Cat. 88), Chagall could now successfully make compositions suitable for any media. For although a tapestry was never made from this design, there are examples of such work at the Musée national Message Biblique Marc Chagall and in the Knesset building in Jerusalem.

94

Night 1953

La nuit

Oil on canvas
$57\frac{1}{4} \times 44\frac{3}{4}$ in/145·5 × 113·5 cm
Ebnôther Collection, Les Arcs

This unusual picture on a black ground, with forms drawn with white outlines sometimes filled in with brilliant colours, is apparently based on a pastel on black paper of 1946 (Haftmann, p. 132). In that year Chagall had spent the summer in Paris after his five years in the United States; it is as though he were now celebrating his return home, for the lovers are shown above the River Seine with landmarks like the Eiffel Tower below them. Paris has established her place as his second home, and the houses of Vitebsk, to be seen in *Bouquet with Flying Lovers* (Cat. 90), have been put aside. As in that picture, the lovers occupy an ambiguous space; dreamlike, it is at once indoors and out of doors. The outline of the moon is enclosed by a doorway or window-frame and the bouquet of flowers and basket of fruit are apparently on a table, irrationally juxtaposed with the scene of the city at night. In this dream world the images succeed each other in an unreal space which has an imaginary quality, defying close interpretation.

It is interesting that when Chagall returned to Paris after an absence he should have adopted a black ground, since he reverted—perhaps unconsciously—to a mode which he had used long before, when he returned to Vitebsk in 1914. The black ground of *The Newspaper Vendor* (Cat. 44), can be seen as a prototype, although the anguish of that picture is here replaced by a mood of lyrical content.

REFERENCE
W. Haftmann, *Marc Chagall* (trans. H. Baumann and A. Brown), The Library of Great Painters, New York, Abrams, 1972.

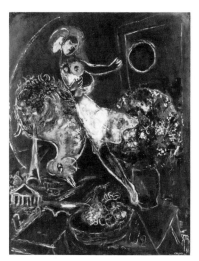

94 reproduced in colour on p. 128

95 reproduced in colour on p. 126

95*

Le Quai de Bercy 1953

Le Quai de Bercy

Oil on canvas
$25\frac{1}{2} \times 37\frac{1}{2}$ in/65 × 95 cm
Collection of Ida Chagall, Basle

This is one of the series of pictures of Paris, the city which inspired Chagall to write for *Verve* in 1952: 'Paris, my heart's mirrored image; I should like to blend with it and not be alone with myself' (Meyer, p. 545). It can be read as an allegory of night, but although it is packed with symbols, they are subordinated by the colour which floods the canvas and seems to have its own life. In the green sky, the naked body of a woman appears, her head swallowed into the disc of the moon, from which her lover's head dimly emerges. The view of the city is chosen to show as much of the river as possible, and Chagall has painted it with a rich shade whose purple overtones contrast with the green above. On each side of this horizontal composition are symbolic bushes, or trees. They could be the two, planted originally in the Garden of Eden, one the Tree of the Knowledge of Good and Evil, the other the Tree of Life, symbolising immortality (see Cat. 92). The two lovers and the two trees are paired by symbolic animals and the whole picture is removed from sentimentality in Chagall's inimitable way, by the little red love bird who turns his head towards the lovers with an expression of defiance.

96

Bridges over the Seine 1954

Les ponts de la Seine

Oil on canvas
$43\frac{7}{8} \times 64\frac{3}{8}$ in/111·5 × 163·5 cm
Kunsthalle, Hamburg

Bridges over the Seine is one of a sequence of pictures from the early 1950s in which Chagall celebrated his love of Paris. The city increasingly took the place of Vitebsk as a symbolic home for the artist, who has so often anchored his imaginative fantasies in an urban setting, ideally suited to the experience of modern man. In this painting the dark

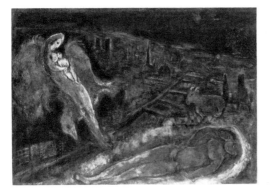

96 reproduced in colour on p. 131

buildings, seen from above, serve as a roughly geometric, static foil to the brilliantly coloured figures who dominate the scene. The red mother and child, nestling in the feathers of a magnificent rooster, look down upon a pair of embracing lovers, resonant in their deep blue colouring. Associated with them is a mythical green beast with cloven hoofs who watches over them with a wary eye.

This strange panorama calls to mind the view of Paris, *La ville de Paris* (Musée national d'Art moderne, Centre Pompidou; fig. 10), the large-scale painting of the city with three large nudes—the Three Graces—by Robert Delaunay, which caused such a sensation at the Salon des Indépendants of 1912. Apollinaire saluted it at the time as the beginning of a conception of art which had perhaps been lost since the great Italian painters, 'a candid and noble picture, executed with a passion and an ease to which we are no longer accustomed' (p. 219). Apollinaire's words are equally suited to *Bridges over the Seine* which may lack any specific quotation from the art of the past, but none the less by its scale and the generosity of imagery reassures the modern viewer of the timelessness of his own preoccupations. In this composition Chagall has celebrated human love in a way that is immediately accessible; with a skill which was to increase over the years, he has created a mythology of our time. Leaving behind the '*surnaturel*' mode which Apollinaire had hailed in Chagall's first Paris period (see Cat. 45), the artist now elevates the experience of a lifetime of love to a scale which indeed begins to rival the achievements of monumental painters of past centuries.

REFERENCE
G. Apollinaire, *Apollinaire on Art: Essays and Reviews 1902–1918* (ed. L. Breunig), The Documents of 20th-century Art, New York, Viking, 1972.

97

Le Champ de Mars 1954–55

Le Champ de Mars

Oil on canvas
59 × 41$\frac{3}{8}$ in/149·5 × 105 cm
Museum Folkwang, Essen

The title of the picture is the site in Paris on which the Eiffel Tower stands, and a skeleton tower is silhouetted against a brilliant, vermilion sun. Buildings in the upper left may suggest Montmartre, though the bride and groom hover over a town which is a reminder of Vitebsk. So this picture is outside the series celebrating Paris, such as *Night* (Cat. 94) or *Bridges over the Seine* (Cat. 96). With its deep blue colour, it is closer to *Bouquet with Flying Lovers* (Cat. 90) which had been altered after Bella's death as a memory to her, his first bride; with the same basic colour Chagall has now created a new symphony, celebrating his second marriage, to Valentina. This union with a Russian reunited the artist with his roots: so the title may be read as a reference to the other famous Champ de Mars (Marsovo Pole), still a Leningrad landmark. Yet he has not linked Paris with the St Petersburg of his youth (which he had depicted quite obviously in the backdrop for the final scene of *Aleko*, Cat. 131); he has preferred to show Vitebsk, the place of his first marriage, recorded perhaps by the bride, Bella, holding a child in the bottom right corner. The picture was started in the year of the tenth anniversary of her death, so the artist holds a bouquet of flowers to her, linking the larger figures to the small.

Although *Le Champ de Mars* recalls earlier themes, the manner of painting is freer; Chagall now exults in colour, which he applies with greater freedom than before.

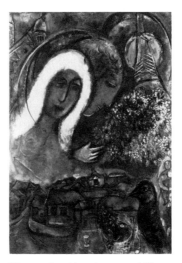

97 reproduced in colour on p. 130

98

The Concert 1957

Le concert

Oil on canvas
$55\frac{1}{4} \times 94\frac{1}{4}$ in/$140 \times 239\cdot5$ cm
Collection of Evelyn Sharp, New York

In spite of the intensity of colour, this is essentially a very quiet and lyrical picture. The blues of the background are interrupted by the curve formed by the principal pair of lovers who seem to be bathed in the sound of stringed instruments streaming up into the sky. Their pink arc circles round the centre of the composition like a halo to the great moon on the right; it meets a green area which plays round a harpist kneeling close beside them, and then disappears past the Eiffel Tower, drawing the arc towards completion. The eye returns to the white moon which dominates the right side of the picture. The sweeping forms are echoed on the left by further musicians: those above, bathed in incandescent orange-red, are introduced in the corner by a tiny angel blowing a trumpet; below, more musicians share the intense blue which serves as a kind of sea or river, unifying the whole picture. Their leader stands on a quarter moon and below him, in the foreground, are a second pair of lovers accompanied by a fish and a violin. Further along the base of the canvas is a small figure, looking up at the musical clown who introduces the scene from his unlikely place on the right.

These repetitions give a clue to an interpretation of *The Concert*, which represents several simultaneous events or levels of imagination. The inhabitants of the broad blue circle round the lower edges of the canvas belong to the everyday world of the Eiffel Tower, although they can hear music from the upper red sphere, which Chagall has introduced by a mythical violinist. He has borrowed the animal-headed figure from his own earlier work, and suggested the sound of music by repeating the instrument three times and then extending the strings downwards like musical staves. This forceful reiteration (an unexpected allusion to devices employed by Futurists long before) cuts across the predominating curves of the composition and draws attention to the inner circle of figures, the lovers and a harpist, who may be resting on a boat. This musician may be Orpheus, or even the young psalmist, David. (Mira Friedman has pointed out that Chagall later used a dual figure, designated Orpheus-David, in his sketch for one of the wall-paintings for the Metropolitan Opera House in New York.) The glow of brilliant yellow paint on the strings of his harp reflects the colour of the final dominant musician of *The Concert*, a winged circus horse with a bird's head.

This harmonious picture allows the viewer to glimpse the planes of the magical world of Chagall's imagination and beyond. No doubt the artist wanted to communicate the 'sound' of the colours in this concert. The idea that colour could create its own emotion has a history going back to the last century, but Chagall's own words clarify his intentions: 'There are no stories in my pictures, no fairy tales, no popular legends. Maurice Denis has said of the French

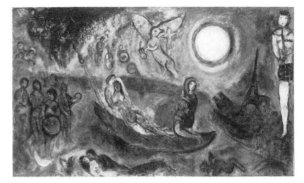

98 reproduced in colour on p. 129

Synthesists of 1889 that their paintings were ''surfaces covered with colours arranged in a certain order''. For the Cubists a painting was a surface covered with forms in a certain order. For me a picture is a surface covered with representations of things (objects, animals, human beings) in a certain order in which logic and illustrations have no importance. The visual effect of the composition is what is paramount.' ('The Artist', p. 35.)

REFERENCES
M. Friedman, 'David-Orpheus in ''The Sources of Music'' by Chagall', *Assaph: Studies in the Arts* 7, Tel Aviv University, 1979–80, pp. 108–17; M. Chagall, 'The Artist' in *The Works of the Mind*, ed. R. B. Heywood, Chicago University Press, 1947.

99

The Farmyard (1954–62)

La Ferme

Oil on canvas
$23\frac{5}{8} \times 28\frac{3}{4}$ in/$60\cdot5 \times 73$ cm
The Israel Museum, Jerusalem; gift of Mr David Rockefeller, New York, to the American Friends of the Israel Museum

This bucolic scene is a celebration of colour, with its pairings of yellow and blue, green and purple, with a well-placed red accent to set it all off. Among Chagall's later oil-paintings it is an unusually vivid and considered reminder of life in the countryside. The farmer's wife, as appropriate to rural southern France as to the backyards of the artist's childhood holidays in Lyozno, comes forward to tend the cow which provides her with her livelihood; a saucy bird from the poultry-yard rushes to share the provender. The animals are those domesticated ones who have lived alongside man for as long as history has been recorded. Their well-being is as important to the farmer's wife as her own; her life is joined to theirs. Twice a day she must milk her cow and gather chickens into the barn to save them from the ravages of the fox.

While this picture can be enjoyed for its ravishing colour and its reminder of an existence ordered by the sun and moon and shared by man and his animals, it carries other

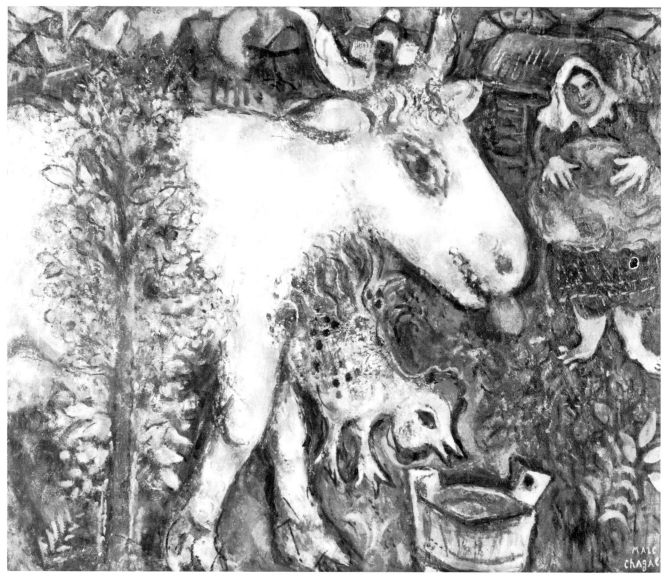

99

messages which the artist has introduced in other
compositions. His cow belongs with the woman in the
hierarchy of female symbols, signified here by the green
moon which hovers overhead; these are paired with the
cockerel, that masculine sign which stands also for the sun.
He brushes against the cow, as does a barely-defined
masculine profile against the woman on the extreme edge of
the canvas. Although the cow may never quench her thirst,
she is assured of immortality by the proximity of a Tree of
Life: or should this be interpreted, perhaps, as that other
tree which stood in the Garden of Eden—the Tree of the
Knowledge of Good and Evil, with its enticing red apples
(see Cat. 92)? Once such symbols are recognised the picture
takes on a dramatic significance, allowing the viewer not
only to enjoy the freedom and sureness by which the artist
has relished the act of painting, but to be touched at a deeper
level. He may carry away a profounder understanding of the
roots of life which, by city dwellers, are too often forgotten
or overlooked.

100

Dance (1962–63)

La danse

Oil on canvas
$51\frac{1}{4} \times 31\frac{1}{2}$ in/130 × 80 cm
Private Collection

Chagall has chosen a theme which was a favourite of Degas
at the end of the last century and was recreated by Matisse
in a fierce, neo-primitive vein for the large canvas which
hung in Shchukin's Moscow collection (*La danse*, now
Pushkin Museum of Western Art, Moscow). In his own late
twentieth-century interpretation, Chagall has imagined his
dancers *sur scène*, not on the real boards like Degas, nor
confined to a hillock like Matisse. Though dressed as for a
stage performance (cf. *Zemphira*, Cat. 129), they disport
themselves across a canvas, freed of the limitations of gravity
and the rules of pespective. His figures express that joy in

228

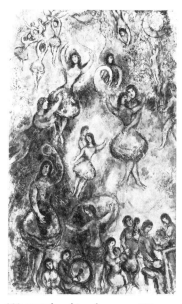

100 reproduced in colour on p. 127

movement which is the prerogative of dancers; they suggest classical choreography with its rhythmic coordination. Those few who are restricted to a chorus line are encouraged by an angel, who, at the top of the canvas, pushes them forwards. Their leader is greeted by an artist, who joins them from the side with an ecstatic leap, reminiscent of Nijinsky, who had painted at an easel next to Chagall's own, so many years before in Bakst's school in St Petersburg (*My Life*, p. 92). In front of these figures, pairs of dancers finish their solos, catching a spotlight—the green and yellow area—which draws attention to them. In the foreground a group of musicians make surprising music, for their instruments are those which Chagall uses in his circus paintings—and, in the bottom right, he can be seen himself, not as conductor, but in front of his easel, as creator of this arcadian scene.

Movement is suggested by the unexpectedly formal patterns made by the dancers which are emphasised by the limited colour. As in *The Concert* (Cat. 98), a blue arc sets up its own pattern to match the dance. This colour also leads the eye across the canvas, so that it picks up a secondary theme, one that is purely mythical: after noticing a figure embracing a swan, the eye comes to rest on a statue hidden in the trees; nearby stands a masked dancer or symbolic beast; and, above, is the moon. All are introduced by a flying figure suspended from some trapeze hidden from sight.

How fresh is the artist's vision; how gracefully he invites the viewer to his celebration. He plays on the canvas as though on some great tapestry, though here he has left the confining lines of *Red and Black World* (Cat. 93), a maquette for that medium, and enjoys the free space, as he does in stained glass. Yet while the essence of stained glass is the light shining through the window, allowing the figures a continually changing coloured light, on a canvas the artist must rely on the constant refraction of light in the pigment. So with a mastery born of years of experience, as well as a remarkable gift, Chagall wields his brush, loaded with

colour, to create a shimmering background, ignoring conventions of shaping pictorial space: instead, he paints a magical, swirling composition of figures and colours which effectively matches the dance of life.

101

Music (1962–63)

La musique

Oil on canvas
$51\frac{1}{4} \times 31\frac{1}{2}$ in/130 × 80 cm
Private Collection

In a lyrical painting on a small scale Chagall has called up *Music* as the sister of *Dance* (Cat. 100). Both are part of a commission for the decoration of a private dining-room, where they can be seen hanging on each side of the doorway (fig. 50). While movement in *Dance* is conveyed by curving bands of blue, the sound in *Music* is suggested by the bursts of strong hues. An intense blue bathes the harpist and his singers; a deep red enfolds the magic cello player and his band; above them Chagall has imagined the boy Mozart, an infant prodigy in his velvet suit of green. Surprisingly, the fiddler, that favourite figure from the artist's Russian days, plays in a patch of gloomy black. Yet he is accompanied by a joyful angel whose expression defies the unexpected dark—by placing it in juxtaposition with his brighter palette, Chagall has, in fact, shown its positive role, for it matches the intensity of blue, red and green and also evokes the violin's sad tones.

Music has often been considered an art of abstraction so, above the figures, Chagall has shown a geometric shape: an angel points out a triangle with amusement, for it demonstrates the formal arrangement of the composition below. Although the artist has tossed off this light-hearted tribute to music, it reveals his own passion for the art.

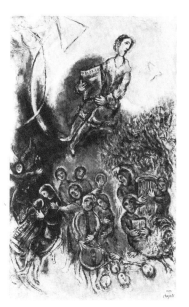

101 reproduced in colour on p. 127

229

102 reproduced in colour on p. 127

fig.51 View of courtyard from dining-room, with mosaics by Chagall

102

Paris (1962–63)

Paris

$22\frac{1}{2} \times 30$ in/57.5 × 76 cm
Private Collection

High above the doorway of a private dining-room, Chagall's unexpected cityscape carries the eye upwards from the evocations of *Music* (Cat. 101) and *Dance* (Cat. 100) hanging below (fig. 50). They are part of a decorative commission which included the majestic *David* (Cat. 103) and *Bathsheba* (Cat. 104) in which Paris, the city of romance, is seen in another light.

While this view of Paris decorates the panelled wall, the windows of the room give another view by Chagall, for the high walls of the small courtyard outside are covered with his mosaics, which give the space a remarkable verdure all its own. The freely arranged tesserae, clustered in blues and greens, are enlivened by tropical birds which hover on the predominantly white walls. The effect of this exterior seen from the formal interior makes an unrepeatable ensemble (fig. 51), for the fluid designs, which are almost like graffiti, allow a feeling of space and freedom to the confined space; this is balanced by two sculptures standing on each side of a central formal pool. While out of doors the high walls block out the city and substitute a magic environment, indoors *Paris* reinstates the locale, transformed into colour and design.

fig. 50 Dining-room showing *Music*, *Dance*, *Paris* and *David*

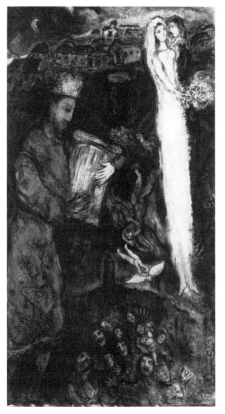

103 reproduced in colour on p. 124

David (1962–63)

David

Oil on canvas
71 × 38½ in/180 × 98 cm
Private Collection

This picture of King David shows him in the role of musician and author of many of the Psalms, with a crowd of people singing his words of praise. They are shown in front of a town whose skyline resembles St-Paul de Vence. In addition, the King is shown as husband of Abigail. Her story, told in the first Book of Samuel, is included here in tiny scenes: for instance, she carries a basket of provisions for David's men in the bottom right corner; higher up is her husband Nabel, sitting at a feast before his seizure after Abigail had told him of her kindness to David. After his death, David rewarded her by marrying her himself and a small wedding canopy is shown in the background. But in order that this story should not be shrouded in the mists of history, Chagall has woven in his own life story. The wedding, taking place just below Vitebsk, could be his own to Bella, and the bride and young groom who balance the figure of David, joining the French town below with the Russian town above, could represent his second marriage to Valentina. Thus the artist identifies himself not only with David as musician (he plays the violin himself) but also as husband of two wives, Abigail and Ahinoam (I *Samuel* XXV, 43).

104

Bathsheba (1962–63)

Bethsabée

Oil on canvas
71 × 37¾ in/180 × 96 cm
Private Collection

As a pair to *David* (Cat. 103), Chagall painted *Bathsheba*, once again taking a story from the history of the Jews, told in the eleventh chapter of the second book of Samuel. He has not illustrated the story in detail, but has simply conveyed the great love that the King had for this beautiful woman. Although David first saw Bathsheba bathing, Chagall has given a modern twist to the story: the couple are seen in front of that city of romance, Paris. The Place de la Concorde is bathed in a blue light, the sun just begins to rise over the buildings. This is a restrained and poetic picture of love, the King tenderly holding Bathsheba who is dressed as a bride, contemplating her married state; in the foreground a war-like eagle symbolises the fate prepared for her husband by her lover (he was sent to the forefront of a battle to be killed by the enemy). But that is only an unobtrusive shadow in this altogether lyrical representation.

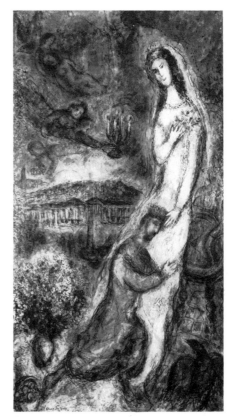

104 reproduced in colour on p. 125

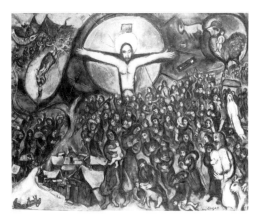

105 reproduced in colour on p. 132

105

Exodus (1952–66)

L'Exode

Oil on canvas
51¼ × 63¾ in/130 × 162 cm
Collection of the artist

The title connects this work with the account of Moses giving the Law to the people of Israel who have just crossed the Red Sea. But although Chagall has included Moses in the bottom right corner, he is not given the prominence that might be expected. A clue to the artist's personal interpretation of the theme is found in a sketch dating from 1952 (fig. 52). This drawing is carried out in black ink and grey wash with white highlights, and the figure of the crucified Christ, who so clearly dominates the oil with his golden body, is there included within a large disc, which doubles as a sun or moon. As Pierre Provoyeur has pointed out, the sketch has a biblical wing on the right, in contrast to the left, which includes the painter with figures from his own life and forms an artistic and poetic pendant; he sees the sacred and human sides of the work of the artist reunited in this large drawing.

Although the oil is little more than twice the size of the sketch, the composition is very much more formal. Chagall has extended the panorama of the history of the Jews, by including references to more stories: the two women in the foreground suggest the judgement of Solomon, the man clutching a container near a woman with a dying child refers to Elijah, who kept a widow alive and restored her son to life. Moses is given more prominence than in the sketch, and above him the bride celebrated in the Song of Solomon can be recognised. These individuals form part of a dense crowd, representing the people of Israel, who now occupy a major part of the composition. Only a small part of the left side is given over to the fate of the Jews in more recent times (rather than to the artist's personal life, as in the drawing).

Exodus was not included in the series of Biblical Message pictures given by Chagall to his museum in Nice, although he made a larger version of the subject as a tapestry for the parliament in Jerusalem in 1964. That version is more faithful to the Book of Exodus, with a large cloud given a central position instead of the dominant figure on the cross of the present picture. The prominence that Chagall gives to Jesus can best be understood in the light of a quotation from the letters of that earlier Russian Jewish artist, Antokolsky, who explained his reasons for sculpting an *Ecce Homo* (State Tretiakov Gallery, Moscow), a figure that had offended many Jews in 1873: 'If there is the hundredth part of humanity in the essence of the Jewish religion, the "Nazarene" not only did not rise up against it, but on the contrary, supported it, repeating Moses' words: "Love thy neighbour as thyself" . . . the difference between them was that Moses was the great practical one and the Nazarene was the great idealist. There should be an immediate clash between such characters. Moses, in accordance with times and his character . . . edited a whole row of strict and energetic laws, which were not supported even by the strongest fanatics . . . In contrast, the Nazarene as an idealist . . . wanted to base all person-to-person relations not on strict laws and fear, but only upon pure love and conscience.' (Antokolsky to Elizaveta Grigorievna Mamontova, 1874.) This viewpoint surely reveals how it is that Chagall can include the Christian Christ in this *Exodus* as 'brother' without compromising his own background.

REFERENCES
P. Provoyeur, *Marc Chagall Œuvres sur papier*, exhibition catalogue, Musée national d'Art moderne, Centre Georges Pompidou, Paris, June–October 1984, p. 175; V. V. Stasov, *M. M. Antokolskiĭ*, St Petersburg, Wolf, 1905, pp. 128–30 (cited in English by Z. Amishai-Maisels, 'The Jewish Jesus', *Journal of Jewish Art*, 9, 1982, p. 90).

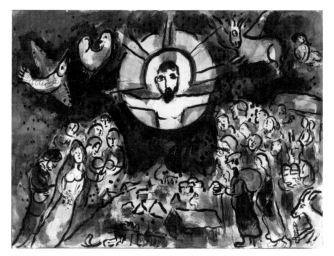

fig. 52 *Sketch for Exodus*, 1952 (collection of the artist)

106

The Prophet Jeremiah (1968)

Le prophète Jérémie

Oil on canvas
45 × 57½ in/114 × 146 cm
Collection of the artist

On a dense and sombre background Chagall has called up an image of the prophet, deeply engrossed in considering the fate of the people of God. The artist had called an etching in his 1930s Bible sequence *Les souffrances de Jérémie*: there he had shown only the magnificent head, whereas here he has envisaged a whole scene. He has balanced the bowed figure with an ethereal angel, which looks on with a quiet expression of concern. Its body is not fully materialised: its wings are suggested by the sweeping white marks nearby; a hand and face are all that link it with the human world. Its phantom quality and floating stance balance the corporeal nature of the golden figure of Jeremiah himself. With his right hand the prophet indicates an open book: perhaps this is the one in which he wrote his description of the disaster that would come upon Jerusalem, for during his lifetime the city was captured and many of the inhabitants were taken into exile. The words of the prophet often seem harsh, but with each of his predictions of calamity he stressed that disaster would or had come about because God's people had not remained faithful to His laws. At the same time, the Lord reassured them with the promise that as surely as He had made a law for day and night and established a fixed order in heaven and earth, He would restore the fortunes of His people and show them compassion.

Such an immutable order is indicated by Chagall, for he has paired the prophet and the angel with 'heavenly bodies' glowing in the blackened sky. The one near the angel seems to be an unknown planet, but the other represents the sun and moon, conjoined in an eclipse. Pouring from it is a violet light that bathes a pair of lovers, whose outlines rise above marks suggesting habitations: 'you shall save your life and nothing more' *Jeremiah*, XLV, 5). White marks over the scene give the rectangular canvas the shape of a lunette, echoing the curve of the prophet's back which continues in a sweeping movement with the angel's wings. However, the eye is not allowed to complete the geometric form, since the white marks above the angel's head urge it onward, out of the canvas, to realms beyond.

Chagall's Jeremiah may be compared to his earlier monumental figure, seated on the ground in *Solitude* (Cat. 79), which is considered in this catalogue to be a general statement about Israel. Thirty-five years later, when Chagall painted *The Prophet Jeremiah*, he wanted to commemorate and bring alive a more specific reminder of the great biblical heritage, a shared tradition which unites a divided Western world. Thus, from the early 1950s onwards, he has continued to paint pictures of a series, which he calls the 'Message Biblique', because he believes passionately that the Word of God enriches the life of man.

REFERENCE
The New English Bible, London, Collin's World, 1970.

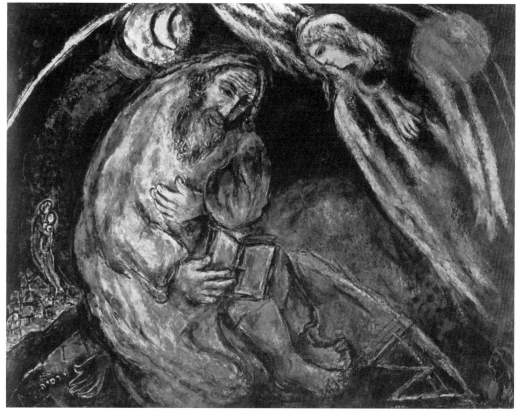

106

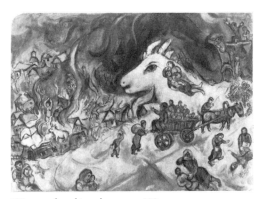

107 reproduced in colour on p. 133

107

War (1964–66)

La Guerre

Oil on canvas
$64\frac{1}{4} \times 90\frac{7}{8}$ in/163 × 231 cm
Kunsthaus, Zurich; Vereinigung Zürcher Kunstfreunde

Chagall has created an ikon for our time: this monumental painting sets out the human tragedy of war, as it is experienced by everyday people all over the world. Here is no glory, but suffering and grief. Gone is victory; only the power of evil to damage thousands of innocents is illustrated here. The sole aggressors seem to be a tiny band of ill-equipped soldiers who rise up upon the neck of the great white mythical creature who dominates the background: otherwise devastation and havoc remain.

The details, the rows of wooden houses jumbled together and burning in a terrible conflagration, echo Chagall's memories of Vitebsk; but they also stand for any settlement where innocent people become the victims of greed and the struggle for power. Among the flames which rise to heaven are naked figures who are translated by the flames rather than consumed by them. Immediately to their right a little group of terrified people tries to escape burning. All this is suggested by a few symbolic figures. In contrast, towards the other side of the picture, a white animal raises its head; it carries horns, and is perhaps a goat, or the heifer symbolising Israel (see *Solitude,* Cat. 79). It is as much friend as foe, personifying impotent fear in the manner of some sacrificial beast. Chagall has intended it as benign, for against its neck are lying two women and a suckling child. On its back, which doubles as a snow-clad hill, stands the cross of Jesus and the oversized figure of Moses, calling out his stern injunctions in vain.

All these activities and the turbulent areas of tongue-like brushstrokes are contained in the upper half of the composition, divided in two by a strongly defined diagonal, repeated in the foreground. This creates several scenes within the whole composition (a device which Chagall may again have borrowed from the compartments of Russian ikons, only to transform it on a unified picture plane; cf. *White Crucifixion*, Cat. 81). The foreground area is devoted to intimate groups, with whom the viewer may more easily identify: the man comforting the woman; the woman comforting her child; the woman mourning a dying loved one; parents weeping and praying over their dead child. In the centre, a group of refugees, attempting to flee the scene of devastation, suggest the results of war: the homelessness, the rootlessness of the dispossessed.

In spite of the tragedy, *War* communicates some messages of hope. The refugees are making their way towards images of another kind of life. Moses is calling out to his people; the artist seems to be flying towards Heaven above the figure of suffering on the cross. In the centre is a peasant carrying a sack, Chagall's Elijah, who, according to Hasidic traditions, reappears with his people in times of great need (see *Over Vitebsk*, Cat. 46).

The most unlikely figure in this monumental composition is the jaunty fellow who walks behind the Elijah-figure. With his cocky profile and small hat, waving his arm and defiantly carrying a stick, it is tempting to read this figure either as another view of the artist himself, or as his hero, Charlie Chaplin (who was, of course, an intrepid fighter for peace). Surely this interpretation is not too far-fetched, for all tragedy must be balanced by a note of comedy. By concentrating on a universal image of the horrors of war the artist has made a more profound statement of the longing for peace than any particularised plea could have done.

108 reproduced in colour on p. 136

108

Portrait of Vava (1966)

Portrait de Vava

Oil on canvas
$36\frac{1}{4} \times 25\frac{5}{8}$ in/92 × 65 cm
Collection of the artist

After he left Russia, Chagall rarely painted portraits: the only examples are of his two wives, Bella and Valentina. He generally showed Bella against a background in the studio, whereas here he has made a symbolic likeness of his second

wife. He has chosen green for her face, the colour he had used for the inspired figure in *Half Past Three (The Poet)* (Cat. 20), and has covered the wall behind her with evocations of Paris and Vitebsk, as in *Le Champ de Mars* (Cat. 97), which celebrated his marriage to Vava. He has also depicted a pair of lovers, emblazoned across her lap, as a tribute of his affection. The role of the brilliant red beast behind is less obvious. However, as it points to a small blue rooster, paired on the other side by a flying fish and a moon, it suggests the sun: a pairing of masculine and feminine symbols occurs in most of Chagall's pictures. It would be possible to read the background as a series of canvases hanging or leaning against the wall behind the model. But as is often the case, the artist has left an element of mystery and uncertainty, allowing the viewer to absorb the effects of the colour without necessarily needing to understand each separate part of the composition.

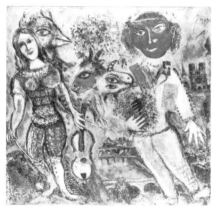

109 reproduced in colour on p. 135

109

The Players (1968)

Les comédiens

Oil on canvas
59 × 63 in/150 × 160 cm
Private Collection, Switzerland

Chagall depicts two strolling players in a Parisian setting, with the river Seine and Notre Dame in the background. He also includes a pair of goat's heads, a reminder of the curtain design he had made for the Moscow State Jewish Theatre in 1921. Although he had used blue as the background colour for a series of pictures (for instance *Bouquet with Flying Lovers*, Cat. 90), in *The Players* he varies this idea by using an unexpected blue, a lighter, brighter colour, as a foil for the brilliance of the costumes; he has added squares of contrasting colour, disposed over the drawing like the elements of some cubist collage. These are closely related to the pieces of material of different types that he glues onto his sketches for stained glass, where they give an immediate idea of the intensity of colour required in certain areas.

Although the figures could be identified as the artist and his wife, they are wearing fancy dress suitable for their role as travelling performers. The figure on the right is wearing

an antique mask, reminiscent of the theatrical convention of the ancient Greeks, while the costume of the woman is based as much upon the figure of an Indian goddess as upon a classical clown's outfit. Thus the actors belong to the age-old convention of travelling players who by their presentation of comedy and tragedy remind the world through which they travel of the paradoxes of human life.

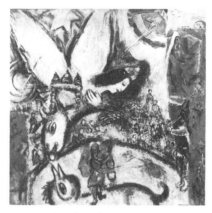

110 reproduced in colour on p. 134

110

The Large Circus (1968)

Le grand cirque

Oil on canvas
67 × 63 in/170 × 160 cm
Pierre Matisse Gallery, New York

Chagall has returned many times to the circus. In 1968 he painted this version which, though smaller than some of his larger arenas, concentrates the theme in a remarkable way. The centre of the picture is devoted to the ring on which a mythical beast takes the place of the more usual circus horse, and on his back is a violinist instead of an equestrienne. She holds out her instrument towards a clown who is playing a pipe. Individual instrumentalists are

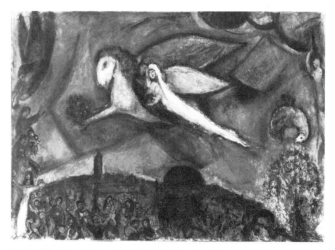

fig. 53 The *Song of Songs IV*, 1958 (Musée national Message Biblique Marc Chagall, Nice)

accompanied by a small group of players who rise above the crowd watching the spectacle. But the scene in the arena is only a small part of this allegory of life, in its comedy and tragedy. The mythical beast in the foreground has the head of a cock, which in Chagall's childhood home was slaughtered on the eve of the Day of Atonement. Bending down in a gracious arc is another symbolic animal with its head attached to a huge pair of white wings, which lift the head and hand of a figure whose face and hair are a reminder of the artist's first wife, Bella.

It would be possible to read this vast, winged beast as the winged horse, Pegasus, from the Greek myth celebrated in one of Chagall's monumental canvases of the *Song of Songs*, no. IV, which hangs in the Musée Message Biblique in Nice (fig. 53). But in this *Large Circus* he has created a paradox by attaching wings to a horse's head, and a bird's head to the horse in the arena, inviting the viewer to react with surprise. On the right there appears, in strange benediction, a hand from Heaven, a schema borrowed intact from an ikon motif. Once more, Chagall's division of the canvas into separate compartments is reminiscent of the ikon tradition. On the lower left, in a green rectangle, a large clown is standing 'in the wings'. On the right another equestrienne wearing the veil of a bride is balanced on a horse in a vivid blue area; above her, in yet another little space, the artist himself, holding his palette, gazes onto the scene in amazement, as it were, next to the hand of God.

A superficial description of this painting fails to convey its strength and power. Although the curves of the major protagonists echo each other in a melodious way, the tension between the symbolic, winged figure and the bird who greets it so piteously is reinforced by the encrusted white surfaces which unify the separate areas of the canvas.

Despite the fact that the circus theme might be expected to evoke the comedy of life, the underlying tragedy of this parody of the human condition is overpowering. Gone are the tumblers of the big top, all simple gaiety in the sawdust ring: here, instead, Chagall depicts some more profound drama in which man is engaged, poised between Heaven and Hell, ever torn apart by the twin desires of hatred and love, and ever seeking a way of reconciliation.

111

In Front of the Picture (1968–71)

Devant le tableau

Oil on canvas
$45\frac{3}{4} \times 35$ in/116 × 89 cm
Fondation Marguerite et Aimé Maeght, Saint-Paul, France

The sombre greys that dominate this painting within a painting, as well as the subject, recall *The Soul of the City* (Cat. 87) which Chagall had painted nearly twenty-five years before. Here again, the artist has pictured himself in front of an easel and included many of the same motifs, but in place of the swirling forms and colour contrasts of the earlier painting, he has centralised the monochrome composition.

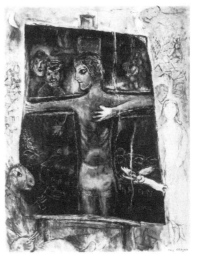

111 reproduced in colour on p. 138

The calm figure of the artist apparently on a cross, quietly dominates the scene. Behind him, heads which resemble those of his father and mother peer out of the greyness: but the blackened greys make it more like some old photograph than a picture of intense anguish.

The motif of the artist in front of his model is one which Picasso had returned to again and again in his later years. But Chagall has introduced a strange variation on that theme by placing himself in the role of the model and denigrating the artist by giving him an animal mask over his own face. Indeed, the picture might be described as a record of different facets of Chagall's personality, for he appears twice more: he is behind the bridal figure, and benignly looking down from the sky above, with hands outstretched in tenderness. The little angel who hovers in blessing in the foreground and the quiet tones seem to counterbalance the cruel subject. Perhaps it is somehow intended to be an allegory like *The Soul of the City*, but the artist has resolved some of the urgency of the earlier picture. The bridal figure now hovers quietly with eyes raised to heaven; the swirling dynamics of the earlier composition have been replaced by graffiti-like marks, incised on the background colours in short, urgent strokes which are echoed by white 'rain' which barely disturbs the calm of the dominant dark 'tableau'.

While it is always easy to see the art of Chagall as unrelated to the work of other artists, in this case it is tempting to remember the importance which, by the end of the 1960s, was attached to the black canvases of a number of other painters of the century. Chagall has eschewed their mode of abstraction. Some words that he gave to Maurice Raynal in 1927 seem particularly appropriate to this picture: 'All aesthetic tendencies do not satisfy me and, persuaded that in art 1 + 1 do not make 2, while not technically undermining the realist principle, I have tried to awaken in my sensibility, the darkest sides, the deepest sides of my nature [*mon moi*]' (p. 93).

REFERENCE
Maurice Raynal, 'Marc Chagall', *Anthologie de la peinture en France de 1906 à nos jours*, Paris, Montaigne, 1927.

112

The Walk (1973)

La promenade

Oil on canvas
45½ × 32 in/115·5 × 81 cm
Pierre Matisse Gallery, New York

This is the second time in the œuvre of Chagall that he devotes an entire canvas to the subject of a hermaphrodite: the earlier version is *Homage to Apollinaire* (Cat. 22), painted some sixty years before. In this new approach Chagall has made the bisexual nature of the figure less apparent by clothing it, but the two heads seem none the less to be anchored in a single body. The creature is fully aware of its surroundings, the male and female heads looking quietly but intently at the world around it. The colour is concentrated in the striking, multicoloured costume decorated by circus motifs which gives the composition such a dramatic air: arcs of colour concentrate implied movement and intensity into the wondrous figure.

The Walk takes place in a mythical landscape, which includes figures and animals drawn from the artist's repertoire of allusions to a wider world. Thus, emerging from the foliage in the left foreground corner is an old man who seems often to represent the artist's father; on the right is a young woman carrying a child; and barely visible in the top right corner is a bird, flying out of the background. On the left side there is also a rearing horse, while above it a strange emanation is hardly differentiated from the dark cloud with which it merges. All these details are portrayed as figments of the creature's imagination, or as a part of shared memories.

The nature of the strange figure is suggested more concretely by the heads which decorate its circus-like costume. There is a fantastic face on each trouser leg; on the left arm is the sun; on the chest is a primitive, mask-like shape; and on the right arm are two views of a horse's or ass's head. These express the human nature of the creature, in contrast to the images in the surrounding landscape which relate to the memories it carries within it.

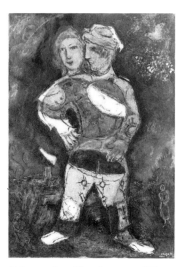

112 reproduced in colour on p. 137

Whereas in *Homage to Apollinaire* most of the colour symbolism is in the background, in *The Walk* the colour contrasts are gathered into the double-person itself and the background is simply a space related to this world, to which the figure belongs. The earlier couple, on the contrary, belong to some primitive era: not only are they only just entering into the condition of male and female, but they are still partaking of the 'music of the spheres'. The present figure is cast in the human condition, and aware, as the pensive expressions of the two heads show, of an age-old background of human history and symbolism which has helped it to become a 'whole' person. In spite of the fact that Chagall has rejected some attempts to interpret his pictures in psychological terms, it is tempting in this instance to recall the ideas of Carl Jung. The harmful divisions between male and female, aggression and love and the other oppositions which tear a human-being apart, are here resolved by the artist.

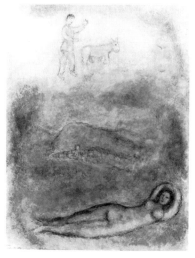

113 reproduced in colour on p. 140

113

Rest 1975

Le repos

Oil on canvas
47 × 36¼ in/119 × 92 cm
Collection of Mr & Mrs Pierre Matisse, New York

The title of this picture is derived from the nude lying in the foreground. She is quietly day-dreaming in a pose familiar from representations of Venus and reclining women in the tradition of Western art. However, comparisons with well-known images may disappoint the viewer, for Chagall has disregarded anatomical perfection, correct drawing, or even the distortions practised by artists like Ingres in their search for an expressive line.

This painting is not realistic in the usual sense, nor is it an abstract picture, for Chagall has flooded his canvas with colour and light of which the figures are an integral part. It is as though he has crystallised the forms out of the colour,

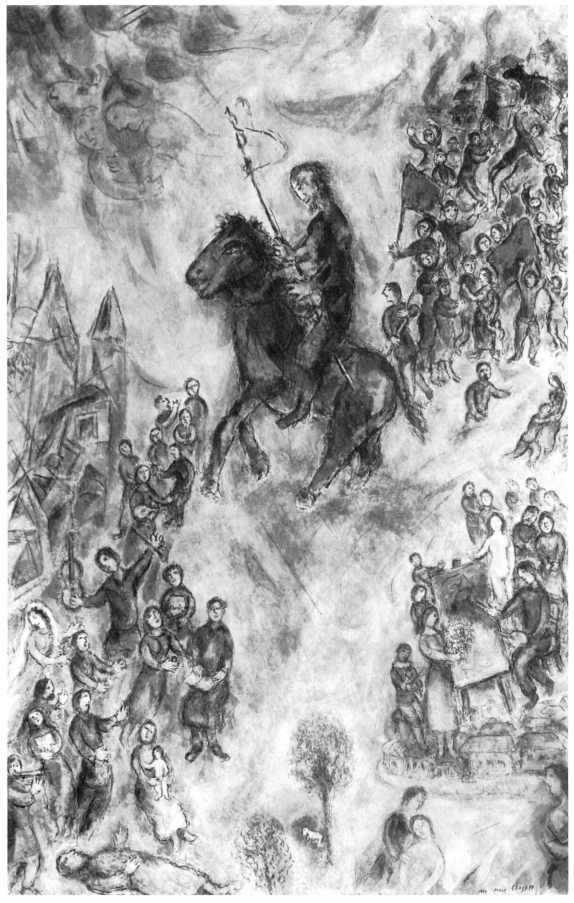

114

which is at least as important as the lines. With many brushstrokes he has made an analogy of a real landscape by placing a sketchily drawn village in the centre of the composition, while the mountains behind the tiny houses are a reminder of that tranquil place in the south of France where the artist and his wife still live. But instead of a sky, which is none the less suggested by the little birds on the right side, there is the figure of a striding man with a small animal: perhaps he is the shepherd Daphnis with a strayed sheep from his flock; or perhaps he is simply a vision in the mind of the woman, musing in the summer light. It is not really important to interpret the subject in any one way: the viewer may bring to it whatever he wishes. But Chagall the magician subtly influences the viewer, using colour to act upon him at an unconscious level. Employing a technique and colour oppositions which he had learned long before from his study of Post-Impressionist pictures, he has conjured his imagery out of the colour fields into which he has divided the canvas. He has achieved a remarkable unity between colour and drawing by manipulating coloured areas with finer brushstrokes, leaving traces which agitate our minds and enable us to accompany him on his pictorial adventure.

While in *The Walk* (Cat. 112) Chagall made an image of the intrinsic wholeness of man, in *Rest* he has split apart the female from the male. Yet the unusual tranquility of this bucolic picture and his colour 'chemistry' bind the two parts indissolubly together. The province of woman may be the earth and its fertility, that of the man the sky and worlds above, but both are captured in a web of paint which conveys the poetry of love and imagination.

114

Don Quixote 1975

Don Quichotte

Oil on canvas
77 × 51 in/196 × 130 cm
Collection of the artist

This picture makes a pair with *The Fall of Icarus* (Cat. 115) of the same year: the artist has again taken a figure, well-known in Western culture, and set him in the centre of his tableau. He has slashed the composition with a diagonal across the centre, with militant aggressors divided from a peace-loving crowd of singers and dancers by the hero himself. The two groups, with their red flags on one hand and joyous mien on the other, are also a reminder of *The Revolution* (Cat. 80), that horizontal composition which the artist had failed to resolve on a large scale. In *Don Quixote*, however, by using a device which would have been familiar to El Greco, he has succeeded in presenting oppositions while uniting the composition as a whole. This he has done by placing the geometric arrangement on a unified surface of paint, which includes a great deal of grey as well as enough colour to link one group with another. The colour has its own life, spreading in patches related to the figures, which are arranged one behind another to create an illusion

of recession so that the eye is led upwards and 'reads' a sky. In that grey area, barely lit by the colour and light issuing from Don Quixote's flag as from a sun or moon, are the outlines of three figures whose role it is hard to interpret. In the bottom right corner is the artist himself, with his own entourage in a triangular arrangement, in a village setting parallel to that from which Don Quixote set out on his 'crusade'. This group adds a note of quietness and sobriety to the dramatic scene.

The musical clown is an allusion to a favourite theme, the circus of life, which in this grand painting encompasses both heedless cruelty and spiritual joy. The two are parted by Don Quixote, who stands for misplaced but true idealism.

As is usual throughout his œuvre, Chagall has given the viewer much to consider. None the less, he has unified the various scenes with an overall magical background in which he has broken all rules of colour mixing and achieved an effect like that of a well-worn wall. On this he has drawn with myriad little strokes, teasing the figures out of the coloured areas, and even including the windmills of Cervantes' story. In addition, this picture illustrates the way that Chagall has managed to transfer to oil-painting the scale and some of the chance light effects that he must have seen when observing his own large-scale stained glass compositions *in situ*.

While younger artists have been inspired by Chagall, few have succeeded in emulating the sure touch with which he creates a modern baroque picture. Freely choosing from among the pictorial inventions which have revolutionised art in his lifetime, he has woven his stories in a masterly way.

115

The Fall of Icarus 1975

La chute d'Icare

Oil on canvas
83⅞ × 78 in/213 × 198 cm
Musée national d'Art moderne, Centre Georges Pompidou, Paris

In his remarkable composition Chagall has defied the rules of painting in much the same way that Icarus defied the laws of gravity. There is little perspective: the scene is created by marks which energise the underlying background. The artist has made an irregular division of the canvas into an upper and lower area, roughly suggesting the sky above a hill. But as is so often the case in his work the scene does not take place in a real space, although the viewer can identify with the onlookers and their homes. They are more like the audience round some great circus ring, with the ultimate clown performing some feat above them, than participants in a scene from ancient Greek mythology. Only a few of the spectators are looking at the extraordinary figure poised in space before his destruction; some have found their way into the composition from other works by Chagall, especially the man outlined against the sky who is herding a reluctant green cow, and the sad nude lying against one of the rooftops. These figures reappear in *Rest*

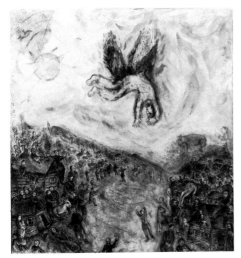

115 reproduced in colour on p. 139

116

The Large Grey Circus (1975)

Le grand cirque gris

Oil on canvas
$55\frac{1}{4} \times 47\frac{1}{4}$ in/140 × 120 cm
Pierre Matisse Gallery, New York

In the last ten years Chagall has returned to the circus scene many times. In this version he has used a technique rather similar to *The Fall of Icarus* (Cat. 115) and *Don Quixote* (Cat. 114), both dating from the same year: he has used an overall light background colour on which the figures are painted with small strokes. But in this case the scene is more coherent than those mythical stories; the composition follows the dictates of the circus ring which is emphasised by the echoing circular form which can be read as a hoop. The gesture of recognition which passes between the equestrienne and the large clown beautifully illustrates some words in his book, *Chagall by Chagall*: 'I should like to approach this circus rider who has just appeared, smiling; her dress, a bouquet of flowers. I would surround her with my flowering and withering years. Kneeling, I would tell her of reveries and dreams, not of this earth' (p. 76).

The equestrienne appears three times, not only in the foreground but coming into the arena between the rows of spectators, and standing on her hands on the horse up on the right side, near the moon, whose soft light provides this picture with its pale background. The sun is not forgotten: it is symbolised by the little rooster who flies above. Chagall has juxtaposed it with the balcony of musicians whose music gives a framework to the antics of the acrobats and equally delights the audience.

REFERENCES
C. Sorlier (ed.), *Chagall by Chagall* (trans. J. Shepley), New York, Abrams, 1979.

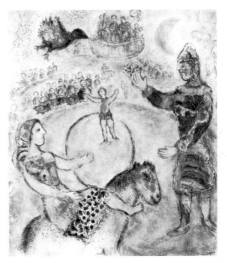

116 reproduced in colour on p. 143

(Cat. 113) of the same year, while the jaunty fellow near the bottom right foreground might be related to the hero of *The Walk* (Cat. 112) of 1973. The creator of the fantasy can be seen faintly outlined in grey, round the grey nimbus of the sun, with his palette echoing the shape of the sun's disc.

The colours are surprisingly subdued: the huge expanse of sky is dappled with many pale colours, grey, soft blue, yellow, with pink near the figure. His form merges with the sky which may be filled with feathers escaping from his wings, causing the bright rays of the sun to be muted. Because Icarus flew too near to the sun, its intense heat caused the wax holding the feathers to melt and directly brought about his fall. The great heat is suggested by the pink pathway below Icarus, with figures drawn on it in a darker shade of the same colour, dividing the lower parts of the picture in two.

The Fall of Icarus makes a pair with *Don Quixote* (Cat. 114) of the same year. The two works break new ground in Chagall's œuvre, for they are his interpretation of well-known heroes from legend and literature, translated into his own magical domain of painting. No one can now accuse him of being a 'literary' painter, as was done in the 1920s: in *The Fall of Icarus* he has simply enriched and revitalised a parable of the past. It is only by direct experience of the paint marks on the canvas, in particular the inventive treatment of the sky, that the viewer can enjoy one of the masterpieces of Chagall's recent years.

REFERENCE
G. E. Marindin, 'Icarus', *A Smaller Classical Dictionary*, London, Murray, 1898.

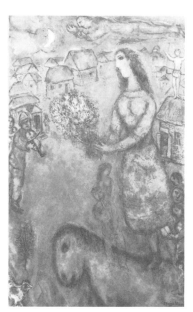

117 reproduced in colour on p. 142

117

Fiancée with Bouquet (1977)

Fiancée au bouquet

Oil on canvas
$51\frac{1}{4} \times 31\frac{7}{8}$ in/130 × 81 cm
Pierre Matisse Gallery, New York

On a red background the artist has deployed some of his favourite figures and motifs. The fiancée of the title doubles as an equestrienne; but Chagall surprises his audience by planting two other figures on the horse's neck. He has overlapped them in a way which would be completely acceptable in an abstract collage, but has confounded the viewer by exchanging the rectangle that one might expect in that medium for a musician and his love behind him. The picture abounds in such tricks: the violinist leading a mother and child floats on the red background instead of striding across the bare ground in front of the small dwellings of some peasant village. On the right a trapeze-artist incongruously stands on a roof, while below him are heads piled one above the other, standing for a crowd in the way only Chagall knows how. Overhead, the magician who created this fantasy floats in a blue capsule, with hands outstretched towards a crescent moon: this is enveloped by a green sphere which represents the rest of the planet and acts as a foil to the predominant red of the picture.

The figure on the horse carries in her hand an ephemeral bunch of flowers, while among the patterns on her dress emerges the shape of a little love-bird. This bird is greeted in turn by its counterpart in the bottom left corner of the picture, who shares the green penumbra of the new moon. The musicians celebrate some quiet love, modestly presenting itself in the humble setting of a Russian village. Once again, Chagall celebrates in a general way that love which is the particularity of humankind.

118

The Myth of Orpheus 1977

Le mythe d'Orphée

Oil on canvas
$38\frac{1}{8} \times 57\frac{1}{2}$ in/97 × 146 cm
Collection of the artist

The ancient story of Orpheus and his descent into the Underworld has allowed Chagall to work on a black background in as inventive a way as the extraordinary manner with which he had worked with white in *The Fall of Icarus* (Cat. 115) two years before. Although at first the eye is captured by the areas of bright colour, when it becomes accustomed to the overall darkness it can recognise myriads of figures and representations with which the gloomy background is populated.

Orpheus, the son of Apollo, had married the nymph Eurydice, whom he loved passionately; one day, she was fleeing from Aristaeus—the god Pan—and was mortally bitten by a snake in the grass. Orpheus was desolate, and decided to descend into the Underworld to reclaim her. Chagall has shown Orpheus, the figure in blue, standing with his harp with which he charmed the gods of the Underworld; they allowed him to take Eurydice back to earth, provided that he did not turn to look at her during the journey. When they had almost reached the gates of Hades, he looked back and thus lost her forever.

As is usual in the case of Chagall, he has recreated the myth in pictorial form, leaving the viewer to interpret it as he may. Orpheus seems to be playing music, but the white monster beside him does not look like a traditional Pan, who had legs, horns and a goat's beard. But neither is it certain whether it is Eurydice who reclines in the foreground, or Persephone, the queen of Hades, who is being charmed by the music. Whichever ancients are read into the scene, the artist provokes thought, with his radiant sun, his little moon and the Tree of Life (see Cat. 92) on its turquoise triangle. He seems to have set out paradoxes of life and death—for surely the black segment is a passage from death to life—in a composition which combines the colour and shape of twentieth-century abstraction with the alluring figures which people the artist's dreams.

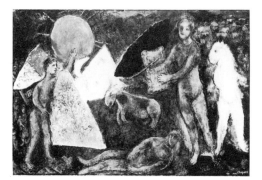

118 reproduced in colour on p. 145

119

The Event 1978

L'événement

Oil on canvas
51 × 63¾ in/130 × 162 cm
From the estate of Aimé Maeght

Leaving aside the heroic format of the pictures of 1975, *The Fall of Icarus* (Cat. 115) and *Don Quixote* (Cat. 114), Chagall has returned to a large horizontal format and explored the canvas with renewed vigour. He has divided *The Event* into unequal zones, a darkened area dominated by a small moon and a candelabra, and a red area dominated by the sun. The paint surface is heavily worked, which gives compositional unity to the figures on these coloured grounds. He has allowed other colours to spill out beyond the outlines to enhance the feelings expressed by the rather restrained figures. The artist himself can be seen on the extreme left, turning away from the scene, which none the less includes many motifs familiar from his earlier work.

The title suggests that some story is taking place, but Chagall has piled up the images to create a composite pictorial event on the canvas; it would be difficult to interpret it as a particular folk-tale or happening. When he was younger, he disliked being told that his art was literary or even poetic, because he wanted to suppress narration in his work in favour of the means of expression. Now, towards the end of the century, the art-loving public has grown accustomed to work which reflects life in a purely symbolic way, so it is easy to look at this picture without needing to recognise any one event. It is enough that throughout his paintings Chagall introduces human beings, who may be arranged in an illogical manner, but who are a constant reminder that art is above all a celebration of the humanity of mankind.

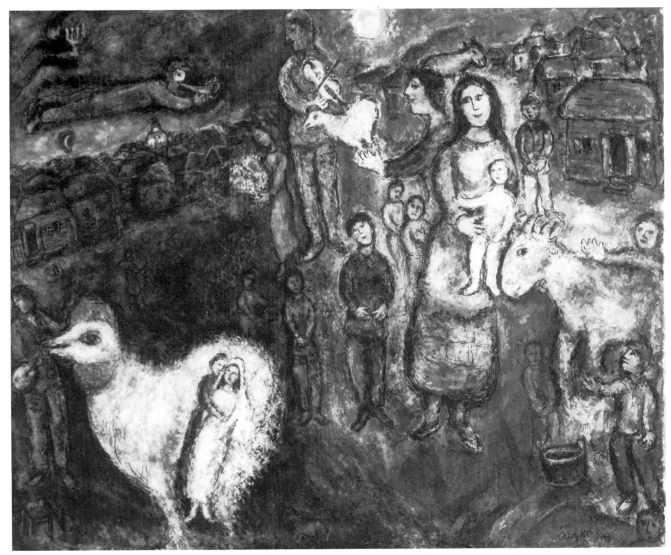

119

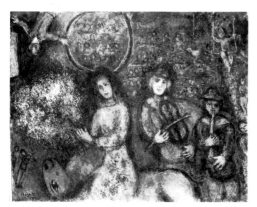

120 reproduced in colour on p. 144

120

Musicians 1979

Les musiciens

Oil on canvas
35 × 45¼ in/89 × 115 cm
Pierre Matisse Gallery, New York

Chagall sees the circus as a tragic performance. 'Throughout the centuries', he wrote, 'it has been man's most piercing cry in his search for entertainment and joy' (*Chagall by Chagall*, p. 174). Here the protagonists are united in a quiet picture, expressing the transitory nature of the entertainment. The equestrienne carries a large bouquet of cut flowers which will wither and die; she sits tranquilly on a horse whose coloured head has rotated in the ecstasy that the artist had expressed in early pictures like *Half Past Three (The Poet)* (Cat. 20). Over her own head a trapeze artist dressed in red holds a hoop which doubles as a halo, while to her right two lonely musicians play their instruments. Chagall uses the image of the circus both as a means of communicating his theme of solitude and sadness, and as an expression of the hope that the clown may dispel the earth's grief.

REFERENCE
C. Sorlier (ed.), *Chagall by Chagall* (trans. J. Shepley), New York, Abrams, 1979.

121

The Grand Parade (1979–80)

La grande parade

Oil on canvas
47 × 52 in/119 × 132 cm
Pierre Matisse Gallery, New York

Chagall has here treated the circus theme in a formal way: the actors in the darkened arena are framed by the same performers in close-up, in an arrangement which completes the semicircle of spectators beyond. The artist himself floats overhead, carrying a large bunch of red flowers. Among the usual circus artistes, the acrobat on a trapeze, the equestrienne, the clowns, he has revived memories from earlier pictures: for example, a red-haired equestrienne sits

quietly on a magic cockerel beside a grotesque animal from *Red and Black World* (Cat. 93). But in this creature and his companions one may be forgiven for recognising characters from a play, for these circus people seem to have strayed from Andreev's *He who gets slapped*, whose heroine is an equestrienne. (It was first performed by the Moscow Arts Theatre in 1914, and was soon translated and played in England and America.) In Act I the circus manager is mocked: 'You're nothing but an ass, a *parvenu* ass.' The musicians in Chagall's picture seem more serious than Andreev's musical clowns, Tilly and Polly, yet the whole scene carries something of the delicate balance between comedy and tragedy, between the life of everyday and the life of the performer which Andreev spells out so convincingly. The artist would surely echo the words of the hero, 'He': 'I become happy when I enter the ring and hear the music. I wear a mask and I feel humorous. There is a mask on my face and I play. I may say *anything* . . .' (Act II).

REFERENCE
L. Andreev, *He who gets slapped* in *Modern Continental Plays* (ed. S. Marion Tucker), New York, Harper Brothers, 1929.

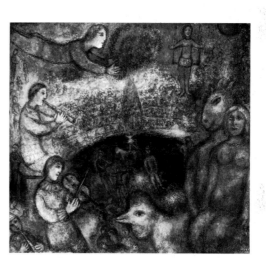

121 reproduced in colour on p. 141

122

Peasants by the Well (1981)

Les paysans au puit

Oil on canvas
51 × 32 in/129·5 × 81 cm
Pierre Matisse Gallery, New York

It can be said, without denigrating the latest work of Chagall, that in recent years he has been able to treat the canvas as an area for freer play. In *Peasants by the Well* the arrangement of scenes on the canvas is envisaged in a new way. The major protagonists, the large couple in the right foreground, occupy only a quarter of the composition. Multiple narratives, typical of the artist's work, are here placed in a ladder-like formation on the left, the small figures arranged one above another, with areas of colour

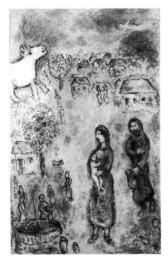

122 reproduced in colour on p. 146

mysteriously conveying the idea of recession; the scenes
continue in a horizontal band in the upper part of the
painting. This arrangement may derive originally from ikon
painting, but Chagall has broken the severe
compartmentalisation of that mode by allowing large free
areas of colour to provide a secondary scheme. The range of
colours is reduced, areas of green and grey complement the
blue; over these he has drawn his figures with small
brushstrokes barely disturbing the ground. His scene defies
all laws of gravity, yet it can be read sequentially, almost
as easily as if it followed the classical rules of perspective.

Some story is unfolding on the canvas. The single figures
grouped in pairs, making their way towards the well, are set
in irrational positions among the trees and houses. The
mythical landscape is dominated by the large white creature
that bursts in on the upper left: it does not seem to menace
the scene, but rather to draw attention to its role, since it
is in proportion to the main figures. If it is a heifer and
represents Israel, as in *Solitude* (Cat. 79), it points to the
moving story of Jacob who fell in love with Rachel by a well
(*Genesis* XXIX). Chagall had used a similar scene the year
before for a decorative harpsichord in the auditorium of the
Musée Message Biblique in Nice, where the themes are taken
from the Book of Genesis. Whatever the connotations, he has
succeeded in working on his canvas in a highly sophisticated
manner, using colour fields as an arena of activity for his
lively brush.

123

Couple on a Red Background (1983)

Couple sur fond rouge

Oil on canvas
32 × 26 in/81 × 65.5 cm
Collection of the artist

The artist introduces himself with a memory of days long
since past in this hymn to love and paint. The fire of love
blazes with such a blinding brilliance of colour that no

photograph can convey its force. Ingredients from Chagall's
earlier pictures of lovers: the row of houses, the church, a
vase of flowers and even the little rooster, seem to tumble
out of the artist's open arms as he stands at the side of the
canvas in the position that he had often given to his clowns
(see *The Concert*, Cat. 98). But now the force of his colour,
the freedom with which he tosses the flowers and bird into
the air, are achieved with *joie-de-vivre* as well as a look of
human concern for the couple. In other centuries artists have
played with convention in later life, abandoning the
restrictions of their time. But late in this century of artistic
iconoclasm, Chagall's work has to be seen beside the freedom
of expression which has characterised the art of other such
dream-makers as the young American, Jonathan Borofsky:
while that artist finds it possible to recreate his dreams on
and off the canvas, Chagall fixes his own in a way which
is a little more conventional, and, one dares to say, pictorial.
For although he marks the canvas with such freedom in
order to portray his figures and houses with the circling blue
area which invokes a sky, he includes his familiar symbols,
the moon and the sun—the latter in the form of the little
rooster. These suggest to the viewer the magic of dawn, that
hour when the cock crows and night gives place to day.
Alternatively, he may identify this symbolism, perhaps
unconsciously, with the daybreak of that love which the
couple are experiencing.

A personal note may also have been intended by the artist
in this picture: he may be remembering his first love on the
banks of the Dvina so many years before, in Vitebsk. In that
case, the figure of Chagall above may represent the vision
experienced by Chagall the lover below, of his hopes for his
own future as an artist. But however the picture may appear
to each individual, the magic of its colour will cheer and
elevate.

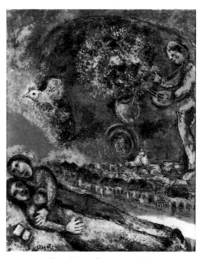

123 reproduced in colour on p. 147

244

124

The Dream (1984)

Le songe

Oil on canvas
$45\frac{5}{8} \times 35$ in/116×89 cm
Collection of the artist

In his long life Chagall has had many dreams, beginning with the nightmares which woke him in his childhood (*My Life*, p. 33). As a painter, many of them have been of lovers, very often accompanied by a vase of flowers or a still-life, as well as a street scene and even a little angel (for instance, *Night*, Cat. 94, of 1953 or *Lovers in the Lilacs*, Cat. 77, of 1930). So the ingredients of this *Dream* are by no means new, although in this recent picture they are freshly imagined with a freedom of handling which makes them so. The composition is comparatively orthodox: seen from a very high viewpoint, a row of houses and a street scene occupy the bottom of the canvas, leaving a large area of sky above. In the foreground right is the still-life element, which does not jar, so completely is it married with the coloured surface. The

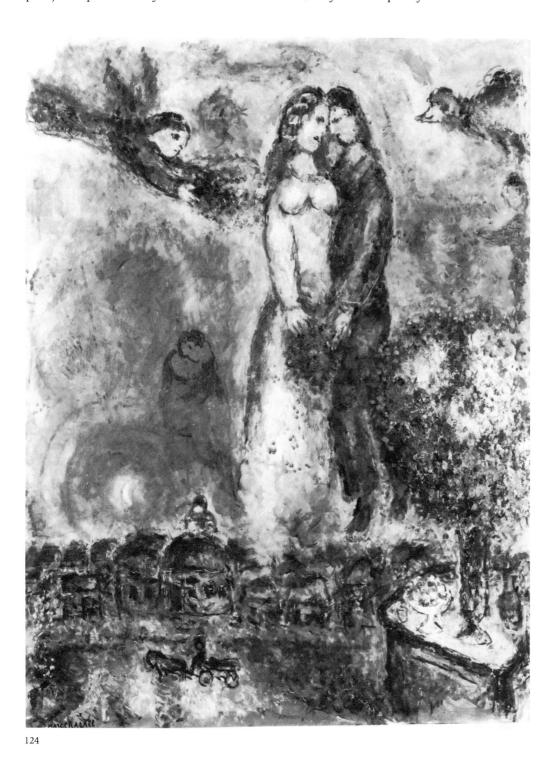

124

flowers themselves interrupt the area of sky, but since this is equally a dream-world, they become fused with the apparition of the lovers, who likewise emerge from the paint like the figments of a dream. Indeed, as a dream, the composition is remarkably coherent, although as a representation it seems closer to a dream.

With its reliance on brushstrokes and colour to knit the whole composition together, *The Dream* makes a fascinating contrast with the dream-like oil-painting, *Night*, where the artist restricted himself to black paint on which he allowed the lovers to materialise in outline form. Likewise, it makes a contrast with the small picture, *In the Night* (Cat. 84) of 1943, where the figures are restricted to the immediate foreground and the artist has cut the canvas down, in order to reduce the area of sky. Now, in his advanced years, he marries the figures and their ground, no longer concerned with day or night, but rather, absorbed by the activity of painting. He can allow colour full rein, so that his brushmarks set up a dream in which colour and image are finally fused.

125

Back to Back (1984)

Dos à dos

Oil on canvas
$51\frac{1}{8} \times 35$ in/130×89 cm
Collection of the artist

In 1977 Chagall was awarded the highest decoration that the French State can bestow: during a luncheon at the Elysée, the President pinned to the artist's lapel the decoration of the Légion d'Honneur. Here, in an astonishing display of paintwork, Chagall has imagined himself perched on a stool in a magic pathway which is at the same time some wide river and the sky of the street below: on the right, an official-looking figure offers a bouquet. The more one looks, the more remarkable the composition becomes, with the strange juxtaposition of the central pair on their stool and the landscape, like some optical illusion, changing from one shape to another according to the way it is seen. But the most amazing feature of the canvas is the web of colour made up of a mosaic of brushstrokes on which are superimposed short black lines, which turn into houses or a bridge or a bird in the sky. Yet in some places the artist has spurned these details, and obliterated them again with additional colour (for there seems to have been a horse and cart on the roadway in the foreground now covered by white marks). In other places he has used only the brush to suggest some shadowy boat or angel, to be seen emerging from the welter of coloured marks.

The sheer enjoyment of painting and the complete freedom with which Chagall disposes the colour expresses his joy. For while the great patch of red-coloured light which surrounds his left hand brings the scene forward, when the eye travels downwards and sees the street receding into the background, it is led to believe that all this is going on in a mysterious realm of the sky. The pictorial devices

evocative of Pointillism, which Chagall had used for his circus arena scenes of the years before (for instance, in *The Grand Parade*, Cat. 121, of 1979–80), have here been freed into a conglomeration of colour and brushwork. This is an act of bravado on the part of the old master, whose mind and hand preserve the freshness of the youths who accompany him so poignantly on their pipes.

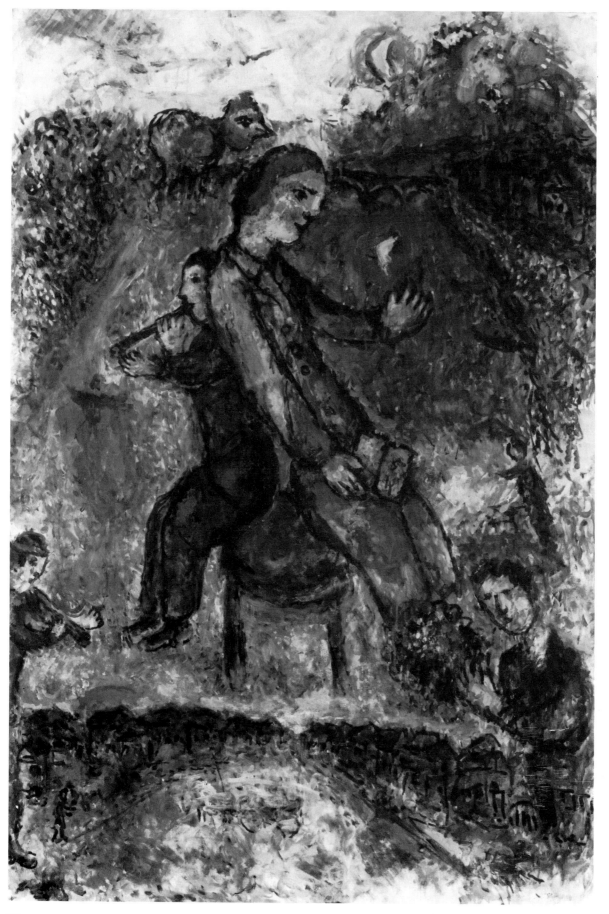

125

Theatre: *Aleko*

1942

Chagall made designs for the theatre at various times in his life, and midway in his career he had the opportunity to realise a ballet with Léonide Massine in New York.

The ballet *Aleko* was devised by the choreographer Massine, who worked with Chagall to create a scenario from Pushkin's poem *The Gipsies* for the Ballet Theatre of New York (now the American Ballet Theatre). The première was given in Mexico City on 8 September 1942; a month earlier, the whole company had left New York with Massine and the Chagalls for Mexico, where the backdrops were painted and the costumes made from the sketches which Chagall had prepared over the previous months. As well as the costume designs catalogued here there is an additional group, unsigned, which once belonged to Massine and is now in a private collection. While working on the ballet, the artist listened to records of the music chosen by himself and Massine, a piano trio by Tchaikovsky, which was especially orchestrated for the event.

The story is romantic: the restless hero Aleko, tired of civilised living, links up with a band of wandering gypsies; falling in love with Zemphira, he lives with her in her old father's tent. Aleko then discovers the infidelity of Zemphira, who has herself fallen in love with a young gypsy; her father tries to reason with Aleko, telling him of his similar experience with Zemphira's mother and how he had forgiven her great love for another. But Aleko cannot follow this example, and, finding Zemphira with her lover, kills them both; rejected by the gypsies, he is left grieving on the grave of Zemphira and her lover.

The ballet was conceived in four scenes: the backdrop for the first, entitled *Aleko and Zemphira by Moonlight* (Cat. 128), is dominated by the colour blue, on which Chagall showed hovering, disembodied figures of the two lovers, as though in a dream above the outlined tents below. The left side shows a full moon shining above a lake and both halves are joined by a flying bird, a cockerel whose flight towards the moon symbolises the pairing of man and woman. As a setting for the dance on the stage, it is a rather curious conception, for although vaguely setting a scene, it is a symbolic representation of love. Likewise, for the second act Chagall devised a backdrop called *The Carnival* (Cat. 131), which suggests a dream-world where a bear may play a violin and a monkey drops from a great bouquet of flowers. To the left of the set, a village is indicated in a sweeping curve, forming a composition as appropriate to a ceiling design as for a vertical backdrop.

For Scene 3, *A Wheatfield on a Summer's Afternoon* (Cat. 126, 134) the artist has suggested a rural theme by placing a field of ripe corn below a large sun to one side;

on the other, the lover and Zemphira are shown in a boat below a harvest moon. The whole backdrop is flooded by brilliant yellow whose intensity, on such a generous scale, beautifully conveys their passion. Although this vivid flood of colour is a complete change from most of the rather sombre pictures which Chagall had painted in the previous decade, he had thought of using a yellow background for décor twenty years before when he was still in Russia (see *Homage to Gogol*, Cat. 61). But this backdrop for *Aleko* also reflects Chagall's experience of the wide plains of the United States: in order to reach Mexico City he had to travel right across the continent and he has transferred something of the scale of that sweeping landscape to this huge canvas.

The tragedy of the final scene is echoed by Chagall's dramatic cityscape *A Fantasy of St Petersburg* (Cat. 127, 137): rejected by the band of gypsies, Aleko returns to the city where he grieves over the grave of Zemphira and her lover (the graveyard occupies the extreme left side of the backdrop). The artist has chosen St Petersburg for this scene, and, though tiny, clearly silhouetted against the lowering sky he has shown the statue of the Bronze Horseman, the inspiration for Pushkin's most famous poem, *The Bronze Horseman*. The statue gives significance to Chagall's horse which unaccountably rears upwards in the background and, with its huge form, dominates the lowering grey sky. Its nose touches the light from a candelabra which has apparently strayed from a St Petersburg ballroom of the time of Pushkin. So the backdrop is also a memorial to the unhappy fate of the young Russian poet, who had died so tragically in 1837, in a duel with a Frenchman whom he suspected of being too close to his wife. This drama of the real life of Pushkin, the author of *The Gipsies* on which *Aleko* is based, is thus brought to the attention of the audience, who watch Aleko grieving at the result of his own misguided revenge.

In his inimitable way, however, Chagall gives his scene even broader significance, for it is strongly reminiscent of Leningrad—the modern St Petersburg—in 1942 and a reminder of the terrible suffering that was taking place there during the war. In this context, the horse with its chariot can be interpreted as an allusion to the chariot which took Elijah away from his people, a theme which had fascinated Chagall in his early years (see, for instance, *The Flying Carriage*, Cat. 35). However, in 1942 the backdrops for scenes 1 and 3, flooded with pure colour, hardly broken by small motifs, must have seemed sensational (for American Abstract Expressionist painting by artists such as Rothko as yet existed only in embryonic form). When the ballet was first performed in New York on 6 October 1942, the scenery

inspired a critic to write in the *New York Times*: 'Chagall has designed and painted with his own hand four superb backdrops which are not actually good stage settings at all, but are wonderful works of art . . . So exciting are they in their own right that more than once one wished all those people would quit getting in front of them'. Chagall told Jacques Lassaigne: 'I wanted to penetrate into *The Firebird* and *Aleko* without illustrating them, without copying anything, I don't want to represent anything. I want the colour to play and speak alone. There is no equivalence between the world in which we live, and the world we enter in this way'.

REFERENCE
J. Lassaigne, quoted without source in A. Werner, *Chagall Watercolours and Gouaches*, New York, Watson-Guptill, 1970.

126 Not reproduced in the catalogue

Backdrop for Act 3: A Wheatfield on a Summer's Afternoon

Tempera on fabric
30 × 50 ft/9·14 × 12 m
Collection of Leslie and Stanley Westreich

127 Not reproduced in the catalogue

Backdrop for Act 4: A Fantasy of St Petersburg

Tempera on fabric
29 × 47½ ft/9·14 × 12 m
Collection of Leslie and Stanley Westreich

128

Aleko and Zemphira by Moonlight (Scene 1)

Gouache, wash, brush and pencil
15 × 22½ in/38 × 57 cm
Museum of Modern Art, New York; acquired through the Lillie P. Bliss Bequest

129

Zemphira: costume design (Scene 1)

Gouache, watercolour and pencil
21 × 14½ in/53·5 × 37 cm
Museum of Modern Art, New York; acquired through the Lillie P. Bliss Bequest

130

Choreographic suggestions for Scene 1

Gouache, watercolour, wash, brush and pencil
21 × 14½ in/53·5 × 37 cm
Museum of Modern Art, New York; acquired through the Lillie P. Bliss Bequest

131 Reproduced in colour on p. 148

The Carnival (Scene 2)

Gouache, watercolour, wash, brush and pencil
15⅛ × 22½ in/38·5 × 57 cm
Museum of Modern Art, New York; acquired through the Lillie P. Bliss Bequest

132

Clown: costume design (Scene 2)

Gouache, watercolour, wash, brush and pencil
15⅞ × 11⅞ in/40·5 × 30 cm
Museum of Modern Art, New York; acquired through the Lillie P. Bliss Bequest

133

Bear mask

Papier-maché
7½ × 9 × 13 in/18 × 22 × 33 cm
Collection of Leslie and Stanley Westreich

134

A Wheatfield on a Summer's Afternoon (Scene 3)

Gouache, watercolour, wash, brush and pencil
15¼ × 22½ in/38·5 × 57 cm
Museum of Modern Art, New York; acquired through the Lillie P. Bliss Bequest

135

Choreographic suggestions for Scene 3

Gouache, watercolour, wash, brush and pencil
8¼ × 10¼ in/21 × 26 cm
Museum of Modern Art, New York; acquired through the Lillie P. Bliss Bequest

136

Dancing Birch Trees: Sketch for choreographer

Gouache, watercolour, wash, brush and pencil
16 × 11⅞ in/40·5 × 30 cm
Museum of Modern Art, New York; acquired through the Lillie P. Bliss Bequest

137 Reproduced in colour on p. 149

A Fantasy of St Petersburg (Scene 4)

Watercolour and gouache, graphite underdrawing
15 × 22½ in/38 × 57 cm
Museum of Modern Art, New York; acquired through the Lillie P. Bliss Bequest

138

A poet and his muse: costume design (Scene 4)

Gouache and pencil
16 × 11¾ in/40·75 × 30 cm
Museum of Modern Art, New York; acquired through the Lillie P. Bliss Bequest

139

Weak-minded man: costume design (Scene 4)

Gouache, watercolour and pencil
12¼ × 9⅞ in/31 × 24·8 cm
Museum of Modern Art, New York; acquired through the Lillie P. Bliss Bequest

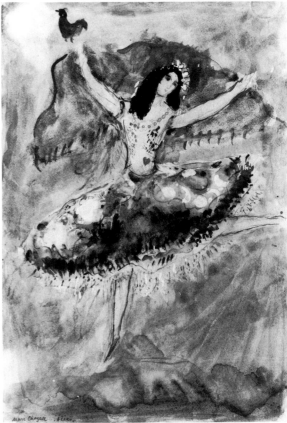

128

129

130

131

132

133

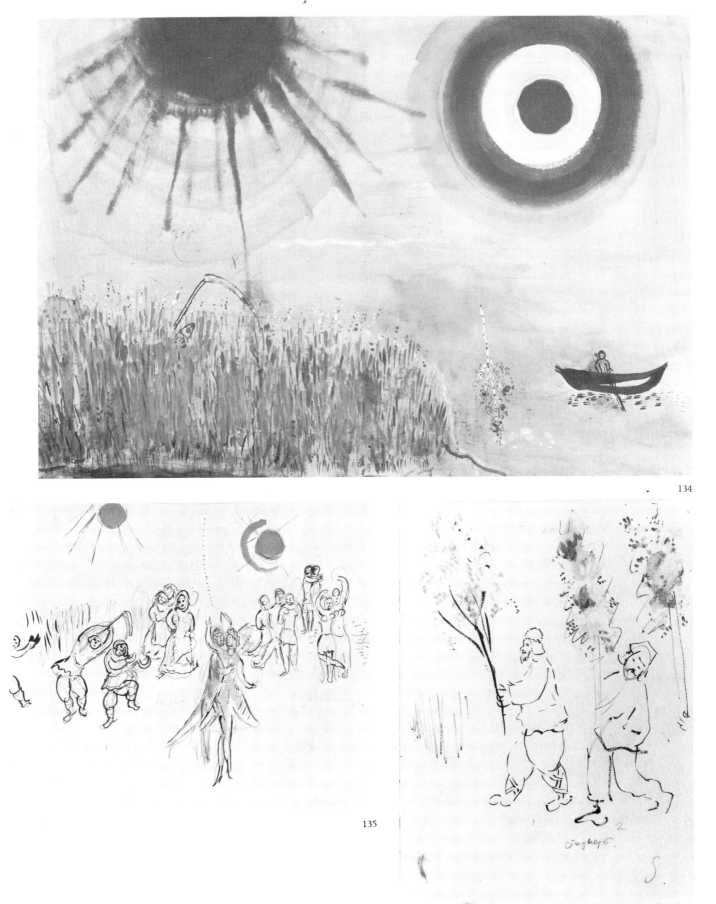

134

135

136

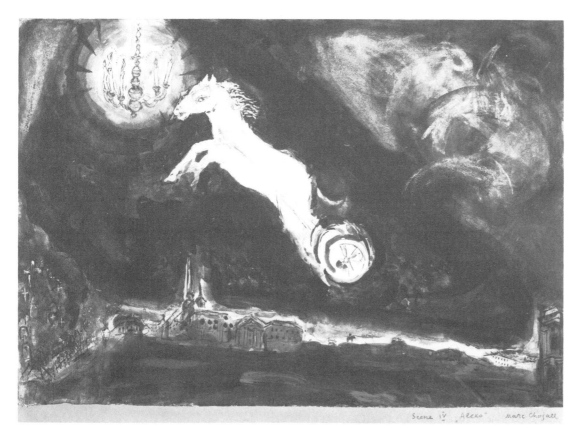

137

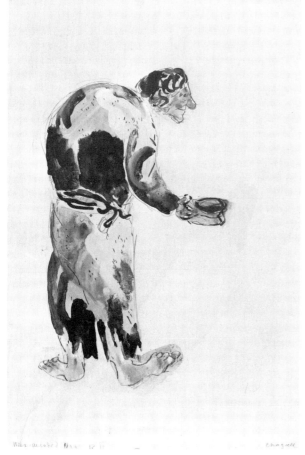

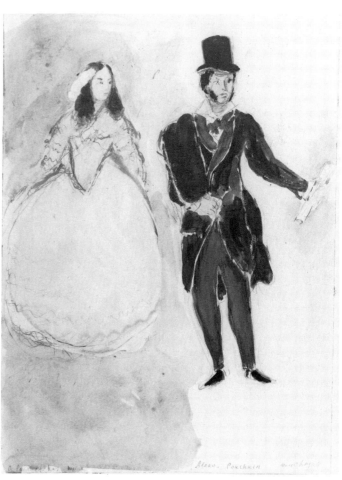

139

138

Stained Glass

It is only since the age of seventy that Chagall has become involved with stained glass; in the last period of his life he has achieved originality in a new medium. The scale of the commissions is vast, his windows adorn cathedrals and public buildings in many countries of the world. He has created religious and secular subjects as appropriate, and must be recognised today as the foremost artist in the field.

He collaborates with Charles Marq, an artist who is both a stained glass specialist and the artistic director of the Jacques Simon Atelier in Reims, a firm that has worked closely with modern artists to realise their designs in glass. Charles Marq has described his collaboration with Chagall and how he uses the artist's maquette (see Cat. 142) which he describes as a work perfect in itself and impossible to copy slavishly: he says that Chagall mysteriously incites him to make the gouache come alive by translating it into glass. They met when Chagall received a commission for windows in Metz Cathedral in 1957, and discussed the way light plays a creative role in stained glass. Because natural light is unpredictable and its brightness changes from moment to moment, it may suddenly transform the shapes, shining more or less strongly through the glass so that form and colour depend ultimately on its power. This is not just a question of technique, of the position of the leads, or the scale, for the effect is quite different from a canvas covered with paint which deflects the light rays: on the contrary, the coloured areas of glass framed by lead are penetrated by light, and density is achieved by creating more or less opaque areas of pure colour. Chagall had a vision of the final result he wanted, so Charles Marq gradually made a complete range of colours with laminated glass which allowed modulation within a single piece. By etching away the glass with acid he varied the colour values within a particular tone, continuing until he reached pure white, so that it was unnecessary to use lead as a separator between each colour change. This method, which allowed light to penetrate the same piece of glass in different intensities, gave a special life to each colour. Marq believes that white makes colour live, determining and defining it, as well as forming a contrast with the black grisaille which is finally painted onto the surface of the coloured glass by Chagall himself.

The successful collaboration with the artist depends on Charles Marq interpreting the original colours of the maquette in pieces of glass. But the work does not end there: when the panes have been prepared and provisionally put together in terms of light and colour, Chagall himself goes to Reims and paints the figures and shadows onto the surface in grisaille. By using brushes for the forms, Chagall adds his own hand before the final firing.

The role given to the lead is unusual: it is needed, of course, to join the pieces of coloured glass together, but in Chagall's glass it does not perform a *cloisonné* effect, limiting and defining the forms, but it is usually arranged in sweeping lines which, in large-scale work, carry right across the composition, giving it a curved, ladder-like construction. Sometimes the line of lead follows the sweep of an animal's back, as for instance, in *The Tribe of Joseph* (Cat. 148); at other times it is used to increase the expressive curve of a figure, as in the angel in *The Dream of Jacob* (Cat. 141). In one pair of windows for Tudeley Church (Cat. 152) the lead takes the organic form of a tree.

Stained glass has allowed Chagall full rein for his pleasure in colour. His first experience of the special property of colour in this medium was as early as 1952, when he visited Chartres and made detailed studies of the medieval windows. As a result, colour flooded into his paintings: *The Concert* (Cat. 98) shows how he increased the brilliance in oil-paintings in that decade. When he came to receive commissions for stained glass, he was able to bring to the work a lifetime's experience of colour relationships.

One writer has described Chagall's achievement thus: 'The spiritual experience of the Beyond, the transcendental, met with by the artist in the Bible and in his own heart, is articulated to perfection in the transparency and translucency of his colours' (Irmgard Vogelsanger-de Roche, p. 5).

REFERENCES
C. Marq, 'Postface', in R. Marteau and C. Marq, *Les Vitraux de Chagall, 1957–1970*, Paris, Mazo, 1972; I. Vogelsanger-de Roche, *Marc Chagall's Windows in the Zürich Fraumünster*, Zurich, Orell Füssli, 1979.

The Cathedral of St Etienne, Metz 1959–62

For ten years Chagall worked on stained glass for three windows in the ambulatory of Metz Cathedral (Cat. 140–44). The commission involved fitting in with a programme of subject-matter as well as adapting it to windows of varying shapes. The first, of 1959–60, was the second window of the north apse made by Charles Marq from the finished maquette (Cat. 143). Each of the three lancets is dedicated to one of the prophets, Moses, David and Jeremiah (compare *The Prophet Jeremiah*, (Cat. 106): above them are two small quatrefoil windows surmounted by a Rose, represented in this exhibition by a trial version).

140 Not reproduced in the catalogue

Rose Window 1962

81 in/205 cm diameter
Fondation nationale d'art contemporain, Paris

The theme of this window is Christ surrounded by symbols and the maquette (Cat. 142) shows that Chagall conceived the individual panes as all that can be seen of an all-embracing composition. In the centre, in a cinquefoil space, he shows Jesus of Nazareth with arms outspread on the cross which is suggested behind the head. Instead of a halo, he wears the *tefillin*, a ritual box of parchment worn traditionally by praying Jews (see Cat. 43); he is supported by his mother who shares his quiet suffering. Round the central light are five trefoils, two showing angels, a third, three candles in a five-branched candlestick; a fourth includes symbols of suffering—rods used to beat Jesus together with a palm from his entry into Jerusalem. These motifs are continued in the final trefoil which includes part of a ladder, continued in the small window which completes the Rose leading the viewer into another realm. The shape of these five remaining lights resembles a pair of wings: the artist has suggested a dove as well as emblems of day and night.

141 Reproduced in colour on p. 152

The Dream of Jacob 1962

Le Songe de Jacob
120 × 41¼ in/305 × 104 cm
Private Collection

This is a trial for the third lancet of the first window of the north apse of Metz Cathedral as part of the second stage of the commission. The scale is conveyed by the maquette, for *The Dream of Jacob* is one of a series devoted to the patriarchs Abraham, Jacob and Moses (see Cat. 143).

From the earliest sketch it was clear that the *Dream of Jacob* was eminently suitable for a narrow window, for the ladder provided a structure on which the rest of the composition could be built. The dominant angel spreads his arms in an expansive gesture which is strengthened by the lead; he is balanced by a descending angel which seems to float, head first, on the other side of the ladder. The little figure of Elijah with a sack on his back, which has reappeared many times since *Over Vitebsk* (Cat. 46), can be

seen standing on a crescent moon in the maquette but not so clearly in the window. This is one occasion on which the translation into stained glass was less than faithful, though the task may have been impossible because of the necessity for the horizontal supporting bar which keeps the stained glass in place in the window opening.

The complexity of the colours and the vivid contrast between the deeper red and the lighter pinks, mauve and blue enhance the composition, while the white light which streams through the angels' bodies helps to dematerialise them in comparison with the solidly human figure of Jacob, asleep on the ground below. A verse from a poem by Chagall indicates how closely he identifies with the subject which he has used many times in his œuvre (see Cat. 182): 'Lying down like Jacob asleep/I have dreamed a dream/An angel seizes me and hoists me up onto the ladder,/The souls of the dead are singing' (*Sur le pays neuf*, [1955–60] in Chagall, *Poèmes*, Geneva, Cramer, 1975, pp. 85–86).

142 Not reproduced in the catalogue

Moses, David and Jeremiah 1959

Moïse, David et Jérémie
Definitive maquette for the second window of the north apse
First lancet: Moses receives the Tables of the Law
Second lancet: David and Bathsheba
Third lancet: Jeremiah and the exodus of the Jewish people
Upper lights: an angel sounding a shofar; a symbolic sign; Christ surrounded by symbols
Watercolour
52 × 32¼ in/132 × 82 cm
Musée national d'Art moderne, Centre Pompidou, Paris

143 Not reproduced in the catalogue

The Prophets, Abraham, Jacob, Moses 1962

Les Patriarches, Abraham, Jacob, Moïse
Definitive maquette for the first window of the north apse
First lancet: The sacrifice of Isaac
Second lancet: The struggle of Jacob and the angel
Third lancet: The dream of Jacob
Fourth lancet: Moses and the burning bush
Upper lights: Joseph the shepherd; Noah's Ark; the bird; Jacob weeping over Joseph's coat; the hand of the artist; the rainbow as a sign of covenant.
Watercolour
56¼ × 36⅝ in/143 × 93 cm
Collection of the artist

144 Not reproduced in the catalogue

Creation (Paradise) 1963–64

La Création (Le Paradis)
Definitive maquette for the north transept, west side
First lancet: The creation of man
Second lancet: The creation of Eve
Third lancet: Eve and the serpent
Fourth lancet: Adam and Eve expelled from paradise
Upper lights: Flowers and animals; people; stars; Moses; lion and fish
Watercolour
57 × 37½ in/145 × 95 cm
Collection of the artist

The Synagogue at the Hadassah Medical Centre, Jerusalem

1960

The four glass samples exhibited here were fired to test the colours. They were made by Charles Marq after the artist's maquettes for three of twelve windows for the synagogue attached to the Hadassah Medical Centre at the Hebrew University just outside Jerusalem (at Ein Karem). It is a square building with three round-headed windows on all four sides, one devoted to each of the twelve tribes of Israel.

Chagall has based his windows on the account of the twelve tribes given in *Genesis* XLIX, 1, 3–4, 13, 19, 22–24. He has followed the words of the scriptures, using the characteristics barely described in the text to create emblematic compositions: for example, the description of Reuben as 'turbulent as a flood' may have suggested the notion of using fishes for the design.

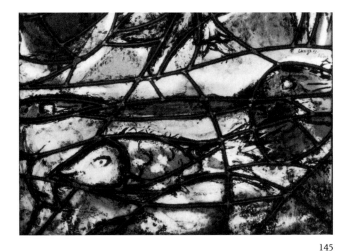

145

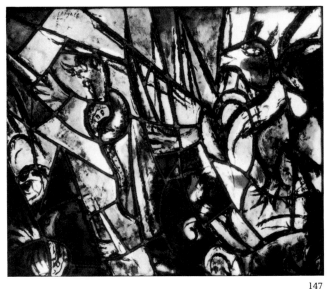

147

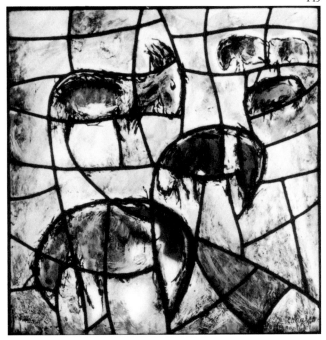

148

146

145

The Tribe of Reuben, detail of the first window

La tribu de Ruben
Glass sample
$30 \times 40\frac{3}{4}$ in/76 × 103·5 cm
Collection of the artist

146

The Tribe of Zebulun, detail of the fifth window

La tribu de Zabulon
Glass sample
$37\frac{3}{4} \times 40\frac{7}{8}$ in/96 × 104 cm
Collection of the artist

147

The Tribe of Gad, detail of the eighth window

La tribu de Gad
Glass sample
$34\frac{5}{8} \times 41\frac{3}{4}$ in/88 × 106 cm
Collection of the artist

148

The Tribe of Joseph, detail of the eleventh window

La tribu de Joseph
Glass sample
$38\frac{3}{8} \times 38\frac{1}{8}$ in/97·5 × 97 cm
Collection of the artist

All Saints, Tudeley, Kent 1966–78

The stained glass for these windows was commissioned by the parents of Sarah d'Avigdor Goldsmid as part of a cycle, of which the main east window commemorates her tragic death in an accident at sea. The four windows on view (Cat. 149–52) are destined for the north and south openings in the chancel. The blue background picks up the colour of the east window, in which Chagall suggested both sea and sky by the overall blue: different hues engulf the girl in the water below, then bear her triumphantly on her favourite horse past a Crucifixion, as though to heaven. The windows exhibited here are more abstract: angels can be seen together with natural forms, implied by the artist's drawing on the blue glass in black, as much as by the areas of contrasting colour. By continuing the use of the one colour through the whole of the chancel Chagall has not only used one of the most effective colours for glass, but he has also brought the expanse of blue sky round this church, deep in the countryside, into the building. He has thus made a poignant reminder of the short gap between heaven and earth.

(The designations of the windows are added in square brackets to identify the intended positions for the new windows which are to take the place of Victorian glass named for saints.)

149 Reproduced in colour on p. 150

[St Paul] 1978

Stained glass window
$76 \times 18\frac{1}{2}$ in/193 × 47 cm
Lady d'Avigdor-Goldsmid

150 Reproduced in colour on p. 150

[St Luke] 1978

Stained glass window
$80 \times 17\frac{3}{4}$ in/203 × 45 cm
Lady d'Avigdor-Goldsmid

151 Reproduced in colour on p. 151

[St John] 1978

Stained glass window
$62 \times 15\frac{3}{4}$ in/157·5 × 40 cm
Lady d'Avigdor-Goldsmid

152 Reproduced in colour on p. 151

[St Mark and St Matthew] 1978

Pair of stained glass windows surmounted by a quatrefoil
$51\frac{3}{4} \times 13\frac{1}{2}$ in/131·5 × 34·5 cm; quatrefoil $13\frac{1}{2}$ in/34·5 cm diameter
Lady d'Avigdor-Goldsmid

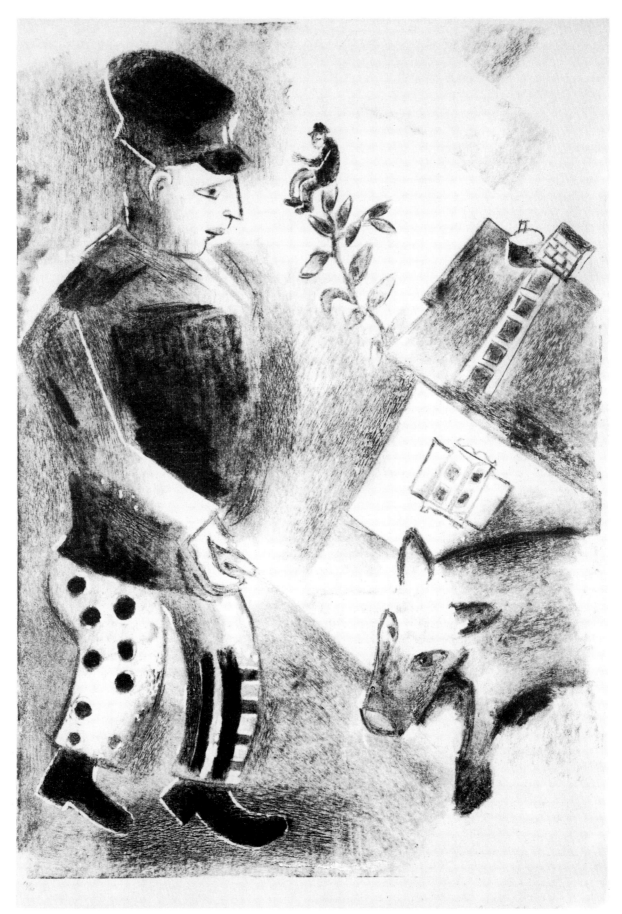

159

Prints & Books

In his long life Chagall has executed very many graphic works; indeed, he must be more widely known as a popular artist for his lithographs than for his work in other media. Less well-known than they deserve to be are his prints in black and white from the 1920s and 1930s, and above all, the etchings of those years. Sustained by commissions from the far-sighted Ambroise Vollard, Chagall devoted himself to illustrating three major texts: the first, Gogol's *Dead Souls*— a Russian classic, chosen by himself; the second, *Fables* by La Fontaine—Vollard's idea; and finally, a series of plates for the *Bible* which Chagall himself had yearned to make. Selections from each of the books, which occupied the artist from 1924 until 1939, provide three parts of this section. The fourth is devoted to the most personal, and in some ways most idiosyncratic, the earliest trials that Chagall made in the medium, most of them executed in the year that he lived in Berlin, 1922–23. Each section, therefore, has a character of its own, in part provided by the nature of the literary text. This is true even of the fourth, because Chagall left Russia with a manuscript—his autobiography—which he hoped to translate and publish with his own illustrations. In the event, the personal and even quirky style proved impossible to translate into German, so a gallery-owner, Paul Cassirer, proposed to publish a portfolio of the plates alone. These were made under the tutelage of a famous printmaker, Herman Struck, author of *The Art of Etching* (Meyer, p. 318).

Chagall certainly benefited from his thorough training in a technique which, in the twentieth century, had been less used by artists than lithography or, indeed, woodcut. He did try out those two methods of making artists' prints and some are included in the first section, though the only woodcut shown here was not printed until 1950. This *Goat with Violin* (Cat. 158) shows the instinctive feeling that Chagall had for black and white: the decisive outlines flow round the animal, the violin and the lamp, in a fluid style which exploits the nature of the medium. The cut-away areas are gouged out with different kinds of texture, enlivening the blank areas of black.

This variation of the surface is to be seen in two lithographs made in Berlin: in *Man Drinking Tea* (Cat. 160), thick lines alternate with very thin ones, creating an expressive record of a Jew at table. In contrast, the *Man with Pig* (Cat. 159), closely related to one of the murals for the State Kamerny Theatre in Moscow (see p. 42), is also more like the compositions that Chagall developed from 1923 to 1927 for *Dead Souls*, but the limitations of black and white in transfer lithography can be seen when this print is compared with the multiple textures and patterns which he achieved when he began etching. That traditional technique

had been enjoyed by masters of the past, especially Rembrandt and Goya, whose work subsequently affected Chagall's own. It permits quite another order of intensity of black and white to be realised. The technique of etching is time-consuming and requires more expertise, and for that reason transfer lithography had been preferred by many Russian artists. Drawing on specially prepared paper, which was subsequently transferred to a plate or stone, allowed the image to appear the right way round when it was printed. This meant that words could be read, which, except for one or two, is not possible when writing directly on a lithographic stone or plate. This facility made transfer lithography popular with avant-garde artists and poets in Russia; beginning with a set of artists' postcards in 1912 (see figs 20, 21), they had produced a series of books which Chagall had very likely known during his first period in Paris. But his own contribution to them was only one illustration, reproduced in the third and final issue of *The Archer* (*Strelets*) a Petrograd anthology. None the less, he had provided illustrations for several Yiddish books, published in 1917 (see *The Red Gateway*, Cat. 56), and had made drawings in black and white, such as *Leave-Taking Soldiers* (Cat. 38), from 1914 onwards. So when he came to undertake printmaking on a grander scale, he was already aware of the limitations of widely used reprographic methods.

No doubt this background meant that Chagall had an exceptional start in printmaking, since he must have been unusually aware of the effects he was aiming for. He quickly found out his preference for etching, as a glance at *The Trough* (Cat. 162) reveals: although this lithograph was worked directly on a stone or plate (because the composition is reversed, see Cat. 68), it reveals the limitation which he found in the medium, compared with the variety of texture that he achieved by etching. His mastery of the technique resulted in outstanding pictorial effects which match his imaginative imagery. While contemporary printmakers in Germany developed their powerful Expressionist explosion of personal anguish, Chagall extended the range of a classical medium which he revived and triumphantly carried forward to a renewed status in the twentieth century.

Mein Leben

Portfolio, Berlin, Paul Cassirer, 1923
110 numbered copies

Chagall's freedom of fancy in these plates matches the inconsequential text of his autobiographical writings, as well as the imaginative compositions of earlier years. Some of the illustrations are based on these, for instance the supplementary plate, *The Rabbi* (Cat. 156), follows *Feast Day (Rabbi with Lemon)* (Cat. 45). However, the composition is reversed since Chagall worked from the original or a photograph and, naturally, when the plate was laid down for printing, the image came out the other way round.

In these plates, Chagall was not afraid of a white surface, which he often enlivened with gratuitous marks, resembling the dots and dashes typical of his style of drawing just before he left Russia (see *Composition with Goat*, Cat. 62). But although he made extensive use of these abstract elements, they always remain subordinate to figuration.

153

Plate 9:
Raskin the Malamed 1922

Etching and drypoint
$9\frac{3}{4} \times 7\frac{3}{8}$ in/24·5 × 19 cm
The Jewish Museum, New York

154

Plate 10:
Dining-Room 1922

Drypoint
$8\frac{1}{4} \times 11$ in/21 × 28 cm
Öffentliche Kunstsammlung, Kupferstichkabinett, Basle

155

Plate 19:
Mother's Grave 1922

Etching
$4\frac{5}{8} \times 3\frac{1}{2}$ in/12 × 9 cm
The Jewish Museum, New York

156

Supplementary plate:
The Rabbi 1922

Etching
$9\frac{7}{8} \times 7\frac{3}{8}$ in/25 × 18·5 cm
The Jewish Museum, New York

157

Supplementary plate:
The Musician 1922

Etching and drypoint
$10\frac{3}{4} \times 8\frac{1}{2}$ in/27·5 × 21·5 cm
Öffentliche Kunstsammlung, Kupferstichkabinett, Basle

153

155

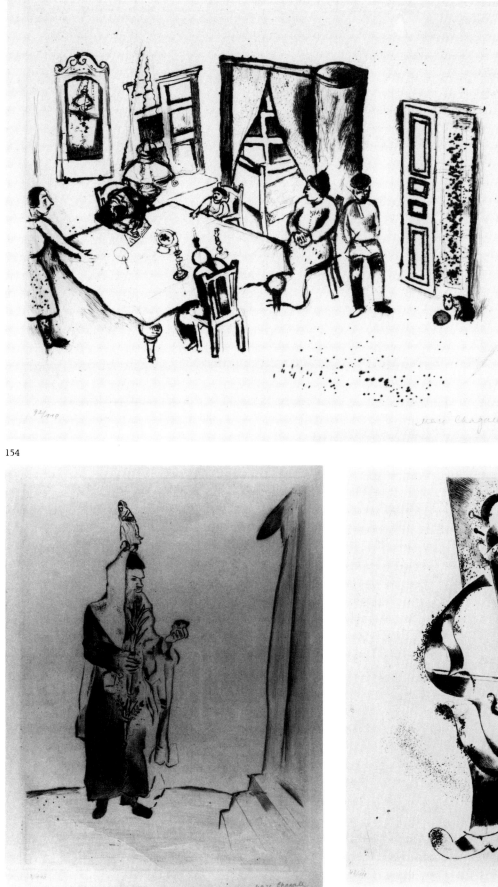

154

156

157

Other Prints

158

Goat with Violin 1922

Woodcut
$7\frac{3}{4} \times 10\frac{3}{4}$ in/20 × 27·5 cm
Edition of 20 copies; published 1950
Philadelphia Museum of Art; The Louis E. Stern Collection

159

Man with Pig 1922–23

Lithograph
$18\frac{1}{4} \times 12\frac{3}{4}$ in/46·5 × 32·5 cm
Edition of 35 copies; Paul Cassirer, Berlin
Philadelphia Museum of Art; The Louis E. Stern Collection

160

Man drinking Tea 1922–23

Lithograph
$10\frac{5}{8} \times 7\frac{3}{4}$ in/27 × 19·5 cm
Philadelphia Museum of Art; The Louis E. Stern Collection

161

Acrobat with Violin 1924

Etching and drypoint
16 × 13 in/40·5 × 33 cm
Edition of about 100 copies; planned by Ambrose Vollard for his
third *Album des Peintres-Graveurs*, which was never published
Collection of Mr and Mrs Jacob Baal-Teshuva, New York

162

The Trough 1924–25

Lithograph
$11\frac{3}{4} \times 9\frac{1}{2}$ in/30 × 24 cm
Edition of 100 copies; Galerie Bucher, Paris
Philadelphia Museum of Art; The Louis E. Stern Collection

163

Self-Portrait with Smile

Etching and drypoint
$10\frac{7}{8} \times 8\frac{9}{16}$ in/27·5 × 22 cm
Edition of 100 copies
The Art Institute, Chicago

164

Self-Portrait with Grimace 1924–25

Etching and aquatint
$14\frac{5}{8} \times 10\frac{11}{16}$ in/37 × 27·5 cm
Edition of 100 copies
The Trustees of the Victoria and Albert Museum, London

161

160

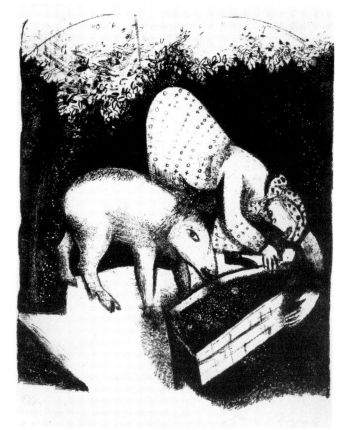

162

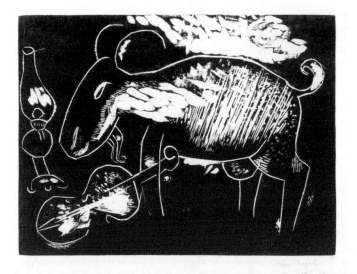

158

163

164

Nikolai Gogol, *Les Ames Mortes*

Paris, Tériade, 1948
3 vols, 335 numbered copies, plus 33 copies *hors commerce*;
110 plates, 1923–27 (printed 1927)

The choice of this text was Chagall's own: Gogol had described *Dead Souls* as a poem and the artist entered the spirit of the tale wholeheartedly, not so much illustrating particular episodes as making a pictorial accompaniment to the story—indeed, no titles are given in the book. Of all the nineteenth-century Russian classics, *Dead Souls* most nearly matches the super-realism (*Surnaturalisme*) that the poet Apollinaire had discerned in Chagall's pictures before he left Paris in 1914 (see Cat. 45). All the characters in the book are slightly larger than life, since Gogol exaggerated them in order to capture the essence of his homeland, with its extraordinary contradictions. Gogol wrote his book abroad, yet he wove into his text details which fix the time and place inexorably in the Russian provinces. When Chagall made his plates (for a French edition) he was, of course, living in France, with no expectation of returning to Vitebsk. Through Gogol's words, read aloud to him by his wife, he was able to conjure up a visual poetry to match. Some of the most effective plates are those in which he gives a partial account, cutting off a street scene in Plate III, *The Small Town* (Cat. 165), or a room, as it were homing in on a close-up view.

In contrast to the etchings for *Mein Leben* (Cat. 153–57) Chagall more generally fills the white space with telling lines: the richness of texture and the crowded surface with unexpected viewpoints excite the curiosity of the viewer, who will thereby be induced to read the text. Chagall evidently partly identified himself with Gogol, for the chapter heading that he added in 1948 (Cat. 172) shows him paired with the writer.

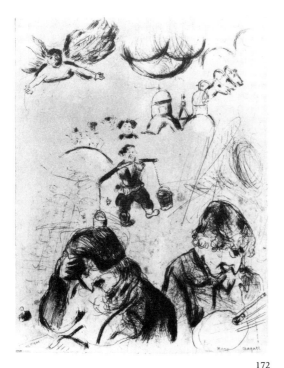

172

165

Plate III:
[The Small Town] 1923–27

Etching and drypoint
$8\frac{3}{4} \times 11\frac{3}{8}$ in/22 × 29 cm
The Art Institute, Chicago

166

Plate VIII:
[Manilov] 1923–27

Etching and drypoint
$11\frac{1}{4} \times 8\frac{3}{4}$ in/28·5 × 22 cm
The Art Institute, Chicago

167

Plate XIII:
[On the way to Sobakevich] 1923–27

Etching and drypoint
$8\frac{3}{4} \times 11\frac{1}{4}$ in/22 × 30 cm
The Art Institute, Chicago

168

Plate XIX:
[Asking the Way] 1923–27

Etching and drypoint
$11\frac{1}{4} \times 8\frac{3}{8}$ in/28·5 × 21·5 cm
The Art Institute, Chicago

169

Plate XXIII:
[The House Painters] 1923–27

Etching
$11\frac{1}{2} \times 9$ in/29 × 23 cm
The Art Institute, Chicago

170

Plate XXV:
[The Police Arrive] 1923–27

Etching
$11\frac{3}{8} \times 8\frac{3}{4}$ in/29 × 22 cm
The Art Institute, Chicago

171

Plate LV:
[?Selifan dancing at Tentetnikov's] 1923–27

Etching
$11\frac{1}{4} \times 9$ in/30 × 23 cm
The Art Institute, Chicago

172

Frontispiece to Volume II 1948

Etching and drypoint
$10\frac{3}{4} \times 8\frac{1}{4}$ in/27·3 × 21 cm
Collection of Hans Newman

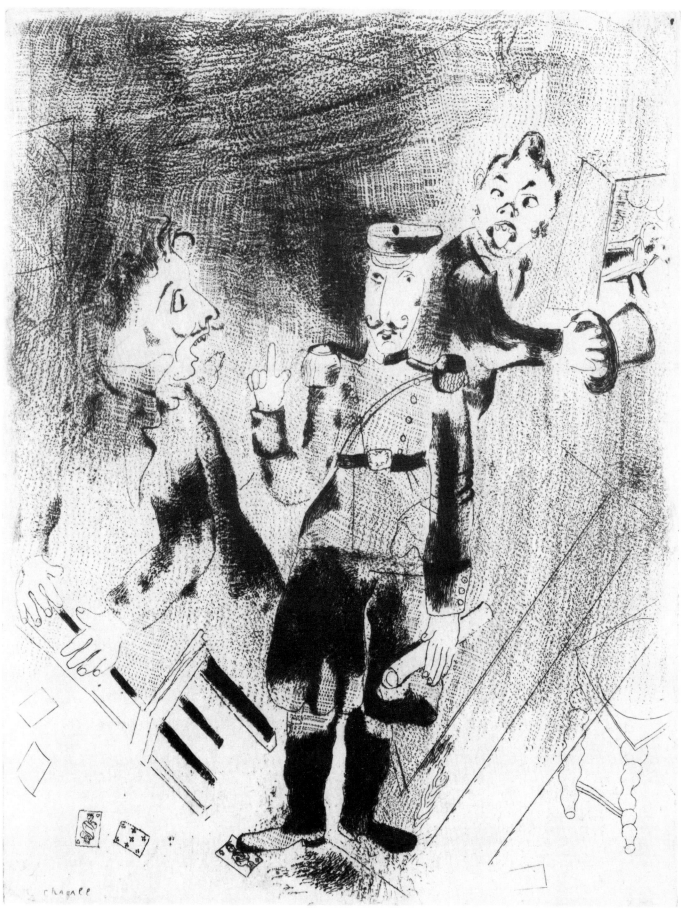

170

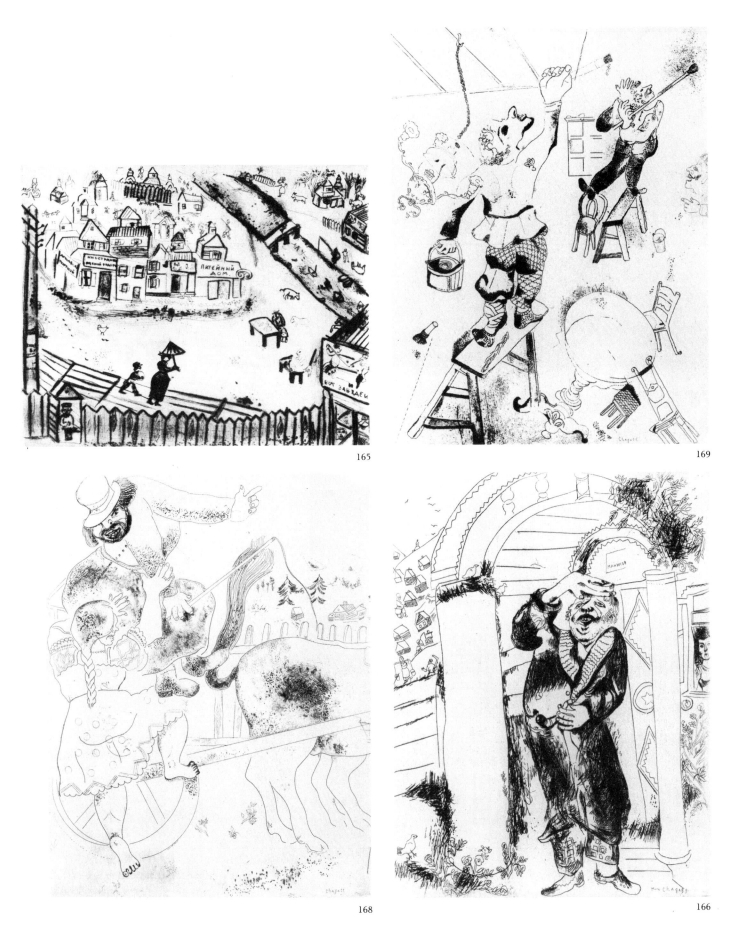

165

169

168

166

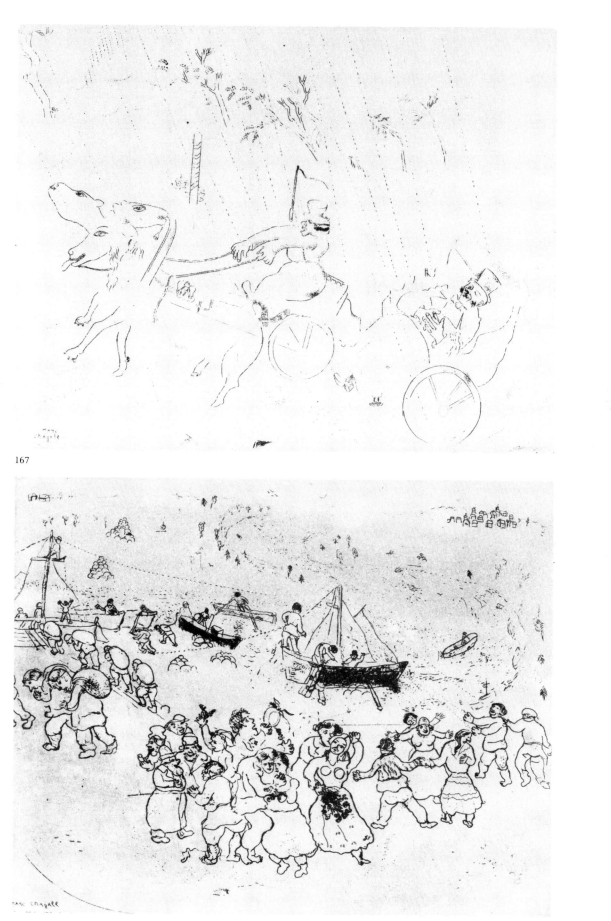

167

171

La Fontaine, *Fables*

Paris, Tériade, 1952
2 vols., edition of 200 numbered copies, and 100 portfolios;
100 plates (printed 1928–31)

Whereas the raw material for Chagall's plates for *Dead Souls* had sprung out of the essence of his experience as a Russian artist, his plates for La Fontaine's *Fables* struck at the roots of French culture. Because the *Fables* were included in the curriculum of every schoolchild, many of Vollard's fellow Frenchmen were outraged that he had invited a foreign artist to illustrate them. Vollard's original idea was for a counterpart to eighteenth-century etchings, which were to be hand-coloured. In preparation, Chagall carried out the subjects in gouache, but these proved impossible for the printers to match, though several master printers made an attempt. Finally, Chagall himself made the plates using a different graphic method, to build 'colour' out of the blacks. He mainly used drypoint (scratching the plate with a needle); he then often covered up the lines with a stopping-out varnish which heightened the pictorial effects. The wealth of textures achieved in these plates is extraordinary: few artists can rival Chagall's translation of freely applied paint—with its colour as well as surface variety—into blacks and whites.

Once again, Chagall did not illustrate in a conventional sense, preferring always to convey the essence of the fable. Some viewers may even be deterred by the artist's enjoyment of apparently random graffiti, which look, at first glance, as though he has used a traditional way of cancelling an etching plate (by covering it with scratches). At the time, Surrealist artists were experimenting with marks achieved by automatic means in order to create an art, in various media, from chance effects, by which they hoped creatively to extend the conscious mind of the viewer. In contrast, Chagall deliberately worked over his plate building up on its blank surface a series of blots, smudges and scratches which miraculously coalesce into recognisable elements from the natural world.

The illustrations for the *Fables* draw a moral for the viewer as much about art as about the human condition. La Fontaine had fashioned poems from the myths and legends of Aesop: Chagall, no doubt better acquainted with the versions by the Russian fabulist Krylov, created visual reminders which are outstanding by the richness and variety of his imagination and technique.

173

The Lion and the Rat, Vol. 1 1928–31

Le Lion et le Rat
Etching
$11\frac{3}{4} \times 9\frac{3}{8}$ in/30 × 24 cm
Private Collection

174

The Wolf, the Goat and the Kid, Vol. 1 1928–31

Le Loup, le Chèvre et le Chevreau
Etching
$11\frac{3}{4} \times 9\frac{3}{8}$ in/30 × 24 cm
Private Collection

175

The Bear and the Two Schemers, Vol. 2 1928–31

L'Ours et les deux Compagnons
Etching and drypoint
$11\frac{5}{8} \times 9\frac{1}{4}$ in/29·5 × 23·5 cm
Private Collection

176

The Heron, Vol. 2 1928–31

Le Héron
Etching
$11\frac{5}{8} \times 9\frac{1}{2}$ in/29·5 × 24 cm
Private Collection

177

How Women kept a Secret, Vol. 2 1928–31

Les Femmes et le secret
Etching and drypoint
$11\frac{9}{16} \times 9\frac{5}{16}$ in/29·5 × 23·5 cm
Victoria and Albert Museum, London

178

The Two Parrots, the King and his Son, Vol. 2 1928–31

Les deux Perroquets, le Roi et son Fils
Etching and drypoint
$11\frac{1}{2} \times 9\frac{1}{4}$ in/29 × 23·5 cm
Private Collection

179

The Two Goats, Vol. 2 1928–31

Les deux Chèvres
Etching
$11\frac{1}{2} \times 9\frac{1}{4}$ in/29 × 23·5 cm
Private Collection

180

The Camel and the Floating Sticks, Vol. 1 1928–31

Le Châmeau et les bâtons flottants
Etching
$11\frac{1}{2} \times 9\frac{1}{4}$ in/29 × 23·5 cm
Collection of Hans Newman

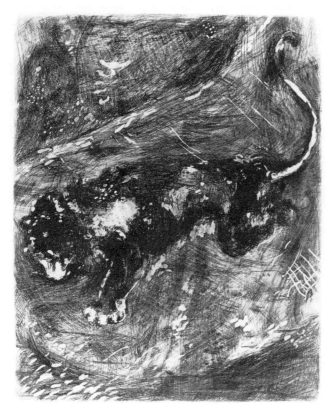

173

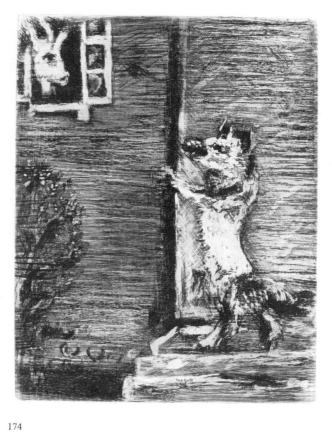

174

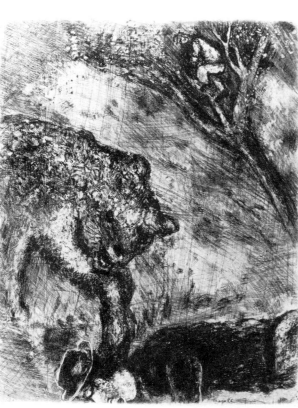

175

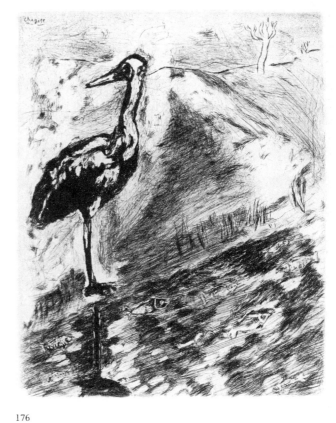

176

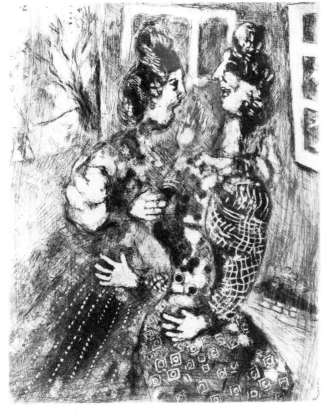

177

179

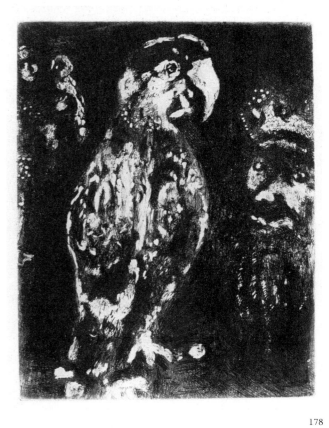

178

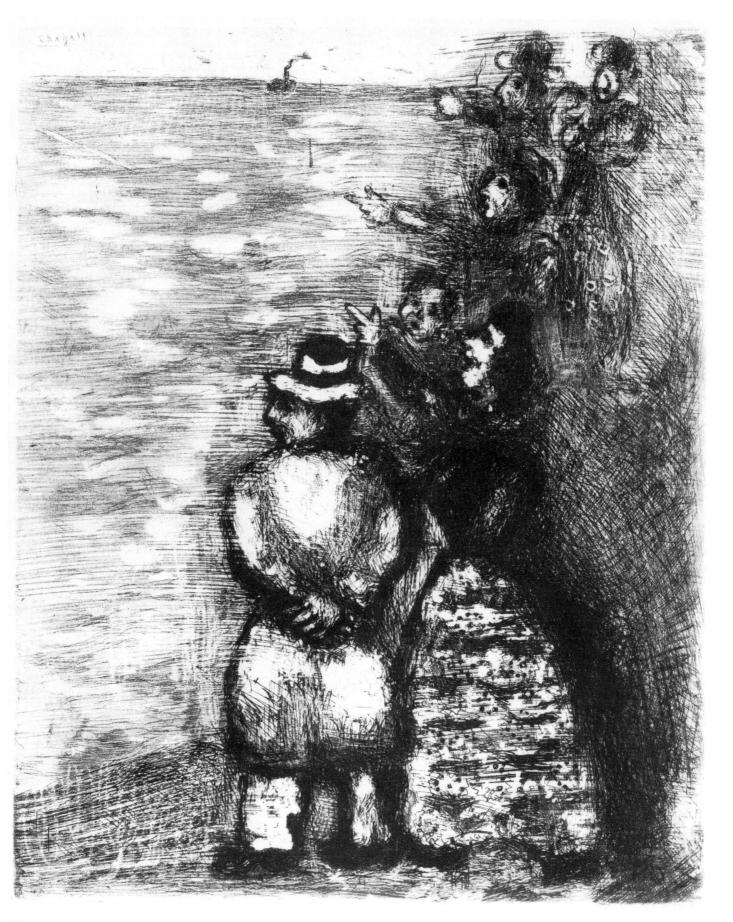

180

The Bible

Paris, Tériade, 1956
2 vols., 105 etchings;
275 copies, plus 20 *hors commerce*;
in addition, 100 numbered portfolios, hand-coloured;
105 etchings from 1931–39 and 1952–56.

Just as his plates for La Fontaine's *Fables* were based on the compositions carried out in gouache, Chagall took the balance of tones in his Bible etchings from his originals in the same medium. However, whereas he had used brilliant colours for many of the gouaches for the *Fables*, the ones for the *Bible* depend on a subtle blend of deep and closely related hues. Furthermore, in the early plates, for instance plate II, *The Dove From the ark* (Cat. 181), Noah in the ark with his family and animals are seen in close-up and mainly in profile; the figures are hierarchical and magisterial in comparison with the idiosyncratic pictorial relationships of man and animals in the *Fables* (such as, *The Bear and the Two Schemers*, Cat. 175). Moreover, in order to render the tones, Chagall etched in a simpler manner: although he continued similar methods of overworking—stopping out areas that he had already worked with varnish—he now used sandpaper or more transparent varnish to achieve effects of lighting. The results reflect his preparatory visit to the Middle East (see *The Wailing Wall*, Cat. 78).

Chagall approached the subject in full awareness of its historical and spiritual significance. As a child, like other boys from Jewish families, he had learnt from a rabbi (*My Life*, pp. 48–49): for the portfolio *Mein Leben* he had immortalised such a teacher in *Raskin the Malamed* (Cat. 153), conceived as a boy might have drawn a caricature of his teacher. But now Chagall entered fully into the spirit of Vollard's commission, one that he desired to carry out in the spirit of his heritage. The emotions evoked by his visit to Palestine shine through the etchings: plate XLIX, *Joshua and the Vanquished Kings* (Cat. 187) arises from a profoundly felt, vivid recreation of the past that transcends any sectarian bias. As Chagall continued to work on the plates, his feelings shone through even more clearly, so that the last plate which he etched in Europe in 1939, Plate CI, *The Capture of Jerusalem* (Cat. 188) was filled with a spirit of foreboding for the present as much as memory of the past. On the eve of the outbreak of war, Chagall sensed horror for Jews which he conveyed by showing an angel or the spirit of Jerusalem hovering over a column of refugees, in a composition which anticipated many of his later pictures (see, for example, *The Wedding*, Cat. 86).

Although it would be possible to draw an analogy with the etchings of great masters of the art in previous centuries (and Chagall himself has expressed his great admiration for Rembrandt), these examples of his skill in the medium show his depth of understanding and sympathy for a spiritual relationship of man and God that sets him apart from other artists of this century.

181

Plate II: The Dove from the ark

La colombe de l'arche
Etching and drypoint
$11\frac{5}{8} \times 9\frac{1}{2}$ in/19·5 × 23·5 cm $12\frac{1}{2} \times 9\frac{1}{2}$ in/31·7 × 23·7 cm
The Trustees of the Victoria and Albert Museum, London

182

Plate XIV: Jacob's ladder

L'échelle de Jacob
Etching
$11\frac{5}{8} \times 9\frac{1}{2}$ in/29·5 × 24 cm
The Trustees of the Victoria and Albert Museum, London

183

Plate XXIII: Joseph recognised by his brothers

Joseph reconnu par ses frères
Etching
$11\frac{5}{8} \times 9\frac{1}{4}$ in/29·5 × 23·5 cm
The Trustees of the Victoria and Albert Museum, London

184

Plate XXXV: The dance of Mary, sister of Moses

Miriam et ses compagnons
Etching and drypoint
$11\frac{5}{8} \times 8\frac{15}{16}$ in/29·5 × 22·5 cm
The Trustees of the Victoria and Albert Museum, London

185

Plate XXXVIII: The golden calf

Le veau d'or
Etching and drypoint
$11\frac{1}{2} \times 9\frac{1}{16}$ in/29·2 × 23 cm
The Trustees of the Victoria and Albert Museum, London

186

Plate XL: Aaron and the candlestick

Aaron et le chandelier
Etching
$11\frac{1}{2} \times 9\frac{1}{8}$ in/29 × 23 cm
The Trustees of the Victoria and Albert Museum, London

187

Plate XLIX: Joshua and the vanquished kings

Josue et les rois vaincus
Etching and drypoint
$11\frac{5}{8} \times 9\frac{1}{8}$ in/29·5 × 23 cm
The Trustees of the Victoria and Albert Museum, London

188

Plate CI: The capture of Jerusalem

Le prise de Jérusalem
Etching and drypoint
$12\frac{3}{16} \times 9\frac{1}{2}$ in/31 × 24 cm
The Trustees of the Victoria and Albert Museum, London

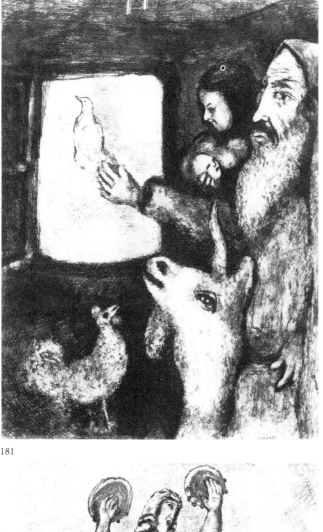

181

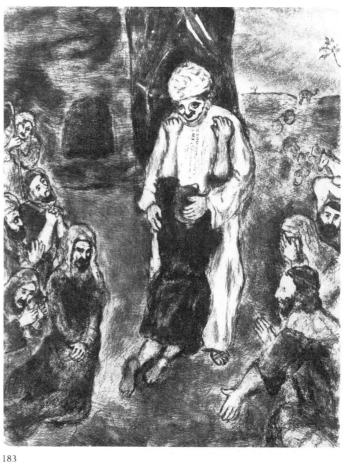

183

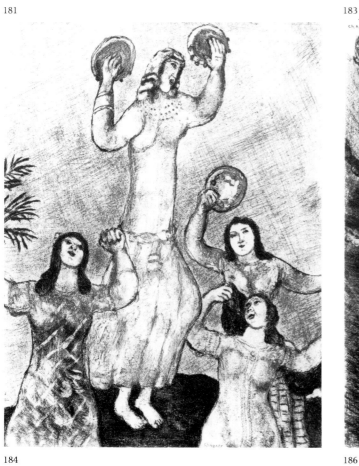

184

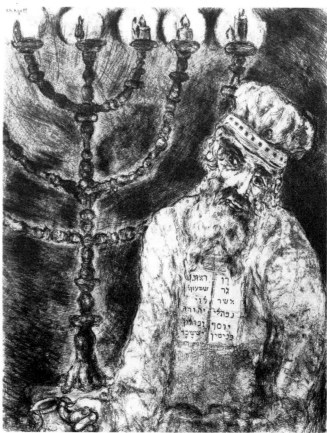

186

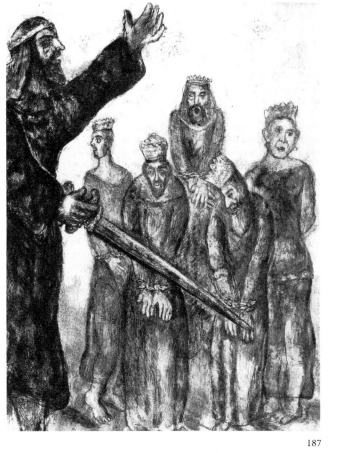

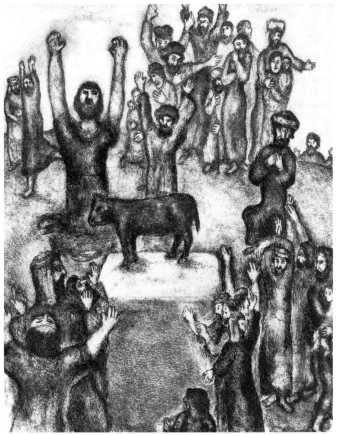

187

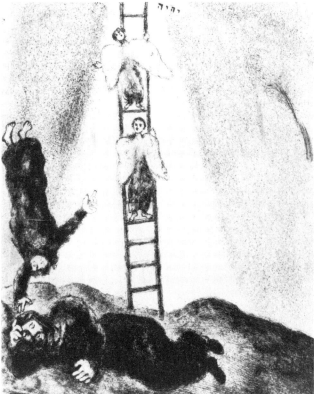

182

185

188

Books

189

A. Efros, IA. Tugendkhol'd, *Iskusstvo Marka Shagala*

Moscow, Gelikon, 1918
Philadelphia Museum of Art

190

Marc Chagall, Sturm-Bilderbücher/1 (2nd edn)

Berlin, *Der Sturm*, 1923
The British Library Reference Division

191

J. Giraudoux and others, *Les sept péchés capitaux*

Eaux-fortes de Marc Chagall, Paris, Simon Kra, 1926
15 etchings printed by L. Fort; no. 266 from edn of 300
The National Art Library, Victoria & Albert Museum

192

La Fontaine, *Fables*

Eaux-fortes originales de Marc Chagall, 2 vols, Paris, Tériade, 1952
100 etchings, printed by M. Potin (1928–31); no. 112 of 200
The National Art Library, Victoria & Albert Museum

193

Bible

Eaux-fortes originales de Marc Chagall, 2 vols, Paris, Tériade, 1956
105 etchings, 66 printed by M. Potin (1931–39)
39 printed by R. Haasen (1952–56); no. 252 of 275
The National Art Library, Victoria & Albert Museum

All my life I have drawn horses that look more like donkeys or cows. I saw them in Lyozno, at my grandfather's, where I often asked to go along to the neighbouring villages when he went to buy livestock for his butcher's shop.

At the sight of horses, who are always in a state of ecstasy, I think: are they not, perhaps, happier than us? You can kneel down peacefully before a horse and pray. It always lowers its eyes in a rush of modesty. I hear the echo of horses' hooves in the pit of my stomach. I could race on a horse for the first time and the last towards the brilliant arena of life. I would be aware of the transcendence, of no longer being alone among the silent creatures whose thoughts of us only God can know.

These animals, horses, cows, goats among the trees and hills: they are all silent. We gossip, sing, write poems, make drawings, which they do not read, which they neither see nor hear.

I would like to go up to that bareback rider who has just reappeared, smiling; her dress, a bouquet of flowers. I would circle her with my flowered and unflowered years. On my knees, I would tell her wishes and dreams not of this world.

I would run after her horse to ask her how to live, how to escape from myself, from the world, whom to run to, where to go.

Marc Chagall, from *Le Cirque* 1967, New York, Pierre Matisse
Gallery, 1981

Select Bibliography

Apollonio, U. *Chagall*, Venice, Alfieri, 1949

Ayrton, M. *Chagall*, with notes by the artist (The Faber & Faber Gallery), London, Faber & Faber, 1948

Bidermanas, I. and McCullen, R. *The World of Marc Chagall*, London, Aldus Books, 1968

Brion, M. *Chagall*, London, Oldbourne Press, 1961; New York, Harry N. Abrams, 1961

Cassou, J. *Marc Chagall*, London, Thames and Hudson, 1965

Chagall, M. *Sturm-Bilderbuch*, Berlin, Verlag Der Sturm, 1923

Däubler, T. *Marc Chagall*, Rome, Valori plastici, 1922

Efros, A. and Tugendkhol'd, J. *The art of Marc Chagall*, Moscow, 1918

Erben, W. *Marc Chagall*, Munich, Prestel-Verlag, 1957; New York, Frederick A. Praeger, 1957; London, Thames and Hudson, 1957

Fierens, P. *Marc Chagall* (Collection les artistes nouveaux), Paris, G. Crès, 1929

George, W. *Marc Chagall*, Paris, Nouvelle Revue Français, 1928

Haftmann, W. *Marc Chagall*, trans. H. Baumann and A. Brown, New York, Abrams, 1972

Kloomok, I. *Marc Chagall, his life and work*, New York, Philosophical Library, 1951

Kornfeld, E. W. *Verzeichnis der Kupferstiche Radierungen und Holzschnitte von Marc Chagall*, vol. I, 1922–1966, Bern, Kornfeld and Klipstein, 1970

Lassaigne, J. *Marc Chagall* (Les trésors de la peinture française), Geneva, Skira, 1952

Lassaigne, J. *Marc Chagall dessins et acquarelles pour le ballet*, Paris, xxième siècle, 1969

Maritain, R. *Chagall ou l'orage enchanté*, Geneva, Trois Collines, 1948

Marq, C. and Marteau, R. *Les vitraux de Chagall 1957–1970*, Paris, Mazo, 1972

Meyer, F. *Marc Chagall, Das graphische Werk* (Biographie und Bibliographie von Hans Bollinger, English edn), New York, Harry N. Abrams, 1957

Meyer, F. *Marc Chagall, Leben und Werk*, Cologne, Verlag DuMont Schauberg, 1961 (edns also in French, Italian and English)

Parinaud, A. *Chagall*, Paris, Bordas, 1966

Provoyeur, P. *Chagall, le Message Biblique*, Paris, Cercle d'Art, 1983

Raynal, M. *Anthologie de la peinture en France de 1906 à nos jours*, Paris, Montaigne, 1927

Schmalenbach, W. *Chagall*, Milan, Uffici Press, 1957

Schwob, R. *Chagall et l'ame juive*, Paris, Roberto A. Corréa, 1931

Sorlier, C. ed., *Chagall by Chagall*, trans. J. Shepley, New York, Abrams, 1979

Sweeney, J. J. *Marc Chagall*, New York, Museum of Modern Art, 1946

Venturi, L. *Marc Chagall*, New York, Pierre Matisse, 1945; Milan, Edizione del Milione, 1950

Werner, A. *Chagall Watercolors and Gouaches*, New York, Watson-Guptill, 1970

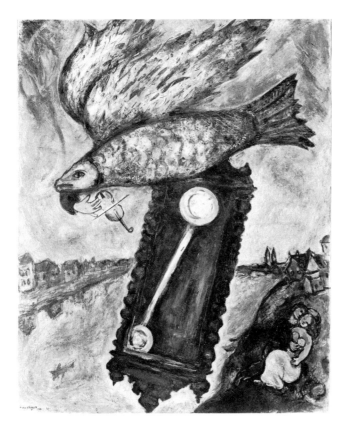

83a

Time is a River without Banks 1930–39

Le temps n'a point de rives

Oil on canvas
$39\frac{3}{8} \times 32$ in/$100 \times 81\cdot 3$ cm
The Museum of Modern Art, New York. Given anonymously